THE BOOK
⚬☀▭☀⚡ OF DIGITAL
PHOTOGRAPHY

THE BOOK OF DIGITAL PHOTOGRAPHY

CHRIS GEORGE

ILEX

The Book of Digital Photography

First published in the UK in 2006 by
ILEX
The Old Candlemakers
West Street, Lewes
East Sussex
BN7 2NZ

ILEX is an imprint of The Ilex Press Ltd
Visit us on the web at:
www.ilex-press.com

This book was conceived by
ILEX, Cambridge, England

ILEX Editorial, Lewes:
Publisher: Alastair Campbell
Creative Director: Peter Bridgewater
Editorial Director: Tom Mugridge
Editor: Adam Juniper
Art Director: Julie Weir
Design: Alistair Plumb
Design Assistant: Kate Haynes

ILEX Research, Cambridge:
Development Art Director: Graham Davis
Technical Art Editor: Nicholas Rowland

British Library Cataloguing-in-Publication Data
A catalogue record for this book is available
from the British Library

ISBN 10 – 1-904705-85-5
ISBN 13 – 9-781904-705857

Printed and bound in China

For more information on this title please visit:
www.web-linked.com/pbibuk

Contents

1.1
1.2
1.3
1.4
2.1
2.2
2.3
3.1
3.2
3.3
3.4

INTRODUCTION

Digital cameras have revolutionized photography in a remarkably short space of time. The new, and ever-evolving, technology brings with it fresh techniques and exciting new possibilities. But it is important to realize that, even if the equipment has changed, digital imaging is still about taking pictures. Despite all the new skills, there are still many old ones that need to mastered.

This book aims to provide an encyclopedic introduction to photography in the digital age. As such it not only offers a detailed look at the technology that makes digital imaging different, it also guides you through the process of taking pictures. After all, whatever camera you use, it is what you point it at, and how you set up the shot, that counts. And with digital imaging, it costs nothing to experiment—and instant results mean that you can immediately learn from your mistakes.

This book is split into three main sections, examining the three key stages in the digital imaging process. It begins with Capture—with the cameras, accessories and scanners that produce the raw image, and the techniques needed to make the most out of them. Then, we move onto Manipulation—and look at the ways in which computer programs can further improve and develop the images that you have captured. Finally, we take a close look at Output & Storage—the different ways in which you can use the digital image, from producing successful hard-copy images through to producing your own web-based photo albums.

1.1 Cameras

Digital cameras come in all sorts of shapes, sizes, and styles. They can be so small that they can be hidden from sight in another electronic device, and they can be so large that they are impossible to use without scaffolding-like supports. They can be shaped like the cameras that our fathers and grandfathers took their pictures with, or they can look like props from a sci-fi movie. Some are simple to use, others are not.

But choosing a camera to capture digital images is not just about fashion. The sort of device you use has a major impact on the sort of pictures that you can take. Some cameras are better at capturing certain subjects than others, while the best all-rounders are the ones that offer a high degree of creative control. Just as important are the speed of operation and the maximum achievable quality that the camera offers.

But adding such sophistication comes with costs. First, there is a price tag. Second, there is the convenience factor—even if budget is not an issue, we may not be prepared to put in the effort and put up with the hassle that some cameras put on their owners.

Choosing the right camera for you, therefore, is finding exactly where that compromise between cost, quality, creativity, and convenience will fall.

1.1 Basic cameras

However basic the model, there are features that are shared by every digital camera, from the webcam that is thrown in with your PC upward. The digital imaging revolution has come so far in a short time that it is easy to forget that there was a time when photography was a game of patience: you took your pictures, but you had to wait until the film was finished before you could find out what they looked like.

A digital camera gives near-instant results. You can view your pictures immediately after they are taken, without having to do anything more than flick a couple of buttons to get the shots back up on screen. The immediacy of the process means that you can share your pictures with those around you—and you can learn from the mistakes that you have made.

All digital cameras are self-sufficient: they can work in isolation and with minimum running costs. Sure, there are advantages to hooking your camera up to computers, printers, and so on, but the camera has a memory that is reusable and can be accessed to view the images without the need for a further device or chemistry. Even the power needed for all this electronics usually comes from a rechargeable source.

4-step process

Whatever the model, there are essentially four different steps to taking a digital image, each handled by a different part of the camera.

1 As with all types of photography, the image that is recorded is light reflecting from the subject. This light is collected and brought into sharp focus by the lens.

2 The light energy is then turned into a sequence of electrical signals by the camera's image sensor, which is made up of thousands or millions of light-sensitive elements known as pixels.

3 The electrical signals are then analyzed, processed, and turned into a digital form, using the standard binary language of computers.

4 The digital file is then stored to flash memory so that it can be retrieved whenever wanted in the future.

Camphones

Cell phones ("mobiles") with built-in cameras are ubiquitous; more pictures are taken with them than with any other type of imaging device and they provide many with their first taste of photography.

On many models, the camera is extremely basic: the resolution of the sensor may be limited to well under 1,000,000 pixels; the non-zoom lens is prefocused at a one-distance-fits-all setting; and creative controls are almost nonexistent. However, the resolution is more than adequate for the phone's screen—and the nature of the device means that these pictures can be sent to other people with ease.

It is would be wrong to dismiss the creative potential of camera phones. Some models boast high resolutions, zoom lenses, and more; in fact, they are designed to look and handle like digital cameras with the added benefit of a built-in cell phone. As cellular networks continue to increase their capacity, we can expect the distinction between digital cameras and cell phones to blur still further.

PRIMARY LENS
Some mobile cell phones have two digital cameras—the one on the back of the camera usually gives the best resolution for stills.

FLASH
Designed for stills and movies, "flashes" tend to be more like flashlights, with limited brightness and range.

SECONDARY LENS
Some phones have a second, low-resolution lens for video calling, if the design requires it.

SHUTTER RELEASE
You press this button to take a picture, but the delay between firing and the image actually being captured varies significantly from model to model (*see page 30*).

LENS
The most basic digital cameras usually have a fixed, non-zoom lens offering a wideangle field of view. To make the subject appear larger in the viewfinder, you move closer, or you sacrifice image quality by blowing up the picture electronically.

RESOLUTION
The number of pixels available may be very limited, and this will restrict the maximum size at which the image can be printed. But this is not always the case: this model has a 4-megapixel sensor with 4,000,000 light-sensitive elements—theoretically good enough for all but the most critical uses. However, the pixel count is not the only factor that affects picture quality.

FLASH
This is not found on all basic models, and hardly ever on those built into cell phones.

CREATIVE CONTROL
With a typical basic camera, the photographer has little control over the how the image will appear. Although there may be various *Scene* modes for dealing with different picture-taking situations, there is no way to influence or to check the shutter speed and aperture that is being used.

VIEWFINDER
Basic models often only have one type of viewfinder. The large LCD is great for reviewing images, but may be awkward to use when shooting, particularly in bright light.

Icon Translator

The bodies and screens of digital cameras are covered with strange graphic emblems; some are easy to understand, but others seem meaningless or are open to misinterpretation. Over the following pages we'll translate some of the more common ones:

Camera
Shooting mode. The camera has two main functions: to take pictures, and to replay pictures already taken. You use this mode when you want the camera to work as a camera.

 Arrow pointing right in a rectangle
Playback mode. You use this mode to review the pictures already stored to memory.

Magnifying glass
Magnifies a recorded image so that you can check detail.

 Flower
Close-up facility that enables the lens to focus nearer to the subject than usual.

 Trash can
Delete button. Used for getting rid of pictures you don't want to keep. Usually only works during playback, and you are asked for confirmation before the file is actually trashed.

One-handed clock
The selftimer is a delayed trigger mechanism that adds a gap of around ten seconds between pressing the shutter button and the picture actually being taken. This allows enough time for the photographer to get into the picture—as long as you can find a way to support the camera.

Lightning bolt
Turns the flash on and off, and accesses other flash operation modes. On some cameras the flash has to be flipped up before this button has any effect.

1.1 Zoom compacts

The zoom compact is the best-selling type of digital camera. The name says it all—even though these models have a zoom lens, they are designed to be small enough to be carried around with the maximum of convenience.

These cameras are primarily designed to appeal to those who want point-and-shoot snapshot pictures that involve a minimal amount of input from the photographer. But the provision of the zoom adds a level of creativity to the picture-taking process that advances it a good step beyond what is possible with more basic models.

The zoom lens allows you to home in on distant detail, cropping away unwanted detail and distraction before the shutter is fired. It allows you to improve composition, to add visual variety to the pictures you take, and to maximize resolution, as there is less need to trim away unwanted areas later.

The zoom's creative potential, however, is dependent on its range, which varies significantly from model to model. Simple models have a 2× zoom range, where the focal length of the lens can be doubled by moving groups of optical elements back and forth. Using this, a subject can be doubled in height within the image area by zooming from the widest lens setting through to the most telephoto setting. Some zooms are capable of more onboard magnification, with 3×, 4×, and 5× zoom ranges being widely available.

The number of other creative overrides available also varies significantly from model to model. You may be able to adjust aperture, sensor sensitivity, the point of focus, and more. However, these overrides are often cumbersome to use, as you need to search through menus, peering at the exterior screen to find the facility you need.

What you see isn't what you get

Zoom compacts typically have two different viewfinders: There is a large color LCD screen for reviewing pictures you have shot, and there is a second, non-electronic viewfinder that is used for framing your pictures. This is essentially a window through the body of the camera, which uses a sophisticated magnification system that zooms in tandem with the lens. This type of viewfinder is easy to use in bright light, and uses much less power than an LCD screen.

The drawback of this porthole system is that you are looking at the scene from a slightly different angle from the lens, so the image taken may end up being incorrectly framed. As with looking at a scene with one eye alone and then noting the jump as you switch to using the other eye, the effect is much more pronounced when photographing subjects close to the frame. Manufacturers use a number of tricks to minimize the problem, but this "parallax error" is still a weakness of the compact design.

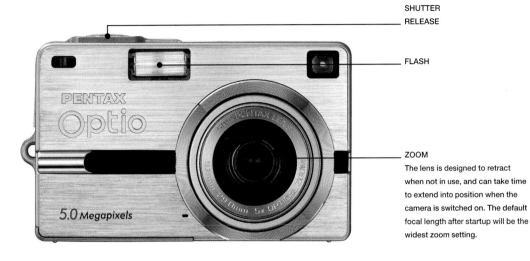

SHUTTER
RELEASE

FLASH

ZOOM
The lens is designed to retract
when not in use, and can take time
to extend into position when the
camera is switched on. The default
focal length after startup will be the
widest zoom setting.

EYE-LEVEL VIEWFINDER
This has its own zooming mechanism that
approximates the view currently been seen
by the lens and imaging chip.

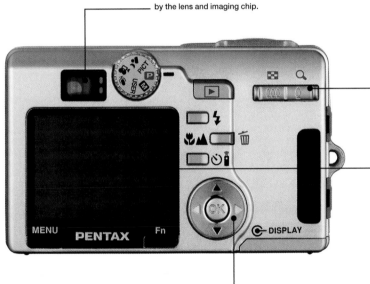

ZOOM CONTROL
The focal length of the lens is
changed using a motor connected
to a rocker switch. Zooming in on
the action may take rather longer
than you might like.

LCD SCREEN
With the provision of a separate
direct-vision viewfinder, this large
color screen is used to show the
picture that is being recorded, or
to review previously taken shots.

MENU NAVIGATION
A four-way joypad control lets
you toggle through and select
various onscreen menu options.
This is used in conjunction with
a separate "OK" button that
confirms a selection.

Icon Translator

Three trees
Wideangle: motors the
zoom lens to give a greater angle
of view. This button is also often
marked with a big letter "W."

Solitary tree
Telephoto: motors the
zoom lens to magnify the image
using a smaller angle of view.
This button is often marked
with a letter "T."

Magnifying glass
Magnifies a recorded
image so that you can check
detail. Usually only available in
playback mode.

Mosaic
Changes playback
mode. Typically, this switches
from showing one picture at a
time to showing several thumbnail
shots across the screen.

Movie camera
Shooting mode for
recording video pictures instead
of stills. This may, or may not,
record synchronized sound at
the same time.

1.1 Hybrid cameras

Hybrid cameras, or bridge cameras as they are also known, are a halfway house. They are essentially high-specification zoom compacts, but are bulkier and less pocketable. They are a cross between the compact and the SLR (*see pages 20–21*), combining the advantages of both types of camera.

The bulky look is very reminiscent of an SLR—and this brings with it immediate handling benefits. Unlike a true SLR you cannot actually see the image through the lens itself, but the eye level viewfinder does the next best thing, providing a live video feed to a miniature LCD screen. This means you can use the display easily in bright light conditions, but, unlike the zoom compact's viewfinder, there is no parallax error so you can frame subjects accurately, however close they are to the camera. Furthermore, unlike with a zoom compact, you can check focus visually, so you can see whether the autofocus system has picked out the right part of the scene, and refocus if necessary.

Having this second color screen also means that it is possible to have a head-up view of what the camera is doing, thus getting valuable visual feedback as to the settings that are currently being used and the decisions that the camera is taking on your behalf. You can usually see the shutter speed and aperture currently selected, and you can change menu settings without taking your eye from the viewfinder.

The lens housing of a hybrid camera is noticeably more pronounced than that of a zoom compact, and this allows you to support the device more steadily. The zoom lens is built-in and cannot be swapped to provide alternative focal length settings, unlike most SLRs. However, the focal length range is usually greater than that of a zoom compact, with typical zoom ratios varying from 6× to 10×. Furthermore, being built-in, the lens protects the imaging chip from the dust that can prove a problem with interchangeable-lens SLRs.

These models provide a high degree of creative control, often with a similar range of metering modes, exposure options, and so on to the SLR (in a lighter body). Furthermore, their potential can often be enhanced by the use of bolt-on accessories: like most SLRs you can usually connect these cameras to high-power hotshoe flashguns and studio lighting systems, for instance. However, processing speed and image quality are likely to be slightly below those found on digital SLRs.

Icon Translator

 Plus/minus
Exposure compensation allows you to give the image more or less exposure than the built-in meter believes is necessary. With digital cameras, you can keep tweaking this control until the onscreen image looks right.

 Light bulb
Turns on the backlight that enables you to see the information on the LCD screen more clearly.

P Program: auto everything exposure mode where the camera sets both shutter speed and aperture.

A Aperture priority: semi-automatic exposure mode, where you set the aperture and the camera then sets a suitable shutter speed for the lighting conditions. May also be abbreviated as Av (aperture value).

S Shutter priority: semi-automatic exposure mode, where you set the shutter speed and the camera then sets a suitable aperture for the lighting conditions.

Tv Alternative abbreviation for shutter priority (stands for time value).

M Manual: exposure mode where the photographer sets both aperture and shutter speed.

FOLDOUT LCD SCREEN
Can be angled to help minimize reflection problems in low light, and can be tilted to aid accurate composition when shooting with camera over your head.

ELECTRONIC VIEWFINDER (EVF)
Monitor provides an identical image to that being seen by the lens: You can check that the picture is in focus before you take the picture.

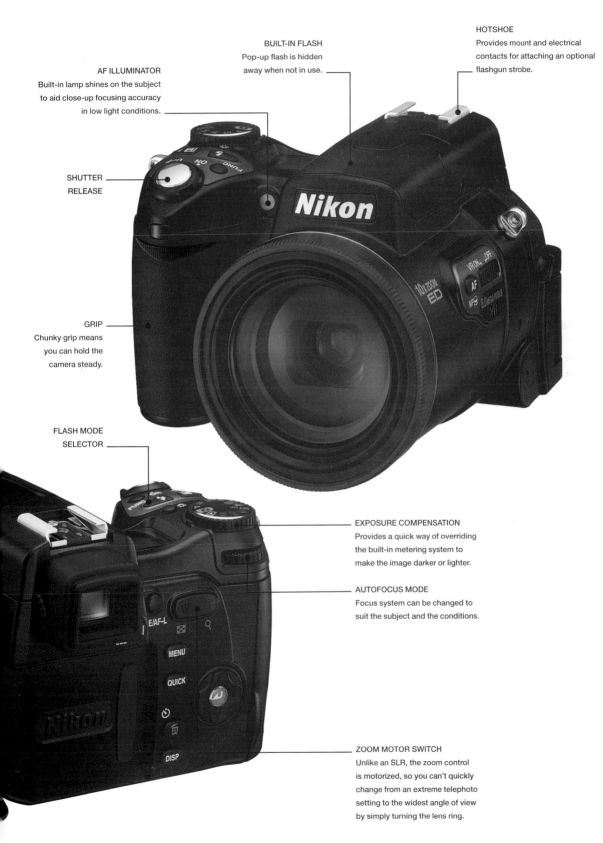

AF ILLUMINATOR
Built-in lamp shines on the subject
to aid close-up focusing accuracy
in low light conditions.

BUILT-IN FLASH
Pop-up flash is hidden
away when not in use.

HOTSHOE
Provides mount and electrical
contacts for attaching an optional
flashgun strobe.

**SHUTTER
RELEASE**

GRIP
Chunky grip means
you can hold the
camera steady.

**FLASH MODE
SELECTOR**

EXPOSURE COMPENSATION
Provides a quick way of overriding
the built-in metering system to
make the image darker or lighter.

AUTOFOCUS MODE
Focus system can be changed to
suit the subject and the conditions.

ZOOM MOTOR SWITCH
Unlike an SLR, the zoom control
is motorized, so you can't quickly
change from an extreme telephoto
setting to the widest angle of view
by simply turning the lens ring.

1.1 Digital SLRs

The single lens reflex (or SLR) gets its name from its unique viewing system, which allows the photographer to see the subject directly through the same lens that is used to take the picture. There is no need for two sets of lenses, as with a zoom compact; and as the secondary viewfinder is optical, unlike the electronic monitor on a hybrid camera, it is not a drain on battery power.

The imaging sensor and viewfinder can both have the same view through the lens thanks to a mirror (reflex is the optical term for a mirror). This mirror is placed behind the lens at a 45 degree angle so that it reflects the image that would otherwise form on the sensor, upward to a screen known as the focusing screen. This image is then viewed through a prism (also known as a pentaprism, even though it is not necessarily five-sided); this ensures that the image looks the right way up and the right way round. When a picture is actually taken, the hinged mirror flips out of the way so that exactly the same image that was seen in the viewfinder is now projected onto the sensor.

SLR cameras usually have interchangeable lenses, and the camera body may be sold separately so that you can buy lenses that are tailored to the types of subject that you want to shoot: specialist wideangle zooms are available for interiors, for instance; macro lenses can be attached using the bayonet mount for ultra-close-up shots of insects; super-telephotos can be used to magnify far-off sports action or wildlife so that that it fills the frame. A wide range of other bolt-on accessories is available, allowing you to tailor the camera to different situations, and to adapt the camera as your interest in photography progresses. SLRs are part of a system, although how far this system of accessories stretches will depend on the particular SLR you buy.

The availability of a wide range of lenses and other system accessories means that a digital SLR can be adapted to shoot almost any photographic subject.

Dust

One of the few drawbacks of the SLR design is that every time you change lenses there is a risk of dust entering the camera chamber. A speck of dust that settles on the image sensor will show up in each and every one of your shots until it is removed.

The specks appear in an image as gray, out-of-focus circles. These are more visible on light-toned areas of an image (such as sky), and appear sharper with wide lens settings and small apertures.

It is easy enough to remove these blemishes on a shot-by-shot basis using standard digital retouching techniques (see page 22). However, the problem won't go away unless the CMOS or CCD image sensor is cleaned. This is a risky operation, as you may make matters worse, and you mustn't touch the sensor with anything. A special camera mode needs to be engaged to lift the mirror to provide access to the sensor, and then a bulb blower cleaning tool is used to puff air onto it in the hope that this will remove the offending speck.

The dust actually settles on a protective cover immediately in front of the sensor, known as the low-pass filter. However, if this gets damaged the whole sensor unit may need to be replaced—and

this could be almost as expensive as buying a new camera body. For stubborn dust more drastic action is needed, but the risks mean it is sensible to leave this job in the practiced hands of an authorized camera technician.

It goes without saying that prevention is paramount: Lenses should always be changed quickly and in as dust-free an environment as possible.

1.1

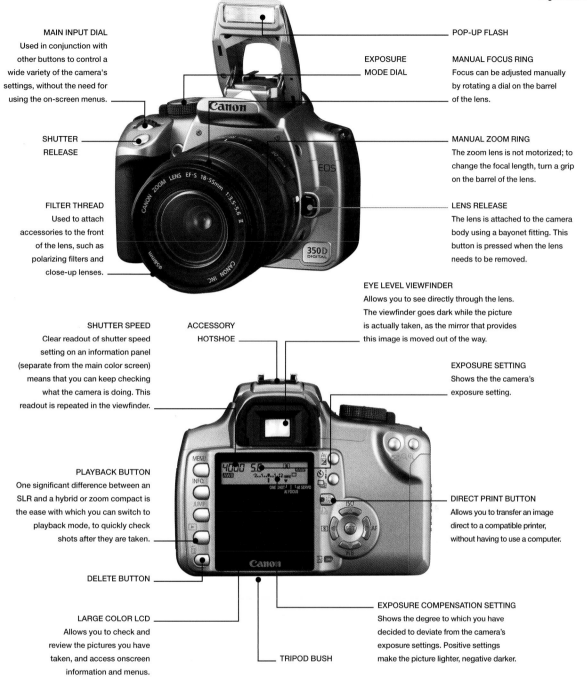

MAIN INPUT DIAL
Used in conjunction with other buttons to control a wide variety of the camera's settings, without the need for using the on-screen menus.

SHUTTER RELEASE

FILTER THREAD
Used to attach accessories to the front of the lens, such as polarizing filters and close-up lenses.

POP-UP FLASH

EXPOSURE MODE DIAL

MANUAL FOCUS RING
Focus can be adjusted manually by rotating a dial on the barrel of the lens.

MANUAL ZOOM RING
The zoom lens is not motorized; to change the focal length, turn a grip on the barrel of the lens.

LENS RELEASE
The lens is attached to the camera body using a bayonet fitting. This button is pressed when the lens needs to be removed.

EYE LEVEL VIEWFINDER
Allows you to see directly through the lens. The viewfinder goes dark while the picture is actually taken, as the mirror that provides this image is moved out of the way.

SHUTTER SPEED
Clear readout of shutter speed setting on an information panel (separate from the main color screen) means that you can keep checking what the camera is doing. This readout is repeated in the viewfinder.

ACCESSORY HOTSHOE

EXPOSURE SETTING
Shows the the camera's exposure setting.

PLAYBACK BUTTON
One significant difference between an SLR and a hybrid or zoom compact is the ease with which you can switch to playback mode, to quickly check shots after they are taken.

DELETE BUTTON

LARGE COLOR LCD
Allows you to check and review the pictures you have taken, and access onscreen information and menus.

DIRECT PRINT BUTTON
Allows you to transfer an image direct to a compatible printer, without having to use a computer.

EXPOSURE COMPENSATION SETTING
Shows the degree to which you have decided to deviate from the camera's exposure settings. Positive settings make the picture lighter, negative darker.

TRIPOD BUSH

Icon Translator

 Battery
Bargraph-like display in the shape of a battery gives you a very rough indication of how much power you have left before the pack needs recharging.

 WB
White balance: the system used for setting the overall color balance for the shot. Many cameras offer manual options as well as an automatic setting (AWB).

 Rectangle with eye in it
Metering mode button: SLRs and some compacts offer a variety of different ways in which the lighting level is assessed.

 Circle with horizontal line through it
Marks the plane of the image sensor. Important only in high-magnification macro work, where the distance from subject to focal plane needs to be measured precisely.

 Circle with vertical line through it
This is followed by a measurement in millimeters, and indicates the diameter of filter thread used for attaching accessories to the front of the lens. Filter threads on different lenses vary widely in size.

19

1.1 Specialist cameras

Most professions and industries use digital photography in some way or another. Although most can make do with the standard camera designs we have already looked at in this chapter, some users need something more specifically tailored to their needs. The medical profession is perhaps the best-known example: doctors use a wide range of digital imaging equipment for diagnosis and research, generating computer images that allow them to see structures that would otherwise be much harder to view, and share these with colleagues around the globe. Digital imaging is similarly used by emergency and defense forces to find fugitives, reconnoiter enemy territories, and gather evidence.

Taking pictures of people's insides or with cameras attached to spotter planes is of little interest to,

and beyond the budget of, the nonspecialist. But some forms of specialist camera are of interest to the photo enthusiast.

Packed with electronics, digital cameras are delicate pieces of equipment that are likely to be irreparably damaged when they come into contact with water. But many of us still want to take pictures on beaches, on board boats, and in the rain; and some want to take pictures at the water park or snorkeling in the sea.

As our interest in photography grows, we also are fascinated by the cameras that pro photographers use. Many use digital SLRs, but there are plenty who use larger, older-looking, cameras that are, nonetheless, capable of producing digital images.

Waterproof cameras

● It is important to distinguish between cameras that are "weatherproof" and those that are fully "waterproof." Weatherproof or splashproof models are designed to work in a shower; waterproof models can be fully submerged.

● Weatherproof and waterproof cameras tend to use the compact design, with or without a zoom.

● For SLR and hybrid cameras, you can use waterproof and weatherproof housings that encase the delicate outer shell of the device; these can also be bought for compacts. If you are a keen diver, ensure that there is a housing available for any camera you consider, as these tend only to be made for selected models.

● Some waterproof cameras and housings are more waterproof than others. The deeper you go underwater, the higher the water pressure—and some cases are not designed to do more than go to the bottom of a swimming pool. Proper diving equipment will clearly state its safe depth limit, usually 30–300ft (10–100m).

● Underwater cameras and housings must be scrupulously maintained if they are to remain watertight. This means washing off salt water after every use, and checking and oiling seals after every immersion.

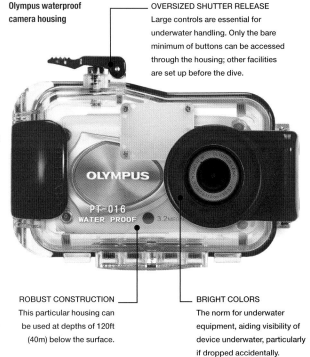

Olympus waterproof camera housing

OVERSIZED SHUTTER RELEASE
Large controls are essential for underwater handling. Only the bare minimum of buttons can be accessed through the housing; other facilities are set up before the dive.

ROBUST CONSTRUCTION
This particular housing can be used at depths of 120ft (40m) below the surface.

BRIGHT COLORS
The norm for underwater equipment, aiding visibility of device underwater, particularly if dropped accidentally.

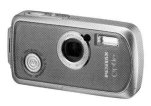
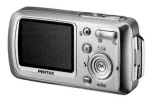

Pentax WP camera
This zoom compact looks similar to others; however its interior electronics have been sealed a lot better than most. It can be used at up to 15ft (5m) below

the water's surface for periods of up to 30 minutes. An underwater camera such as this would be invaluable to the potholer, sailor, surfer, or anyone who is particularly accident-prone.

● Big cameras get their names from the films that they were designed to use: medium-format cameras used rolls of film measuring 2¼in (60mm) across; large-format cameras used sheets of film measuring 5 × 4in (125 × 100mm) and up. Both types of camera have been successfully adapted to the digital era.

● These cameras can often still use film if necessary. This is useful for some commercial photographers, as film may be what a client prefers. Swapping from digital to traditional silver media is simply a matter of putting on a different camera back.

● Medium-format cameras are capable of using backs with large image sensors, which may contain tens of millions of pixels. This does not necessarily mean, however, that the resolution is any better than a standard digital SLR.

● Medium-format SLR cameras offer more system components than normal digital SLRs: the viewfinders, for instance, are interchangeable.

● Digital backs are often controlled from, and save their images to, a laptop computer. They don't necessarily have their own built-in screen or memory.

● Medium-format cameras are bulky, and have more limited lens ranges than digital SLRs. They are not really suited for some photographic subjects, such as sport, wildlife, or photojournalism.

● Many large-format cameras (and some medium-format models) use a monorail construction, where the image and lens planes can move, twist, and turn independently of each other. These "movements" allow the photographer to avoid normal optical distortions, or exaggerate them for their own effect. The lens and image sensor planes can also be angled so as to maximize or minimize image sharpness to a degree that simply isn't possible with other camera types.

● Monorail cameras are used primarily by commercial photographers (who need maximum image quality for giant billboard blowups), or by product photographers (who want complete control of image sharpness in the studio). Sometimes the backs digitize the image line by line (like a desktop scanner), feeding the data to a computer via a cable.

Mamiya ZD

Things change slowly in the world of big cameras. This is one of the few medium-format cameras that has been designed exclusively for the digital era. It looks and handles much like an oversized digital SLR.

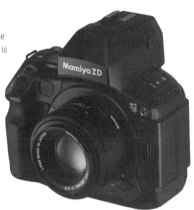

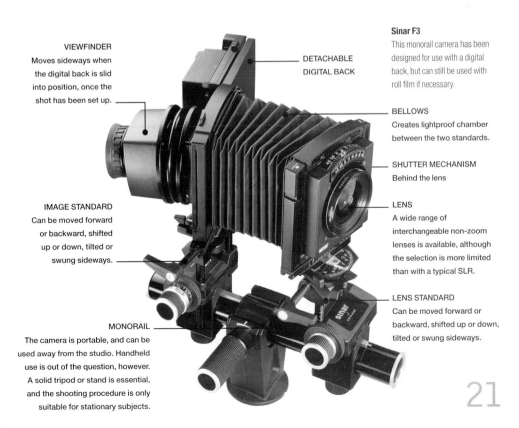

VIEWFINDER
Moves sideways when the digital back is slid into position, once the shot has been set up.

IMAGE STANDARD
Can be moved forward or backward, shifted up or down, tilted or swung sideways.

MONORAIL
The camera is portable, and can be used away from the studio. Handheld use is out of the question, however. A solid tripod or stand is essential, and the shooting procedure is only suitable for stationary subjects.

DETACHABLE DIGITAL BACK

Sinar F3
This monorail camera has been designed for use with a digital back, but can still be used with roll film if necessary.

BELLOWS
Creates lightproof chamber between the two standards.

SHUTTER MECHANISM
Behind the lens

LENS
A wide range of interchangeable non-zoom lenses is available, although the selection is more limited than with a typical SLR.

LENS STANDARD
Can be moved forward or backward, shifted up or down, tilted or swung sideways.

1.1 The lens

Photography and cameras have changed considerably since those early Victorian pioneers captured their first images. But the picture taking process still involves recording the light that reflects from the scene in front of us. The first step in doing this remains collecting and projecting this light so that it forms a clean, sharp image—a task that is performed by the lens.

The lens is the eye of the camera. Despite its name, the "lens" is invariably constructed using a number of different highly-polished plastic or glass lenses, called "elements," that are arranged in parallel groups along a single central axis. There may be a dozen or so of these—with the number, placement and shape of each effectively controlling how wide a view is projected onto the image sensor. In zoom lenses, groups of elements can be moved independently from others to alter the angle of view—magnifying the subject or, conversely, allowing more of the scene to be included. This angle of view is not usually used to compare different lenses, or different lens settings. Instead the "focal length" of the lens, or zoom range, is usually measured in millimeters (mm).

The focal length of a lens is the distance from its optical centre to the image sensor. For many non-zoom SLR lenses, this is essentially similar to the actual physical length of the lens. The longer the focal length, the smaller the angle of view—giving a greater telephoto effect. The shorter the focal length, the wider the angle of view.

Types of lens

It is not just the focal length that varies from lens to lens. There are other factors to take into consideration when comparing alternatives.

● The maximum aperture of the lens. For a typical zoom this may be f/2.8 on one model, but f/5.6 on another. When necessary, the first is capable of letting in four times more light than the other. The maximum aperture is usually quoted on the front of the lens as a ratio, where 1:2.8 means a maximum aperture of f/2.8. Many zooms have a smaller maximum aperture at the telephoto end than at the widest focal length.

● The range of aperture settings available is also dictated by the lens—which houses an iris diaphragm opening that controls how much light passes through. The range of aperture settings is limited on many zoom compacts—with a typical minimum aperture setting being f/11. On an SLR lens the minimum aperture is typically f/22—but may be smaller.

● A principal difference between the zoom lenses on SLRs and hybrid cameras is that SLRs have a manual zoom action, while with hybrids the elements are moved by motor (as on a zoom compact). A manual action is quicker, and more battery efficient.

● The focusing range varies. Some lenses will be able to focus much closer to a subject than others (see pages 48–9).

● Some lenses are optically superior to others. They may resolve more detail, and suffer less from the distortions and color aberrations that affect all lenses to some degree.

Tip

Don't confuse optical and digital zooms. A digital zoom simply extends the range of the actual lens by magnifying the central portion of the image electronically. As some of the pixels are not used, the facility reduces overall resolution. It is shunned by serious photographers (and serious cameras)—but can be invaluable on a camera phone, where a digital zoom may provide the only way of getting a close-cropped image of the subject. The digital zoom usually magnifiies the effective focal length by 2× or 4×—higher, and more ridiculous, magnifications are found on some camcorders (which have been known to offer a 1000× zoom range!). A 2× digital zoom will use half the sensor pixels in either direction—only ¼ of the pixels on the chip—so quality is worthless long before a factor of 1000× is reached.

The problem with focal length (unlike the angle of view) is that it depends on the size of the image area. In digital photography this creates a huge problem as the size of the imaging chip varies enormously from one model to a model. A camera that has a 10mm lens might, therefore, give the same angle of view as another camera with a 30mm lens.

Obviously this could (and occasionally does) lead to a degree of confusion when comparing two different zooms. For this reason, it is not the actual focal length that is quoted. Instead, Effective Focal Length (or efl) is usually quoted. This converts the actual focal length to what it would be on a 35mm-format film camera. If you use an SLR with a large 24 × 36mm sensor, then the actual focal length is the same as the efl. But for the majority of digital photographers the actual focal length is significantly smaller than the efl.

From wide to telephoto

These shots were taken from the same spot and show the range of different angles of view and subject magnifications available with some typical efls.

27mm

42mm

95mm

157mm

315mm

450mm

600mm

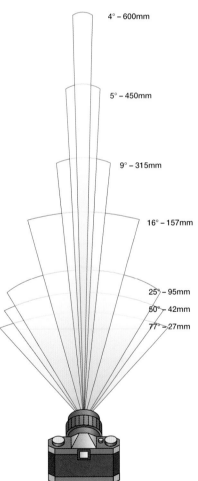

4° – 600mm

5° – 450mm

9° – 315mm

16° – 157mm

25° – 95mm

50° – 42mm

77° – 27mm

PROJECTED IMAGE
Lens projects a circular, upside-down image of the scene.

SENSOR AREA
The sensor is often smaller than 35mm film, so the angle of view is smaller, providing a telephoto effect.

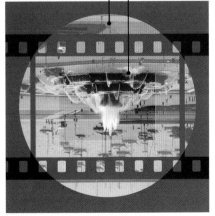

Angle of view diagram

The angle of view of a lens is one of the main creative controls available to photographers (see pages 98–107). However the range of options that are available will largely depend on the the type and make of camera that you use. The effective focal lengths and corresponding angles of view show here show the range of options available for a good SLR camera system.

Effect of smaller sensor area

Many lenses for SLRs are also designed to be used with 35mm film cameras. As the sensor may well be smaller than the film area, the effective focal length is automatically increased. The factor by which this happens is known as the field of view multiplier. On Canon's "Digital Rebel" (or EOS-350D) this is 1.6×, so an old 28mm EF lens would crop as if it was 45mm.

1.1 Sensors

The imaging chip or sensor is the magical component of a digital camera, even though it is a non-digital component. It is the retina or "film" of the camera onto which the lens projects the image. Its job is to convert the light in the image into an electrical signal, which is then processed and digitized.

The sensor is more commonly known as the CCD or CMOS chip, depending on which of the two most common technologies it uses. There are differences between these two types of sensor (see below), but the basics are very similar.

Each sensor is typically made up of millions of tiny light-sensitive cells known as photosites, each of which corresponds to a pixel in the final picture. These photosites are arranged in a grid formation, covering a rectangular area that may be no bigger than your thumbnail.

Each pixel is incredibly small, measuring perhaps five microns across (0.0002in or 0.005mm, or around 1/14th of the width of a human hair). Despite the microscopic scale, each creates its own electrical signal and is covered by its own lens.

However, individual pixels cannot see color—each one just measures the brightness of its part of the picture. To help turn this information into a form where a full-color image can be produced, each pixel has its own filter: some filters are red, some are green, and some are blue. A pixel with a blue filter will essentially only see colors that have some blue light in them. But as practically all colors under the sun can made by mixing red, green, and blue light together, this still provides valuable information.

The really clever bit, however, is how the pixels work as a team. When you look at an enlargement of a digital image, you will see that each pixel actually records one of at least 16.7 million different colors, and not just one of 256 different intensities of blue, green, or red typically recorded by the photosite. A blue-filtered pixel can effectively "see" red light by comparing the information from one pixel with that from neighboring pixels as the information is processed. Known as demosaicing, this interpolation process makes a surprisingly accurate "guess" as to the precise color of each pixel part of the picture.

Types of sensor

CMOS (complementary metal oxide semiconductor)

The key difference between CCD and CMOS chips is in the way that the information is read by the camera. In a CMOS chip each pixel has its own individual circuitry, so that the information collected by each photosite can be read separately. This is a more power-efficient system that also means that brightness information can be used by some cameras to help with other camera systems, such as autofocusing and exposure metering. CMOS sensors are used widely in low-cost cameras (such as camera-phones), but are also successfully used in some makes of digital SLR.

X3

An alternative system, pioneered by Foveon and used on Sigma digital SLRs, is the X3 or triple-well sensor. This uses similar architecture to a CMOS chip, but makes do without the individual filters for each pixel. Using the principle that some wavelengths of light can penetrate deeper into silicon than others, it measures a brightness for red, green, and blue primaries at each photosite.

3CCD

Another system, popular on top-of-the-range camcorders, is to use three CCDs in unison. The image is split into its three primaries using a prism, and the sensors are positioned so that each sensor measures each primary color separately.

CCD (charge coupled device)

The CCD is the traditional sensor design used in a large proportion of digital cameras. Its beauty is the simplicity of its design: For each shot, the information from each pixel is read by the camera a line at a time, with the information from each photosite filing its way through the chip in an orderly queue.

Structure of a photosite

Photons of light travelling from the lens

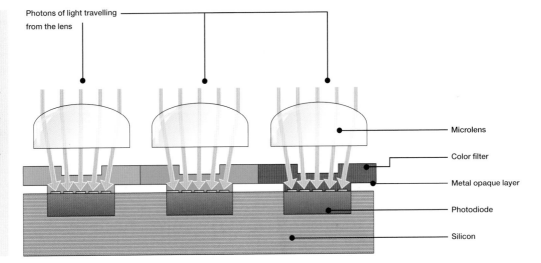

- Microlens
- Color filter
- Metal opaque layer
- Photodiode
- Silicon

Color filter array

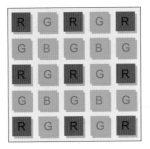

This is the most common pattern of color filters used in a digital camera's sensor. In a typical color filter array (CFA), half the filters used are green, whilst 25 per cent are red, and 25 per cent are blue. The resulting mosaic is called the Bayer pattern, named after the Kodak scientist who invented it. More green filters are used, as they mimic the way the human eye works and therefore help produce a sharper image.

When magnified, every digital picture is made up of squares. Each of these, a pixel, can be one of 16.7 million colors—the total number of different permutations possible made by mixing the three colors in each one of their 256 recordable states. This is known as 24-bit color. Some cameras can record even more shades at each photosite, to produce billions of different-colored pixel possibilities.

Low-pass filter

In addition to the individual red, green, and blue filters, there is a set of filters that covers the whole sensor area. The most significant of these is the low-pass or antialiasing filter. One of its jobs is to help minimize the interference pattern created when using the sensor to photograph fine, grid-like detail, such as in the weave of a silk shirt. Perversely, this filter actually softens the image slightly, which is the main reason why digital images usually need to be sharpened electronically, either by the camera or in post-production.

Moiré pattern
The weave pattern of the shirt creates a ripple-like interference pattern—known as moiré. Although the low-pass filter helps suppress this, it can still be seen with certain subjects at particular magnifications.

CCD chip
A CCD sensor from a digital SLR. The image area measures $1 \times {}^2/3$in (23.5 × 15.7mm), but contains 6.3 million individual photosites, or pixels.

25

1.1 Sensitivity

Digital cameras need to gather a certain amount of light in order to produce an image. The actual light level is not crucial, since using a longer shutter speed projects the image onto the chip for longer, compensating for dimmer illumination. Alternatively, the aperture—the hole through which the lens sees the world—can be made smaller or wider.

A variable shutter speed and adjustable aperture are the two fundamental exposure controls that are used to ensure that the photosites gather enough photons in a wide range of lighting conditions. However, the digital camera also has another weapon up its sleeve to ensure that it can carry on shooting when the light gets low: The sensitivity of the sensor can effectively be altered.

Back in the old days, film photographers could help control exposure by changing the type of film that they used. Today's digital cameras have adopted the same ISO (International Standards Organization) scale that was used with film. The difference with digital cameras is that you can change the ISO setting on a shot-by-shot basis, without affecting the pictures you have already taken.

The number of ISO options that are provided will depend on the camera. On basic cameras the sensitivity may be fixed, typically at an ISO rating of 50–200. On some cameras the ISO is set automatically depending on the light level. The best cameras give you a range of different values that can be set manually,

with the highest sensitivity typically being ISO 200–ISO 3200.

Adjusting the sensitivity with a higher ISO rating means that you can take pictures indoors without the need for flash, for example. It can also mean that you can use faster shutter speeds to freeze action (*see page 78*) that would otherwise have been impossible in the prevailing weather conditions.

However, raising the ISO value does have a cost. You are not actually adjusting the sensitivity of the photosites themselves; instead, you are amplifying the electrical current that they are generating. You are boosting the gain, and by doing so you also amplify the noise within the signal—this shows up as blotchy grain, which becomes more and more noticeable the further that the ISO rating is increased.

In order to preserve image quality, the ISO value should only be increased when this is absolutely necessary. This means that high settings are not always used in the lowest light—in fact, when using flash or a tripod it would be usual to use the slowest ISO setting.

Some cameras offer ND, or neutral density, which effectively reduces the camera's sensitivity. This can be useful when you wish to use a slower shutter speed than would otherwise be possible (*see pages 82–3*). On cameras without this facility, a ND filter can be placed in front of the lens to achieve this (*see page 108*).

A sensible approach

The simple rule for setting the ISO is to use the lowest possible value that you can get away with. However, it is better to settle for a slightly grainier shot than to end up with one blurred because the shutter speed was not fast enough (*see page 80–1*).

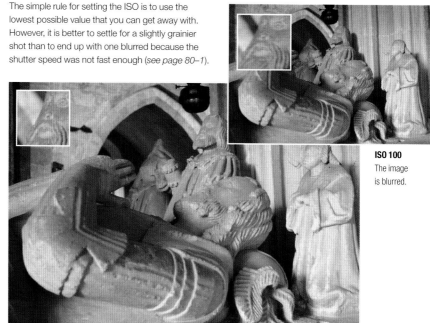

ISO 100
The image is blurred.

ISO 400
With a higher sensitivity a faster shutter speed is possible, ensuring a much sharper handheld picture.

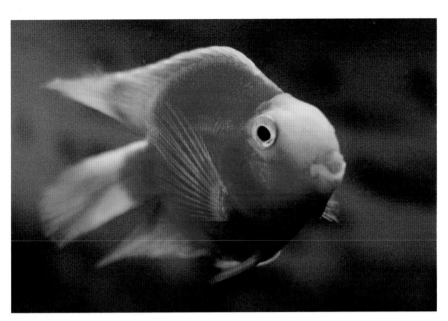

Extending picture possibilities

The majority of pictures in this book have been shot at ISO 100, but faster speeds often allow you to take pictures in situations where pictures would otherwise be impossible. Behind glass and constantly moving, this parrot fish would be hard to photographic easily with artificial light. The existing light was low, but setting a sensitivity of ISO 3200 enabled a presentable shot, even if the noise is very visible.

The ISO scaler

CHOOSING THE RIGHT ISO

ISO value	Speed	Noise	Applications
50–100	Slow	Low	General photography in daylight. Studio photography. Lowlight photography with flash. Any photograph where a solid tripod can be used.
200–400	Medium	Medium	Used in low light in order to get a fast enough shutter speed to safely handhold the camera. To enable the use of a faster shutter speed or smaller aperture than could otherwise be used in current lighting conditions without a tripod. Used to increase the effective range of a flash.
800–3200	Fast	High	Handheld photography in the lowest lighting conditions where flash is not being used, or where the subject is out of flash range. Examples: Museum exhibits, candid portraits at indoor parties, architectural interiors where tripods are not allowed.

Every time the ISO setting is doubled, the amount of light needed to create a perfectly-exposed picture is halved. This means that if you shift from using ISO 100 to ISO 200 you can use a shutter speed that is twice as fast, or open the aperture by a full stop. Shift from ISO 100 to ISO 1600, and you can use a shutter speed that is 16 times faster than before, or open up the aperture by four stops.

ISO 100—the camera's native sensitivity

ISO 200

ISO 400

ISO 800

ISO 1600

ISO 3200

1.1 How many pixels?

The number of pixels created by the digital camera is a major factor (but not the only one) in deciding the quality of the picture: the more pixels in the image, the more detail you capture. How much detail you need will depend on exactly what you want to do with your images—and also how fussy you are.

There are essentially two different ways in which an digital image can be used. First, it can live in the digital domain—being viewed on a computer screen. Whether used as part of a presentation, a webpage, a desktop screensaver, or in an electronic photo album, these onscreen applications do not demand excessive amounts of detail.

Alternatively, you can produce hard copies of your pictures: You can insert them into newsletters, print them onto thick, glossy paper, or get them turned into "real" pictures by a professional photofinisher. It is is here that having millions of pixels available really becomes useful. The exact number that you have will depend on just how big you want your blowup prints to be.

The number of pixels available depends first on the camera you use, as the maximum available depends on the number of photosites in the sensor (*see page 28*). But it also depends on the setting chosen: On most cameras you can restrict the resolution so that you have a smaller size and fit more pictures onto the same memory card. A 4-megapixel camera (with 4,000,000 pixels) may allow you to shoot pictures with as few as 300,000 pixels (a resolution known as VGA).

Whatever the use, the number of pixels you actually need is not set in stone. A picture with just 400 pixels could be enlarged to fill a giant sheet of paper—but the mosaic of squares that make up the image would be huge. Pixels have no predefined size, but onscreen or printed out they become dots—and as the dots get larger, the easier they become to see.

The generally accepted standard for onscreen work is that 72 dots per inch (72dpi) is the usual benchmark (although with some screens you can do with more detail, *see page 134*). For commercial printing, 300dpi is the accepted standard. But this depends on how closely you are going to view the print: For most people, 200dpi is more than enough.

The difference between these different figures is significant: At 300dpi you need 90,000 pixels for each square inch of the hard copy, while at 72dpi, you only need just over 5,000 pixels for each square inch of screen space.

Maximum sizes

Camera		Usage		
No. of megapixels	Sensor	Onscreen (72dpi)	Nice printout (200dpi)	Photo-quality printout (300dpi)
0.3	640 × 480 pixels	8.9 × 6.7in 22.6 × 16.9cm	3.2 × 2.4in 8.1 × 6.1cm	2.1 × 1.6in 5.4 × 4.0cm
2	1600 × 1200	22 × 16in 56 × 42cm	8 × 6in 20.3 × 15.2cm	5.3 × 4in 13.6cm × 10.2cm
3	2016 × 1512	28 × 21in 17.1 × 12.8cm	10.1 × 7.6in 25.6 × 19.2cm	6.7 × 5in 71 × 53cm
5	2592 × 1944	36 × 27in 91 × 69cm	13 × 9.7in 33 × 25cm	8.6 × 6.5in 22 × 16.4cm
6	3264 × 2448	45 × 34in 115 × 86cm	16 × 12in 41 × 31cm	10.9 × 8.1in 27.6 × 20.7cm)
12	4288 × 2848	60 × 40in 151 × 100cm	21 × 14in 54 × 36cm	14.2 × 9.5in 36.3 × 24.1cm

VGA (640 x 480) resolution

2 Megapixel

6 Megapixel

● It makes sense to shoot images with as many pixels as possible, as you never know for certain how a picture you haven't even taken could end up being used. Although you might expect only to use the image for the Web, where low resolution is acceptable and even preferable, however, the picture might turn out great and you might want to print out an enlargement, or you may find that the image is useful for a brochure.

● The more pixels available, the more you are able to crop your pictures and still produce them as good-sized prints. You need to crop most pictures to get rid of unwanted areas, or simply to fit them nicely on regular-size paper.

● If you need a lower resolution image for a specific use, shoot it at top resolution and then downsize on the computer. This way you keep your options open.

● Pixels are not the be-all and end-all of image quality. Lens quality, image processing (*see page 30*), and the file format (*see page 32*) are also important. It is perfectly possible that a 4-megapixel camera can produce better-looking prints than an 8-megapixel model.

● The maximum sizes given in the table opposite are only a working guide. It is possible to resize images after they have been shot so that they end up with more pixels, using interpolation (*see page 282*).

1.1 Digital processing

Although the sensor captures the basic data, there is a lot that needs to be done with this before it is in any state to be stored to memory. These processing stages are every bit as important as the number of pixels when it comes to the quality of pictures that the camera produces. The electrical signals created by the sensor need to be converted into the language of ones and zeroes—the job of the A/D (analog/digital) converter. The demosaicing process (*see page 24*) needs to assign exact color values to each of the pixels, and color balance, focusing, flash, and exposure all need to be controlled. An enormous amount of information needs to be analyzed, tweaked, and processed—a job for an onboard computer, in fact.

It probably comes as no surprise that some cameras have much more computing power than others. This is not just shown in the quality of the images that they produce; it is also apparent in the time that it takes for the camera to do even the simplest task. Unlike a computer, however, you can't upgrade the clock speed, working memory, cache, or processing power; you are stuck with what is onboard, unless you upgrade the whole camera.

The most basic type of camera may take whole seconds to power up before it is ready to take a picture. You may have a long wait between taking each shot, and you may have to twiddle your thumbs before the picture that you want to check comes back on screen. There is an irritating delay between pressing the shutter button and the actual picture being taken.

These handling difficulties are more than just irritations: The inbuilt delays at every stage can make action photography almost impossible. But it's not just high-speed sports that are affected—taking a quick shot of a child pulling a funny face may prove just as difficult. It is these differences that are the most noticeable between using a camera such as a digital SLR and a run-of-the-mill zoom compact.

Furthermore, the more data there is to process, the longer things take: even when using the most powerful digital SLRs, there is a noticeable difference in handling speed when the top resolution settings are used. Even on top professional digital SLR models, there is a limit to how many images can be taken in rapid succession before the processor refuses to take any more as it tries to catch up.

Processing choices

Many cameras provide a number of choices as to how the images are processed, over and above exposure settings, special effects, and shooting modes.

● **Sharpness** Digital cameras produce images that without the aid of further processing look unsharp, or "soft." It is usual, therefore, for cameras to offer to sharpen the images electronically before they are stored to memory. Although your pictures will undoubtedly need sharpening before they are actually used, it is best to decline this option. This is because different images, and different applications, demand varying amounts of sharpening, which are best left to the processing stage (*see page 226*).

● **Color space** High-end cameras give a choice as to the "color mode" or "color space" that the camera will use to process the pictures. This defines the extent of the palette of colors that it will use. Typically, there are two main options, sRGB or Adobe RGB. Both create colors by mixing reds, greens and blues, hence the acronym RGB, but the Adobe RGB color space allows a wider range of colors and is the option that should be selected by serious photographers. The sRGB color range is deliberately restricted to more closely match the color range of computer screens.

● **Saturation** Richness of color in an image is essentially a matter of personal taste. Some subjects can do with a boost in saturation, while others don't. You may want to boost saturation for a portrait of someone with pale skin, but avoid it for those who already have suntans. A boost in saturation is often welcome in dull weather. Use one of the lower camera settings, one that provides accurate colors; shot-by-shot corrections are (like sharpening) best left to post-production.

Lowest saturation setting

Intermediate saturation

Highest saturation

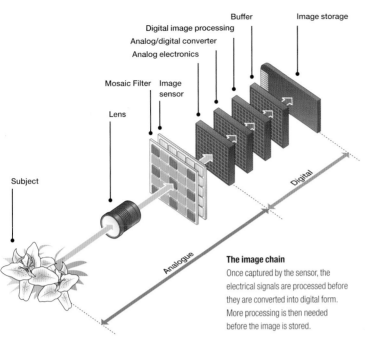

Buffer
Image storage
Digital image processing
Analog/digital converter
Analog electronics
Mosaic Filter
Image sensor
Lens
Digital
Subject
Analogue

The image chain
Once captured by the sensor, the electrical signals are processed before they are converted into digital form. More processing is then needed before the image is stored.

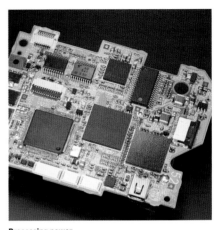

Processing power
The integrated circuit boards from a typical digital SLR.

Shutter lag
For pictures of people and family events you need a camera that can react almost as quickly as you to the picture possibilities that present themselves. Some digital cameras do not have the processing power to be able to catch fleeting expressions in this way, as there is a delay between pressing the trigger and the actual picture being taken.

Be prepared
Keeping up with the action is much easier for some cameras than others. However, you can improve the processing speed of less sophisticated models by simplifying the camera's task—use lower resolution and quality settings, and focus the camera in preparation for what may happen (using the focus lock or manual focus).

1.1 File formats

Even by modern computing standards, digital cameras produce large amounts of data. For every megapixel of image that you produce, you need three megabytes (MB) of memory to store every digit of the information; an 8-megapixel camera, for instance, could use 100MB of storage for every four shots recorded.

However, as portable memory is still a reasonably precious commodity—and because big files are slower for both camera and computer to handle—it is usual for the data to be simplified in such a way that it takes up less space. This reduction process is known as compression.

There are two different forms of compression: Lossless compression takes a cautious approach, which loses none of the detail but leads only to a modest space saving. Lossy compression, in contrast, takes a more casual attitude and produces smaller file sizes by sacrificing some of the data. This sort of compression can be set to different levels. At less extreme levels the amount of visible detail lost is negligible; at its most radical, a huge percentage of the data is lost, with a very noticeable effect on the picture quality.

The approach taken by the camera will depend on the file-format or image-quality setting chosen by the user. These settings are often given nebulous terms, such as fine, HQ, normal, and so on, but the immediate effect of choosing one setting rather than another is in the number of pictures that you can fit on the card. The top quality setting may allow you to fit only a handful of images on the memory card, while the lowest setting may allow you to shoot hundreds. If you reduce the resolution (*see page 28*), you will be able to fit in even more.

The lossy compression used on all cameras is the JPEG standard, which produces the file format with the same name (usually with .jpg after its filename).

This is by far the most popular digital image format in the world today. Its beauty is that it can be scaled easily, allowing you to cut an image to fit the size you want. The size of the file can be reduced by around 75 per cent without significant effect on the quality, although higher compression is possible. Cameras typically provide two or three JPEG options for each picture resolution setting.

Some cameras provide an option to save images as a TIFF file (.tif). This is another internationally accepted image format, which, as far as cameras are concerned, is stored without any compression whatsoever.

The third option is the RAW format. This produces a file that is typically between a third and half the size of a TIFF file, but does not actually lose any of the data. The way that this is done, however, makes this format of particular interest to the serious photographer as RAW stores the raw information from the camera's sensor in a semi-processed state, along with a recording of the specific processing requirements set by the camera or user at the time of shooting. To create a final image, however, the data processing needs to be finished using a computer. This requires specialist software (*see page 202*), but it does mean that exposure and color balance settings, which would usually be finalized in-camera, can be altered at a later date.

RAW, in one sense, is not actually a format: It is a pre-format—a digital latent image that needs to be saved in a more traditional format (normally a TIFF) when it is developed by the computer. Its advantage is that it allows more manipulation alternatives than a TIFF file or high-quality JPEG. Its disadvantage is that this adds another step to the production process.

Size and format

Resolution	Basic JPEG	Normal JPEG	Fine JPEG	Ex-Fine JPEG	RAW	RAW +JPEG	TIFF
12 megapixels	1.5MB	3MB	6MB	12MB	18MB	24MB	36MB
8 megapixels	1MB	2MB	4MB	8MB	12MB	16MB	24MB
4 megapixels	0.5MB	1MB	2MB	4MB	6MB	8MB	12MB

File sizes are approximate; actual figures will depend on camera and subject matter.

RAW file (8MB) saved as 17MB TIFF file.

Extra-fine JPEG—6MB.

Fine JPEG—4MB.

Standard JPEG—2MB.

● Don't confuse the format used with the resolution—many cameras combine both settings within the same menu. The resolution defines how many pixels are created by the camera, while the format (or quality) defines how much compression (if any) is used. They can be used in combination to minimize picture size, or to maximize picture quality.

● The size of a RAW or TIFF file is the same for all pictures with a particular camera; these formats are only available when using the camera's top resolution setting.

● The size of a JPEG file depends not only on the resolution set and the amount of compression, but also on the subject matter: the more detail in the shot, the bigger the file. If there are large areas of uniform color, the data is compressed further.

TIFF

Low JPEG

Medium JPEG

High JPEG

Secondary mosaics

Four shots of the same still life, each shot at full 6-megapixel resolution with a quality digital SLR. The difference between them is subtle, even at high magnification; however, the bigger image files produce the smoother gradation of tones. JPEG compression works by analyzing and coding pixels in groups of 64—these secondary mosaics of 8×8-pixel squares begin to become more noticeable the more compression is used.

Many zoom compact and hybrid cameras can be used to shoot video footage. Sometimes this is shot with synchronized sound, while with other cameras you get silent movies. The amount of storage required for digital video means that resolution is greatly reduced from that available when using stills, and heavy compression is used. In addition, the number of frames that are shot may be reduced to 10–15 per second—only a few offer the 25 or 30 frames per second used to create a regular TV picture. It is a fun feature to have, but the jerky, low-resolution footage can end up being disappointing.

Some digital SLRs allow the user to save both a RAW version and a JPEG version of a shot simultaneously. This allows the photographer to choose which to use later—RAW for greater creative potential, or JPEG for speed. This option may also give better access to in-camera review facilities. You may not be able to zoom in on RAW files to check focus, but you can do so with the JPEG version. Note that the amount of compression actually used for the JPEG version varies widely from camera to camera.

33

1.1 Memory

Although digital cameras are memory-hungry, particularly when used at their top quality and resolution settings, the amount of storage is nearly always expandable. A few basic cameras have a fixed built-in memory, but the vast majority use slot-in flash memory chips.

The exact type of memory card depends on the make and model that you use. Popular types include CompactFlash, SD, xD and MemoryStick Pro; however, over digital photography's brief history, several other types of recording media have disappeared. The search continues to produce cards that offer higher capacities, that work faster, and that take up less space in the camera. Camera phones, in particular, often use extremely miniature flash memory cards.

The maximum capacity available on a single card will depend on its type: the higher the capacity, the more pictures that you will be able to record onto it, whatever resolution and quality settings you use, before having to delete or download.

Memory card capacity is measured in megabytes (MB) or gigabytes (GB), with a gigabyte being equal to 1,024 megabytes.

The amount of memory that you will require depends not only on the file size that your camera produces with your chosen settings (*see page 32*), but also on how many pictures you are likely to take before your images are copied to your computer's hard drive or a portable memory device (*see page 270*). Although additional memory is reusable, it is possible to spend almost as much on it as you did on the camera.

It is tempting to buy one high-capacity card to cover all your needs. However, this is not necessarily the best move. Flash memory can become corrupted, so it is best not to have all your eggs in one basket. You may accidentally delete a shot you wanted to keep, and to give a data-recovery program the best chance of saving it, it is best to not save any more pictures onto the card before you can get back to your PC. It can pay, therefore, to use two or more cards in rotation.

In addition to capacity, cards also vary in the speed at which they can read and write data. This is partly dependent on the card format you use and the camera; however, another part of the equation is the manufacture of the particular card. Some brands are designed to record and access data faster than others: this can be particularly crucial for serious digital SLR users using top quality settings, as well as for those who want to shoot video at a camera's top frame rate.

The speed at which a card writes information is measured in megabytes per second (MB/s). Confusingly, however, card manufacturers normally quote the performance increase when compared with a card transferring information at a sedentary 150KB/s. A 40x card is therefore capable of 6MB/s, and a 133x card offers write speeds of up to 20MB/s. These are theoretical maximums, however—on a typical digital SLR you can expect a fivefold improvement in performance using the fastest (and generally most expensive) card available, compared to a run-of-the-mill budget version.

Clawing back memory

The beauty of digital memory is that it is reusable. You can wipe the card and start refilling it from scratch, or you can delete images one at a time. In order to ensure that you have enough spare memory, it is tempting to always delete weak shots as they are taken. However, this seemingly sensible policy does have dangers:

● There is a risk that you may delete the wrong shot or even all the shots (particularly easy with an unfamiliar camera, or when using the LCD screen in bright light).

● What you think is a strong shot may turn out to have flaws when viewed more closely and at greater leisure on the PC. Maybe the shot you deleted was better?

● A weak shot and a strong shot may be combined in post-production to make an even stronger shot.

● By keeping your poor shots for a period of time, you can learn through your mistakes.

● A device like the Nikon Coolwalker, pictured below, is a handy stopgap for photographers who will be away from their computers for some time. It is a portable hard disc to copy your memory card to, either freeing up space or acting as a backup.

Heading needed

Card	Dimensions	Cross-compatibility of card	Max capacity*
CompactFlash Type I	36.4x 42.8x3.3mm	CompactFlash Type II drives	8GB
CompactFlash Type II	36.4x42.8x5mm		8GB
Microdrive (mini hard disk)	36.4x42.8x5mm	CompactFlash Type II drives	6GB
SD	24x32x2.1mm		4GB
Mini SD	21.5x20x1.4mm	Can be used in SD drives using adaptor	2GB
xD Picture Card	20x25mmx1.7mm		1GB
Memory Stick	21.5x50x2.8mm	MemoryStick Pro drives	128MB
Memory Stick Pro	21.5x50x2.8mm		8GB
Memory Stick Duo	20x31x1.6mm	MemoryStick Duo ProDrives MemoryStick Pro & MemoryStick drives with adaptor	128MB
Memory Stick Duo Pro	20x31x1.6mm	MemoryStick Pro drives with adaptor	2GB
MultiMediaCard (MMC)	32x24x1.4 mm	SD drives using adaptor	256MB
RS-MMC	18x24x1.4 mm	MMC & SD drives using adaptor	1GB
MicroSD (Transflash)	15x11x1mm	SD drives using adaptor	1GB

* MAX CAPACITY SUBJECT TO CHANGE

Card care

● Compact flash cards are remarkably resilient, but they can become corrupted if not handled with care.

● Ensure that a new card is formatted by the camera you are going to use it in, to be sure of trouble-free operation.

● Always turn the camera off and wait for the drive activity light to switch off before removing the card. Ignoring this is the easiest way to corrupt a card. Similarly, "eject" cards and wait for the activity light to stop when using a card reader.

● Keep cards in the plastic case supplied with the card or in an optional caddy, to ensure that the contacts remain clean and unscratched.

35

1.1 EXIF

When a digital camera takes a picture, it doesn't just commit the image to memory, it also stores a detailed log of how the photograph has been taken. This table of information is stored within the image file itself, and the textual notes, known as metadata, can prove extremely valuable for the photographer—or anyone else, for that matter—explaining how the picture was taken.

The information that is written by the camera is known as EXIF data (the letters stand for Exchangeable Image File Format). This data logs practically every camera setting that was used for each and every picture. It shows the actual focal length used, the effective focal length, the aperture, the shutter speed, and the ISO setting. It reminds you whether the flash was fired, and tells you the color saturation and sharpness settings that you used—and it can tell you much more besides.

Not all of this is necessary information each time, but the exposure information, in particular, is an extremely useful learning tool. If one shot in a sequence looks sharp but the others look out of focus, for instance, and you would like to know why, the EXIF data will probably point you towards the answer.

The EXIF data also stores the date and the time that a picture was shot (as long as the clock has been set correctly in the first place). Unlike the date stamps on old photographs and home movies, this information is embedded invisibly; however, it is always there when you want to work out, in years to come, how old a child was when the picture was taken, for example.

The EXIF system is also capable of recording GPS (Global Positioning by Satellite) data. Although not supported by many cameras at present, this data gives cameras the ability to record exactly where a picture was taken.

The other type of metadata that is stored is the IPTC data, which was introduced by the International Press and Telecommunications Council as a way for newspaper photographers to add captions to a picture. Generally, this information is added after the picture is shot before being uploaded to the picture desk for the pro on a deadline, or as part of the cataloging process (*see page 274*). However, some of these fields can be preset by some cameras: You may be able to embed your name with each picture, for instance, or even add a short caption to the file.

Print order form

Another form of metadata that can be added by some cameras is DPOF. Digital Print Order Form is a way of placing your order at your local photofinisher while you look at your shots on your camera's screen. You tag each frame you want printed, and the number of copies that you want of it, then compatible labs (or even home printers) can simply read your order from the memory card. Other options may also be available.

Digital dictaphone

Some cameras give you the option of recording spoken notes (or ambient sounds) to accompany your photographs. This provides a simple way of, say, jotting down the name of a location when traveling.

Empty mailbox
Viewing the EXIF data with the camera manufacturer's own software, in this case Konica Minolta's DiMage Viewer, usually gives the most detailed and intelligible account of the EXIF data.

Reading the data

EXIF data can be read by a range of different programs, including popular cataloging and manipulation programs. Specialist programs that just view EXIF data can be downloaded for most computer operating systems, and are generally distributed as freeware.

The viewing software supplied by your camera's manufacturer can usually give the fullest amount of EXIF data. Although many of the fields stored are standardized, and can be read by other programs, manufacturers often add fields to suit their cameras' particular features.

EXIF data is not necessarily kept with a file once it has been edited. For this reason, the original camera file should always be kept intact—and any manipulation work should be done on a copy (this is good working practice for many other reasons).

Young lamb

Adobe Photoshop CS2 provides access to EXIF information and a whole host of other metadata through its File Info option. Adobe uses its own XMP (Exchangeable Metadata Profile) format for this information.

Bridge photo data

Camera settings as extracted using the freeware program, EXIF Viewer.

1.1 Power

Digital cameras are completely reliant on battery power—as soon as the output from the cells drops below a certain voltage, you cannot take pictures or view them. Furthermore, digital cameras can use up available power in a surprisingly short period of time.

Fortunately, all digital cameras can be used with rechargeable batteries—ensuring that running costs are kept to the minimum. Rechargeable packs and their requisite chargers are supplied as standard with many digital cameras. But just as it is worth investing in extra memory almost as soon as you purchase a camera, it is also a good idea to buy at least one spare rechargeable battery, as cameras have a habit of losing power at the time you need them most.

Budget cameras are usually powered with standard AA or AAA pen cells. This system has the advantage that replacements can be bought at every convenience store around the globe. These cameras can also be used with rechargeable batteries, which need to be bought with a suitable charger. The rechargeable cells may not last as long as an alkaline or lithium disposable battery, but they will prove much more cost-effective in the long term. Again, it is worth ensuring that you have one or two spare sets with you.

Unlike disposable batteries, rechargeables do not hold their power well, typically self-discharging at a rate of one per cent per day, so they should be recharged as soon before use as practical. Rechargeables also, contrary to popular opinion, do not last for ever—typically, they last around 500 usage cycles. A new rechargeable battery will take several cycles before it delivers its best performance, and will provide a shorter amount of power between charges as it reaches the end of its usable life.

All batteries use a chemical reaction to produce an electrical charge, and this reaction depends on the ambient temperature. When used in low temperatures, you can expect batteries to power down faster than usual, so those using batteries in sub-zero conditions (on a ski slope, say) should carry additional spares and keep battery packs close to the body to maintain temperature until needed; normal performance will resume when the batteries are used in warmer temperatures.

A-Z of battery types

Alkaline
The most popular choice of disposable battery for high-drain devices such as digital cameras and flashguns. Some brands offer a much better performance than others, but these are more expensive.

Lead acid
As used in car batteries, lead acid packs are a hefty alternative to a built-in battery. Available to be carried on the shoulder, worn on a belt, or screwed into the tripod socket of the camera, these offer the huge running times (and fast flash recycling) required by wedding photographers and other professionals.

Lithium
The ultimate disposable solution for those with AA- or AAA-powered cameras. These are claimed to last up to seven times longer than alkaline cells, but are significantly more expensive.

Lithium ion
The most popular rechargeable technology used by camera manufacturers, lithium ion produces smaller, lighter batteries than are possible with nickel metal hydride or nickel cadmium technologies. Lithium ion batteries can be recharged before rundown with no adverse effects on their long-term performance. The battery shapes are specific to each camera manufacturer; however, lower-priced, compatible products are usually available from accessory and battery specialists.

Lithium polymer
Similar to lithium ion, these similarly powered batteries are even smaller and lighter. The dry chemical process used means that batteries can be produced in any shape required, and also has safety advantages over lithium ion. Lithium polymer is offered by some accessory companies as an alternative or backup for a camera's standard lithium pack (the same charger can be used).

Nickel cadmium
Nickel cadmium (or NiCad) is an old-fashioned rechargeable battery technology that is not used by camera manufacturers. Although this is an option for AA- or AAA-powered models, NiCad has poor power capacity, and its performance suffers if batteries are not run down fully before recharging.

Nickel metal hydride
NiMH batteries are the modern alternative to NiCads, and are the best choice for those looking for rechargeable replacements for AA or AAA batteries. Unlike NiCads, NiMHs can be recharged before the cells are run down. They are also available as separate power packs, as an alternative to sealed lead acid units.

Zinc chloride
Their low power, short life, and tendency to leak mean that these low-cost, disposable batteries should not be used in cameras that use AA or AAA batteries.

When away from home, your ability to keep shooting will depend on the accessibility of electricity, as well as the amount of memory available.

● Chargers for lithium ion batteries can be used with most voltages—typically from 100–250V—so they can be used in most countries around the globe. A suitable adaptor or plug will be needed, however, to use the unit in local sockets.

● Some accessory chargers can be powered from the 12V supply provided by a car's cigarette lighter socket.

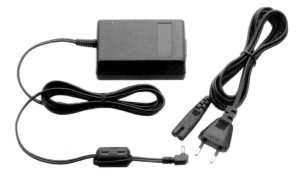

Typical camera power supply (charges battery when connected to camera).

● Accessory grips that provide extra battery capacity are available for some digital SLRs. These bolt-ons are invaluable for photographers who want to minimize the number of times they need to change packs (important when shooting an event such as a ball game or a wedding). External power packs can also be bought for some models.

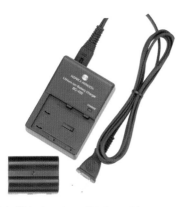

Typical lithium ion rechargeable battery and charger.

External rechargeable pack provides power to the camera via a cord.

How long a battery pack lasts will depend on how the camera is used. If you want to keep the pack going as long as possible:

● Use the main LCD screen as infrequently as possible. Resist reviewing your pictures, as these large color screens are power-hungry. Zoom compact and hybrid camera users should use the eye-level viewfinder alone for framing shots (SLR users have to work this way).

● Don't use flash, as this typically consumes power at twice the usual rate.

● Digital SLR users should turn off the autofocus whenever possible.

● Use lower-resolution and higher-compression picture-quality settings. The bigger the file you record, the more processing the battery needs to power.

● Always put the case or cover over spare batteries, whether charged or in need of recharging: Uncovered contacts could result in shorting out.

● Use mains power when available to download or view images.

1.1 Screens

A camera's main liquid crystal display, or LCD, plays a vital role in keeping the photographer up to date with what is going on. It can act as an information board, a viewfinder, a computer monitor, and as a playback screen; it can be used to judge how successful a shot has been, or even whether an image should be deleted immediately.

Useful though LCDs are, they are not perfect. While they provide an approximation of an image that has been, or is about to be, saved, the size of the LCD area means that it is a mistake to read too much into what you see; an electronic magnification facility, if provided, does mean that you can check detail and focus accuracy a small area at a time. The main problem, however, is that LCD screens are hard to read in bright light: The polished plastic outer surface of the screen not only reflects light, but the image is backlit and cannot compete with the power of the sun.

Most cameras provide a secondary viewing system to ensure that the image can be framed accurately outdoors. A zoom compact has a Galilean optical viewfinder (*see page 14*), which gives a direct view of the subject through a pair of windows either side of the camera; a hybrid camera usually has a second, miniaturized color LCD screen, which is viewed through an eyepiece (*see page 16*); and an SLR offers a periscope-like viewing system that allows you to see the subject through the lens itself (*see page 18*). These different viewfinders minimize the number of times that the main screen is used, but the LCD is still needed for reviewing the image. LCDs are not all the same, however.

LCDs come in different sizes which are measured from the diagonal of the viewing areas. Typical sizes vary from 1in (25mm) across to 2½in (62mm) across. Size is only a rough indication of quality, however: the number of elements (again called pixels) that the LCD screen is made up of is important (the more the better), as is the number of colors that the screen is capable of showing (these may only display 262,000 of the 16,700,000 colors that the camera actually records).

The visual quality of an LCD is also highly dependent on the technology that it uses. Most use active matrix technology, with TFT (Thin Film Transistor) and TFD (Thin Film Diode) being the most popular types. TFT has a slight edge over TFD on quality, but TFD screens tend to be thinner and use less power, making them popular with some manufacturers. Basic cameras may have inferior passive screens that use CSTN (Color Super Twisted Nematic) technology, which looks noticeably less bright and colorful than TFT.

Adjusting the eye-level viewfinder

Many digital cameras provide an eye-level adjustment that allows you to alter the viewfinder to suit your eyesight.

Do not adjust this slider or knob to correct the image itself; instead, adjust it so that you can see the LCD or LEDs in the viewfinder, or the lines on the screen, more clearly.

This dioptric correction means the viewfinder can be adjusted for use without eyeglasses, although the amount of adjustment available means this is only suitable for those with weak prescription lenses.

Additional corrective lenses are available for the viewfinders of some digital SLRs, allowing photographers with stronger prescription lenses to shoot without their spectacles.

SLR Viewfinder
A typical view through a digital SLR's viewfinder. When adjusting the dioptric correction, focus the lines rather than the image.

Seeing in the sunshine

There are a number of ways to help you see the pictures on the main LCD screen, even when you are shooting outdoors on a bright day and can't find a shady area to stand in.

● Some manufacturers make sunshields that fit around an LCD screen.

● Some cameras have a screen that can be tilted or rotated independently from the camera so that it can be used as a viewfinder with minimal reflections.

● If all else fails, take a tip from oldtime large-format photographers and put a black cloth over your head and the screen. If you have no black cloth handy, a sweater or coat will do just as well.

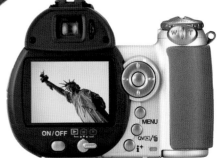

Basic camera
Just one screen for everything. The large LCD screen, however, is not ideal when framing shots in bright light.

Menu screen from Nikon SLR
The main LCD is not just used for viewing the picture you have just shot—it is also used to display menu options, providing access to a wide range of controls that do not have dedicated buttons.

Hybrid camera
Mini color LCD screen viewed at eye-level. Larger color LCD screen. Dioptric correction wheel.

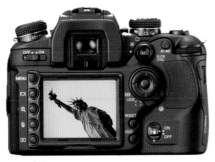

Digital SLR
Direct through-the-lens viewfinder. Color LCD screen.

Typical zoom compact
Optical viewfinder acts like a window. Color LCD screen.

Screen protection

● The outer surface of the LCD screen can become scratched; it pays to try to minimize this damage, which will make it hard to see detail on the screen.

● Never place the camera screen down on a table or worktop—rest it on its base.

● Put the camera in a protective case when carrying it in a pocket or a bag.

● Digital SLRs are usually supplied with a clip-on plastic cover that sits permanently in position protecting the screen. If this gets scratched, it can be replaced far more cheaply than repairing the LCD itself.

1.1 Focus

Because lenses can only focus on a single distance, the photographer focuses on a point—but everything on a parallel plane with the imaging chip and going through this point is equally sharp (everything in front or behind is technically out of focus).

Fortunately, the amount of the image that looks in focus is rarely this limited. Thanks to a phenomenon known as depth of field, there is usually a range of distances that look sharp. However, the area in the picture that looks sharpest becomes the focal point for the photograph. Get it wrong, and the subject may well look blurred—one of the few shooting mistakes that is hard or impossible to correct using software.

On very basic cameras, there is no focusing control. The focus is fixed on a distance 3–6ft (1–2m) away, and relies entirely on depth of field. More sophisticated cameras cannot afford to take this approach, particularly if they are also to offer an adjustable aperture, a zoom lens, and the ability to focus on things that are closer than a couple of paces away.

While some cameras provide the option to adjust focus manually, every zoom compact, bridge camera, and digital SLR provides an automatic solution. Not surprisingly, the speed and sophistication of autofocus, or AF, varies widely. However, all digital cameras use the same principle to work out how to adjust the lens to produce an in-focus image.

AF systems

Passive autofocus is so-called because it judges focus by looking at parts of the image itself, measuring the distance between the subject and the sensor. The idea is that a fuzzy, out-of-focus image has less contrast than a sharp one, so by monitoring the chosen part of the frame using an image sensor, similar to but smaller than the main one, the system can then adjust the lens to create as much contrast in that area as possible.

The great advantage of this system is its accuracy, whatever the distance to the subject and whatever the focal length of the lens (which isn't the case with older autofocus technologies, such as infrared). It is ideally suited to cameras that have a powerful telephoto lens (built in or interchangeable) and is sometimes referred to as TTL (through the lens) AF.

The problem with contrast-detection systems is that they are inherently unstable, and you can sometimes end up constantly "hunting" for a more contrasty image, especially in bad conditions. AF systems work poorly in dim light and with low-contrast targets. To help in low-light situations, some cameras and flashguns have what is known as an AF illuminator, essentially a flashlight that projects a high-contrast pattern onto the subject, on which the passive autofocus system can then lock; however, this facility has a limited range.

Shooting off-center

Although autofocus can adjust the lens accurately based on the target it locks onto, what it can't do is decide which part of the frame it should focus on in the first place.

Basic autofocus models use a single autofocus sensor positioned dead center of the frame, which will assume that this is where the main part of the subject is, unless you persuade it otherwise. Of course, your subject may well be more toward one of the edges of the frame—and there are good compositional reasons why you should avoid having the main element of the image placed too centrally (*see page 128*).

For this reason, even basic autofocus cameras have a focus lock: You point the central target in the viewfinder at the subject you want to focus on, then press the shutter button halfway down to focus and lock the lens. You then keep your finger locked down and recompose the picture, and then press the trigger all the way.

Many digital cameras use a more sophisticated autofocus system with three or more focus points across the frame (some cameras have dozens of points). The camera analyzes each of these, but makes the assumption that the one you wish to use is the point that is closest to the camera. Of course, this may not be the case, and the point you want to focus on may not be covered by any of the focus points; again, the focus lock will have to be used.

Central AF
The autofocus system assumes that the subject is in the center of the frame and focuses on the background, not the subject.

Setting focus
The shot is temporarily reframed with one of the boys in the center of the frame and the shutter is pressed halfway down. An LED in the viewfinder confirms that focus has been locked.

Reframing shot
Keeping the focus lock engaged, the camera is reframed with the subject off-center, and the shutter button is then fully depressed to take the picture.

Unfair advantage

One of the main advantages of digital SLR and hybrid cameras is that you can actually see where the lens is focusing. With a zoom compact, you cannot see which parts of the picture are out of focus until the picture has been shot—and by then, it might be too late. The eye-level finder provides at least a good approximation of where the autofocus system is focusing, allowing you to take remedial action should it struggle to lock onto your chosen target.

Autofocus obstruction
When shooting in a marine aquarium, the glass of the tank can cause problems for an autofocus system: there is a danger that the camera may focus on the glass, particularly if it is dirty or has reflective highlights. An AF illuminator would only help the camera to focus on the glass, rather than on the beluga whale behind.

Using the illuminator
The strength of built-in AF illuminators varies from camera to camera. However, an illuminator is ideal for taking portraits in low-light conditions, whether or not you are using flash—manual focusing in such dim conditions would be extremely difficult to do accurately.

Choosing the subject
The main subject in this picture is the building in the background, not the line of conifers in the foreground. Autofocus would struggle to make the right choice here, so the focus lock had to be used.

Contrast detection
Autofocus systems require contrast to adjust the lens. But some subjects have no contrast, as in this white piece of chinaware in a white room. In this case, it was necessary to lock focus on the line at the back of the shelf.

43

1.1 Focus modes

Because of a passive autofocus system's tendency to constantly adjust the lens in the search of a higher contrast image, some cameras provide different operating modes. Each of these AF modes is better suited to some subjects than others.

Focus priority AF

Focus-priority or single-shot autofocus is best suited to general photography, where you are shooting a non-moving subject that is a fixed distance from the camera. In this mode, the camera will not fire until the autofocus system is satisfied that it has focused the lens on the selected part of the target. The autofocus system can be engaged by pressing the shutter button halfway down, and is then locked when focus has been achieved (see p43).

Continuous AF

The alternative, continuous autofocus, takes a different approach that is designed for when a subject is moving, so that the focus needs to be constantly adjusted until the moment that the shutter is fired. As you frame the subject, the autofocus engages and tries to track the target, and the usual focus lock facility becomes unavailable.

The trouble with this approach, however, is that there is a delay between the shutter being fired and the image being taken. Even with a digital SLR with a fast processor, the amount of time it takes to close the iris, raise the mirror, and open the shutter can be 100 milliseconds (one tenth of a second). This might not sound a lot, but if the subject is moving fast enough

to or from the camera, it is long enough for the calculated focus position to have become completely inaccurate—an Olympic-standard sprinter, for instance, would have moved a whole yard down the track during this time.

Predictive AF

The best digital cameras use a refined version of continuous autofocus, known as predictive AF. This essentially measures the speed of the subject and then adjusts autofocus to allow for the shutter delay. It does this simply by taking a series of readings just before the shutter is fired, plotting how much it needs to adjust the lens between each; it can then add the amount of extra adjustment based on the shutter delay for that particular camera. Using several sensors in unison, it can even detect and allow for subjects that are accelerating or decelerating toward or away from the camera.

The amount of adjustment that an autofocus system needs to make depends on the focal length used, the speed of the subject toward or away from the camera, and the distance. The closer the subject and the longer the focal length, the faster the lens needs to adjust. It is not usually the fastest subjects (such as planes and cars) that fool predictive autofocus, but action subjects that can be shot from a closer vantage point, such as cyclists and runners.

The extremes at which predictive autofocus can be successfully used depend not only on the camera, but also on the lens being used; some are lighter, or have better built-in focusing motors, to aid high-speed focus adjustment.

Riding dolphins through spray
The direction in which the subject is moving is all-important for autofocus systems. This trainer riding on the back of two dolphins is moving across the frame, so the focus doesn't need to be adjusted as much as if he were heading directly toward the camera. Multipoint AF ensures he is sharp, even though he is not in the center of the composition.

A typical viewfinder will show the area in which the autofocus is effective.

Knight jousting
A jousting knight approaching the camera at full tilt with his lance. Shot with an effective focal length (efl) of 450mm, this is a tough test for predictive autofocus. However, although not every picture in the sequence was sharp, the success rate was a lot higher than most people could manage by manually focusing the lens.

Question of trust

A stunt motorcyclist and assistant perform an extended wheelie on a quad bike, while the focus is constantly adjusted during the picture sequence by the digital SLR's predictive AF mode.

Predictive AF takes a while to get used to and trust—you can't see the effect, as the viewfinder is dark when the shot is actually taken, you can therefore only check the accuracy of the system later.

1.1 Manual focus

Used with care, autofocus allows photographers to shoot pictures that are consistently sharper than is usually possible with manual focus. However, there are occasions when it is simply quicker or more reliable to switch off the AF and focus the lens manually.

One great advantage of manual focus is that it uses less battery power than AF, and has a quieter camera operation. Furthermore, there are occasions when passive autofocus systems fail—in low light, for instance, when taking shots of subjects that are out of the range of the AF illuminator, manual focus becomes almost essential. In some scenes there are so many foreground distractions that an automatic system cannot help but get confused as to where the subject lies. For some studio, landscape, and architecture shots, you may want to take a series of shots from a fixed camera position, and there is little point adjusting the focus for each and every frame.

Focusing manually, however, is not always straightforward. The focusing screens of autofocus SLRs, for instance, are designed for AF use, and all you get to help is a ground matt surface that exaggerates the focusing effect slightly. To help focusing precision (and to make the viewfinder brighter), the amount of depth of field you see is limited, showing the image that would be produced using the maximum aperture of the lens in use. Interestingly, the autofocus system is still partially working as you focus manually, with a green light still coming on in the viewfinder when the camera thinks you have focused accurately on the target.

Hybrid cameras, indeed all those that use separate viewfinders rather than a through-the-lens approach, force you to judge focus accuracy using the eye-level LCD monitor; however, they may offer the ability to enlarge part of the image to help focus accuracy.

Speed of operation

The speed with which you can switch to manual focus from AF is an important consideration for many serious photographers. If autofocus proves unsuitable for the shot in front of you, you don't want to have to scroll through lots of menu options to find the override. An excellent solution, found on some digital SLRs and some AF lenses, is a button that defeats the autofocus for as long as the button is depressed. Some lens/body combinations allow you to adjust the lens's manual focusing ring, even when the autofocus is switched on.

The speed of the focus control itself can also be crucial. On some cameras, manual focus is controlled using a motor that slows down operation. The fastest solution is a wide ring around the lens, which gives direct control over the lens's optical elements.

Focus bracketing

Although some zoom compacts provide a manual focus control, this is not a particularly useful feature, as you cannot see the effect that this has through the viewfinder (see page 42). For this reason, some manufacturers add a focus bracketing feature to their cameras. This shoots a series of three or five shots, each with the lens focused at a slightly different distance. You can then choose the one you prefer, or combine two using editing software.

Deliberate mistake
Who says your pictures have to be pinsharp all the time? Deliberately defocused shots sometimes work particularly well with bright, colorful, and easily identifiable subjects. Manual focus is the simplest way to achieve this effect.

1.1

Prefocusing

Manual focusing is invaluable for sports in which the subject only comes into view at the last minute, and where predictive autofocus would prove ineffective. Instead of focusing on the subject, you focus on an area of the track or field of play through which the subject is due to pass. You then fire when the action reaches this spot. For this shot of motocross scrambling, the lens was focused at the brow of the hill, allowing each competitor to be shot in turn as he or she reached this point.

Rocking to and fro

With subjects that are very close to the lens it is often best not to use the lens to focus precisely. Instead, rock from the waist to move the whole camera forward and back by a small amount; you stop and fire when the focal point for the image appears its sharpest, as in this shot of a tree fern frond unfurling.

Statue of Venus

In low light, and with low-contrast subjects, it is often more reliable to turn the AF off and focus the image manually, as with this picture of a Roman statue in a museum.

Through a double window

Airplane windows create a double problem for autofocus systems, as the glass is protected by a clear acrylic sheet, making it likely that the camera will focus on the surface of the glass. The solution is to get the lens right up close to the acrylic sheet, and then focus manually on the landscape below. This was shot from a passenger jet above the Pyrenees.

47

1.1 How close can you go?

The minimum focusing distance is a crucial part of the specification of any lens, whether built-in or bolted on. How close it will allow you to get to your subject and still produce a sharp image, governs how much the subject can be magnified.

Most zoom compact and hybrid cameras have built-in macro facilities that extend the focusing range to allow you to focus to within 1in (25mm) of a subject. This is done by extending the distance between the rear elements of the lens and the sensor.

The standard zooms bundled with digital SLRs, in comparison, may offer rather disappointing close-focusing abilities. The shorter the focal length, the closer you are usually able to get, but this effect is canceled out by the fact that shorter lenses have wider angles of view. Some digital SLR zooms have much better macro facilities than others, but getting the best performance means being forced to focus manually, or losing the ability to zoom.

The best solution for those wanting to get close to the subject is a macro lens. This is a prime lens (that is, a non-zoom lens with a fixed focal length) that is specifically designed for close focusing. Maximum magnification is measured by comparing the size of the subject with the size that is projected onto the imaging chip. Macro lenses typically produce a lifesize image (with a 1:1 magnification ratio), or a half-life size image (with a 1:2 magnification ratio). The ideal focal length depends on the kind of subjects being shot —an effective focusing length (efl) of around 100mm is a good all-round choice. Longer focal lengths allow you to work that much further from your subject (good for some types of insect, for instance), while shorter lengths may prove more useful for copying flat artwork. These lenses can still focus at infinity (optical term for the distant horizon), and so they can also be used for other subjects.

Extension tubes

A low-cost alternative to a macro lens is to use extension tubes. These are hollow, lensless tubes that fit between the digital SLR and the lens. They are usually supplied in sets of three, each of a slightly different length that offers a different amount of extension by reducing the minimum focusing distance of the lens it is being used with by a different amount. By using the three tubes singly, in pairs, or all together, seven different amounts of magnification are possible.

The sets are usually designed so that the maximum magnification possible (with three tubes used together) is lifesize when used with a lens with an efl of 50mm. Extension tubes can, however, be used with any lenses, including zooms. They can also be used in combination with a macro lens to give larger-than-life magnification.

To get even greater magnifications, some digital SLRs can be used with a bellows unit, a concertina-like, extendable, extension tube.

Close-up lenses

Close-up lenses act like magnifying glasses, and because they fit on front of the lens they can be used on cameras with built-in zooms, as well as with digital SLRs. They attach to the lens in the same way as filters (*see page 108*), either screwing directly into the filter thread, or fitting into a filter holder.

The lenses come in a variety of strengths and are measured in diopters, ranging from +1 to +4. The diopter value allows you to calculate the magnifying lens's fixed focus distance, when used with any lens focused at infinity. You simply divide one yard or meter by the diopter value, so a +3 lens would focus at 1ft (0.33m). You can then get closer still by adjusting the focus of the camera lens on which the attachment is mounted.

Close-up lenses provide inferior image quality compared with macro lenses and extension tubes, but they are a very low-cost solution; in fact, they are the only solution for extending the macro capabilities of a zoom compact or hybrid camera.

Extension tubes
Set of low-cost extension tubes. Although these still offer automatic exposure with the lens, autofocus operation is lost.

These shots illustrate the maximum magnification available with different types of equipment:

Canon Macro lens
Macro lens for digital SLR produces a lifesize image on the camera's sensor.

Acer leaf
A digital camera's macro mode allows you to home in on detail that would otherwise be impossible to capture, such as this close-up of Japanese acer leaves.

Purple Hellebore flower
For this sort of close-up shot, a digital SLR with a macro lens is ideal. Macro lenses have smaller than usual minimum apertures to help to maximize the limited depth of field (see page 94).

Standard zoom
Digital SLR with standard zoom set at efl at 80mm at minimum focus distance.

Macro mode
Digital SLR with standard zoom set at efl at 80mm with macro mode engaged.

Macro mode with diopter
Digital SLR with standard zoom set at efl at 80mm with macro mode engaged with +3 diopter close-up lens.

Macro
Digital SLR with specialist macro lens set at efl at 135mm used at maximum 1:2 magnification.

Macro with extension rings
Digital SLR with specialist macro lens set at efl at 135mm used at maximum magnification with three extension rings.

Hybrid at 6x
Hybrid camera with 6x zoom at minimum focus distance.

Hybrid at 6x macro
Hybrid camera with 6x zoom used in macro mode.

Hybrid with diopter
Hybrid camera with 6x zoom used in macro mode with +3 diopter close-up lens.

1.1 Exposure metering

An imaging sensor needs a certain amount of light in order to create a good picture of the scene; this is known as the exposure. How much exposure is needed depends on the ISO sensitivity (*see page 26*) of the chip: too much light, and the picture looks too bright, or even washed out; too little light, and the image appears too dark.

Because some scenes are much brighter than others, the camera needs a way to control how much light reaches the sensor. It uses two controls for this, which work in parallel to control precisely how much light reaches the sensor: the aperture setting opens the iris blinds of the lens wider, or closes them smaller, to vary the amount of light getting through to the sensor; then the shutter speed controls how long the sensor is exposed to the light.

You can think of exposure as similar to filling a pitcher with water: The ISO speed is the size of the pitcher; the shutter speed is the length you leave the faucet open; and the water pressure is the intensity of the light in the scene. The length of time you leave the tap on is balanced by the other two factors.

Things are complicated by the fact that most scenes are not uniformly lit—in fact, some parts may be considerably brighter than others. Choosing the right exposure for the scene is open to some interpretation, depending on which parts you want to show. Furthermore, because the sensor can only successfully record a certain range of brightnesses simultaneously (and a more restricted range than our eyes can cope with), there are times when exposure is a compromise.

Whatever the lighting conditions, the camera needs to measure the amount of light there is in the scene. This is measured by a meter that takes brightness values from different parts of the image, from which a suitable "average" can be chosen on which to base the exposure. Because of the difficulties of contrast and interpretation, many cameras offer two or more metering systems, designed to make different assumptions.

Metering systems

Three different metering systems are commonly found on digital cameras:

Center-weighted

Center-weighted metering takes light readings from across the whole image area, but instead of just taking a straight average, it biases the result to the central area of the picture. This, after all, is where the subject probably is, and it gets around the fact that the top half of the picture may well be much brighter than the rest of the scene, because this is where the sky is.

Cons: Can be fooled by off-center subjects, by bright- or dark-toned subjects, or by very dark or very bright backgrounds.
Pros: It is possible to learn and predict when center-weighted metering will get it wrong, and then compensate for error.

Matrix

Also known as evaluative, multizone, or intelligent metering, matrix metering takes readings from a number of different zones across the frame. But instead of taking an average, or biasing the reading in a predictable way, it tries to interpret the type of picture that you are taking. Using a databank full of typical picture-taking situations and their corresponding light readings, it tries to work out, for instance, whether the background is meant to be black because it is the night sky or because it is lighter-toned and simply needs more exposure. Often this kind of metering is linked into the multizoned focusing system, so that it already knows in which zone the main subject is positioned.

Cons: It is almost impossible to predict when the matrix metering system will get it wrong, and how it will get it wrong, making it hard to compensate for its mistakes.
Pros: More accurate than center-weighted metering, matrix metering is perfect for those who are unlikely to ever manually override the exposure.

Spot

A spot meter takes a straight average reading from just a small central area of the frame. A photographer typically points the spot meter at a part of the subject and then locks that reading, or calculates an average based on a number of readings. Some digital SLRs may even have two spot-metering options—a true spot mode that reads perhaps just two per cent of the image area, and a partial mode that analyzes a wider ten per cent circle.

Cons: You need to know where to point the meter. This metering system has the most scope for getting the exposure entirely wrong if you take an area that is brighter or darker than the ideal average.
Pros: Gives very precise information about brightness values in a scene, and is invaluable in high-contrast scenes, or with subjects dominated by very bright or dark tones. Digital cameras at least allow you to review the exposure after the shot is taken, so that there is minimal risk of getting it wrong.

A question of compromise

Underexposed

"Correct" exposure

Overexposed

It is easy to see which of these three shots is the best. However, the high-contrast subject means that there are parts of the swan that look better in the over- and underexposed versions.

The red fleshy carbuncles above the bill look brighter with underexposure, while overexposure provides better detailing to some parts of the black neck.

Metering system

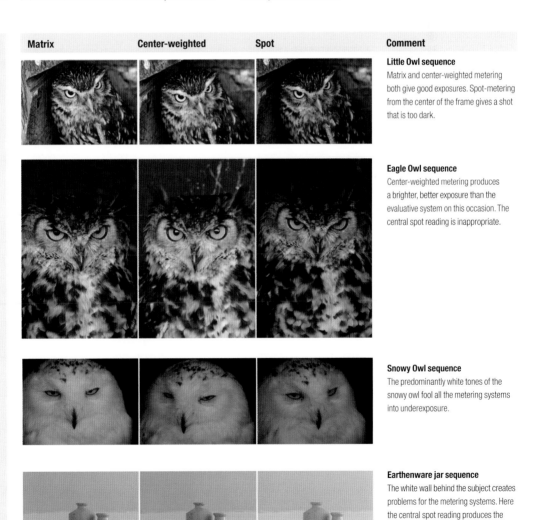

Matrix	Center-weighted	Spot	Comment
			Little Owl sequence Matrix and center-weighted metering both give good exposures. Spot-metering from the center of the frame gives a shot that is too dark.
			Eagle Owl sequence Center-weighted metering produces a brighter, better exposure than the evaluative system on this occasion. The central spot reading is inappropriate.
			Snowy Owl sequence The predominantly white tones of the snowy owl fool all the metering systems into underexposure.
			Earthenware jar sequence The white wall behind the subject creates problems for the metering systems. Here the central spot reading produces the best exposure.

1.1 Setting exposure

Exposure modes

Once the metering system has worked out a representative brightness value for the scene, this information needs to be translated into shutter speed and aperture. But however dark or sunny the scene, there is no one correct solution—for a particular scene, if you can use a midsize aperture with a medium-length shutter speed, you could also use a shorter shutter speed with a wider aperture; then again, you could also choose to use a longer shutter speed in combination with a smaller aperture value. The number of possibilities is usually limited by the settings available on the camera or lens—particularly the aperture values, which usually have a narrower range than the shutter speed settings.

In terms of the exposure, which of the possible pairs of settings that you use to capture the scene is unimportant. But the particular choice of shutter speed or aperture has other effects on the recorded image.

A shutter speed that is too slow may mean that even stationary subjects are blurred, particularly when using longer lenses (*see page 80*). Moving subjects may mean faster shutter speeds still (*see page 78*). The aperture used, meanwhile, will have a major influence on how much of the scene appears sharp, being a factor affecting depth of field (*see page 86*).

The ideal combination of shutter speed and aperture you choose, therefore, will depend on the subject matter, or your interpretation of it. Alternatively, the camera will use its own logic to come up with a compromise between keeping the shutter speed high and using a small aperture. Whether you actively get involved in the decision or not, most cameras provide a number of different exposure modes, each of which chooses the exact combination of shutter speed and aperture in different ways.

"P" Program mode A fully automatic mode where the camera sets both the shutter speed and aperture; this chooses the combination not only on the metered brightness of the scene, but also based on the lens setting: it sets the smallest aperture possible while ensuring that the shutter speed is fast enough to avoid camera shake at this focal length.

The program mode is the only exposure mode on simpler zoom compacts. On other cameras it may be part of a more general "all-auto" idiot proof point-and-shoot mode that also sets other features, such as flash and focusing, to automatic settings.

Program shift An extremely useful variation on the program approach, where although the camera selects shutter speed and aperture, you have the option of overriding the setting. The usability of this mode depends on having clear readouts of the values the camera has chosen, which should ideally be displayed in the viewfinder. Without changing the exposure, you shift the settings towards the shutter speed or aperture you'd prefer, normally using a thumbwheel dial.

"A" Aperture priority In this semi-automatic mode, the user sets an aperture, and the camera

sets the shutter speed based on the metered light level. This can be useful in situations where you need a specific aperture setting; you may want the widest aperture available, for instance, to throw the background as far out of focus as possible (*see page 90*). Aperture priority can also be useful when the type of shutter speed required is more important than the aperture; you may use aperture priority to set the widest aperture so as to force the camera to set the fastest shutter speed possible for a series of shots.

"S" Shutter priority A semi-automatic mode, where the user sets a specific shutter speed, and the camera then selects the necessary aperture based on the metered light level. Can be used when a specific shutter speed is required—say, when you want to experiment with different slow settings to create motion blur (*see page 80*).

"M" Metered manual In the manual mode you set both the shutter speed and aperture independently. Although the camera's meter is still functional, the user can stray from its recommended shutter and aperture pairings. Can be used with a separate hand-held meter, or when shooting a subject at differing exposures, to ensure a

range of options later. May also be the only way of setting an extra-long "bulb" or "B" exposure (*see page 82*).

Subject program modes
Many digital cameras provide a selection of exposure modes that are specifically tailored to particular photographic subjects, such as sport, portraits, or landscapes. Not only do these set the aperture and shutter speed combination with the subject in mind, but they may also change the color balance, motordrive setting, autofocus mode, flash, and so on to suit.

Their ease of use gives these modes appeal, particularly if there is no other way of changing shutter speed or aperture. However, it is often hard to guess the exact assumptions these programs make, and whether they are really applicable to the scene in hand.

A sports program will tend to set the fastest shutter speed possible; however, some of the best sports pictures are taken with slower shutter speeds. A portrait mode will tend to set the aperture to ensure that the background is out of focus—but sometimes the setting is as important as the sitter.

Sports
A very general rule when shooting sports is to use a fast shutter speed, so that movement is frozen.

Landscape
A very general rule when shooting landscapes is to set a small aperture, to keep as much of the frame in focus as possible.

Night
When hand-holding the camera becomes impossible, the exact shutter speed becomes less important. A tripod allows you to have a free choice as to the aperture set.

Portraits
A very general rule when shooting portraits is to use a large aperture to throw the background out of focus, ensuring that the subject is the center of attention.

Assessing exposure

LCD screens give a good estimate of whether a shot is correctly exposed. Most cameras preview the shot before saving, or provide a confirmation post-view as the shot is automatically saved. Look at the shots carefully, as they provide an indication of exposure difficulties. If you suspect any problem, you can then look at the shot in more detail using playback. Remember the screen only gives an approximation as to the brightness actually recorded, but it is in general perfectly good enough for making exposure judgements.

Many cameras also provide a more quantitative way of assessing the exposure of pictures. The histogram display may look scary to the non-scientist, but is simply a representation of how the tones are distributed across the image. It simply analyses the brightness of each pixel on a scale from 0–255, with 0 being jet black, and 255 being the brightest white, and then shows this information as a bar graph, showing how many of each you have.

It is the shape and position of the histogram that really count. You don't want to see the graph squashed up at either end of the display, as this suggests underexposure (with too many black tones) or overexposure (too many white tones). Ideally you want a well-centered shape, with values dropping off at either end.

A histogram is particularly useful when photographing high-contrast subjects—as the accompanying thumbnail image shows the parts of the image that are going to be burnt out, and which shadow areas are going to have no detail.

In digital photography, "clipped" shadows are more acceptable than "clipped" highlights, and this should be taken into consideration with subjects where the full range of tones cannot be held neatly within the histogram's range.

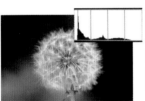

Well-exposed shot The dandelion scene is a typical high-contrast subject where the histogram proves useful. The graph shows that shadows and highlights are all within the range of the sensor's capabilities at this exposure.

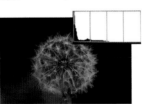

Underexposed The graph is stacked up against the left-hand side of the display, showing the dominance of dark tones. The peaks at the far left show that shadow detail has been lost.

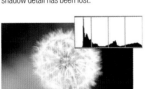

Overexposed The histogram is positioned slightly to the right of center, implying an overbright picture. Highlight detail has not been lost, but this is not a ideal exposure, particularly given that the highlights are the main subject of this shot.

Exposure mode selection
The actual exposure mode that you use is often simply a matter of personal taste. However, what is essential for those who want to use the exposure settings creatively is to be able to see how the shutter speed and aperture are set. This information should not only be shown on the exterior LCD panel; it should also be visible as you look through the viewfinder; this allows you to check and change settings without taking your eye off the subject.

1.1 Exposure compensation

Although built-in metering systems can get the exposure right most of the time, there are occasions when they fail to produce an acceptable result.

The difficulties usually arise when there are large areas of black or white in the shot, such as when photographing a building against a dark night sky, or when shooting a snow-covered landscape. Metering systems make the assumption that when the brightnesses of all the shadows, highlights, and the tones in between, are averaged out you would end up with a mid-gray. The sample on which this assumption is based changes depending on the metering pattern used (*see page 52*), but the meter will still adjust the exposure to try and achieve this average midtoned gray. But if the scene is dominated by light- or dark-toned subjects, this produces an underexposed or overexposed image.

Mistakes are also made when there is more contrast within the scene than the image sensor can cope with. Should the camera save detail in the highlights and let the shadows go dark, or vice versa? This is an artistic judgement that you cannot expect a metering system to always get right.

In these circumstances, it is necessary to override the meter. The easiest way of doing this on most cameras is to use exposure compensation: rather than ignoring the meter completely, you make an informed prediction as to how far its reading is going to be out. You then use the exposure compensation facility (an onscreen slider control on most cameras, and a mechanical dial on others) to dial in the required amount of correction. The amount of correction is measured in stops, with each whole stop correction representing a halving or doubling of the exposure. Compensation is usually available in half-stop, or third of a stop, increments.

You can gradually learn how much compensation is needed based on experience with your particular camera. However, digital cameras allow you to review your shots so that you can see when compensation may be needed, and whether your adjustment works (*see box*). However, it helps to know when there might be a problem, and what what exposure compensation values to start with:

Backlit scenes: to ensure that the subject in the foreground is correctly exposed, you need to add more exposure—a correction of +1 to +2 stops would be typical. Don't correct (or deliberately underexpose) if you want a silhouette. Don't expect miracles—backlit subjects will never look the same as front-lit ones, however much compensation you use.

Snow scenes: snow can tend to look muddy and strangely colored if exposure is not corrected, as the meter tries to turn the expanses of white into grayish midtones. Increase exposure between +0.5 and +1.5 stops, depending how much of the image area contains snow.

Dark backgrounds: a classic example of overexposure is when photographing a stage performer: lit by a spotlight, the entertainer is well lit, but the background behind is very dark. The meter tries to adjust for the expanses of black by increasing exposure. You need to decrease exposure, with an adjustment of typically -1.0 stops.

Auto bracketing

Many cameras have a facility that automatically shoots off a series of shots at slightly different exposures. Auto exposure bracketing (AEB) is particularly useful in tricky lighting situations when you can't be sure of how much exposure compensation to use. Typically, three or five shots are taken in succession, and you can set the difference in exposure between each shot in the bracketed sequence—usually one stop, half a stop, or a third of a stop.

It is usually sensible to use auto bracketing in combination with exposure compensation. Typically, you will know that a scene needs a certain amount of overexposure, so the last thing you need is a shot that is more underexposed. Instead, you use the two systems to give you a sequence with varying degrees of "overexposure."

+0.2 stops

The light-colored skin of the garlic meant that exposure compensation was

+0.5 stops

likely to be required. Setting +0.5 stops compensation, the auto-bracketing

+0.8 stops

facility was used to provide a sequence of +0.2 stops, +0.5 stops, and +0.8 stops.

Snow scene
A sunny snowscape creates a bright
scene that a camera's meter will
underexpose if left uncorrected.
Compensating the exposure by +2 stops
created a more natural-looking scene.

If you shoot using RAW, precise
exposure compensation becomes
far less important. Exposure
compensation can be applied,
or changed, when the image is
converted to a standard file format
at the image-manipulation stage.

Bridge
A typical backlit scene. The bright, almost
featureless sky dupes the meter, and the
subject appears in shadow. But by using
the exposure compensation dial at +1.5
stops, a much more presentable image
has been achieved.

1.1 Color temperature

Whether you read this book using a candle, a desk lamp, or sitting on a sunny beach, the paper will always look white. In reality, though, each of these light sources has a different color, known as its color temperature. The reason that we don't see this is that the brain automatically compensates for these differences, and thus we see the white that we expect to see.

Light comes in a huge range of different colors, and it is only at the most extreme ends of the scale that the human eye can perceive the difference. A sunset, at one end of the color scale, will look orange; a clear sky, which is a light source in its own right, looks a deep blue.

Color temperature is commonly measured in degrees Kelvin (K), and this scale is provided on some digital cameras as a way of manually setting up the camera for particular lighting situations (*see page 58*). However, all digital cameras have a system for automatically adjusting the color of the pictures they record to suit the lighting they detect currently lighting the scene. This is known as auto white balance (or AWB).

Auto white balance uses electronic filtration at the processing stage to correct the color temperature it measures in the scene.

Although most people know that indoor bulb lighting is actually orange in color, few people realize that color temperature varies significantly even in daylight: Natural light is always a mixture of sunlight and skylight; sunlight is a mixture of colors, or wavelengths, and the overall color temperature is affected by the amount of cloud cover and atmosphere it has to pass through. Skylight is sunlight that is reflected back by the atmosphere or sky, and is always bluish in color. In bright sunlight, skylight has little significance on overall color temperature. However, in dull overcast weather, or before dawn, the proportion of skylight is much higher—shady areas are therefore also more blue, as these are lit predominantly by skylight. It is these subtle shifts that mean that the camera must assess white balance in every shot that is taken.

Floodlights
Different artificial lights have a wide range of colors. The lights illuminating Cologne's cathedral have a visible green tint.

Flash
Flash units are designed to provide a color temperature similar to that of "average" midday daylight.

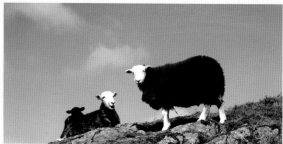

Blue sky
The sky looks blue due to wavelengths of light that bounce back towards us from the Earth's outer atmosphere.

Spectacular sunset
The color of the sunset is deeper or redder on some occasions more than others, due to there being more particles in the atmosphere at these times.

Setting sun
The low angle of the sun means that light must pass through more of the Earth's atmosphere, which scatters some wavelengths more than others.

This scale shows where the various light conditions a photographer will face fall in terms of the physicist's temperature scale, Kelvin.

Relative conditions

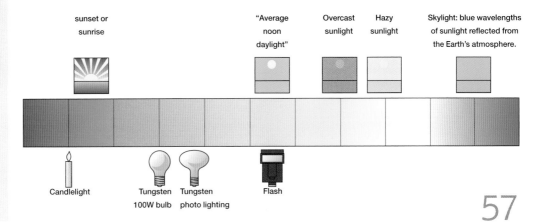

sunset or sunrise

"Average noon daylight"

Overcast sunlight

Hazy sunlight

Skylight: blue wavelengths of sunlight reflected from the Earth's atmosphere.

Candlelight

Tungsten 100W bulb

Tungsten photo lighting

Flash

1.1 Manual white balance

A camera's automatic white balance generally makes a good job of measuring the color temperature and adjusting the color balance of the digital image accordingly. However, as with all automatic controls, it cannot produce perfect results in all conditions. For this reason, most digital cameras provide at least one way of setting the white balance manually—and many provide two separate systems.

The auto white balance will have a particular problem setting an appropriate and accurate value if one color dominates the composition, as this will skew the readings that it takes.

Certain types of lighting may also lead to overcorrection by the camera. When photographing sunset scenes, for instance, you generally want the orange, reds, and yellows of the sky to be as deep and saturated as possible. But the auto white balance, instead, tries to compensate for the warm coloration, effectively adding blue to the image, which will slightly neutralize the colorful scene.

But it is not just a matter of the camera getting things wrong. In photography, precise, accurate coloration is not always what is required. For years, color films were produced that were deliberately designed to produce flattering skin tones that were slightly warmer in color than in reality, to give the impression of a healthy suntan. Professional photographers, similarly, have used filters to tweak the color produced by certain film emulsions to suit the subject that they are shooting.

A digital camera's manual white balance controls effectively provide a full set of color compensating filters that allows the photographer to manipulate the color balance of the picture to flatter the subject, or to deliberately distort the color for artistic effect.

It could be argued that slight problems with color temperature can be corrected during image manipulation. However, as with all things, it is better to get it right first time; excessive manipulation also tends to reduce the quality of the final result, and increases the amount of work that is needed before the shot can be used. Even those using RAW format, where the white balance can be changed when the file is fully processed on the PC, can save time in front of the computer screen by getting the colors as accurate as possible at the time of shooting.

Using WB presets

The most common type of manual white balance setting is one that provides a number of preset color temperature values. Occasionally these are defined in Kelvin (see page 56), but they are more often depicted using icons representing the type of lighting they are designed for: you are likely to have a sunny setting for use in bright, direct lighting outdoors, plus a cloudy setting for use in overcast conditions with softer, indirect lighting. For interiors, there will probably be one "tungsten" setting for use with household bulb lighting, while there may be several settings for different types of tube lighting (some of these are color-corrected to be more like daylight than others).

This simple system, of course, cannot cater for all conditions: sunny conditions can easily vary between 5,000 and 10,000K; and with tungsten lighting, the Kelvin reading will increase with the wattage of the bulb being used. However, these simple settings can still be a handy way of deliberately tweaking the color balance of the shot.

One of the most useful effects is to use the "Cloudy" setting in clear outdoor lighting conditions. This will produce a warmer glow in landscape and architecture shots, and gives a healthier appearance to Caucasian skin tones.

White balance icons

Sunny: Designed for outdoors in direct sunlight (approx. 5,500K).

Cloudy: Designed for outdoors in overcast conditions (approx. 6,250K).

Shady: For use outdoors when there is no direct sunlight (approx. 6,900K).

Fluorescent: Designed for use indoors when the main illumination is from strip lights. Some strip lights are closer to daylight than others, so there may be more than one setting with this symbol (approx. 4,000K).

Tungsten: Designed for use indoors when the main illumination is from bulb lighting (approx. 2,800K).

Cool portrait
Portrait taken in bright outdoor conditions using auto white balance. The skin tones are accurate, but unflattering.

Warm portrait
White balance set manually by selecting a "cloudy" setting. This produces noticeably warmer skin tones.

Weak sunset
Sunset over the Blue Nile in Khartoum using auto white balance. The colors of the sky are less intense than remembered, as the camera tries to correct for the warm coloration.

Strong sunset
To produce stronger colors, which are even warmer than remembered, the white balance was set manually to the "cloudy" preset.

1.1 Advanced white balance

Although white balance presets provide a simple way of setting the color temperature for a scene, they are a less than perfect solution. The number of presets is limited, so you can only set an approximate value.

With the alternative form of manual white balance control, however, you effectively use the camera to measure the color temperature of the scene. Instead of taking a reading from the scene itself—where the color of the subject will affect the value—it is taken from a sheet of white card. Professional TV cameramen (who were manually adjusting white balance for decades before digital cameras came along) carry around a sheet of white plastic especially for this purpose.

In practice, a sheet of white paper (even a printed sheet of newspaper) will suffice. The procedure varies slightly from camera to camera, but essentially you fill the frame with the noncolored sheet, using the zoom or close-up as necessary; it is not necessary for the surface to be in focus. Then a button is pressed to lock the reading. The sheet should be held so that it reflects the light source that you want to measure, which usually means placing it over the subject, or where the subject will be in the final composition.

The white reading is particularly useful in "mixed lighting" situations, where the color temperature varies across the scene. Indoors, for instance, part of the room may be lit from daylight creeping in through a doorway, but other parts may be lit with bulb lighting; you need a reading taken from where the main subject is, not a meaningless average for the room.

However, the trouble with using a white sheet is that an exact, scientific measurement of color temperature is not always what is needed. For this reason, colored card is sometimes used instead to force the camera to set a warmer or cooler value. A piece of blue card, for instance, will fool the camera to set a lower color temperature than was measured, producing a warmer coloration: the darker the shade of hue, the more pronounced the effect. Packs of cards of different shades (such as Warmcards) are available commercially, offering a variety of adjustments. However, it is possible to fashion your own.

Mock moonlight

Manual white balance can be used to deliberately create a strong color cast in a picture. Day-for-night, or mock moonlight, is a technique from the early days of television. A tungsten color balance setting was used in daylight to produce blue images to evoke a night scene (or at least an early morning or moonlit one); this was much cheaper and easier than actually shooting without the aid of the sun.

Werewolf
Here, a white balance reading was taken from a piece of orange card to produce a weird blue look, which works well with the Halloween portrait.

WarmCard

WarmCards provide a sort of compensation system for white balance. You use the actual light to make the measure, but you bias the result using a sheet of colored card. WarmCards come in sets of three, each with a slightly different shade of blue, which then in turn can be used to warm up the scene to different degrees, depending on personal taste and the subject matter.

ExpoDisc

An alternative to using a card to set a white point value is the ExpoDisc. This is a filter you place in front of the lens while taking a color temperature reading, and is available in a warm-up "blue" version, or pure "white" version.

Leaf on Auto

Hosta leaf shot with automatic white balance. The result looks acceptable, but the color is not accurate—a fault created by the dominance of the color green in the composition.

Leaf on Manual

This time a white balance reading was taken manually from a piece of white paper held over the leaves, which provides a much truer representation. This form of white balance is used when scientific accuracy of color is essential.

Warmer tones

Although automatic white balance provides a perfectly acceptable shot, it is transformed into a warmer, more photogenic scene by using manual white balance. For this shot, white balance was read from a light blue card held in front of the camera.

1.1 Flash

The strobe is the one control that every camera user understands, providing a portable light source that can be pressed into service when light levels get low. However, as digital cameras are so good at taking color-corrected pictures in very low light conditions, the difficulty comes in deciding when the flash should be used. Should you set a fast ISO speed (*see page 26*) or use an extra-long shutter speed (*see page 82*), so that you can make do with the existing light? Or should you use the flash?

Strobe light is created by storing battery power in a capacitor, and then firing a high voltage spark through a tube filled with xenon gas. This light is directed forward using polished metallic reflectors behind the tube, and through a plastic diffuser that ensures that the light is relatively even. The flash is extremely short-lasting: The actual duration varies on how much light is needed, but it can be as short as 1/40,000sec.

Portable flash units have a very limited effective range. The power of a flashgun is normally expressed as a guide number (GN): The bigger the number, the bigger the firepower. The guide number tells you the maximum range (in feet or metres) that the flash can be used over, when used in conjunction with an aperture of f/1, using an ISO setting of 100. A typical built-in flash unit may have a GN of 12 (m/ISO 100); an accessory strobe attached to the camera's hotshoe will typically have a GN of 28–40 (m/ISO 100).

Unfortunately, an aperture value of f/1 is only a theoretical value for most of us (it's only available only a single 50mm digital SLR Canon lens). Instead, we use lenses that only let in a fraction of this much light, even when used at the widest aperture setting. To get the actual maximum range of the flash, therefore, you need to divide the guide number by the aperture being used: A built-in flash with a GN of 12 can work over 10ft (3m) if used at f/4, but just 5ft (1.5m) if used at f/8.

As flash provides harsh lighting, optional more-powerful guns can be used, both to increase the flash range and to use the extra power to soften the lighting, using diffusers or by reflecting the light off a surface (*see page 152*). In addition to the hotshoe attachment, some cameras offer an additional plug-in system for connecting flash accessories, the standard PC socket being the most universal way of attaching studio flash units.

Some flashguns can be used manually, with the output being set separately on the flash, and the shutter speed and aperture set on the camera. However, most offer some degree of automation, or "dedication." A dedicated flashgun works in partnership with the camera. At its simplest level, the shutter speed is set automatically on the camera, while flash output is controlled using a sensor on the flashgun. However, with built-in flash units and some accessory guns, flash output is metered and controlled through the camera itself.

Dedication can entail a sophisticated two-way exchange of information, with the camera "zooming" the head of the flashgun to match the lens currently being used, for instance, and using information from the autofocus system to ascertain the subject distance. The amount of dedication can vary enormously from flashgun to flashgun.

Shutter speeds and flash

Because a burst of flash lasts for such a short period of time, it is essential that the camera synchronizes the opening of the shutter with the firing of the flash.

Synchronization is a particular problem with digital SLR cameras. These use focal plane shutters that are a pair of blinds—one that swings across to expose the sensor to the light, and another that follows shortly afterward to close the light. It is obviously essential that the blinds are both out of the way when the flash fires. Unfortunately, at the fastest shutter speeds this does not happen—instead, one blind opens as the other closes behind it, exposing the sensor through a moving slit. Fire a flash at these shutter speeds, and part of the image is obscured by one or two black bands.

The maximum usable shutter speed a digital SLR is known as its synch speed; this can typically vary between 1/150sec and 1/500sec, depending on the model.

The problem does not arise with cameras with built-in lenses, as these usually use a leaf shutter, that creates a circular opening in the lens, which also serves as aperture. Any available shutter speed can therefore be used with flash.

Some digital SLRs allow you to use flash with the fastest shutter settings if they are used with a flashgun that is capable of high-speed synch (HSS). In this mode, the series of flashes is fired as the curtains cross in front of the the sensor. This ensures that each part of the image sensor sees a flashlit view of the scene, despite seeing the scene through a slit-like opening.

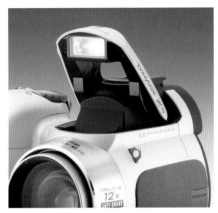

Built-in flash
Built-in flash can be useful, particularly for fill-in. But the lack of power and its close proximity to the lens axis means that it is not an ideal solution in lowlight.

Not only do flashguns have a limited range, but the amount of light reaching a particular point within a scene is highly dependent on its distance from the flash: Close objects within a scene will look bright, and distant ones will look dark.

All light obeys the "inverse square law," which basically says that the falloff in brightness is directly proportional, not to the distance, but to that distance multiplied by itself: An object that is 6ft (2m) away will therefore only get one quarter as much light as

an object that is 3ft (1m) away. The sun obeys the same law, but as everything on Earth is effectively the same distance away from the light source, the math becomes irrelevant.

With flash, this dropoff becomes extremely noticeable if you have elements within the scene that are at different distances, and the effect can look quite unnatural. It is often good practice, therefore, to ensure that key elements are at the same distance away, and that backgrounds are far enough away to appear black in the image.

The Canon 580 flashgun

Diffuser in front of flash tube

Head zooms in and out, so flash can match angle of coverage of lens

Head can be tilted up and rotated, to diffuse flash by bouncing it off ceilings or walls

Tightening ring ensures flash is securely attached to hotshoe or bracket

Without flash
The candles become more prominent and softer, due to movement during the slower shutter speed. The colors are more muted than with flash, but this shot captures the atmosphere of the scene better—and there are no problem shadows or highlights.

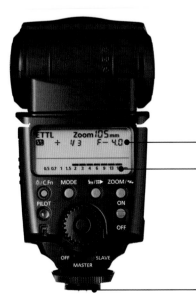

LCD information panel shows flash status

Scale shows flash range, which can be increased by increasing the ISO setting being used

Hotshoe plate makes electrical contact with camera

With flash
Built-in flash gives a harsh result, with strong shadow on the background, and unpleasant highlights on the girl's nose and forehead.

1.1 Flash modes

Built-in flashguns provide several operation modes that allow you to use the strobe in different ways, and help to minimize the problems that flash creates in the first place.

The most obvious of these are the on and off modes. On zoom compacts, the camera is generally set up to fire automatically, depending on the light level, so if you want to turn the flash off after dark (when photographing fireworks, for instance, or at a sporting event where flash is banned), this is essential. With digital SLR and hybrid cameras, you usually need to raise the flash before it is becomes both visible and operational.

While flash is used most frequently by photographers after dark, it can prove just as useful during the hours of daylight. In fact, built-in and low-powered portable flash units arguably work best in these conditions. Built-in flash has an even shorter range during daylight, but it can be used to enhance foreground detail. It complements existing light, rather being the only source of illumination, so there is little risk of the background appearing unnaturally dark.

Fill-in flash is best used for increasing or decreasing contrast in the scene. A backlit subject, for instance, creates a high-contrast scene that can end up appearing as a silhouette if the background is exposed correctly. However, with a burst of flash, both the subject in the foreground and the bright backdrop can retain detail.

On a dull day, conversely, colors can look dull and subjects can look flat because of the low-contrast illumination. A burst of flash adds the sparkle and coloration that makes up for the lack of direct sunlight.

Fill-in flash can also be a useful effect to use with sports where you can get close to the subject. Flash is always effectively two exposures—one created by the flashlight, and the other by the existing light. With moving subjects, the flash freezes the subject, but the ambient light creates a ghost image. The combination can provide an interesting way of conveying the movement in the scene.

Slow-sync flash

Flash exposure is controlled using the camera's aperture setting and by varying the duration of the flash output. The shutter speed is often irrelevant (as long as it is slow enough to synchronize with the flash).

Increasing the length of the shutter speed, however, does increase the effect that ambient light has in the picture. Backgrounds that are turned dark by the use of flash, because they are out of its illumination range, can be made lighter the longer the shutter is left open. This has minimal effect on the flash-lit foreground, unless the subject is moving, in which case you get a secondary ghost image (as with fill-in flash sports shots).

The slow-sync flash mode deliberately sets a shutter speed that suits the background, while setting an aperture and flash power setting that will adequately expose the immediate foreground.

Slow-sync flash shot of toddlers in animal masks
With normal flash, the hallway in this Halloween portrait would have been dark and unrecognizable. With slow-sync flash, you get an image that is much closer to what the human eye would see.

Rear curtain sync

The focal plane shutters used by digital SLRs not only create difficulties when using flash with fast shutter speeds (see p62); they also prove problematic with slow shutter speeds. The flash is usually set up as the first shutter curtain is fully open, so the flash goes off at the beginning of the exposure. When shooting moving subjects with a slower than usual shutter speed, however, the ambient light creates a ghost image in front of the sharp flash image.

Some digital SLR and flashgun combinations allow you to set the camera so the flash fires just before the second curtain begins to close. This rear-curtain sync (or second-curtain sync) provides a more natural-looking ghost image that trails behind the main image.

In the shade
Diffuse light means that colors are subdued.

Fill-in flash
Restores some vigor to the primrose's petals.

Cyclist
Shot with flash and a wide-angle lens, this action shot is essentially a double exposure. A sharp image created by the fill-in flash merges with a ghost image created by the ambient daylight

Into the light
Backlight means that boy's face is in shadow.

Fill-in flash
Creates a better tonal balance between foreground and background.

Redeye

Red eyes are a common consequence of using built-in flash with portraits. They are caused by the flash bouncing off the retina at the back of the eye, illuminating the blood vessels in the eye. The effect is marked when flash is used in low light, when the pupils are fully dilated.

There are several ways to defeat or minimize redeye:

● Most digital cameras have an anti redeye mode, which uses the flash itself to force the pupils of the subject's eyes to contract before the picture is taken. This pre-flash system works well—but there are disadvantages. First, it just minimizes the effect, making the red pupils smaller, rather than eliminating the effect. More significantly there is an increased delay between firing the shutter and the picture being taken, so you lose spontaneity and the ability to take surreptitious candids.

● Redeye can be completely eliminated if you increase the angle sufficiently between the lens axis, flash, and subject. You can do this by using an add-on rather than the built-in flash, as this raises the flash tube slightly. You can increase the angle between lens and flash still further by using the flash off-camera, via a bracket and connecting cable. An even simpler solution is to get closer to the subject, using a more wide-angle zoom setting as necessary. Redeye becomes more of a problem the longer the telephoto setting that is used.

● Digital manipulation allows you to remove the problem at the editing stage, replacing the color of the offending red pixels.

Classic redeye
Telephoto lens and on-camera flash combine to give monstrous eyes.

Redeye reduction
Typical result using redeye reduction mode—again, on-camera flash and telephoto have been used, but the size of the pupils is greatly reduced, so the redeye is far less visible.

Get closer to eliminate the problem
No redeye, thanks to an alternative approach, here, a wider lens setting from closer camera position. This avoids the problem, as the angle between flash and lens in relation to the eye has been increased.

1.1 Drive modes

Often used by fashion and sports photographers alike, a "motordrive" facility allows the camera to take a pictures in rapid succession, in the hope that this will increase the chances of capturing the perfect pose or moment of drama.

As there is no film to wind on, this feature is normally called the continuous drive mode. When engaged, the camera fires shot after shot when the shutter release is held down, while in the normal, single-shot drive mode, only one picture is taken each time you press down the shutter release.

The continuous drive mode puts a serious strain on the camera's processing capabilities, and because of this the camera can not keep taking pictures forever. Just how fast it can recover between shots varies significantly from camera to camera: Some may shoot at a sedate one frame per second, while professional digital SLRs may be capable of firing off at 8 frames per second (8fps).

But whatever the speed of this "burst rate," there still comes a point when the camera needs to stop, in order to catch up with the backlog of processing. Just how many shots can be taken at this top speed is largely dependent on the size of the camera's buffer memory—a temporary storage area specially designed to allow you to get on with the next shot, before the last one has been written to the flash memory card.

However, another important part of the equation is the file format, quality setting, and resolution that you have set. A digital SLR that can shoot at 3fps may be able to keep this up for 15 shots when shooting JPEGs, but may only manage 5 when shooting more memory-hungry RAW files.

Many cameras offer a video recording option that can shoot images at 15fps, or even 30fps. However, the resolution is then often limited to, at best, 640×480 pixels (a resolution called VGA, which creates images with less than one third of a million picture elements). In addition, the compression system used to write these minimovies does not usually allow you to freeze individual frames.

Despite the constraints imposed by proper continuous shooting, however, a motordrive setting is often extremely useful. It provides a sequence that gives a better overall view of a moving subject than a single shot, or can help to provide a variety of shots to choose from.

However, it must be understood that the facility is no guarantee of getting the perfect shot of the action—even if you are standing in the right place at the right time. Motordrives miss more of the action than they actually shoot. If a camera is set at a respectable 5fps continuous with a shutter speed of 1/1000sec, it is effectively closing its eyes for 199/1000sec before taking the next shot, thus capturing just 0.5 percent of the total action.

Continuous shooting
The aim of this sequence was to capture the excitement of the stunt motorcyclist's jump over an exploding car. Despite being shot at 3fps, the sequence still fails to capture the moment when the car dramatically explodes as the stuntman passes overhead.

Time lapse

Another useful drive option is the intervalometer. This is a cross between a selftimer and a motordrive, which automatically takes a series of pictures over an extended period of time. The sophistication of these devices varies significantly from camera to camera; in essence, they are programable timers that allow you to set the number of minutes or hours between each shot, the point at which you want the sequence to start, and the number of frames you want.

The intervalometer can be used to capture movement or progress that is otherwise hard to see, such as the opening of a flower or the building of a spider's web. It can be used to capture more elusive wildlife, such as early-morning visits of a fox. Just as rewarding is to film a street scene over the day, seeing how the light changes, and how the cars and people come and go, depending on the hour.

As you leave the camera unmanned, it is usually best to set exposure and white balance to automatic, but switch the focusing system to manual.

Timelapse photography
These osteospermum flowers open and close their petals depending on the light levels. A timelapse sequence provides the evidence; these particular shots were taken 45 minutes apart.

Self timer

Another facility that is usually given with the camera's drive options is the selftimer. This is a delayed trigger setting, designed for when you want to take a picture that includes yourself. With the standard selftimer you press the shutter release, and you have 10 or 12 seconds before the camera actually takes the picture. All you have to do is ensure the camera is well supported and framed up correctly before you make a dash to join the group portrait.

The selftimer is also useful for taking shots when using a camera support with slow shutter speeds (see p72). Using the delayed trigger means that you eliminate the slight camera movement as you actually press the shutter release (and saves you having to use a cable release or remote control). On some models a secondary selftimer, with just a 2- or 3-second delay, is provided for this very purpose.

Motordrive
With the limited vantage point that you get at most sports events, a motordrive at least allows you to capture as many shots as possible when the action comes into camera range. This sequence of female middle-distance runners in action was shot at 3fps.

1.1 In-camera effects

The beauty of digital imaging is the ease with which pictures can be manipulated. Pixels can be changed in an instant, creating all manner of interesting pictorial effects. It is so easy to make these changes that many cameras provide a whole range of instant tricks that can be applied to the pictures as, or after they are taken.

However, because these digital effects can just as easily be added at the post-production stage—while editing the images on a PC—these fun features are often frowned upon by serious photographers. For this reason, you tend to get more effects the more basic the camera—digital SLRs have very few, if any, while some camphones offer a whole suite of editing and shooting effects.

The difference in approach comes from the way in which these cameras are used. Serious photographers apply any transformations they feel that are necessary on the computer, using manipulation software that provides access to extensive libraries of effects filters. Others want to play around with their pictures immediately. In fact, some cameras not only allow you to add special effects—they allow you to crop pictures, add borders, and even superimpose graphics such as haloes, love hearts, and speech bubbles.

The one digital effect that is found on practically every camera, however, is the ability to record your shots in black and white. Colorless photographs still have a high degree of artistic appeal and are particularly suited to some photographic subjects, such as portraiture (*see page 160*). Shooting in black and white can also prove a more successful strategy in poor lighting conditions, where colors would lack any vibrancy.

Despite this, however, it is usually best to shoot in color, even if you actually want a black-and-white image, and use the camera to simply apply a straight grayscale conversion to the scene. However, if you shoot the scene in color, you can use the color information to change the relative strength of the tones at the post-production stage—manipulation software, for instance, can be used to make the greens a lighter gray than they would otherwise appear, while making the light blue of the sky darker and more dramatic (this can be done in various different ways; *see page 240*).

Where the black-and-white camera effect is most useful, however, is as a compositional aid. It can be hard to visualize exactly how a particular scene will look in black and white, as the human eye sees everything in color. The facility can therefore help to find subjects that may suit being converted to monochrome at a later stage, and then shoot them without the effect, to retain the benefit of the color channel information.

The same caveats also apply to the sepia effect also found on many cameras. This shoots a monochromatic image, but uses shades of brown, rather than white, to create the image. This creates an image that is reminiscent of Victorian photography, where the sepia coloration was achieved by using toning chemicals on the print.

Sepia-toning is ideal for giving a feeling of a bygone era in a photograph. However, it is again best applied at the editing stage, rather than in-camera, as shooting the scene in color, as with black and white, gives you more control over tonal distribution. The color toning can also be easily and more precisely controlled on the computer—and with a far greater range of colors (*see page 242*).

Multiple exposures

The ability to combine two or more images on the same frame used to be a highly sought-after camera feature. But in the digital world, the ability to blend images together is now usually left to the digital darkroom, where shots can be montaged together with a high degree of control, and in ways that just weren't possible in the days of film. However, there are still a surprising number of digital cameras that do allow you to combine two or more images on top of each other.

It can be a challenging project to do this in-camera. The two images need to be taken in succession (you can't carry on shooting until a suitable companion comes along), and there is a good chance of getting a picture that looks like a messy mistake. A secret to success is to combine an identifiable image (such as a person's face) with something that is more abstract (such as an isolated skyscape). Exposure compensation should also be used, although each shot will invariably need different amounts. Cameras do preview what the shot will look like, however, so it is possible to end up with successful results.

The George Inn

Dull lighting conditions and the subject matter combine to mean that a color shot of these two old pubs does not really work; a black-and-white version is much better. However, although this can be done in-camera, it is better practise to shoot the picture in color and then convert it using computer software.

Further effects

Negative

This produces color images where the colors are reversed, similar to looking at a color print film negative, but without the orange background. Giving a post-apocalyptic view to a picture, it can easily be applied using software, such as Photoshop Elements' "Invert" command.

Solarization

Despite the name, this usually provides a posterization effect, which restricts the number of colors used in the image—to create a poster-like image; it is akin to looking to a completed painting-by-numbers picture. Posterization can be applied in post-production with full control over the number of colors used; true solarization—where part of the image are reversed, while others are not—can also be achieved using applications such as Photoshop (*see page 258*).

Stitch assist

This is less of a digital effect, and more of a clever use of digital photography to help you compose a picture. The facility is designed for shooting panoramic shots made up of a panned sequence of pictures (*see page 256*). It takes the guesswork

Black and white

Negative

Sepia

Solarization

These four pictures show the range of effects available from a typical digital

camera, in this case a 2-megapixel cellphone.

out of lining up the individual shots—as it superimposes the last image you took on screen, so that you can ensure that the next shot you take overlaps by the right sort of amount.

1.2 Creative control

However sophisticated the camera, with however many buttons, there are just three key factors that decide how the picture turns out. While exposure metering, focusing, and white balance can often be left to automatic, these trio of controls have a significant on the way that the real world is turned into a photograph.

Aperture, shutter speed, and focal length are the three essential tools in the photographer's palette. It is these camera controls that can turn a snapshot into a great photograph. While most cameras will set aperture and shutter speed for you, learning to switch from full auto to having at least some control over these settings will give you direct input over the way that your shots turn out. Furthermore, although few cameras have ever attempted to set the zoom automatically, it is important to learn that focal length is a creative control in its own right—not simply a way of making distant objects look bigger.

1.2

1.2 Shutter speed

Shutter speeds and apertures

The shutter speed is one of the two main controls used to govern how much light reaches the camera's chip (*see page 50*). In addition to having an impact on exposure, however, the exact shutter speed used can often affect how a subject appears in the image.

Compared with the aperture (*see box*), the scale used for shutter duration is relatively easy to understand. Shutter speed is nearly always measured in fractions of a second (although in some low light applications the shutter can remain open for whole seconds, minutes, or even hours).

On the shutter speed scale, an exposure that lasts 1/125th of a second (1/125 sec) is twice as long as a 1/250 sec exposure, and allows twice the quantity of light to reach the sensor (assuming the aperture has not been changed in tandem; *see page 52*).

The full stop scale, along which each step represents a doubling or halving of light, is typically: 30 sec, 15 sec, 8 sec, 4 sec, 2 sec, 1 sec, 1/2 sec, 1/4 sec, 1/8 sec, 1/15 sec, 1/30 sec, 1/60 sec, 1/125 sec, 1/250 sec, 1/500 sec, 1/1000 sec, 1/2000 sec, 1/4000 sec, 1/8000 sec.

Many cameras offer a more restricted range, while others offer longer or shorter exposures. Some cameras also offer intermediate values, representing a third- and half-stop steps. Shutter speeds of 1/500 sec or shorter are typically known as "fast" shutter speeds, while those of 1/15 sec and below are "slow."

Unfortunately, many camera displays make shutter speeds rather more complicated to understand than they actually are. They usually abbreviate 1/500 sec to simply "500." This is fair enough, but then a shift to a value of 1000 looks like an increase in shutter speed, when in fact the exposure time has been decreased. This is a convention you simply have to get to used to; and when forced to use slower shutter speeds, you must be particularly careful that you do not confuse a setting of 1/4 sec with one for four whole seconds.

Aperture values

The scale used to measure the size of the aperture is known as the f/stop scale, and the values used are rather more difficult to understand than those used for shutter speed. To the novice the numbers seem to have no logical progression, and matters are further confused by the way the measurements are abbreviated.

F-stops are actually a measurement of the diameter of the aperture. They should (like shutter speeds) be expressed as a fraction, where the number tells you the diameter in millimeters as a fraction of the actual focal length of the lens. So with a zoom set at 40mm with an aperture of *f*8, the diameter of the iris opening is 5mm (40 divided by 8).

It is for this reason that an aperture of *f*8 is actually smaller than an aperture of *f*4. As these are often abbreviated to simply the numbers 4 and 8 in camera displays, you need to become completely familiar with how to change the lens to a smaller (narrower) or larger (wider) aperture.

To make matters worse, most aperture values are not whole numbers—and the jumps from one value to the next seem irregular, if not random. This is because the amount of light reaching the sensor is not proportional to the diameter, but to the area of the opening (so it's all to do with the square of the half of the diameter).

The essential full stop aperture range is worth learning as soon as possible, typically progressing from a wide setting to a small setting as follows: *f*4, *f*5.6, *f*8, *f*11, *f*16.

Some cameras or lenses have a wider (or narrower) range and may well offer intermediate half-stop (or third-stop) values, which are given in the table on the right. It is worth noting that if you halve the f number (from 16 to 8, say), the aperture lets in a quarter of the amount of light—a 2-stop decrease.

Full stops	Half-stops	Third-stops
f1.4		
	f1.7	f1.6
		f1.8
f2		
	f2.4	f2.2
		f2.5
f2.8		
	f3.4	f3.2
		f3.6
f4		
	f4.8	f4.5
		f5
f5.6		
	f6.7	f6.3
		f7.1
f8		
	f9.5	f9
		f10
f11		
	f13	f12
		f14
f16		
	f19	f18
		f20
f22		

f-stop values are often approximations, typically rounded to two digits. So f11 is not quite "twice" f5.6. Furthermore, different camera manufacturers may use different rounding systems, particularly for third of a stop increments.

1.2

Strawberries and sugar

Shutter speed is an essential creative control—a different value will often give you a significantly different type of shot. The three shutter speeds used in this still-life set-up give very different representations of the sprinkled sugar.

Slow: 1/4 sec
So much sugar has fallen during the exposure that it appears in the image as a white haze.

Medium: 1/45 sec
Grains of sugar have become individual lines of white, tracing their route as they fall.

Reciprocal arrangment

Remember that shutter speed and aperture are usually changed in tandem (*see page 52*). If you make the shutter speed faster for a particular effect, the aperture needs to be opened up wider to compensate. If you can't open the aperture any wider, you will need to increase the ISO setting—or find a way of increasing the light levels.

Fast: 1/750 sec
The shutter speed allows you to see individual grains of sugar, even though the movement is not frozen.

1.2 Camera shake

The first, and most important, thing to consider when choosing the shutter speed is whether it is fast enough to give you a sharp picture. Using shutter speed creatively is all very well, but it is more important to avoid unintentional blur.

The movement of the subject itself is part of the consideration (as we'll see in the following pages), but before that it is essential to allow for the movement of the camera. This is not a problem if the camera is firmly attached to a sturdy tripod (*see page 84*), but most people want the freedom and convenience of hand-holding the camera for as many shots as they can possibly get away with.

Unfortunately, the human body is not quite the stable platform that we imagine it to be. However steady we try to hold a camera, it moves in response to our heart, lungs, and other involuntary muscle twitches; this results in what is known as camera shake.

You can learn to hold the camera more steadily (*see page 76*), and some people are better at it than others, but it is important to be realistic as to what is possible with the equipment being used. By using a fast enough shutter speed, it is possible to counteract the effects of camera shake. The exact shutter speed you need is largely dependent on the focal length of lens that you are using. The type of camera also has a role to play: digital SLRs have a mechanical mirror and shutter that add more vibration to the equation than a zoom compact. Size also has a role: a small camera is hard to hold still compared with a heavier digital SLR,

although a large-format camera's weight and size make hand-holding practically impossible.

However, it is the angle of view of the lens that is crucial. The narrower the view, the more the camera shake is magnified, creating an image that is harder to keep steady. Think of camera shake as a degree's movement from side to side; if using a wide-angle lens with a field of view of 120 degrees, this shake is relatively unimportant. But use a long telephoto with an angle of view of five degrees and this one degree movement becomes highly significant. You therefore need to use a faster shutter speed when hand-holding a telephoto lens than you do with a wide-angle one; in fact, you will have to use faster minimum shutter speeds with one end of the zoom's range than you will do with the other.

As a guide, you should ensure that the minimum shutter speed used is a reciprocal of the effective focal length. So if you are using a lens setting with an efl of 250mm, then you should use a shutter speed of 1/250 sec or faster. Similarly, with a 28mm wide-angle, a shutter speed of 1/28 sec would be a minimum— when rounded up to the nearest setting actually available, this would mean using a setting of 1/30 sec.

Many cameras warn you with a flashing icon, designed to look like a shaking camera, or with an audio beep, when they believe that the shutter speed is too low. However, it is useful to know why this happens, and to know whether the warning is really worth paying attention to.

Minimum shutter speeds

This table gives a rough guide to the slowest advisable shutter speed when supporting the camera with your hands alone. They are not precise figures because:

● Some people can hold a camera more steadily than others, due to better technique, or because they have a slower resting heart rate, say.

● Cold and windy conditions make it harder to hold a camera steady.

● Camera shake is not constant. If you use a slightly slower shutter speed, you may get away with it, but your success rate will decrease. Experiment with slower speeds, if you need to, but take more pictures to help you ensure success. With critical shots, it is better to increase ISO than risk a blurred picture (*see page 26*).

Effective focal length (efl)	Minimum shutter speed
16mm	1/20 sec
28mm	1/30 sec
35mm	1/30 sec
80mm	1/90 sec
200mm	1/250 sec
400mm	1/500 sec

St Paul's Cathedral
Two different views of St Paul's Cathedral in London. With both these shots I wanted to use the slowest shutter speed feasible, so that I could use the best aperture for the job, without having to resort to a tripod. For the shot of the dome on its own, a zoom lens with an efl setting of around 250mm was used, so I used a shutter speed of 1/250 sec. For the shot with the magnificent modern statue in the foreground, I used an ultra-wide-angle lens with an efl of 20mm, and a shutter speed of 1/30 sec to avoid camera shake.

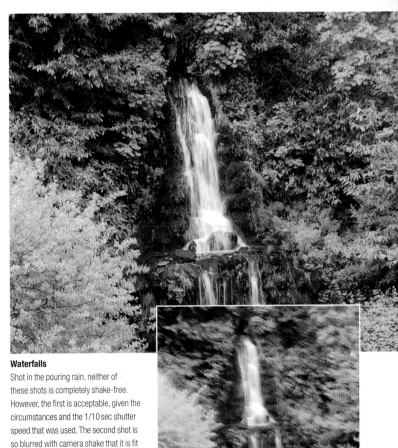

Waterfalls
Shot in the pouring rain, neither of these shots is completely shake-free. However, the first is acceptable, given the circumstances and the 1/10 sec shutter speed that was used. The second shot is so blurred with camera shake that it is fit only for the delete button.

Suit of armor
Sometimes you need to push the limits imposed by the minimum shutter speed table, otherwise you may miss out on a picture. This grand suit of armor was in a display case in a dimly lit museum. Shot with a 28mm lens, the shutter speed used was a risky 1/15 sec. But the gamble paid off.

75

1.2 Steady shooting

Whatever shutter speed you are using, it pays to hold and use the camera in a way that minimizes camera shake. Even if you are using the "correct" kind of shutter speed to avoid the blur caused by body movement, the more solidly you hold the camera, the sharper your pictures will be. Good technique, however, is particularly important when you are forced to take pictures at or below the suggested minimum shutter speed for the lens setting that you are using (*see page 74*).

How you stand and grip the camera is the key to the basic technique. Your body needs a solid base, so stand with your feet slightly apart, so that they are directly below your shoulders. Then hold the camera with two hands—don't be tempted to use a camera one-handed, however light it is. Grip tightly with the right hand, to take the weight, with your finger comfortably over the shutter button. Then support the camera with your left hand; with a digital SLR or camera with a big enough zoom lens, cradle the lens in the palm of this hand. Keep your elbows tucked into the side of your body if possible; this may be difficult or uncomfortable if shooting with the camera turned sideways for a portrait format shot (*see page 162*), so in this instance just hold one elbow tight into the body.

This creates a good platform—now you must try to fire the shutter with the minimum of involuntary movement. Try to relax, and breathe easily as you compose the shot, but release the shutter just after exhaling. There is even a knack to pressing the shutter button—squeeze gently and don't stab at it if you want to minimize camera shake as much as possible.

Impromptu supports

Just because you are handholding the camera, and have decided not to use a tripod, does not mean that you should spurn all forms of extra support. There is no need to carry extra bulky equipment, as you can find ways of steadying your body and your camera all around you. Simply by sitting down on a chair or bench in order to take a picture, for instance, you give yourself a more rigid platform to shoot from—even if the camera is still held in your hands.

Look out for surfaces and objects that will give the camera extra support and can allow you to use a shutter speed that is a stop or so slower than you would otherwise be able to use with a particular lens. Here are some examples of supports that you can use:

● Lean into walls, mature trees, or doorways, pushing your shoulder hard into the surface to brace yourself as you shoot.

● Look for surfaces that you can rest the bottom of the camera on as you shoot; the top of a stone wall, for instance, or the roof or a car may allow this.

● Sit down on the ground, or even lie down on the floor, using your elbows to prop up the camera as you shoot.

Image stabilization

Camera manufacturers have come up with all mannner of ingenious ways to allow photographers to use slower than usual shutter speeds and still get a blur-free handheld picture.

Image-stabilization, or vibration-reduction, used by Canon, Sony, and Nikon cameras uses sensors to measure the amount the camera is moving. This information is then used to adjust the elements within the lens so as to move the focused image to negate any movement created by camera shake.

A similar detection system is used by Konica Minolta cameras, but here it is the CCD sensor that moves, rather than the lens. The advantage of this system for the digital SLR is that the stabilization system will work with any lens used with the camera body; with Nikon and Canon digital SLRs, special stabilization lenses must be used.

However, the results possible with these systems have to be seen to be believed. Typically, they allow the photographer to use a shutter speed that is two or three stops slower than would otherwise be possible. This means that it becomes possible to use a 500mm lens with a shutter speed of just 1/125 sec, or even 1/60 sec.

How to hold a camera steady—some suggestions.

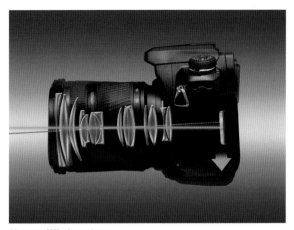

Diagram of Minolta system
Konica Minolta image stabilizer moves
the image sensor to counteract some
of the effects of camera shake.

Shooting in low light
These two shots of an ornamental
heather were taken in fading light with
a macro lens with an efl of 135mm,
using a shutter speed of just 1/20 sec.
The one with the Konica Minolta image-
stabilization system is as you'd expect
from such a slow, handheld shutter
speed. The result from the shot with
the stabilizer in action is miraculous,
providing blur-free detail in the flowers
that are in focus.

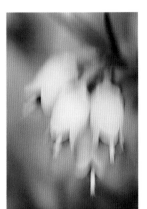
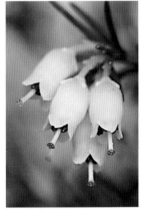

Canon 70-300mm IS lens
One of the many Canon EF image-
stabilization lenses for the EOS digital
SLR range.

Image stabilizers
Image stabilization is particularly useful
with longer telephoto lenses that demand
fast handheld shutter speeds. This
detail of a classic car was taken at an
efl of 450mm, with a shutter speed of
1/350 sec. The version taken with the
stabilizer switched on gives sharper detail
than the one with the feature turned off.

1.2 Freezing movement

Once camera shake has been allowed for or eliminated, the shutter speed and corresponding aperture can then be chosen based on creative concerns. As far as shutter speed is concerned, one of these is the different ways in which subject movement can be depicted when translated into a still image.

For most of the time, the usual inclination is to freeze the movement: by setting a fast enough shutter speed, you are able to bring action to a complete halt. This not only allows us to capture high-speed action crisply, it also allows us to see things that we cannot normally see, such as the blades of a helicopter's spinning rotor, or the moment that the driver hits the teed-up golf ball.

The exact shutter speed that you require to freeze the action, however, is not entirely dependent on the subject's speed. What counts is how fast the subject is moving across the image frame—and this depends as much upon image magnification as it does on subject speed. You may need a faster shutter speed to freeze a passing pedestrian than to catch a jet fighter on the horizon breaking the sound barrier. What counts is the subject distance and the effective focal length of the lens. The closer the subject, or the longer the lens, the faster the shutter speed you are likely to need; in

practice these two factors often cancel each other out, as you use a longer lens the further away the subject is.

Just as crucial, however, is the direction of movement. The image of a subject moving across the frame changes more quickly than that of a subject heading directly toward or away from the camera, so a faster shutter speed is needed. In practice, you need a shutter speed that is four times faster (all other things being equal) if the subject is crossing straight across your field of view, compared to when it is heading straight at you; diagonal movement across the frame demands an intermediate shutter speed.

It must also be pointed out that the exact shutter speed required to successfully freeze movement is open to interpretation, as whatever setting you use, the subject is never completely still. An Olympic sprinter, who covers 100m in around ten seconds, moves $3/8$in (10mm) during a 1/1000 sec exposure. This amount of blur may well be acceptable in many shots, particularly as we are more forgiving about sharpness with moving subjects than we would be with stationary ones. Additonally, some of the subject's movement may be counteracted by "panning" the camera to track the subject during exposure (*see page 80*).

Minimum Shutter Speeds for Freezing Action

Subject	Speed	Distance	Focal length	Direction of movement		
				Across frame	Toward camera	Diagonal
Car	50mph (80km/h)	30m	100mm	1/1000 sec	1/250 sec	1/125 sec
Car	100mph (160km/h)	30m	100mm	1/2000 sec	1/500 sec	1/1000 sec
Sprinter	12mph (20km/h)	10m	200mm	1/1500 sec	1/350 sec	1/750 sec
Sprinter	12mph (20km/h)	20m	300mm	1/1000 sec	1/250 sec	1/500 sec
Train	100mph (160km/h)	50m	35mm	1/500 sec	1/125 sec	1/250 sec
Train	100mph (160km/h)	50m	200mm	1/3000 sec	1/750 sec	1/1500 sec
Jogger	6mph (10km/h)	5m	100mm	1/750 sec	1/180 sec	1/300 sec
Jogger	6mph (10km/h)	2m	35mm	1/750 sec	1/180 sec	1/300 sec
Jet plane	500mph (800km/h)	2000m	400mm	1/500 sec	1/125 sec	1/250 sec
Jet plane	500mph (800km/h)	1000m	400mm	1/1000 sec	1/250 sec	1/500 sec

1.2

Aerobatics team

You need a shutter speed that is four times faster to freeze a subject if it is moving across the frame, compared to when it is heading straight at you. For this shot of an air display team, a shutter speed of 1/4000 sec was used for the jets flying overhead, and one of 1/1000 sec for the shot of the formation heading toward the crowd.

Sam Smith

When selecting a shutter speed to freeze movement, you should allow for the fact that some parts of the subject may be moving in different directions and at different speeds than others. A sprinter may be running toward you, but his hands may be moving up and down, so these are more likely to appear blurred. In this shot, the young tennis player is sharp, but the returned ball is slightly blurred. Such peripheral movement may enhance the feeling of action.

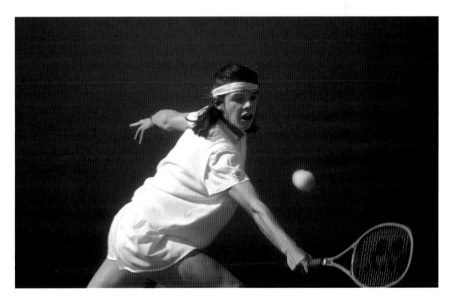

Waterskier

The direction of a waterskier continually changes as he or she zigzags from side to side. Waiting for a moment where the skier is heading toward the camera gives more flexibility with the shutter speed setting.

79

1.2 Blurred movement

One of the disadvantages of using a shutter speed that is fast enough to freeze movement is that the subject can end up looking staid and stationary. A racing car speeding at 200mph (320km/h) around a track caught with a shutter speed of 1/4000 sec may end up looking little different to a shot of a similar car parked on the starting grid.

An alternative approach is to deliberately choose a slow shutter speed with which the subject—or at least part of it—will appear blurred. This creates a more artistic interpretation of the subject, with the streaks created by the moving parts in the scene creating a strong feeling of action.

There is a delicate balance to be struck when selecting the actual shutter speed. If it is only just slower than that necessary to freeze movement (*see page 78*), the slight amount of blur can just look like a careless mistake. Go too far, however, and the scene will be so blurred as to be unrecognizable.

The exact amount of blur is a matter of taste, and can be discovered by trial and error. However, a good starting point would be to choose a shutter speed that is four stops—or 16 times—longer than the slowest you would use to capture the action sharply. So instead of using a shutter speed of 1/250 sec to capture a dancer crisply, you would experiment with settings of around 1/15 sec.

Panning

An interesting twist on the slow shutter speed approach is to track the subject with the camera as it moves across the frame. Known as panning, this technique minimizes the subject movement created by the slow shutter speed, but turns the background into blurred streaks. These "go-faster stripes" give a strong sense of movement to the image, and can be particularly useful in helping to hide distracting backgrounds (such as advertising hoardings at race circuits).

This is a technique that takes practice to master, but it is invaluable for all kinds of sporting and action subjects.

● Hold the camera steady with two hands, with your feet slightly apart to create as solid a platform as you can.

● Swing your shoulders from your waist without moving your feet. You will find that you can't rotate more than a quarter turn without risking losing balance.

● Focus manually if possible, and frame the shot so there is slightly more space in front of the moving subject than behind.

● Follow the subject across, and press the shutter button smoothly, again using a shutter speed that is 4–16 times longer than that which you would use to freeze the movement.

● Take lots of shots. However good you get at the technique, only a few of the shots will be worth saving.

Blurring the background

For closely-cropped, fast-moving subjects moving across the frame, you nearly always need to pan the camera round as you shoot, if only to ensure that you get the subject in the frame. For this shot of showing the horsemanship of two top polo players, a lens with an efl of 500mm was used with a shutter speed of 1/250 sec. The movement of the camera during the exposure has made the background much less distracting than it would otherwise have been.

Marching band

A shutter speed of 1/15 sec helps to convey the movement and rhythm of this marching band. In bright light, it may be necessary to use a neutral density filter (*see page 83*) to help you obtain a suitably slow setting.

How to pan

Zoom bursts

This is a fun in-camera special effect that can be used to turn a bright, colorful scene into an explosive abstract. Again, a much slower shutter speed than usual is selected, and then the shutter is fired as the lens is zoomed. The effect does not work with motorized zooms, so you need to have a digital SLR. Try shutter speeds ranging from 1/4 sec to 1/15 sec, and turn the zoom ring at an even speed. It is best to zoom outward, from telephoto to wide-angle, as this helps ensure that the central part of the frame is correctly focused and appears less blurred than the edges of the scene.

1.2

New England abstract
The fall foliage of Vermont, shot in a way that conveys the riot of color in an abstract way. The lens, with an efl of 75–300mm, was zoomed during an exposure of 1/15 sec.

Out of the shadows
A slow shutter speed approach to action is often essential in low light conditions. For this shot of Thai boxers, the vantage point and poor lighting made a fast shutter speed approach impossible.

Using a shutter speed of 1/30 sec with a efl setting of 200mm, an interesting impressionistic shot has been salvaged. The rope in the foreground was carefully cloned away using Photoshop to give an unobscured view.

Follow the action
Panning is not just useful for sports subjects; it can be used for everyday subjects, too. This toddler's steps are made to look more dynamic thanks to the use of a slower than usual shutter speed.

1.2 Extended exposures

The slowest shutter speeds

While most pictures are taken in a fraction of a second, there are occasions where an exposure that is much longer is needed to record the subject in an adequate fashion. Shutter speeds measured in seconds are frequently needed when taking photographs after dark, for example: the long exposure means that scenes of stationary subjects can be photographed in a way that would be impossible with flash.

While image-stabilization systems and "creative" blur can help you avoid using a camera support in some low light situations, a solid platform becomes essential when the shutter speed drops below one second, otherwise there will be too much blur to provide a recognizable image.

A tripod is the obvious choice to provide a shake-free exposure (*see page 84*). However, when one isn't to hand, it is usually possible to find a surface on which the camera can be placed so that it can remain stationary and stable through the exposure. The top of a wall, a car roof, a window ledge—you just need to find the most stable surface with a suitable vantage point.

When using any camera support, it is preferable to avoid firing the camera directly using your hand —with such impromptu supports, this advice becomes essential if you are to minimize camera vibration. Some cameras can be fitted with a cable release, which will electronically (or mechanically) fire the trigger without having to touch the camera itself. Some models can even be used with a remote control, which will fire the camera using an infrared command. If you do not have these options, using the selftimer control can also help; although this is designed for self-portraits, the delayed reaction means that although you touch the camera to fire it, it will have stopped moving by the time the shutter actually fires (*see page 66*).

Once you have a stable shooting platform, long shutter speeds can be used, whenever lighting conditions permit them. This is particularly important when shooting early in the morning or late in the evening, or indoors. A long shutter speed is not only useful for its own sake; it also allows you to have complete freedom over aperture setting; this means that depth of field does not need to be compromised just to avoid camera shake (*see page 88*).

● The maximum automatically controlled shutter speed available will depend on the camera that you are using, and the exposure mode that it is set to. This may vary between one and 30 seconds in most modes.

● Many cameras also provide a "B" (short for "Bulb") setting for even longer shutter speeds. This facility keeps the shutter open for as long as the trigger button is pressed down, providing (in theory at least) exposures that could be hours long. In practice, the maximum shutter speed available with B is usually restricted because of the amount of power that this facility uses.

● When using long shutter speeds, it is important to realize that the exact shutter speed is often not important. It could be 2 seconds, it could be 20 seconds, say, and still produce similar results. Because of this, the aperture and ISO setting should be set to maximize image quality and sharpness.

● Although used in low light, the slowest ISO setting should be used to minimize digital noise.

● Avoid using the widest aperture settings, as this will reduce quality; similarly, only use the very smallest apertures necessary to get a particular shutter speed, or to maximize depth of field (*see page 96*).

● If you can't get a slow enough shutter speed for the effect you want using the smallest aperture and slowest ISO setting, you can reduce the amount of light entering the lens using a neutral density (ND) filter. Some cameras have one built-in, but they can also be bought as add-on accessories for all cameras, in a variety of strengths.

Remote control
Some cameras have remote controls, which allow you to fire the shutter without having to touch the camera, to avoid any unnecessary vibration.

Neutral density filter
Cuts down the amount of light reaching the sensor, to allow longer than usual shutter speeds.

1.2

Abstract blur

This unusual abstract shot is of stationary lights along a main street in town, shot from a moving automobile. The camera was placed on the dashboard, and the trigger released using a remote control to produce an exposure of 20 sec at f/22.

Using a tripod

Although there was enough light for handheld photography, a solid tripod was used for this picture of an ancient monument. An aperture of f/27 to be used to ensure that every blade of grass in the foreground was sharp, and to record both the prehistoric burial chamber and the distant tin mine sharply. This produced an automatic shutter speed of around one second.

London by night

With the mass of lights and reflections along the River Thames in London, the longest possible shutter speed was not necessary. Instead, a mid-range aperture of f/11 was used to maximize image sharpness, with an exposure of around 10 sec using a tripod.

Streaked lights

In this night scene, the foreground would have been empty were it not for the streaks of red light created by the car and bus taillights. Using the camera's B setting, a tripod, and an aperture of f/19, the shutter was kept open for some 40 sec.

Streaks of light

A favorite photographic technique is to use long shutter speeds after dark to turn moving lights into colorful streaks. The exact shutter speed you need to produce streaks of light depends on many factors, and it may be necessary to experiment to ensure a successful shot. However, here are suitable starting settings for some popular moving subjects.

Subject	Shutter speed	Aperture	ISO setting
Car headlights and taillights on busy road	30 sec	f/22	100
Rockets at pyrotechnic display	8 sec	f/5.6	100
Funfair rides at night	15 sec	f/16	100
Stars so they appear as streaks	1 hour +	f/5.6	400

83

1.2 Camera supports

A tripod is a cumbersome, uninspiring photographic accessory. It is not only difficult to carry around, but it also makes picture taking a much slower process. However, this old-fashioned piece of mechanical engineering is invaluable simply because its stability means that camera shake can be forgotten about, freeing you to use whatever shutter speed or aperture that you need.

In addition to providing a solid platform, a tripod is designed to provide a fixed vantage point; when shooting still-life subjects, for instance, it keeps the frame still while the subjects are moved into their final position.

Unfortunately, the best-performing tripods are also the largest and heaviest: Hefty construction tends to provide more rigidity, although the use of modern materials such as carbon fiber means that tripods have actually become lighter in recent years. However, the smaller and neater that the tripod collapses to when not in use, the wobblier it is likely to be when used on location; a tripod that moves around in the wind is not going to allow a free choice of shutter speeds.

Just as important a consideration is the maximum height of the platform. A standard tripod should allow you to use the camera at normal eye level—but there is immense benefit to being able to elevate the platform even higher. Smaller tripods may have difficulties seeing over wall and fences, which may mean having to find an elevated surface (such as a table) before the picture can be taken.

For those shooting nature subjects, the minimum shooting height can also be crucial, as the legs of a standard tripod can often get in the way of getting close enough to your subject. Special tripods get round this problem with independently maneuverable legs and center column (as made by Benbo and Uni-Loc), although these are more awkward to set up.

Alternatives to a tripod

Many alternatives to the tripod have been dreamt up over the years. These are two of the more useful:

● **The beanbag.** This allows you to adapt uneven surfaces (such as the tops of walls) into a stable platform on which to rest a camera. Commercially produced versions can be found; however, you can fashion your own simply by filling a sock with dried rice (ideal when traveling light, as the rice can be bought and abandoned at each destination).

● **The monopod.** With just one leg, this is no substitute for the tripod. However, a tripod is of limited use with subjects such as sport, where you need to change camera position quickly and there are crowds to contend with. A monopod typically allows you to use a shutter speed that is two stops slower than would usually be required to avoid camera shake.

Surfer dude
Sports such as surfing demand long, long lenses, particularly if you want to keep the camera well away from the water. This was taken with an efl of 600mm, with a monopod on the beach not only helping stability, but providing an extra "hand" to take the weight during the shoot.

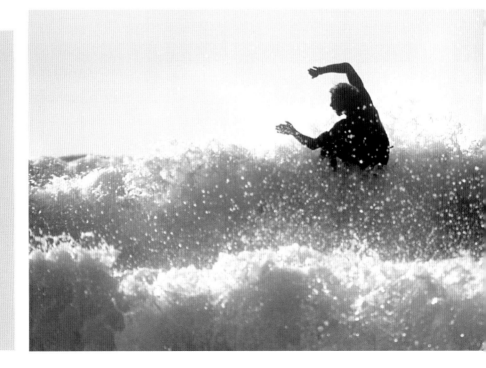

84

Light-up time
A solid tripod is essential after dark. The island castle of St Michael's Mount is only floodlit during the height of summer, and the tripod was put in position to catch this shot shortly after the lights came on and before the color left the sky.

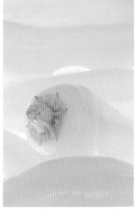

Still life
A tripod is invaluable when setting up still-life shots, as you can make small corrections to the composition by moving the subject around, based on what you see in the viewfinder or on the LCD screen.

Running water
Always carrying even a small tripod allows you to take pictures that would otherwise not be possible. The first shot of the stream was taken handheld with a shutter speed of 1/125 sec. Using a pocket tripod, an alternative, more atmospheric, shot was taken with a 2 sec exposure.

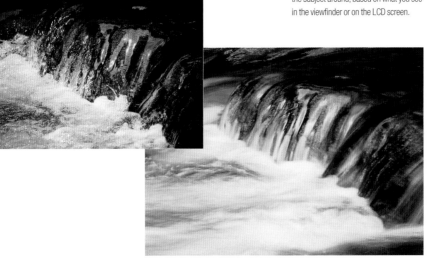

Choosing a head

There are two common types of tripod head:

● A pan-tilt head allows provides separate smooth adjustments for moving the camera around, and for tilting it up and down. However, the legs need to be leveled beforehand.

● Ball-and-socket heads allow the camera to be moved through all planes simultaneously. These are quick to maneuver, but harder to make fine adjustments with. Legs do not need leveling before use (making ball-and-socket heads essential with Benbo and Uni-Loc tripods).

● Be aware that pan-tilt heads for video use are different from those for still photography. Their video heads do not allow you to swing the camera platform up for vertical shots, and they have a locating pin on the platform that can damage the base of your camera.

● The best tripods are sold headless, allowing you to buy the head, or heads, required independently.

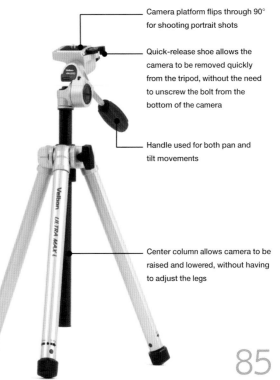

Camera platform flips through 90° for shooting portrait shots

Quick-release shoe allows the camera to be removed quickly from the tripod, without the need to unscrew the bolt from the bottom of the camera

Handle used for both pan and tilt movements

Center column allows camera to be raised and lowered, without having to adjust the legs

Telescopic legs extend to vary the camera height, and to level the camera platform

85

1.2 Depth of field

The main creative use for the aperture setting is to control depth of field. Although a lens can only focus precisely on one plane at a time (*see page 42*), there is always a certain distance in front of, and behind, this that looks sharp. The extent of this in-focus zone—known as depth of field—varies significantly, depending on the aperture.

Depth of field, however, is not just dependent on aperture; in fact, how much of the scene that actually looks in focus depends on four different factors.

Aperture is the most important of these, solely because it is the one that can be changed without having to alter the composition of the picture. By making the aperture smaller, the amount of picture that looks acceptably sharp increases. Similarly, by opening up the aperture you restrict how much of the picture appears sharp.

The second factor that affects depth of field is the distance at which the lens is focused—in most (but not all) cases, this means the distance between the camera and the main part of the subject. The closer the lens is focused, the less depth of field there is. In fact, at the very close distances used in macro photography (*see page 48*), depth of field disappears almost entirely, with just a tiny fraction of an inch making all the difference between being in focus and being out of focus.

The third factor is the focal length: the longer the focal length, the less the depth of field available. Wide-angle lenses offer great depth of field, often allowing you to keep everything from your feet to the horizon in focus. Long telephoto settings, however, often need to be focused with great care, simply because the depth of field is so limited. As far as depth of field is concerned, it is the actual focal length of the lens (or zoom setting) being used that counts, not the effective focal length.

The final part of the equation is the "circle of confusion." Image sharpness is partly a matter of personal opinion. Even within the limits of depth of field, things get slightly less sharp the further they are away from the plane of focus. Points of light form circles on the image, and there comes a stage (at the limits of depth of field) where you can see that the image is made up of circles and not points.

Where you draw this line between what is sharp and what is unsharp, however, is subjective. It also depends on how closely the image is viewed, and how much it is magnified; the bigger the picture, and the closer it is scrutinized, the sharper the parts of the image need to be. The circle of confusion gives a measurement as to what we will and will not accept as sharp. This is partly dependent on the size of the sensor—as the bigger the sensor, the less the image is magnified when printed or viewed onscreen.

Differences in depth

The amount of depth of field you get with a particular shot—and how much control you have over it—varies significantly from camera to camera. Zoom compacts have small image sensors and therefore use lenses with actual focal lengths that are very short. These offer far greater depth of field for any given effective focal length and aperture, when compared to using a digital SLR, which uses larger image sensors with lenses with longer focal lengths.

Zoom compacts have an immediate advantage when trying to maximize depth of field. Digital SLR lenses usually have a greater range of small aperture settings to help compensate. Furthermore, zoom compacts can struggle to restrict depth of field for creative effect, whereas with a digital SLR, it is much easier to combine focal length, focused distance, and aperture to ensure that unwanted elements are unsharp, and even unrecognizable, in the picture.

Varying focal length
These two shots show the effect of using both extremes of a 3x zoom to create similar shots. The aperture was set to f/5.6, and the lens was focused on the stem of the green bell pepper. The camera-to-subject distance was altered to achieve similar pictures.

135mm: Both the red and yellow bell peppers are noticeably out of focus.

45mm: All the bell peppers are noticeably sharper using the wider lens, even though the distance between camera and scene has been reduced.

Varying aperture

These three shots were taken with a digital SLR fitted with a zoom set to 80mm, and focused on the crown of the central bell pepper.

f/4.5: The widest aperture gives the least depth of field.

f/8: A mid-aperture setting; the difference in depth of field can be clearly seen in the sharpness of the stripes on the tablecloth.

f/16: A small aperture setting gives the most depth of field.

Varying focused distance

These three shots were again taken with an 80mm zoom setting, with the aperture at f/11. Only the focus was changed.

Focused on first bell pepper—the least total depth of field.

Focused on middle bell pepper.

Focused on far yellow bell pepper—the most depth of field.

1.2 Maximizing depth

In some photographs you need to use every trick at your disposal in order to ensure that as much of the scene is as sharp as possible. This is particularly important in scenes where you want to provide a realistic, or scientific, view—such as in traditional landscape photography, or with commercial "pack" shots.

You maximize the amount of depth of field by choosing the widest lens setting that you can get away with, shooting so that foreground elements are as far away from the camera as possible, and closing the aperture right down. You usually have to use these three factors in unison to get everything sharp.

With digital photography, it is relatively easy to check whether you have enough depth of field for a particular shot: you shoot the picture and then review the image, using as much magnification as the camera allows. By looking carefully at the key elements in the picture, you can see whether everything is sharp. This works well enough for subjects where you have the time and opportunity to reshoot if things are not quite right, but it is not ideal for a changing scene.

Some cameras provide systems where the depth of field can be checked before the picture is taken.

● A number of cameras with multi-point autofocus systems have an automatic depth mode that sets the focus and the aperture so that each of the focus points

is sharp. However, it will not be possible for the camera to succeed if the depth is too great for the prevailing camera distance and lens setting. Furthermore, important elements (such as the rocks just in front of you in a mountain landscape) may not be taken into account by the focus areas.

● The through-the-lens viewfinder on a digital SLR gives a rough idea of the depth of field that you would get if you used the widest aperture available (as this keeps the viewfinder bright, and aids focusing). However, on some models there is a "depth of field preview" button, which temporarily closes the aperture to the currently set value. This gives a very approximate idea as to what is, and what isn't, sharp in the scene. However, as the viewfinder darkens progressively with smaller aperture values, it is impossible to use this facility with any accuracy.

● Some digital SLR lenses (particularly older ones originally designed for 35mm film use) have a depth of field scale that allows you to see the range of distances covered by depth of field for certain aperture settings with the currently set focused distance. However, the information will be misleading, as it is based on a circle of confusion size that is not accurate for your digital camera (except for the few digital SLRs with a 24×36mm sensor).

Wide-eyed solution
A simple solution to depth-of-field problems is to use an ultra-wide-angle lens. Here, a lens with an efl of 18mm was used; this keeps the mermaid statue and enough of the bridge sharp even with a moderate aperture setting, which neatly avoided having to use a tripod.

Double subjects
In architectural and travel shots you often need to create a feeling of depth in a picture by including something in the foreground in addition to the main subject. Here, an ornate light is framed in front of the French Cathedral in Berlin. An automatic depth program, in this instance, did the calculation to keep both objects sharp.

Depth on the hoof
With this scene, there was not time to check the depth of field in review and then adjust the setting to shoot. The French farmer appeared from nowhere, and it was essential to act fast to get the shot as he passed. A 28mm lens setting was used, along with the smallest aperture that the light level would allow.

Waterfall
Sometimes everything works together to create the depth of field that you need. A shutter speed of around 30 sec was used to turn the moving water into a cloudy foam—but this also meant using the smallest aperture available with the 20mm lens. At f/22 there was no problem keeping everything from the moss in front of the lens to the distant trees in sharp focus.

Hyperfocal distance

The secret weapon for ensuring that you have as much of the scene in focus as possible is to switch to manual focus. You can often gain extra depth simply by focusing on something other than the main subject elements.

Depth of field is often said to stretch twice as far behind the subject as in front; in fact, this is a gross generalization. At very close distances, the depth of field is almost equally spread in front and behind the point of focus, and for many scenes, the depth of field stretches to infinity, so you could argue there is infinitely more depth of field behind than in front of the point of focus. However, this is still a handy rule that reminds you that it is best not to focus on the subject in the foreground if you want to maximize the depth of field.

Assuming that you want the far horizon (infinity) in focus, the actual distance that you need to focus on (for a particular aperture and lens setting) is known as the hyperfocal distance. Focus here, and everything from half the focal distance to infinity will be sharp.

The lack of useful depth-of-field scales on digital camera lenses makes this hyperfocal distance impossible to work out on paper (although there are online calculators and downloadable programs that will do the calculations for you). However, focusing just beyond the nearest point in the scene that you want to be sharp in the image will often allow you to increase depth of field without losing foreground sharpness (and your success can be checked using playback).

White Mountains, New Hampshire
This is a typical landscape scenario, where you want everything from your feet to the distant hills to be in focus. The solution is to use a wide lens setting (here, an efl of 28mm) along with a small aperture. The focus was set from the big boulder in the foreground.

89

1.2 Minimizing depth

For the digital photographer, trying to restrict depth of field is often much more difficult than maximizing it. Many cameras simply offer so much depth of field at normal shooting distances that it can be near-impossible to throw the background out of focus. This is probably one of the strongest arguments in favour of the digital SLR, where it is relatively easy to retain control over what is sharp in an image.

It might seem strange that you would want anything other than a shot where everything is as sharp as possible. But the ability to draw attention to a particular element, while obscuring others, is one of the most useful creative in-camera effects that is available.

In practical terms, restricting depth of field allows you to throw backgrounds or foregrounds out of focus so that they are no longer a distraction from the main subject. This allows you to isolate an element within the scene, and it is the fact that it shows something in a way that is different to that seen by the human eye that makes it such useful effect.

The three key ways in which to minimize depth of field are to:

● Use as wide an aperture as possible. For digital SLR users, the maximum aperture will depend on the particular lens being used at the time—some models have particularly wide apertures, and are particularly useful for creating shallow focus effects.

● Use as long a telephoto setting or lens as you have available. The longer the lens, the less the depth of field.

● Get as close to the subject as possible. This may seem to contradict the choice of a longer lens, but depth of field decreases the closer the lens is focused. Sometimes you can increase the out-of-focus effect in the background by focusing slightly in front of the main subject. Alternatively, it may be able to increase the distance between the subject and the background—so the backdrop then falls outside the zone of sharpness.

Nepalese man with prayer wheel
With portraits, you frequently want to restrict depth of field—so that a cluttered background is obscured, and the sitter remains the focus of attention. This candid was shot in a busy temple complex in Kathmandu—a large aperture and long lens were essential to isolate the old man from his surroundings.

Football

Restricting depth of field is often crucial for good sports photography, simply because you do not want advertising hoardings and spectators on the other side of the field to be in focus. Fortunately, long telephoto lenses are the norm, and it is then simply a case of using the largest aperture possible. This shot of a professional football match was taken with a 300mm efl zoom setting, and an aperture of f/4.

Looking to sea

Throwing a background out of focus not only shifts emphasis, but also helps to create a more abstract, softer backdrop to shoot against. The out-of-focus ocean makes a perfect backdrop for this shot of a toddler with his beachball.

San Gimignano

Sometimes it is the foreground, not the background, that you want to disguise in the shot. The vantage point for this shot was chosen because the foliage obscured the modern buildings in the middle distance, which would have detracted from the famous skyline of the medieval town of San Gimignano in Tuscany, Italy. However, a wide enough aperture was used with the 200mm efl lens to ensure that the foliage was thrown out of focus.

1.2 Degrees of unsharpness

Because of the importance of image sharpness, depth of field and accurate focusing are an essential part of photography. However, because of this obsession, there is a tendency to think that a part of a picture is either acceptably sharp or simply blurred.

In fact, the degree of unsharpness in the out-of-focus part of the image varies. The point at which depth of field ends is not an absolute wall marking the boundary between sharpness and unsharpness: not only is placement of the "wall" open to a degree of interpretation (*see page 86*), it is actually more like a continuous slope than a sudden barrier.

An image is only actually sharp at the plane of focus; any point away from this appears in the image as a circle, rather than a point of light. The further away the plane of focus, the bigger the circle becomes. The bigger the circle, the more blurred this part of the image appears.

All this is important to the photographer because often it is not simply enough to have part of the image slightly out of focus. Frequently, out-of-focus subjects are still recognizable and therefore still distracting—you will need to restrict depth of field even further, to make this part of the image even more blurred.

Conversely, absolute sharpness (or even acceptable sharpness) is not essential for elements of the picture that you want to include as an integral part of the composition. As a background, if they are slightly out of focus, they can still add to the understanding of what is going on. This can be particularly useful in low light or with long telephoto lenses, where it would otherwise be impossible to get everything that you want strictly in focus.

Boke

Not only does the degree of unsharpness in a picture vary—the quality of the out-of-focus areas varies too, depending on the equipment you use! The smoothness of the blur is principally defined by the shape of the aperture: On many cameras this is a rough polygonal shape (often a hexagon), but on some lenses, the iris opening is more circular in shape. This is said to produce better out-of-focus effects, and is particularly sought after by portrait photographers. The shape of the iris is most noticeable, however, in

Out-of-focus pentagons
This 1 second exposure of a twirling sparkler clearly shows out-of-focus lights in the background as pentagons, corresponding to the shape formed by the iris blades of the hybrid camera.

out-of-focus highlights, as seen in the background of a picture taken at night. This quality of unsharpness is often referred to as "boke" or "bokeh," after the Japanese word for fuzziness.

In focus

Just out of focus

More out of focus

Blurred, but still recognizable as berries

Red berries

To fill the frame with the spectacular Christmas berry crop of this holly tree, a telephoto lens with an efl of 300mm was used. This not only means that only some of the berries appear sharp, but that some are much more out of focus than others.

Very blurred—berries are shapeless, and colors are more muted

Extremely blurred—berries are unrecognizable, and red hues are washed out

The need to get backgrounds that are as blurred as possible, rather than simply out of focus, leads some photographers to turn to special lenses that have wider maximum apertures than normal.

"Fast" lenses are available for digital SLRs in most focal lengths, but the fastest are often not zooms, but "prime" lenses with a fixed focal length.

The huge lenses used by professional sports photographers do not usually have a longer focal length than you would find on a typical digital SLR zoom or hybrid camera. They are so big simply because of the size of the maximum aperture:

typical examples are lenses with a maximum aperture of f2.8 with effective focal lengths of 300–600mm, which are four times brighter than a budget zoom lens with the same angle of view.

Although such long telephoto lenses are beyond the means of most digital SLR users, some fast lenses are more affordable. The best example is the 50mm (which would have an effective focal length of 75mm on an average digital SLR). These offer a low-cost solution for blurring backgrounds as well as for handheld low light photography, with budget versions usually having a maximum aperture of around f1.7.

Prime lens

Prime, or fixed, lenses require less glass than complicated adjustable zooms, so can be used at faster speeds.

1.2 Difficulties with depth of field

In some circumstances, it is simply impossible to get the depth of field to extend to every single part of the image that you would like sharp; it becomes inevitable that significant parts of the subject will appear out of focus. This makes it essential that you pick the areas that you want in focus with great care, and then ensure that these appear sharp in the picture.

This problem arises when depth of field is extremely limited—when using long telephoto lenses, for instance, or when the working distance between the camera and subject is small. There are also problems when working in low light with a handheld camera or with moving subjects, where you are forced into using a much wider aperture than you would otherwise have chosen.

When shooting macro subjects, the lack of depth of field is particularly acute: even with small apertures, the depth of field may extend for only a tiny distance.

Unless the subject is flat, some parts are not just going to be out of focus, but will appear significantly blurred.

You can reduce this problem to some extent by choosing the angle of view so that the variation in depth within the image area is as limited as possible. Most importantly, however, you need to pick a point on which to focus—you need to decide which part of the flower or insect, for example, will create the best, or most representative, part of the image.

With some subjects, such as portraits, this is easy. When we look at things, our eyes don't just stare—they actively scan the scene, moving from one point in the picture to the next. When looking at faces, whether those of people or animals, it is the eyes that we look at most often. If you focus on the eyes, therefore, and ensure that these are sharp, the picture will look acceptable, even if the rest of the shot is out of focus.

Focused on the eyes

Eagle Owl eyes
Two extreme close-ups of a Eurasian Eagle Owl, using the macro facility of a 75–300mm zoom. Although shot using a monopod, an aperture of f6.7 was needed to ensure a suitable shake-free shutter speed. The depth of field, therefore, becomes extremely limited, requiring much more care with focusing than usual. In one shot, the lens has focused on the beak; in the other, it is focused on the eyes. The second makes the much stronger image, even though a higher proportion of the image is now out of focus.

Focused on the beak

Cod-liver oil capsules

If you have a group of items that are all the same, it is not necessary to have them all in focus. For identity purposes, only one of these capsules needed to be sharp. If all the cod liver oil tablets had needed to be sharp, the independently tilting lens and film plane of a monorail camera would have been essential (*see page 20*).

Telephone keypad

If you can't get everything sharp, it may sometimes be better to exaggerate the difference between in-focus and out-of-focus areas.

Shot with a macro lens and extension tube, this close-up of a cordless phone restricts the depth of field to just part of one number button.

Red-Breasted Goose

The patterned plumage of a gaggle of red-breasted geese would have made a nice group shot. However, with an effective focal length of 600mm needed to get in close enough, it was necessary to concentrate the available depth of field on the one central bird.

1.2 Aperture and resolution

In many picture-taking situations, aperture values can be decided either by the need for a particular shutter speed, or by depth-of-field considerations. But with some subjects you end up with a wide choice of possible shutter speed and aperture combinations, each of which provides a practically identical picture, free of camera shake and with sufficient depth of field.

In these situations, one other factor can be taken into account when choosing the aperture: lenses provide better resolution images at some apertures than others. Typically, they provide less detail when used at their widest aperture setting, with quality increasing gradually as they are stopped down over the next two or three stops. Lens quality then takes another nose-dive with smaller aperture settings.

All things being equal, then, it is always worth using a mid-aperture setting in order to guarantee the best resolution image possible. This is particularly pertinent when taking pictures where the subject has little depth to begin with, such as when shooting the face of a building from directly in front of it.

How marked the improvement is, when switching from a maximum aperture to a mid-sized aperture, depends on the lens. With cheaper lenses, the resolution and contrast improvement will be much more marked than with a more expensive lens; the more expensive lens will still show an improvement, and will give a better performance at the optimum aperture, but will start from a higher level when fully open.

This initial improvement as you stop down can be simply explained by the fact that lenses perform better at their center than at their edges. The larger the aperture, the more these edges come into use when creating the image. For this reason, too, the central part of an image (whatever the aperture) resolves more detail than the edges.

Diffraction and small apertures

The fall-off in resolution at small apertures is not caused by the lens, but by the aperture itself. Whatever aperture setting you use, the hard edges of the opening make the light diffract. Light normally travels in a straight line, but when squeezed through a hole, the rays tend to bow outwards. This leads to interference, and a drop in image resolution.

At wider apertures, this diffraction has a negligible effect on image resolution. But as you close down the opening, it becomes more and more significant.

At the smallest apertures, it can soften the image so much that the effect becomes noticeable, even at moderate magnifications. This can effectively cancel out the depth-of-field benefits of a smaller aperture.

The amount of diffraction is not just dependent on the aperture size, but also on the size of the image sensor: the smaller the sensor, the more marked the effect. Partly for this reason, zoom compacts usually have a minimum aperture of f8, while a lens for a digital SLR typically closes down to around f22.

f/2

f/2.8

f/4

f/5.6

f/8

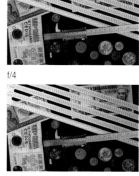
f/11

f/16

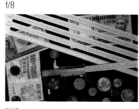
f/22

The aperture used affects the amount of resolution that can be captured; the image is noticeably softer at maximum and minimum aperture settings. In this sequence, there is a marked improvement by closing the lens down just one stop, from f2 to f2.8. The best resolution is achieved at around f8; resolution then drops off at small apertures due to diffraction.

Spanish store exterior
Shot with an ultra-wide-angle lens, the depth of field would not have been an issue, even at maximum aperture. However, this would not have given the best resolution, so a smaller f-number was chosen.

Dry stone wall
With this typical dry stone wall parallel to the image sensor, depth of field was not an issue, so again an aperture of around *f*8 was used on the digital SLR's standard zoom.

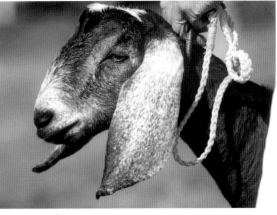

Agricultural exhibit
Telephoto close-up of a goat at an agricultural show. As the depth of field was unimportant, the aperture was stopped down to *f*8 in order to capture as much detail in the animal's coat as possible.

Taj Mahal
The bright light on the Taj Mahal meant that there were no camera-shake worries. And because all the subject was at practically the same distance from the camera, depth of field was not an issue. A mid-sized aperture was therefore used to maximize resolution.

German mosaic
Detail from a tiled frieze in Dresden. When photographing flat artwork, it is worthwhile avoiding maximum and minimum aperture settings, to capture as much detail as possible.

1.2 Focal length

The function of the camera's zoom is easy to understand: by changing the focal length of the lens, the angle of view is simply increased or decreased. At its simplest, therefore, the zoom is a cropping tool that allows the photographer to vary how much of the scene is included in the picture and it allows this to be done without having to move the camera.

It is easy, however, to underestimate the creative potential of changing focal length. For the digital photographer, zooming in allows you to maximize the effectiveness of the pixels so none are wasted and resolution is maximized. Changing the angle of view also has important implications for the composition of the image.

Being able to change the angle of view means that you can alter the camera-to-subject distance and still get the subject to fit the same part of the frame. By changing focal length and camera position in unison, you can therefore change the perspective and alter how the background appears in a picture.

Most important, changing focal length brings variety to your picture-taking. One of the disadvantage of basic cameras is that every picture is taken with a restricted range of angles of view—there may even be just one focal length. This inevitably means that shots look similar, as they have the same view of the world.

The greater the range of focal lengths that you have available, the more variety you can introduce into your pictures, and the greater the range of subjects you can tackle. A more extensive zoom range is a start, but even if this is built-in, you can often add other focal lengths using wide-angle and telephoto converters.

Cameras with interchangeable lenses, such as digital SLRs, provide the greatest range of focal-length choice. Not only can they access a wide variety of zooms, but prime lenses can also be used to provide unusually wide-angle or telephoto focal lengths.

Focal length and digital SLRs

To avoid the confusion caused by the effect that sensor size has on focal length, manufacturers tend to refer to effective focal length (efl) rather than the actual focal length of their lenses (see page 22).

The interchangeable lenses used on digital SLRs, however, can often also be used on SLRs that use 35mm film. As the efl depends on which type of camera it is actually used on, these lenses are usually described by their actual focal length (which is the same as the effective focal length when used with 35mm film, or with digital SLRs with 24 × 36mm sensors).

To calculate the effective focal length for most digital SLRs, this actual focal length needs to be multiplied (as the sensor only covers part of the projected image created by the lens, effectively cropping the picture before it is even taken). This magnification factor typically varies from 1.3× to 1.7×, depending on the make and model of digital SLR.

Widen your choice
The Konica Minolta Maxxum 7D employs a CCD-shifting anti-shake technology, which moves the CCD in response to camera shake. This means it can add this feature, and the benefits of digital, while remaining compatible with all Konica's AF lenses.

One of the difficulties with using a zoom to precisely crop the image to maximize picture area is that the viewfinder may only approximate the angle of view. The direct vision viewfinder of a compact camera may show more of the scene than is actually captured, and a digital SLR's eye-level viewfinder will typically show only 95 per cent of the image area. This must be taken into consideration if you want to frame the subject as tightly as possible.

Getting closer 100mm

Increasing the focal length can often be a more practical alternative to getting physically closer to the subject. These shots of a family of white rhinos in a South African game reserve were taken from the closest position that the guide felt the SUV could get. By zooming, however, group shots and individual shots were still possible.

300mm

Variety

Changing focal length doesn't just affect image size—it also makes different types of shot possible. These two shots were taken from the same spot in a cathedral cloister, but the architectural detail taken with a 200mm zoom setting gives a very different picture than the super-wide-angle 18mm prime lens.

18mm

200mm

75mm

New vision

Part of the attraction of zooming is that it allows you to show things in ways in which they would not normally seen. The 75mm view shows the building in a way in which we can marvel at the architecture, while the 400mm shot creates an abstract pattern.

400mm

1.2 Perspective

Strictly speaking, perspective has nothing to do with focal length. Perspective is the optical effect that makes distant objects appear smaller than those that are closer to you. It makes railroad tracks seem to converge, even though we know that they are perfectly parallel; and it provides vital clues about depth when looking at a two-dimensional image.

Artists have to learn about perspective and vanishing points if they are to draw realistic views of the world. Photographers do not have to worry about such things, as the lens and the sensor do it all for them. However, it is the use of different focal-length lens settings that makes perspective interesting to the photographer.

Perspective changes solely depending on distance. So if you shoot a scene with a wide-angle lens, the perspective remains identical if you shoot the same scene from the same spot with a long telephoto—all you are doing is cropping the picture differently.

The power of changing lenses, however, is that it shows crops that we wouldn't normally see. The central (non-peripheral) vision of the human eyes equates to an effective focal length of around 55mm. As the focal length becomes markedly different from this, this "unnatural" crop becomes much more dramatic.

Focal length also changes the picture simply because telephoto lenses are generally used from further away from the main subject than are wide-angles, which leads to an actual change in perspective. Telephoto lenses are said to compress perspective, making subjects at different distances appear much closer to each other than they actually are. Wide-angle lenses have the opposite effect, seeming to making the foreground larger and more prominent in the picture, while pushing the horizon further into the distance.

300mm

Compressing depth
These huge space-age domes stretch over a distance of some 500 yards (450m), but shot from an elevated vantage point with a 300mm telephoto zoom setting, the sprawling greenhouses are squeezed tightly into a frame.

18mm

Enlarging the foreground
Wide-angle lenses can be used to exaggerate the size of objects in the foreground. This perspective effect occurs because the lens can be used close to a subject, but still fit it all into the frame. The fungus in the shot was focused at around 1ft (30cm).

24mm

The same perspective

These two shots of London were taken from almost identical vantage points and therefore share the same perspective; in fact, the telephoto view could almost be a simple crop of the wide-angle shot. However, the absence of foreground in the telephoto view makes these London tourist attractions—the Big Ben clock tower and the London Eye wheel—appear much closer than they are in reality.

300mm

1.2 Manipulating the background

Whether you use a wide-angle or telephoto lens to take a head-and-shoulders portrait, you can end up with essentially the same picture. To compensate for the different angle of view with the telephoto lens, you simply move back until the face fills the frame again. There are slight changes in facial perspective (*see page 162*) which may make the subject look more attractive with one shot, but for many situations, these two approaches produce very similar views of the subject.

The big difference between these two approaches is in the background. With a telephoto lens, a much smaller section of background is shown than with a wider angle of view, and it is this difference in backdrop that can prove a powerful reason for choosing one focal length over another.

In the studio, for instance, wide-angle focal lengths are not usually used, simply because there is not enough backdrop available to make their use possible. A standard or short telephoto lens is essential, as this ensures that areas of studio that are not part of the "set" remain unseen (long telephotos are not normally used, as the camera-to-subject distance is restricted by the walls).

Outdoors, the choice between wide-angle or telephoto allows the photographer to choose the most appropriate background. A wide-angle allows you to show much more of the surroundings, which can help to set the scene for subject. A telephoto, on the other hand, can be used so that only a small part of the surroundings are on show.

By changing the camera position, therefore, you can change the background in quite dramatic ways: you can pick an identifiable object that works well with the subject because of its color, pattern, or subject matter. Alternatively, you can engineer the background so that it is a featureless canvas against which to show off the main subject.

Telephoto lenses do not always provide the most clutter-free solution, however. With larger objects, you often have to increase the tilt of the camera slightly as you get closer to them. A wide-angle shot of a building may work better than a similar telephoto composition, as other buildings in the background become hidden from view, so that a clear sky becomes the backdrop.

Sepia tree
From a distance with a telephoto lens, the group of trees becomes one. From closer up, only the tree in the foreground is prominent.

Bell tower

Simply by moving farther away, you can completely change the background. Up close with a short telephoto lens, the clock tower is pictured in front of a cloudy sky; from farther back with a longer lens, trees and other buildings provide the backdrop.

Flower basket

Both versions show the hanging basket at the same size, but the wide-angle shows much more of the wall on which it hangs than the telephoto shot.

War memorial

The telephoto version shows much less of the town surrounding the war memorial than the wide-angle version. However, the wide-angle shot works best, as the closer camera position means that the horizon is further down the frame.

Globes

Even when the background is not far behind the subject, the amount shown can be varied significantly by changing the subject distance and focal length in unison. For this still-life setup, 50mm and 300mm effective focal lengths were used.

103

1.2 Using wide-angles

A wide-angle lens is simply one that offers a greater field of view than that seen with our eyes. Any lens with an effective focal length of 35mm or less, or with an angle of view of 60 degrees or more, is called a wide-angle.

The primary appeal of a wide-angle is that it allows you to fit so much of the scene in front of you into a single frame. However, some lenses offer much wider angles of view than others—the shorter the focal length, the more extreme and unusual the pictures that can be produced. Specialist wide-angle zooms designed for use on digital SLRs can offer effective focal lengths that are as short as 15mm; however, ultra-wide-angle lenses designed for 35mm film SLRs are of limited use on digital SLRs, due to the cropping effect, which increases the effective focal length. The key characteristics of wide-angles increase as the focal length becomes shorter: depth of field becomes greater, as does the ability to produce exaggerated effects using perspective; ultra-wide-angle lenses can be used to make items in the foreground look unnaturally large, simply because they can get so close to a subject and still fit it into the frame.

The construction of wide-angle lenses also produces distortions. The most obvious of these is barrel distortion, which makes horizontal and vertical lines tend to bow outward, particularly toward the edge of the image area. This effect can be put to creative use, but in order to minimize the visibility of the effect, it pays to place key elements (such as faces) in the center of the frame, where they will not appear distorted. Similarly, keeping the composition as symmetrical as possible will help to avoid accentuating the optical effect.

Fish-eye effects

While all wide-angle lenses produce some optical distortion, manufacturers are careful to design the lens to keep this barreling effect to a minimum. With fish-eye lenses, however, this rule is abandoned, and barrel distortion is deliberately used in order to produce the widest angle of view possible.

Circular fisheyes produce the most warped effect, and typically have an angle of view of 180 degrees; the image only partially covers the sensor, creating a circular vignette. Semi-fisheye and full-frame fish-eyes endeavor to fill the whole sensor area with their distorted view of the world.

True fish-eye lenses are not widely available for digital SLRs, which means that all digital camera users have to use supplementary converters in front of the lens to achieve the effect.

Mock fish-eye effect
This image was taken using a 0.42× semi-fisheye converter with a hybrid camera set to an effective focal length of 35mm. The setup produces a poor-quality image, but successfully creates the effect of a circular fish-eye lens.

10-22mm Canon
This specialist wide-angle zoom offers a range of ultra- and normal wide-angle settings in one digital SLR lens.

Stretching legs
The confined space in a rowboat meant an ultra-wide-angle lens with an efl of 17mm was essential to capture this action shot. However, the lens shows the setting well. Note how the close subject distance makes the boy's legs seem unnaturally long.

Wide-angle converters

In the race to produce cameras and lenses with greater zoom ranges, it is often the wide-angle end that suffers. Combining ultra-wide-angle and ultra-telephoto in the same lens is not an economical proposition, so many built-in zooms offer just a moderate wide-angle setting, and then impress with their telephoto capabilities.

It is possible to increase the angle of view even if the camera's lens is not interchangeable, as supplementary converters can be bought for many zoom compact and hybrid lenses; these attach to the front of the built-in lens using a screw-threaded filter ring.

Wide-angle converters are sold with different magnifications: A 0.8× converter turns a 35mm zoom setting it to an effective focal length of 28mm; a 0.5x converter changes this efl to around 18mm.

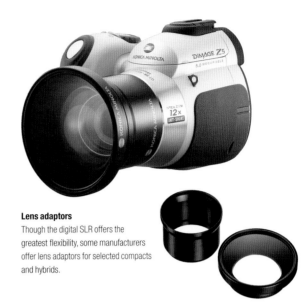

Lens adaptors
Though the digital SLR offers the greatest flexibility, some manufacturers offer lens adaptors for selected compacts and hybrids.

Filling the foreground
Ultra-wide-angle lenses can be useful for landscapes, but only if there is sufficient visual interest in the immediate foreground. Here, this is provided by the lumininescent field of rapeseed. Because large expanses of sky are almost unavoidable, weather conditions are also important.

Barrel distortion
Shot with a semi-fisheye converter on a digital SLR fitted with a 50mm lens, this shot shows the bowed vertical and horizontal lines of extreme barrel distortion.

Abbey archway
The difference between a standard wide-angle setting and an ultra-wide-angle one can be significant, particularly with architectural shots. The upright shot is the best possible solution to a difficult angle with only a 28mm efl zoom; using an 18mm efl on a subsequent trip did better justice to this interesting vantage point.

1.2 Using telephotos

A telephoto is any lens that gives a narrower angle of view than normal human vision, thus providing a telescopic effect that allows the camera to see into the distance. Telephoto lens settings have a field of view that is less than 35 degrees, and have an effective focal length of 70mm or more.

The maximum focal length of telephoto lenses is only really limited by the practicalities of using extra-large lenses and keeping their images steady when shooting. Built-in zooms offer focal lengths of up to 300mm, while digital SLRs can be equipped with zooms, prime lenses, and converters to produce more extreme focal lengths. The fact that image sensors crop into the image area produced by an SLR lens works to the advantage of the digital SLR user requiring the longest telephoto lenses, as focal lengths of 600mm or more can be achieved relatively inexpensively.

A telephoto allows the user to cut down distances, allowing far-off subjects to be magnified so that they fill an appreciable part of the frame. However, these lenses are usually used to capture subjects that are a few paces away, rather than those which are miles into the distance. Dust and atmospheric pollution mean that the effective resolution of a lens deteriorates depending on the subject distance—this becomes particularly noticeable with telephoto enlargements.

The amount of magnification needed depends on the size of the subject and how close you can get to it. A wildlife photographer needs the longest lenses that are practical to cover small birds, or to capture dangerous large mammals in the open. For the sports photographer, the focal length is decided by the dimensions of the field of play; you are typically further away from the action when shooting baseball than basketball, so you require a longer lens.

Teleconverters

Built-in lenses can often be given more zoom power by the use of a teleconverter that screws into the front of the lens, magnifying the maximum effective focal length, by a factor of 2× or 3×. More powerful converters are available for some models.

Teleconverters for digital SLRs fit, like extension tubes, between the lens and the camera body. These usually magnify focal length by 1.4× or 2×.

Teleconverters
For either built-in lenses (above) or SLRs (right).

Approaching surfer
Surfer shot from shallow water using a 400mm prime lens that provided an efl or 600mm.

Tripod collar

The bigger the lens, the harder it is to hold steady, and the more it makes the camera outfit front-heavy. For this reason, the biggest digital SLR lenses have their own socket or "bush" for attaching a tripod or monopod; this is often attached to a rotating collar that allows the camera and lens to be quickly twisted from horizontal to vertical formats.

Telephoto lens with rotating tripod mount.

Thai children

Short telephotos are the lenses of choice for portraits because they give a slightly compressed perspective that flatters, as it flattens facial features. Longer telephoto lenses come into their own for candid shots. For this shot at a Thai dancing display, a lens with an efl of 300mm was used.

Overcoming timidity

The smaller the bird and the more timid its behavior, the longer the lens needs to be. This shot was taken with a zoom, offering an efl of 450mm.

107

1.2 Filters

Made of glass, plastic, or resin hundreds of different photographic filters are available. But although most can be successfully used on digital cameras, the vast majority serve little useful purpose. The special effects and color adjustment that they provide can be achieved easily, and with more control, at the computer manipulation stage.

There are a handful of notable exceptions, however, filters which perform tasks that are difficult or impossible in the digital darkroom.

The most basic of these is to protect the lens. The front element of a built-in or interchangeable lens can easily become scratched during even careful use; such damage can prove expensive or uneconomical to repair, and will ultimately lead to a deterioration in image quality. A filter placed over the front of the lens is, of course, just as likely to be damaged—but is much cheaper to replace. The usual choice is UV, as this will also cut out some of the ultraviolet light which can create blue horizons in landscape photography. An alternative is the skylight filter, which is simply an amber-tinted UV filter (although the coloring effect will be canceled out by the camera's white balance system).

The really useful filter for the digital photographer is undoubtedly the polarizer. This performs a number of almost-magical effects simply by cutting out polarized light that would otherwise affect the content or the color saturation of the image.

Light becomes polarized when it reflects off glass, water, sky, or any shiny surface. It shows up as visible reflections—or simply weakens color saturation. Unlike normal light, polarized light only vibrates in one plane. Twist a polarizing filter to the correct angle and the polarized light vanishes or is substantially reduced—producing a cleaner image.

It is important to choose a "circular" polarizing filter, rather than "linear" versions which can interfere with a digital camera's autofocus system.

Used in front of the camera lens, it can remove reflections from non-metallic objects—such as on a pond's surface or in a storefront—allowing you to see through more clearly. It improves the saturation in many subjects, by removing reflections that you would not notice. It can also help to strengthen the blue of the sky—although here it is sometimes best to avoid over-saturation by rotating the filter slightly away from the angle at which it has the maximum effect.

In landscape photography, polarizers can help to reduce atmospheric haze—caused by polarized reflections of light particles. As with all uses of the polarizer, the efficiency of the effect depends partly on the angle of the light source to the surface—and in the case of haze, you get the best results with sidelighting.

Square or round?

Filters are either available in round mounts that screw directly into the thread found at the front of most lenses, or in unmounted square sheets.

Square filters are fitted to the camera using a frame and screw-in mount—and have the advantage that one filter can be used on a variety of lenses (which will almost inevitably have different-sized filter threads). Confusingly, some "square" filters are circular (such as the polarizer), so that they can be rotated easily to get the desired effect.

A protective skylight or UV filter should be bought in circular form in order to protect the lens.

Other useful filters

Graduate gray

Graduated filters are available in every shade of color, and are designed to change the color or shade of a sky. However, as this effect can be applied so precisely and simply using an adjustment layer during editing they have little value in the digital era. The one "grad" filter that still is of use is the graduated gray. This adds no color, but works like a progressive neutral density filter, clear at the bottom, but gradually getting darker from just below the center and up. It helps with the almost inevitable exposure problems created by a sky that is much brighter than the land. Even though this correction can be applied in the digital darkroom, a grad gray gives a far better starting point for manipulation – as shadow detail can be retained without blowing out the highlights.

Cross-screen

Also known as a starburst filter, the cross-screen filter has a grid pattern etched on it. This turns bright highlights into stars. This is a particular useful effect when shooting in low light, as the points of the stars can be made to stretch across a large proportion of a dark-coloured frame.

Neutral density

Used to reduce the amount of light reaching the sensor, so that a slower shutter speed can be used than would otherwise be possible (see page 82).

1.2

No Filter

With graduate gray filter

The grad gray filter effectively darkens the upper part of the picture—allowing you to use a longer exposure than the sky would otherwise make possible. Without the filter the exposure was 1/350 sec at f/9.5; with the filter in place the settings became 1/90 sec at f/9.5. This allows far more detail in the foliage to be captured.

No filter

With polarizer

A polarizing filter, or "polarizer."

Sometimes a polarizer can completely transform a scene. Here the two shots look as if they were taken in completely different lighting conditions—and not just moments apart.

No filter

No filter

With polarizer

With polarizer

Polarizers are good at reducing reflections from glass and other shiny surfaces—such as the polished hood of this wedding car.

No filter

With polarizer

Polarizers can have an effect with unexpected subjects. The detail on a wooden carved door becomes much clearer when extraneous reflections are removed.

Polarizers can remove some of the reflections from the surface of water. If the water is clear, it can help you see below the surface—but not with this muddy canal.

109

1.3 Seeing the picture

It does not matter how sophisticated the camera you use is—you still need to decide in which direction to point it and when to fire the shutter. We are surrounded by a world of picture possibilities, but some are much more promising than others.

Learning to take great photographs means learning to see in a different way. Human vision is active, constantly searching a scene for information. Photography is about breaking down such scenes into single, static shots; it is about turning a three-dimensional reality into a two-dimensional reality, and it is about realizing that lighting is the secret ingredient that turns the mundane into the magical.

Such skills can be learned. But photography is not just about following rules, it is also about personal expression. Your pictures show your view of the world, and your own interests. As you gain confidence in composition and learn to use lighting, you can begin to develop your own, individual style.

1.3 Composition

Composition is not just about what you place within the frame of the camera's viewfinder; just as important is what you decide to leave out of the picture. We are surrounded by a cluttered world, and however photogenic the location, there are parts of the scene which we do not want to include in the shot. If, as many point-and-shoot photographers do, we just shoot what we see before us, we are likely to end up with a disappointing image. The shot fails because it lacks emphasis.

The first rule of composition, therefore, is to try to simplify the scene. The eye scans this way and that, picking out objects of interest to look at for longer than others. The camera cannot do this—it shows everything. Unlike a painter, you can't just leave out the distracting, unwanted elements; instead, you need to use the lens setting and viewpoint to create an image that is as free from mess as possible. You should think of the picture as a story, and use composition to make the tale as easy to understand as you can.

In most cases, your pictures will become stronger if you frame the shot so that there is only one main focal point. Often, you can frame a subject so that it appears alone in the frame; however, if you include further elements, these should complement the main subject, adding to the detail of the story, rather than competing for our attention.

Manipulating the elements

In some forms of photography, you can actually move elements within the scene to simplify the composition. With outdoor portraits, you can ask your subject to move to a different part of the garden to find a less distracting background. With a still-life shot of, say, a bowl of fruit, you can move elements in and out of the frame until you create your perfect composition.

In most other types of photography, however, you cannot move the elements in the shot; instead, you change the camera's angle of view to vary the relationship between the different elements. You move to the side to avoid having a busy road in the foreground, for example; and you move in close, or use the zoom, to find ways of creating a stronger and simpler composition.

This is a typical scene where everyone gets their cameras out. The street carnival has pictures at every turn, of the colorful entertainment and the happy spectators. But including everything in a single shot, however, just doesn't work: the result is too cluttered. It is better to find a viewpoint, and choose a zoom setting, that simplifies the scene. Here, the obvious shot is of the psychedelic one-man band.

1.3

Bangkok floating market

The best photograph is not always the one that shows the most accurate view of the scene. The wide shot of Bangkok's famous floating market gives a good idea of the hustle and bustle of the scene...

...however, it is the shots of individual traders, carefully picked out from dry land, that provide the best results.

1.3 Using the formats

Although the size of image sensor varies from camera to camera, the image shape is always rectangular. In fact, with most cameras the proportions of the image fall into one of two camps: some have aspect ratios of 3:2, with two sides that are 50 per cent longer than the others. These are the same proportions as used by 35mm film cameras, and by a number of commonly available inkjet printers (such as 4×6in). Others use an aspect ratio of 4:3, where the long side is one-third longer than the others. These are the proportions of a traditional, non-widescreen computer monitor or TV screen, and close to the proportions of popular A4 and A3 printing papers.

In composition terms, there is little to choose between the two formats. However, it is important to realize that each format in fact offers two different aspect ratios when shooting—you can shoot the longer side along the horizontal, often referred to as the landscape format, or you can turn the camera and use the long side as the vertical side. This is referred to as the portrait format.

Because of the way that digital cameras are designed, it is much easier to shoot (and view) horizontal format shots than vertical ones; some snapshooters never switch aspect ratios. But rotating the camera, to see if this works better with the subject in front of you, is an important habit to get into. It might feel uncomfortable using the camera like this, but you will soon get used to it.

Some subjects, such as full-length portraits, or shots of tall towers, are obviously likely to work better with more vertical picture space. However, the subjects that work best in this way cannot be easily categorized—some portraits are far better framed with the landscape format, and some landscapes may be more simply composed using the vertical format. The most important point about learning to turn your camera for at least the occasional shot is that it is a great way of adding visual variety to your pictures.

Trying the formats
It is easy to fall into the trap of thinking that a particular subject will work best with one format, but it is better to try out both whenever you have the time. Here, the landscape benefits from not using the more obvious landscape format.

1.3

St Cirq Lapopie
Rotating the camera allows you to add variation to your portfolio of pictures. Both of these shots of this picturesque French village in the Lot valley are successful compositions.

Fitting the frame
Sometimes the subject dictates which of the two formats you should use. For these shots in a waxwork museum, the vertical format was more effective for the shot of punk rocker Johnny Rotten, while the pose of the Michael Jackson statue suited the landscape format.

Preparing to crop

Although the proportions of the CCD or CMOS imaging chip are fixed, there is no reason why your pictures need to stay this shape forever. When editing your pictures, you can change the aspect ratio to whatever you fancy, particularly if this helps to strengthen the composition. You can also crop your images using non-rectangular shapes—circles, shapes, or clouds, say—if you so wish.

When composing, you can begin to plan for post-production cropping, for instance, choosing a more panoramic aspect ratio to avoid including unnecessary

River panorama
This shot was taken with a panoramic format in mind. The alternative would have been to include more sky, or distracting foreground fields. The narrow aspect ratio concentrates the viewer's eye on the snaking river.

expanses of foreground or sky when photographing a landscape. Such cutting of the image will mean there is more surrounding white space when printing onto standard paper sizes, but these can be left as an artistic border or trimmed away.

115

1.3 Color

When composing a photograph, it is often helpful to think of the structural elements that are being used in the picture. Color, form, shape, pattern, and texture are the five fundamental elements that define how a subject, or a part of the scene, looks. Although they are frequently used in combination, you can often create stronger pictures by framing the shot so as to emphasize just one of these elements.

Color is undoubtedly the most powerful of these elements. Certain colors attract the eye more than others, and therefore always make an impact in a picture: reds, for instance, can leap from the screen, while yellows, pinks, and other bright hues can also be used to attract attention. Other colors draw a subtler emotional response, particularly when used in combination—just as when painting a room, some go together well, while others clash. You can therefore frame the picture with a restricted palette of colors to create a harmonious, romantic picture, or you can try and create maximum impact with hues that create maximum contrast.

Intensity and shade of color can be controlled to a great extent during post-production, but it is important to realize that color is highly dependent on lighting. For maximum color saturation across the frame, it pays to shoot with the sun behind the camera (*see page 142*); similarly, colors tend to be their weakest when using backlighting (*see page 146*), and this can be a useful trick to use when you want to subdue the riot of colors in a subject.

Computerized color control

The digital photographer does not have to worry too much at the time of shooting whether color combinations work well; colors can not only be strengthened or weakened in specific areas during manipulation, they can often be successfully changed. The *Hue/Saturation* tool found on most image-editing programs is usually the first port of call. This allows you to change six sets of colors, altering their depth, hue, and lightness so that they suit the composition better. Finer control can be gained by tailoring the color range being altered, or by masking the image, so only parts of the frame are affected.

This fill-flash portrait features strong colors in the knight's tunic and in the tent behind. During the editing stage, the purple panels were changed to blue in the hope that it would strengthen the composition.

When shooting portraits or still-life subjects, the photographer has a great deal of control over the colors that are within the scene. You can ask subjects to wear clothes in colors that create a strong visual impact, or you can pick outfits for them that blend in with the setting. With still-life setups, an arrangement can be lifted by the careful choice of a colorful prop or backdrop.

Boy with binoculars
These toy binoculars were such an eye-catching color that they were an obvious prop for a portrait. The boy was asked to put on a matching red sweater.

1.3

Deckchairs
Frontal lighting normally brings out the colors best in a scene. But because the canvas of these beach chairs was translucent, backlight produced the most powerful results.

Natural color
While reds, yellows, and oranges seem to leap forward in a picture, blues have a tendency to recede. This psychological effect can help to add depth to your two-dimensional pictures, as in this shot of a New England church in the Fall.

Primary colors
Reds and yellows work particularly well in photographs: red creates the most dramatic impact, while yellow creates the brightest tones that attract the eye. In this shot, the bunches of roses in a wholesale flower market take on the appearance of a color chart.

1.3 Form and outline

Shape is perhaps the most important element in identifying a subject; but in photography, it is important to distinguish between two-dimensional and three-dimensional shape.

Stressing the two-dimensional shape, or outline, of a subject can mean that flat photographs look two-dimensional. Three-dimensional shape, or form, is all-important, as it helps to inject information about depth into our pictures.

The shadows in a picture provide the clues about three-dimensional form: if some surfaces are in the shade, while others are lit, we know that they are at different angles to the light. Rounded surfaces, meanwhile, can be identified by a gradual change in tone.

It is useful to emphasize form in most types of photograph, because otherwise a subject can end up looking like a lifeless, card cutout. The direction of lighting that works best will depend on the surfaces of the subjects, but in general, sidelighting works best (*see page 144*).

Outline can be emphasized to depict a subject with graphic simplicity—although by doing so, information about form can sometimes be lost. The classic example of a photograph that accentuates shape is the silhouette (*see page 146*), but how good this actually proves at identifying the subject will depend on the camera angle—a face, for instance, can be recognized better in profile than when seen head-on.

A more useful strategy for stressing the shape of a subject is to shoot it against a light, uncluttered background, so that the outline can be seen clearly, and so that backlighting is not essential.

Victorian statue
By combining sidelighting and a plain background, outline and form can be shown successfully in the same picture. Here, the statue of a Victorian Field Marshal allows the pale blue sky to be used as a backdrop, while the strong sunlight creates a complex pattern of light and shade that gives a good idea of three-dimensional form.

Asakusa Japanese temple
Shot against a featureless sky, the intricate outline of this famous Tokyo pagoda can be seen clearly. The picture was processed to give it a look reminiscent of a hand-tinted postcard, and this effect seems to suit the subject well.

1.3

Change of viewpoint

The effectiveness of shape as a compositional strategy depend upon camera viewpoint. In these two shots, the rear-end view of the beast has humor, but is of little use for identification purposes. The profile shot of the Southern White rhinoceros gives a much clearer view.

Chateau de Val

The shadows on the turrets make it obvious that this is a photograph of a French castle, and not just a simple drawing in a fairytale story. The subtle gradation of shades between light and dark help us to distinguish the round towers from the octagonal one.

1.3 Texture

Texture is the picture element that tells you what a subject would be like to feel: it helps to differentiate the rough from the smooth, to tell feathers from fur. It is the indentations on a surface that give this information, and their presence is shown in a picture by a telltale pattern of shading.

Texture is, in a sense, just like form, only on a smaller scale, as both rely on lighting to provide shadows and highlights across the surface of the subject. The lighting requirements for accentuating texture, however, are slightly different. For maximum effect, you want the pits and furrows of the surface to be in the deepest shade possible; this can be achieved by using raking light—light that hits the surface from as oblique an angle as possible. Sidelighting can often be the perfect solution, but for vertical surfaces, lighting that is directly overhead (top-lighting) can also work well.

Because texture tends to be found on a miniature scale, and relies on good resolution to be seen, it is best accentuated by getting in close to the subject, otherwise the texture can be lost. Sometimes this will mean using a long telephoto zoom setting, but more frequently it involves using whatever macro facilities you have available to decrease the focusing distance (*see page 48*). Cropped in tight, simple subjects such as the grain of a piece of weathered wood, or the peeling paint on a window ledge, can make fascinating abstract studies.

Gunnera leaf
Contrasting light on this section of the leaf gives an accentuated idea of the rough surface of the giant, rhubarb-like pond plant, *Gunnera Manicata*.

Sharpening texture
It is possible to accentuate the texture of a subject by image manipulation. The cauliflower florets create a multifaceted surface that looks great in photographs, and to make the most of this, the white part of the vegetable was selected using the lasso, and then sharpened using Photoshop CS2's *Smart Sharpen* filter.

Nepalese woman and baby
Texture is an important element in portraiture, as it allows us to tell a person's age from the smoothness of the skin, or the presence of wrinkles. In some cases, you may want to accentuate the lines of a face in a portrait—in others, the sitter may pay to minimize them!

Turkey
It is not just the red color of this turkey's head that attracts the attention, it is the wrinkly texture, too.

Orange peel
The amount of texture visible is highly dependent on depth of field and lighting: The small detail necessary is only seen in sharp areas of the image. Furthermore, there is greater texture where the light hits the orange peel from an oblique angle, compared with areas lit directly.

1.3 Pattern

Of all the structural elements within a composition, pattern is perhaps the least obvious to appreciate. We all understand what pattern means, but it is hard to see its relevance to picture-taking.

The trouble is that patterns are all around us—not just in wallpaper, tiles and clothing. It is found in nature: in the repeated shapes of leaves on a tree, or the cells of a honeycomb. It is found in the bricks of every wall, and in every junkyard. You can see patterns in the way in which grocery shelves are stacked, and in the contents of every can and packet that you buy there. Pattern is so pervasive that, for most of the time, we just don't notice it.

But it is because we are so comfortable with pattern that it makes such a great compositional ally. By placing similar or identical subjects within the same frame, we can create a busy image, but the arrangement is still simple enough to result in a successful shot.

Furthermore, the selective viewpoint of the camera means that pattern can be isolated in a way that means that it can be seen afresh. By cropping into the scene with a suitable telephoto setting or close-up vantage point, even a pile of empty bottles or a heap of paperclips can be made to look interesting.

Pattern that is too uniform, of course, can end up looking rather dull, so it is worth finding ways to present the pattern in an interesting way. It can be used as just one of the compositional elements, for instance, creating a backdrop or foreground that acts as a foil to something else in the frame. Alternatively, you can look at ways to break down the pattern—a pile of apples can be made more photogenic by using a wide-angle lens up close to make one of the fruits look bigger than the others, for instance, or you could try putting one red apple in a pile of green apples, so that that you have an obvious focal point for the picture.

There is no set, "ideal" lighting for pattern, as this relies on repetition of one or more of the other elements. Whether the pattern relies more on repeating outlines, forms, textural detail, or color will help decide the best lighting setup.

Lotus flowers
The unusual shape of these blooms attracts attention. The forms of the lotus flowers create one pattern, while within this there is the additional pattern created by the bunches themselves.

Mountain terraces
The foothills of the Himalayas are carved with ledges to maximize the amount of farmable land. A telephoto shot (300mm efl) gives an idea of the contour patterns that these manmade terraces create across the landscape.

Nepalese standing army
Nepalese soldiers waiting patiently for the parade to start. Here
it is the break in the regimented pattern that attracts us, with the
soldier facing toward the camera becoming the focal point for
the picture.

Coral surface texture
Tiny indentations cover the surface of this piece of coral, and
their texture is best revealed with appropriate lighting.

Rusting chains
Rusting chains sitting on a fishing
wharf. The symbolic nature of the links,
and the intense color of the rust, make
this a fascinating macro study. Shot on
a digital SLR with a telephoto zoom in
macro mode.

1.3 Drawing with diagonals

Because photographs are rectangular, diagonal lines play an extremely important part in picture composition. Horizontal and vertical lines simply run parallel to the borders of the picture, and therefore look rather plain and predictable; diagonal lines, however, fail to follow the edge of the picture, thus creating a certain amount of visual tension. In short, diagonals create drama—and by careful choice of viewpoint and angle of view, these angled lines can be used to create stronger pictures.

Diagonals lines are everywhere—a path crossing the countryside in front of us, for instance, or the line created by a person's forearm as they scratch their chin. Such lines create the maximum impact if they originate at, or near, the corner of the frame, and when they create the biggest difference in angle from the sides of the frame (45 degrees). With two or more diagonal lines, you simply want each to be at noticeably different angles, yet still contradict the straight sides of the frame.

One of the reasons that diagonals work so well in photographs is that they can create a path that leads the eye through the composition. Even if there are no lines in the scene, an imagined line created by placing two key elements at opposite corners of the frame will have a similar effect.

The choice of lens and viewpoint can often be used to turn horizontal lines into diagonal ones. By getting in close to a building, say, and using a wider lens setting, the effect of perspective can start to make parallel lines on the structure converge, creating diagonal lines that you can use to your advantage.

Natural curves

In some forms of photography, a diagonal line can be too aggressive a way in which to force the viewer's eye across the frame. A gentler solution is to use a curve. In landscape photography, curves are particularly useful, as you can often engineer the view so that a river or winding road can act as the backbone to the composition.

Chova Gorge, Nepal
In this shot, the river and valley create an S-shaped bend that leads the eye through the landscape.

Dutch tilt

Diagonal lines, which create a feeling of movement in a photograph, can be created artificially simply by tilting the camera at an angle. Known to film cameramen as a Dutch tilt, this simple trick is often used by automobile photographers—whether moving or stationary, the vehicle immediately looks dynamic when shot in this way. An angle of around 45 degrees usually works best—a smaller angle can end up looking like an unfortunate mistake, rather than a deliberately thought-out technique.

1.3

Unusual beach
A tilt can occasionally be successful for other shots. For this shot of a resort town, the wide-angle lens was rotated to ensure that the maximum available picture area was filled by the shoreline and its buildings. However, this is a trick you don't want to use too often.

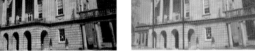

Reichstag
A detail from Berlin's Reichstag. The close camera position helps engineer the strong diagonal line.

Building diagonals
Two different shots of the same building. From a distance and from straight on, the shot conforms to an architectural drawing, with columns and ledges running parallel to the side (shot with an efl of 350mm). From close up and at a slight angle, the building is shot to ensure the verticals are still upright, but the horizontals then create strong diagonals across the frame (shot with an efl of 28mm). Which shot you prefer, however, is a matter of personal taste and purpose.

Formula One racing car
The sides of the track and the tire marks create diagonals that help create a feeling of movement in this high-shutter-speed shot of Formula One driver Alain Prost. Note that the vantage point also ensures that the car chassis is at an angle to the frame.

No need for trickery here
The natural diagonal of the French lavender is at the perfect angle. The shot was composed so the stem enters the frame near to the corner to emphasize this.

Cliff tops
A mass of diagonals, the eroded chalk cliffs create a zigzag line that leads the eye through the seascape.

1.3 Adding depth

A fundamental drawback with photography is that it is a two-dimensional medium. Using just the one lens, a normal camera cannot give the stereoscopic view of the world that our eyes enjoy, and this means that our flat images provide no direct information about distance and depth. It doesn't mean that we can't tell anything about the missing third dimension from photographs—it is just that this information needs to be pieced together from clues in the picture. The human brain can do this quickly and without conscious thought, but the way in which a picture is shot can help to accentuate the 3D experience.

One of the simplest ways of doing this is to ensure that there are elements within the image that are at different distances from the camera. With a strong foreground, background, and middle ground, you can obviously create a better idea about depth than in a shot where the subjects are all at the same distances. Once this is done, perspective can be used to maximize the effect: A wide-angle lens, say, can create a feeling of great depth by exaggerating the relative sizes of

near and far elements in the frame (*see page 100*). The parallel lines of a railroad or highway converging into the distance is a classic trick of linear perspective for accentuating a feeling of distance in a picture.

The trouble with using wide-angle lenses, however, is that you have to work hard to fill the foreground effectively: without a nearby element, the bottom half of the picture can look empty. To fill the frame and maximize the feeling of depth, you need to seek out suitable foreground focal points: a rock, a colorful flower, a gateway—such elements can often be found nearby to fill the lower part of the shot, without sacrificing the background that you actually want to shoot.

Another useful trick is to use foreground elements as a veil or frame through which to shoot the scene. The trick is not to think of overhanging foliage or gateways as obstacles, but as elements that can be incorporated into the composition. These can give a "different" view, while adding the foreground interest that helps to give a feeling of depth to the picture.

Aerial perspective

Because of dust, pollution, and water vapor in the atmosphere, you can see things less clearly the further they are away from you. The more distant a pictorial element is from the camera, the less colorful and more hazy it will appear in the picture. The effect is known as aerial perspective, and it provides visual clues about depth that can be exploited by the photographer.

Aerial perspective can be particularly useful when shooting landscapes with a telephoto lens, which tends to provide a flattened perspective that does

little to give a feeling about depth. However, by framing a scene with a long lens, hills that are miles away from each other can be squeezed together tightly in the frame, accentuating the tonal differences created by aerial perspective.

Storm coming
Storm clouds over the Lake District in northern England. Each hill appears progressively more muted and lighter, the farther away it is from the camera.

Break in the trees
Sometimes it is worth resisting the temptation to zoom in too far.
The ruins of this monastery could have been shot with a longer
lens; but framing them more loosely allows the viewer to peer
through the trees, thus creating a stronger feeling of depth.

Behind the veil
Artists sometimes use a trick known as "overlapping forms"
to create a better illusion of depth. The concept is simple: If an
element is partly obscured by another, you know it is further
away than the element obscuring it. Here, it also gives a less
conventional view of a typical New England church.

Frame within the frame
Overhanging trees provide foreground interest, and fill an area
of empty sky, in this wideangle view of a formal garden.

Linear perspective
The converging lines of
the track create a strong
feeling of distance, as
well as leading the eye
from the foreground to
the monument beyond.

Finding the foreground
The dramatic lighting
over this harbor makes
the picture, but to avoid
an empty foreground, a
vantage point had to be
found so that the rowboat
neatly filled the space in
the bottom of the frame.

127

1.3 Eschewing symmetry

Once you have decided on your subject and your vantage point, you then need to decide where you are going to place the main elements within the frame. It is tempting at this point to go for the easy option, and place the key focal point right in the middle of the viewfinder. However, you will frequently get better pictures by avoiding this, and by deliberately placing the main focus of the images away from the center.

There are times when putting the subject in the middle of the frame works. This creates an even amount of space or background around the subject, and creates simple order in the frame. It is a great way of accentuating harmony and tranquility, and so can work with shots of peaceful landscapes, or in scenes where you want to stress the symmetry of the shot. On most other occasions, however, this center-stage approach is just plain boring. You can create a much more dynamic picture by placing the subject off-center—and noticeably so.

The old compositional guideline known as the "rule of thirds" can be a helpful way of learning where to put things. The idea here is that you imagine your viewfinder split into a grid of nine equal-size rectangles, made from drawing two vertical lines down, and two horizontal ones across, the frame. You then place key focal points on any of the four points where these lines intersect, so that they are off-center in both the horizontal and vertical axes. Larger elements—such as a church tower, a person, or a line of trees—are placed to follow the lines themselves.

There is no need to follow this rule too slavishly, however: you can simply set out to ensure that key focal points are kept out of the center of the frame (this is conveniently marked in the viewfinder of most cameras). Furthermore, on some occasions it is worth being more extreme than the standard rule book dictates; putting main subject elements much farther toward the edge of the picture.

Window on wooden house
The imbalance of deliberately positioning the main element of a picture off-center creates immediate dynamism even with a simple subject, such as this open farmstead window in Old Sturbridge Village, Massachusetts.

Sad old donkey
With animals and people, it is the face—or, more specifically, the eyes—that are the focal point for the picture. This sad-looking donkey was placed so that his stable occupied three-quarters of the frame, making his head significantly off-center.

Shellfish collector on beach

A figure searching for supper on a Borneo beach is a perfect photogenic candid shot in the making. But where do you put the crouched figure? With the face out of view, the focal point is the round straw hat. Placing this in the top right corner, or bottom right, creates a stronger composition than leaving it in a central position.

1.3

Placing the horizon

One of the key compositional elements in landscapes and other photographic subjects is the horizon. The line where the sky meets the land is significant in the picture as it crosses the whole image and is something that the eye is naturally drawn to.

According to the rule of thirds, there are two obvious places to position the horizon in a picture: It can either run across one-third of the way down from the top edge of the frame, or one-third of the way up from the bottom.

In the majority of cases, photographers tend to divide the frame so there are two parts land to one part sky. This makes exposure metering more straightforward, and gives emphasis to the landscape itself. However, there are occasions when you will want to do the opposite—fill the frame with more sky than land—such as when there is a photogenic cloud formation, or when a spectacular sunset becomes the key element in the composition.

There are times when it is worth breaking the rules. You can accentuate tranquillity with a central horizon, or be more radical by placing this key line very high, or very low, in the frame.

These four shots were taken in and around Kathmandu, and show some of the positions where the horizon can be placed.

33 percent sky
The traditional approach places Himalayan summits along a key rule of thirds line.

66 percent sky
An incredible fiery sunset deservedly takes the lion's share of the picture.

50 percent sky
A more symmetrical approach can help emphasize tranquility.

20 percent sky
A radical approach; this makes amends for the fact that the first ridge splits the foreground and background into two almost equal sections.

1.3 Varying camera angle

One of the simplest ways of improving your photography is to shoot more pictures. More shots won't guarantee you better images, but then can accelerate the learning process. In the digital era, there is no real excuse for not trying to get as many shots of a scene as possible. There is no real cost to taking extra pictures, so it is worth getting into the habit of being trigger-happy.

There is little point in shooting the same scene from the same viewpoint, however. You need to work at finding new views of a particular subject. You can change focal length, aperture, and shutter speed, of course, but for really varied portfolio you need to work around your subject. By varying the camera distance and the camera angle, you not only provide different views of the subject, but other things in the picture change, too.

The lighting will visibly change as you circumnavigate the subject (*see pages 138–47*). But just as important, the background and foreground will also change: an unusual foreground object, for instance, is one of the best ways in which to get an original picture of a well-photographed building. A change of camera angle can also help you to discover simpler, or more complementary, backgrounds against which to shoot the subject.

Frequently, people travel for hours to visit a particular location but then fail to take more than a handful of shots of something they may never see again. By making the effort to walk around a subject, or by finding distant views that show the whole setting, you can greatly enhance your chances of great pictures.

Statue of Liberty
You have the chance to visit some sights and scenes for just a short period of time. Others you can visit at different times of day and in different weather conditions. But even with just a few hours in a single day at a location, you can achieve significantly different shots. The secret is to continually try to find new angles and vantage points.

1.3

1.3 Varying camera height

It is very tempting to shoot the majority of your pictures from eye level—after all, cameras are generally designed to be used at this height. However, part of the trick of adding variety to your shots is to keep varying how far the camera is from the ground, in either direction.

The adventurous photographer will not just walk around a subject (*see page 130*), he or she will also be constantly crouching down, or finding suitable surfaces to stand on—in the hope that by doing so, new and more interesting shots will be discovered. You need to be able to combat the embarrassment of lying down on a sidewalk to get a worm's-eye view; and you must be prepared to climb onto a park bench or wall in order to get a clearer view from your newly found elevated position.

When traveling, it is worth hunting out towers, skyscrapers, or nearby hills that provide a bird's-eye view of a town or city. Not all tall buildings are accessible to the general public, but those that you can gain entrance to can provide not only wide panoramas, but also unusual detail shots.

Changing camera height by even a small amount can make a significant difference to the background. For a shot of a building or person, a low angle may allow you to use the sky as a plain backdrop. A high viewpoint may provide a grassy backdrop for a portrait, instead of a cluttered urban sprawl.

Siena Campo, Italy
The top of a Tuscan belltower gives an interesting view of the ancient city below, and is well worth the steep climb up the steps.

Chicago
High vantage points allow you to see the spatial relationships between buildings that cannot be appreciated at ground level. The famous skyscrapers of downtown Chicago don't have to peered up at when viewed from the Skydeck of the Sears Tower.

Matching eye levels

When shooting pictures of people, it usually pays to ensure that the camera is at the eye level of the sitter, as this provides the most natural-looking pictures. While this is done without thinking with most portraits, special care must be taken when shooting pictures of children, whose modest height means that you can end up shooting downward for all your shots of them. For toddlers, this may mean kneeling on the ground to match the lens height to the eye level—for crawling babies, it may mean that you too need to get down on all fours.

There is some value, however, to breaking this rule from time to time. A different camera height may help you achieve a more suitable background, for instance. But there are other reasons...

A high camera viewpoint allows you to look down, both literally and figuratively, on a person. The tilted camera angle tends to make the person look small and inferior.

A low viewpoint, however, makes a person appear taller and stronger, as you are forced to look up at to them. This can be good if you want to suggest power or independence in a person. It can be a particularly worthwhile trick when photographing older children.

Low camera angle
Shot from kneeling position.

Matching eye level
Camera level with the girl's head.

High camera angle
Looking down on the girl.

Thai guard
Low-angle views give a feeling of power and size to a subject. This approach gives a real feeling of menace to the ancient statue of a warrior guarding the entrance to Bangkok's Grand Palace.

Corinth canal, Greece
Seen from above, people, objects and buildings can look like toy models. It is hard to appreciate the scale in this shot of a tug leading a boat through the Corinth Canal until you realize that each of the blocks on the cargo vessel is a full-size shipping container.

1.3 Planning for pixel processing

Taking the picture is only the beginning. Composition is important in digital photography, but however thoroughly you look for that perfect shot, you need to remember just what can be done to improve the picture still further in the digital darkroom. It makes sense to try to get as clean and uncluttered a shot with the camera as possible, but you can also plan for image manipulation later.

Knowing what is possible with cloning techniques (*see page 222*), can save you time and effort in taking your shots. There is no need to find a view that obscures the crane on the horizon, or to find a foreground focal point that will hide an ugly bag of trash. These visual scars can usually be spirited away in seconds with the *Clone* tool or *Healing Brush*; it therefore makes little sense to walk for miles to find an unobscured view.

It is also useful to bear in mind that two or more frames can be combined to create a view of the scene that is better than reality. There may be a vehicle or streetlight, for example, obscuring the subject from the ideal viewpoint. You could compromise and move the camera, but it is possible to shoot round the obstruction: take the shot from your ideal vantage point, then take a second shot from several steps to the side. The second shot then reveals what is behind the obstruction. By combining the two images together carefully, the streetlight or vehicle can be made to disappear magically.

Similar composite techniques can be used to improve the depth of field, or to combine the perfect foreground with the perfect background. You may have an ideal viewpoint of a fishing harbour, but need something to fill the foreground. An anchor on the quay a few yards away would be ideal, but including this either changes the backdrop, or is impossible to get sharp in the shot due to limited depth of field. The solution is two shots—one focused on the ideal background, and the other on the perfect foreground. When you have both on the computer, they can be seamlessly stitched together.

Another useful composite technique is to shoot several shots from the same spot, using a tripod to lock the camera in position, so the composition is identical for each. You can use this technique to take two or more shots at different exposures, allowing you to successfully capture detail in both highlights and shadows in even high-contrast, backlit scenes. A similar technique can be used in crowded areas, combining several shots of the vista in such a way that all the people disappear.

Hemispheric
For this shot of a futuristic building in Valencia, Spain, it was impossible to get a perfectly symmetrical view of the structure without including the crane on the horizon. Rather than compromising on camera viewpoint, it was shot knowing that the crane could be removed in seconds using the computer.

Anticipating correction

Sometimes there is no time to find the perfect camera angle. Mont St Michel, France is only accessible from the mainland at low tide, and this shot was taken on a half-hour visit to avoid getting stranded. The lighting is less than ideal, and the sky is rather washed out. On the computer, however, a new sky was created using a colored gradient layer; if necessary, a sky from a completely different shoot could have been sandwiched with this view of the ancient French monastery.

Four into one

Whatever the camera position, a clear view of the carved urn could not be found: the magnolia branches immediately in front obscured the view. By taking four shots, just moving 3ft (1m) sideways for each shot, a composite giving a much clearer view of the architectural detail could be constructed. Ten patches of different sizes were placed over the base image to create the final result. This is a laborious process, which should be used only when there is no other realistic option.

1.3 Lighting

The word "photography" comes from the Greek, and literally means "writing with light." Even in the digital era, picture-taking is impossible without light. However, some photographers wrongly assume that you need lots of light to take pictures: they only use their cameras on sunny summer days, and put them away in their cases when the day is over. But it is possible to take great pictures in any weather conditions, at any time of the day or year. It is not the quantity of light that is available—it is the quality of the light that counts.

Lighting is perhaps the one key ingredient that separates a reasonable picture from a great one. And just like picture composition, it is a tool that you can use to your advantage, whatever type of camera you use. The secret is to learn to read the light and see the scene as it will appear when captured by the camera.

Even when using daylight, the photographer has to exercise a surprising amount of control over the lighting conditions. First of all, the camera position you choose will affect the angle of the lighting: if you stand on one side of the subject with the sun behind you, for example, the shot will look very different from one taken on the other side of the subject with the sun streaming towards you.

The other crucial control that the photographer has is in deciding when to fire the shutter. Sometimes you just need to wait if you want to get a better picture. The intensity, color and contrast of sunlight can vary from hour to hour, and even from minute to minute, and a top landscape photographer will often wait for hours, or even days, for the best lighting conditions, and then return to the same spot weeks or months later, in search of even better illumination.

The best conditions

Sunny weather can give you the most consistent lighting for photography, but rarely produces the most dramatic pictures. The best weather conditions for photography often occur when the lighting is changing rapidly, late or early in the day, or when there are storm clouds moving in the sky. You have to work harder for your pictures in these conditions, and you may get fewer usable shots than when the sun shines, but the successful shots are more likely to be great ones.

Wingwalkers
These two shots are of the same wingwalking aerobatics team, taken on different occasions in very different lighting conditions. One was taken on a glorious summer afternoon, with blue sky and photogenic fluffy clouds—conditions that make aerial photography relatively straightforward. The other was taken on a gray Spring day, with heavy cloud cover. I had dozens of useful shots on the sunny day, but on the gray day, my patience was rewarded by a brief break in the clouds that provided a spotlight on the planes and an atmospheric, dark backdrop.

1.3

South Bank Centre

It pays to have your camera with you even on the most unpromising days. Here you can see from the clouds just what the weather had been like, but the brief moment of sunlight creates a spectacular picture. This is the South Bank Centre, which, in some people's eyes, is one of the least photogenic buildings in London; however, this quality of lighting has the power to make any scene look stunning.

Beynac archway

Light can often become the primary focal point in the scene. Here, the late afternoon sun shines through a great medieval archway in the French village of Beynac, creating an irresistible picture opportunity.

1.3 Changing natural light

Lighting varies not only with the weather and the time of year, but also with the time of day. Early in the morning and late in the afternoon, the sun is relatively low in the sky, creating angular lighting that can accentuate form, pattern, and shape. Once the sun has risen 45 degrees or more above the horizon, subjects are effectively lit from above, with little shadow for the photographer to use to creative effect. This top-lighting can last for the best part of the day in some seasons and at some latitudes (it lasts for longer the nearer the Equator you are, and in Summer).

Light also varies in color temperature throughout the day (*see page 56*). This is partly because of the scattering of certain color bandwidths in the sun's rays—early in the day and late at night, the light passes at an oblique angle through the atmosphere, filtering out bluer tones and creating an orange glow to the light. But this is only the case if the sunlight is not obscured by clouds. If the sunlight is not direct, sky light becomes more noticeable, making things bluer.

It is these changes in color that make early-morning photography so attractive to some photographers. Before dawn, the landscape is just lit by sky light, creating a blue icy light. After dawn, the color temperature becomes warmer—but how much warmer is dependent on the cloud cover and the atmospheric conditions. Although digital cameras can correct the different colors of daylight to some extent, you can still tell a picture taken in warm light from one taken in cloudy conditions.

How long you have to take advantage of late afternoon and early morning lighting will depend largely on where you are in the world. In temperate regions you may have hours to work with, while within the Tropics the sun can rise and set so sharply that you have only minutes to play with.

Edinburgh
Two panoramic shots of the Scottish capital taken from the same hotel room window on the same day. In the first shot, the lighting is even, providing lots of detail. In the second, the lighting is more intense, but only illuminates parts of the scene, creating a more artistic image.

These three shots of London's Charing Cross Station and the Hungerford bridges were taken at different times of the day, each with a different quality of light. But to take advantage of this range of conditions you usually need a tripod—only the midday shot in this sequence was handheld.

Dawn

Looking south. Note that although one side of the buildings is lit directly, there is plenty of detail in the shadows, because skylight is more effective in low light.

Dusk

Looking north. Although the sun has set, there is still some light in the sky. This creates a colorful backdrop, and is therefore generally a better time to shoot nightscapes than waiting for it to be completely dark.

Noon

In the middle of the day, looking north from the bridge itself. Direct overhead lighting creates strong highlights and strong shadows.

Skylight

Shadows in daylight are never black but are lit to some degree by light reflecting from the sky. This sky light also affects the color of the light in directly lit areas.

1.3 Soft and hard light

The quality of lighting is not just dependent on its angle and color; it also depends how diffuse the light has become. The more that the light is scattered, the softer and less direct it becomes, and shadows appear within the picture less distinctly.

Outdoors, it is cloud that has the greatest effect on the harshness of the sunlight. Direct light from the sun, which has not passed through clouds, is "harsh" or "hard," and creates well-defined shadows. But when the light passes through clouds, the water vapor diffracts the light in a multitude of directions, creating a softer, more even illumination.

Reflections from the ground, buildings, and other surfaces also contribute to the amount of soft light reaching a subject. Sky light is another soft, diffuse light source. Light is also softened by diffraction by dust particles, as on a hazy day, or late on a Summer evening.

Hard lighting suits some subjects, but some degree of softening is frequently desirable to provide an even, less contrasty effect. Of course, the amount of softening of the light source is itself extremely variable: light wisps of cloud have only a marginal effect, so that the sunlight is still essentially direct; heavy cloud cover, on the other hand, makes the light so soft that shadows are lost (eliminating any suggestion of form and texture), and color becomes extremely subdued. The amount of diffusion, therefore, becomes key to the overall quality of light, and to the subject elements that you want to emphasize in the shot.

Clouds as diffusers
On a sunny day, light rays have only the atmosphere to pass through, so cast strong shadows. Clouds, however, act as giant diffusers, providing light from all angles.

Hard lighting

Harsh sunlight rarely works well with portraits—the strong shadows that it creates across the features are unflattering, and do not help with identification. Shooting in the shadows, where the face is lit entirely by reflected and diffracted light, creates a more informative portrait.

Soft lighting

Clouds do not just act as diffusers like a net curtain over a window, they also act as movable screens, like blinds or drapes. The gaps between clouds effectively become searchlights scouring over a landscape or city, picking out different features of the scene in turn. You have no control over this theatrical spotlight, but by waiting for the right moment, you can shoot when the focal point of your picture is lit. The lighter patch in the area will immediately draw the eye, while other elements in the scene are "grayed out," being lit only by the softer, less intense, diffused light.

Flat calm
Late in the day over a surfer's beach. A brief break in the clouds creates a pattern of light over the sea that draws the eye and acts as a focal point for the composition.

Two different aerial views taken with different types of lighting. The seaside resort town is lit by direct light, throwing some structures into shadow, while highlighting others. This produces a dramatic picture, but detail is lost. The shot of a Vermont village below, however, is softly lit by a cloud-covered sky, creating a more evenly lit scene.

Hard lighting

Soft lighting

The strong shadows created by direct sunlight are helpful in this composition, as the shading accentuates the form of the pumpkins. Soft lighting, which has been diffused by cloud cover, creates a much more subdued picture, with softer colors.

Soft lighting

Hard lighting

1.3 Frontal lighting

Photographers used to be told always to stand with the sun behind them. The lighting that this produces is probably still the safest choice for the digital camera user. The great advantage of frontal lighting is that the shadows are thrown behind the subject and are predominantly out of view. As there are no dark areas, there are no problems with contrast to worry about, and the camera can expose for the scene without having to sacrifice either shadows or highlights.

Frontal lighting is not just easier, however; it also brings compositional advantages. With relatively even illumination across the frame, colors are uniformly stronger, and in addition to being the best type of lighting for stressing color, if not too harsh, frontal lighting can ensure that you get maximum detail.

The big disadvantages of frontal lighting are that, because there are so few shadows in a picture without shading, there is little information about form and texture in the image. Taken to its extreme, lighting that is straight onto a subject can remove vital evidence about depth, creating an image of a building, say, that is little more than a two-dimensional card cutout.

Hard and semi-diffuse frontal lighting can also prove a problem with portraits, as the subject is forced to look towards the light source, which can force him or her to squint uncomfortably.

Storm light
Classic storm lighting conditions—when the sun breaks on a dark day, the most dramatic results usually come when you stand with the sun behind you.

A bridge in Fall
With the sun behind the camera, the frontal lighting helps intensify the color of the traditional Vermont covered bridge.

Crooked house
Shot at a theme park, the bright colors of this crooked house are shown with full intensity, thanks to the frontal lighting.

Spanish castle
Frontal lighting will create the deepest colored skies in your picture, as in this shot of an ancient gatehouse in Spain. However, the head-on lighting makes the structure look rather two-dimensional.

Describing lighting angles

Whether outdoors or in the studio, the direction of lighting is usually split into three different categories:

● If the sun or artificial light is behind the photographer, this is known as frontal lighting.
● If the lighting is to one side of the subject as the camera looks at it, this is known as sidelighting.
● If the light source is behind the subject as the camera looks at it, this is known as backlighting.

In reality, of course, the angle of lighting can vary through 360 degrees; and in addition, the vertical angle of the light can vary through at least 90 degrees.

The terms sidelighting, backlighting, and frontal lighting are therefore just broad terms—and the division between one and the other is not set in stone. The terms are just a useful shorthand to help describe and learn the different effects that the angle of lighting has on the subject; in fact, some lighting angles will exhibit some of the qualities of both sidelighting and backlighting.

The characteristics of front lighting are even illumination across the visible surfaces, with few shadows.

143

1.3 Sidelighting

Some degree of sidelighting is important for many photographic subjects, as this is an excellent way of showing depth and three-dimensionality in an image. With the light to the side of the camera or the subject, shadows tend to be cast across the surface of the subject itself. This provides the vital shading that gives the information about a subject's form and a surface's texture.

Sidelighting is by its very nature much more theatrical than frontal lighting: it highlights some surfaces, but throws others into shadow; it hides some detail, but accentuates other parts of the scene. In the well-lit areas, colors are intense, but in the shadows colors are drab or unnoticeable. Sidelighting can prove difficult for the camera to handle, simply because of the contrast of tones that it creates across the scene;

metering systems may need to sacrifice either shadows or highlights, and may make the "wrong" decision.

How well sidelighting works for a particular scene depends largely on the complexity of the composition. A cluttered scene creates such a mass of shadows that it can be hard to work out what the individual elements of the picture are. With simpler, solitary subjects, sidelighting frequently adds a sense of drama to the image.

The division between the light and dark areas will vary depending on how hard or soft the main light source is, and on how much reflected fill light reaches the shadows; the effect can therefore be bolder and more dramatic in some situations than others. Small changes in the angle of the subject, camera, or light source may also have dramatic results, changing the pattern of light and shadows across the scene.

The main characteristic of sidelighting is the contrast caused between the areas that are lit and those that are not. The shading between the two gives all-important information about three-dimensional shape.

Rape of the Sabines
Light from a solitary window creates strong, but diffuse, sidelighting, and creates a line of light along the outline of the marble statue.

1.3

Puppets
The variation of color intensity and interfering shadows means that sidelighting is less than ideal for complex scenes. It is hard to make out one puppet from another in this shot of a Nepalese store.

Power plant cooling tower
The sidelighting in this shot is subtle, with the sun only slightly to the side of the camera. However, it provides enough shadow to show the tubular form of the massive cooling towers.

Grapes on vine
Strong sidelighting works well in this picture, accentuating the spherical shape of the Chianti grapes lit by Tuscan sunlight.

145

1.3 Backlighting

When the lighting is facing toward the camera, the subject will tend to be completely in shadow. This means that colors are subdued or lost; there is not enough differentiation in lighting to give any information about form, and you can learn nothing about the texture of the subject's surface.

At the extreme, backlighting leaves you with a silhouette—a black outline that accentuates the subject's shape, but tells you little else about it. How informative this outline is will depend not only on the contrast with the background (the lighter the better), but also on the angle of the subject: a silhouette of a bicycle seen head-on is less descriptive than one seen from the side.

Backlit subjects, however, are not always silhouettes. Although the main light source is in front of the camera, the subject facing you is inevitably lit indirectly—by sky light, reflections from buildings, reflections from the ground, and so on. This lighting is, by its very nature, soft, and this can prove particularly useful with some subjects: with head-and-shoulder portraits, for instance, it ensures that the face is evenly lit and features are not obscured by ugly shadows.

To avoid a silhouette, however, the backlit subject needs to be framed carefully. To avoid excessive contrast, the bright background should be largely cropped from the shot. This will also help with exposure, which will be thrown out if the light source is included in the frame. Taking a light reading from the central part of the subject (using a spot meter, for example) helps ensure that the picture is exposed correctly in the right areas.

Rimlighting

Rimlighting is a special form of backlighting. In certain situations, part of the outer edge of the subject becomes brilliantly lit, while the rest remains in shadow. The effect is most noticeable if the subject has a shiny surface, or is covered with a semitranslucent material such as fur or hair. The rimlighting can create a halo around the subject that accentuates the shape of the subject without losing all color and form.

With backlighting, the subject is thrown into shadow, as only the side that isn't facing the camera is lit. Detail is only visible if the facing side is lit indirectly.

Backlit silhouette

Teasels
These teasels were shot from almost the same position. In the first shot, they appear as a colorless silhouette. But by moving the camera just a step or two to the side, the light source comes closer to the lens axis, creating rimlight that accentuates the spiky heads of these dead flowers.

Rimlight

Flare

When shooting into the light, there is always a risk that light rays from outside the image area enter the lens and reach the sensor. At its worst, this flare can produce streaks of light across the image, including one or more polygonal pools of light that are the same shape as the lens aperture. But sometimes flare goes unnoticed, as it simply softens the detail and color in the image.

To minimise flare, lens manufacturers coat lens elements, and cover the inside of the lens housing with nonreflective black paint. In addition, a lens hood (often supplied with digital SLR lenses) should be used to help reduce the effect. When the sun is just out of the frame, placing your hand in a strategic position in front of the lens can also prove a useful tactic to remove flare streaks.

Dark blue background with sun in frame
Flare is not always awful in photographs. In this silhouette of the Giant Swing in Bangkok, the streak of light creates an interesting diagonal line across the dark blue sky. The sun itself has been turned into a star by the use of a very small aperture (f22) that can create this optical effect with bright highlights.

Tulips
The normal rules for backlighting do not apply with translucent subjects. The light shines through the petals of these tulips, intensifying their color against the carefully chosen dark background.

Pier
Almost everything is in silhouette, but the angle of the sun shines some light onto the pier boardwalk, as well as reflecting off the choppy surface of the sea.

Girls on a train
With strong backlighting, the light seems to creep around the sides of the subject, almost eating into its edges. There is minimal detail in the faces in this candid portrait, taken on board a restored American trolley car in East Haven, Connecticut.

Gateway
This is the other side of the gateway in Valencia shown on page 143. Lit by skylight and reflected light from the ground, the detail in the brickwork is soft and almost colorless.

147

1.3 Modifying the light

With many photographic subjects, it simply isn't possible to change the light falling on the subject. To modify the quality of lighting over a landscape, for instance, you have little choice but simply wait patiently for the clouds to move, or for the sun to progress along its daily path.

However, with small-scale scenes it is possible to have more of a direct influence over the ambient lighting—even if this is being provided by the sun. There are two different ways in which to do this. First, you can soften the light before it reaches the surface, using a sheet of white translucent material as a diffuser. Alternatively, or additionally, you can tackle the shadows rather than the highlights, by placing a reflective sheet on the opposite side of the subject to the light source. Reflectors are most commonly white, so that they do not affect the color of the subject; however, they can be bought in a variety of hues and materials to warm up the subject, to add extra sparkle to the image, or to deliberately add a color cast. Black reflectors can even be used to provide dark lines on highly reflective subjects, such as glassware.

It is possible to buy purpose-made reflectors and diffusers. However, for those not using these accessories every day, it is just as productive to make them. A white reflector can be a simple sheet of newspaper or white card, or a cotton bedsheet. For a more contrasty effect, you can bounce light into shadow areas using a household mirror. Whatever you use, the reflector should be larger than the surface that it needs to bounce light onto.

Diffusers can also be fashioned using white sheets as drapes, or using net drape curtains. These makeshift devices can be held in position by a willing assistant, or draped over a line or homemade frame, to hold them in place.

No reflector

White reflector at 3ft (1m)

White reflector at 1ft 6in (45cm)

White reflector at 8in (20cm)

Figurine of dog
Reflectors are particularly useful when using sidelighting, as they can be positioned to soften the shadows slightly until you get the contrast that you want. The first shot in the sequence was taken without a reflector. In the others, a Lastolite white reflector was moved progressively nearer the figurine to give an increasingly strong fill-in effect.

White reflector at 4in (10cm)

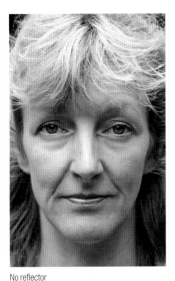
No reflector

White reflector

Gold reflector

Using a reflector

A reflector is invaluable in outdoor portraits, helping to fill in the ugly shadow areas that form under the nose and in the eye sockets. These shots were all taken in overcast conditions, but the shot without the reflector has noticeable shadows. The effect of the model holding a reflector just below her chin makes an instant transformation to the picture—a white reflector gives a neutral result, while a gold reflector warms up the skin tones.

Gold reflector

Commercially-bought reflectors, such as those made by Lastolite, have sprung frames so that they can be collapsed to a fraction of their size when not in use.

Light tent

When photographing highly reflective subjects, such as silverware, it can seem impossible to eliminate unwanted reflections from the surface. Any light used becomes a beacon on the surface, everything in the room is mirrored, with light-colored materials being clearly seen—even the camera and photographer become part of the picture. These reflections are a real distraction, and cannot be eliminated by using polarizers, as these filters have no effect on reflections in metal surfaces.

The professional solution is to use a light tent, which is a diffuser that completely surrounds the subject. Commercially produced light tents are often conical in shape—the subject stands within the cone, and a slit is provided for the camera lens to poke through. Lights are placed outside the tent. It is possible to make your own light tent, using white sheets to completely surround the subject.

Brass Reliable hairdryer

They don't make hairdryers like this any more! The polished brass reflects the photographer, tripod, window frame, and fill light when photographed normally. By screening the window with a white sheet, and then using a further pair of sheets as drapes around the camera, the image has far fewer intrusive reflections. The white sheeting drains much of the color from the subject, but this can be added back easily enough using Photoshop's *Selective Color* facility.

1.3 Using camera flash

Although flash is invaluable in low light or for fill-in (*see pages 62–65*), it produces harsh lighting which is less than ideal for many situations. Although all flashguns are fitted with a reflector and a diffusing front panel, when pointed at the subject they have a tendency to produce hard, well-defined shadows. This is made worse by the fact that built-in flash units and accessory guns that sit on the hotshoe are positioned to give perfectly aligned frontal lighting. The combination of face-on illumination and lack of softness mean that subtlety of color, form, and texture can end up being lost.

It is for this reason that professionals try to use the most powerful flashguns that they can get their hands on. A high guide number is not primarily so that they can use the camera farther away from the subject; it simply means they can use a variety of devices and techniques to diffuse the light source as much as possible, yet still have enough light to illuminate the subject, and a range of different apertures to choose from.

One of the simplest ways to diffuse a strobe is to convert the direct flash into an indirect light source. This is done by pointing the flash at a wall, ceiling, or reflector so that the light bounces off the surface and is scattered in the general direction of the subject. A flash with a tiltable and/or swivelling head is generally used for this.

This technique greatly decreases the power of the flash—the light is not only diffused, but has farther to travel to the subject. It is also limited by the availability of a suitable surface to bounce off: ceilings may be too high, and walls may be covered in paint that tints the reflected light (white walls are ideal). You can get attachable reflectors, such as those from LumiQuest, for some flashguns. These provide a convenient surface to bounce the light from wherever you are.

An alternative approach is to cover the flash with extra diffusing material: Sto-Fen, for example, make white plastic attachments that cover the head of the flash to soften and spread the light output. The Westcott Micro Apollo is a miniature version of the studio softbox—a tent-like contraption mounted over the flash head and enlarging both the flash's diffusing panel and reflector.

It is also worth the trouble of getting your flashgun away from the camera hotshoe. This generally involves using a bracket on which to mount the flash unit, and a special cable to connect the electronics, ensuring that you retain at least some of the flashgun's "dedicated" features. With some guns and cameras, you can use a simple "PC" socket (the PC stands for Prontor/Compur, the shutter manufacturers that came up with this industry standard connector)—however, this simply allows flash and shutter synchronization, so exposure cannot be managed by the camera.

Sword fight knights
The extra power of an accessory flashgun can prove useful with fill-in: It allows you to use a greater range of apertures to ensure that the background is as dark or light as you would like. These knights were fighting outdoors in daylight. The overcast conditions have been turned to darkness using a small aperture with the flash, to eliminate any distracting background from the shot.

Making do with built-in flash

Accessory flashguns are great, but you don't always have one when you need one, and they are not available for all cameras. One of the best ways to help make pictures taken with a built-in flash effective is to ensure that subjects are as far away from any background as possible, while keeping the camera close to the subject. This will result in a uniformly black background, and an uncluttered composition. If cramped for space, take your flash portraits outdoors after dark, where there is generally more space to play in and it is therefore easier to achieve a jet-black background.

This Halloween portrait was taken taken with built-in flash; by taking the shot outdoors, it was easy to make sure that the background was completely dark.

Built-in flash
With a digital SLR's built-in flash, exposure is managed automatically, but harsh light creates hard shadows and over bright highlights.

Hotshoe flash
This is similar to the result with built-in flash, although the risk of redeye is reduced, and the higher maximum guide number allows a wider range of aperture settings.

Bounce flash
With flash reflected off the ceiling, the portrait no longer has the "look" of a picture taken with flash.

Off-camera flash with Micro Apollo diffuser
With a diffuser over the lens, the off-center lighting is slightly diffused, creating shadows that are not quite so strong.

Off-camera flash
With hammerhead flash on a bracket, the light source is to the side of the camera, which gives a slight, but welcome, increase in modeling, creating a more three-dimensional image. However, the lighting is harsh.

1.3 Studio lighting

The beauty of studio photography is that you gain complete control over the lighting. There is no need to wait for clouds, for example, you can create soft lighting effects that are impractical to produce with portable flashguns.

Most professional studio lights are, in fact, giant flash units. The heads are either monoblocks with built-in capacitors and output controls, or they plug into a separate power pack. In addition to their flash tubes, they are fitted with tungsten modeling lights which are used to give you a visual representation of the lighting as you compose the shot.

These "flash heads," however, are simply the heart of the lighting system. What defines the quality of the lighting is the use of accessories that can be attached to the flash head, to soften the light to various degrees, or to channel it into a beam (*see box*). The relative power of different lights is altered by changing the amount of diffusion, altering their distance from the subject, and varying their output.

There is no need to take the flash route, however. Digital cameras are equally at home with continuous light sources, which are particularly effective when photographing static subjects. The ability to alter white balance to suit different lighting means that tungsten, halogen, and fluorescent lamps are becoming increasingly common. They are less expensive than flash units, and but often use the same extensive range of accessories; however, the heat produced by some models can prove uncomfortable to work with over prolonged periods. Continuous light sources are easier to learn with, as you can see more clearly how the shadows and highlights change as you move the lights.

The power of studio lights is not usually given as a guide number. Flash heads are usually rated in joules (or watts per second), with small units offering 250 joules, and large heads 2000 joules. Continuous light units are rated in watts, typically varying in output from 300W to 1000W.

Lighting attachments

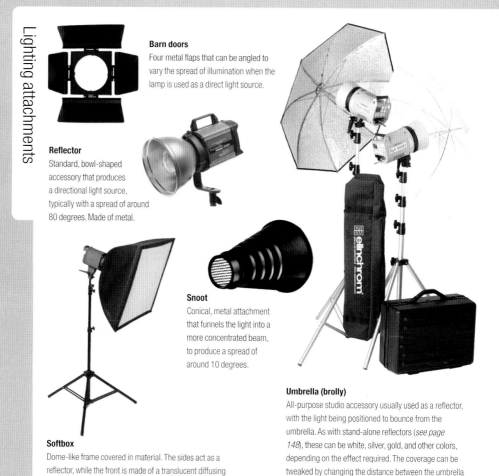

Barn doors
Four metal flaps that can be angled to vary the spread of illumination when the lamp is used as a direct light source.

Reflector
Standard, bowl-shaped accessory that produces a directional light source, typically with a spread of around 80 degrees. Made of metal.

Snoot
Conical, metal attachment that funnels the light into a more concentrated beam, to produce a spread of around 10 degrees.

Umbrella (brolly)
All-purpose studio accessory usually used as a reflector, with the light being positioned to bounce from the umbrella. As with stand-alone reflectors (*see page 148*), these can be white, silver, gold, and other colors, depending on the effect required. The coverage can be tweaked by changing the distance between the umbrella and the light. White umbrellas can also be used as diffusers, with the light turned to face the subject.

Softbox
Dome-like frame covered in material. The sides act as a reflector, while the front is made of a translucent diffusing white material. Designed to give window-like soft lighting. The front can be square, rectangular, or octagonal in shape.

Hamster

The basic lighting setup for portraits of people or pets is to place two lights, one either side of the camera, at 45 degrees to the subject. The power setting is lower on one light (or, is placed farther from the subject), so that there is some suggestion of modeling. This picture was taken using two 300W lamps, originally produced for use with a cine camera.

Golden Eggs

These flaxseed oil capsules were photographed using a lightbox—a device originally designed for looking at transparency films. With a daylight-balanced striplight fitted with a large diffuser, this makes an ideal studio light source. The capsules were placed on its surface, with a large sheet of card being used as a reflector to fill in the tops of the capsules.

Garlic

In many studio pictures, the surface that the subject sits or stands on is the same as the backdrop. The curved "cove" that is formed by the background paper or material ensures there is no visible "horizon" line where the foreground meets the background.

Shells

A single studio light can be used effectively for many studio subjects, but you need to use reflectors to soften the shadow side of the subject. Here, a flash with softbox was used to the right of the shells, with a white reflector facing it on the other side of the miniature set.

153

1.3 Style and subject

As with any craft or art form, photographers have various styles. You may or may not be consciously familiar with the images of Ansel Adams, Anne Geddes, or Sebastiao Salgado, but few would fail to note the distinctive styles that have made these photographers famous.

Style is partly about subject matter: Anne Geddes has gotten rich photographing babies; Ansel Adams's photographs of American landscapes continue to adorn people's walls long after his death; Salgado, meanwhile, is known as a photojournalist.

It is only natural that we tend to favor the subjects that we enjoy most, or that inspire us. Some of us prefer photographing people while others prefer birds, even if we have tried our hand at both. There is no need to specialize, but expertise can grow out of familiarity and practice. Knowledge of the subject matter also helps—you are likely to be a better baseball photographer if you can understand the game and anticipate what is going to happen. Landscape photographers, similarly, tend to become weather experts as they wait for the light to break and clouds to move into place.

But style is not just about subject. It is also about technique. The techniques that you tend to favor as you shoot, or as you manipulate your images on the PC screen, become your signature. Geddes is known for her elaborate constructed studio sets, Salgado for his gritty monochrome images, and Adams for his legendary obsession with exposure and print quality. This personal way of portraying the subject develops over time, and continues to do so over the years.

Just as importantly, your photographic style is a window into your own of seeing the world. For every scene, there is an almost limitless number of pictures that can be taken. The images you shoot are not just taken through conscious choice, but also partly because of your own experiences—a city center may suggest poverty and pollution to one photographer, for example, but may represent wealth and glorious architecture to another. It is the photographic style that decides which way the lens is pointed and how the pixels are presented.

The decisive moment

Few people would disagree that Henri Cartier-Bresson was one of the best photographers that ever lived. He had a knack of being able to capture the essence of a scene in a single snap. He called this approach *"le moment decisif."* It is a "decisive moment," in that you need to press the shutter at the right instant, but this does not mean that split-second timing is essential for all such pictures.

A better interpretation of the famous French photographer's phrase would be "the defining moment"—in this way, the approach can be equally applied to nonmoving subjects, where simply framing the landscape in a certain way and waiting for lighting conditions that reveal the scene at its best, will provide an image that perfectly describes not only the view but the emotions that it evoked in the photographer.

Often, of course, such pictures are based on a lie: In truth, we shoot dozens of frames in the hope of the perfect, defining shot—and, if we are lucky, several of these moments define the scene equally.

Surfer surge

This surreal image of a surfer owes a lot to luck. The approach was simply to focus on a surfer as he prepared for the arrival of a promising wave, and then shoot if and when he made it up onto the board, and when the composition looked interesting. Here, the surfer has missed riding the wave, and instead has been thrown up by the water. The appearance is that the man is rising from the waves. The shot seems to sum up the struggle that the surfer has in trying to tame the mighty power of the sea, to get only seconds of success.

1.3

Press photography

Owls at a country show. For a press photographer working for
a local newspaper, the picture opportunity would be of the boy
holding the bird. For the exhibition and competition photographer,
the closer crop would be ideal, using Photoshop trickery to
produce a more artistic approach. There are dozens of different
styles of picture that could have been produced from this scene.

155

1.3 Conveying a message

A picture, as they say, is worth a thousand words. It can show in detail and with accuracy things and events that are almost impossible to describe. What's more, a picture can communicate with the viewer without language barriers—and the content can be assimilated without effort and within seconds.

Documentary photography is probably the most fundamental and down-to-earth use for a camera. We all use digital imaging as a simple way of creating a record of the things that happen and the things that we see. Whether taking snaps at a wedding, shots of the places we visit on vacation, or pictures of a war zone for a news agency, the aim is the same—to document what we have seen. There are practical uses for such record shots, too—producing an accurate picture of

a work in progress to show a client, or to help sell our surplus paraphernalia on eBay.

But documentary photography can have a more weighty purpose. Pictures have the power not only to inform people about things that they would not otherwise see, but also to help change people's opinions. Photography can provoke thought—and it can arouse emotions.

There is no need to frame famine and point your lens at poverty in order to produce your own documentary portfolio. A series of portraits of people around your home town, college, or workplace can be just as effective in conveying a message. All you need to do is to link with a chosen theme, and then link the series of shots using your own photographic style.

Animal cruelty
The best documentary pictures are those that need little explanation in order to get their message across. Many of us assume that cockfighting and bear baiting are pastimes found only in historical dramas. But these pictures show that these forms of animal cruelty still go on in parts of the world—the emotional response is then left up to the viewer.

1.3

Composition

Pictures do not have to be hardhitting to have a message. Each of these shots has its own compositional strength: the power of the water spray, the color of the solitary green bottle, and the pattern of the metal in the water. But as part of a portfolio, the theme of aggressive urban culture begins to come through. Shopping carts get thrown into rivers, garbage is left on the prettiest beaches, and aerosol abuse is sprayed on any city wall.

157

1.3 Abstract approaches

The trouble with photography is that it can be too exact in the way that it depicts the world. It has a great tendency to show things as they actually are—with vivid realism, warts and all. This is fine for the documentary photographer and those making any sort of scientific record. But for those trying to be more artistic with their imagery, the camera's tendency to show the truth is something of a drawback.

For many photographers, therefore, techniques and approaches are deliberately chosen that turn the digital images into more abstract entities. Using camera and computer tricks, the idea is to create images that are a step or two away from a simple snapshot of the subject. To borrow well-known phrases from the world of painting, the artistic photographer tries to be more impressionistic than photorealistic.

A multitude of approaches can be used to make the final image less photographic in quality. A simple solution, for instance, is to convert images to monochrome, as the lack of color creates a picture that is automatically more abstract (*see page 160*). Even camera effects such as limited depth of field (*see page 90*) can be used to create an image that is different from that which we would actually see. Similarly, subjects can be deliberately shown out of focus or overexposed to create a more mysterious image.

The great advantage of digital imaging, of course, is that so many aspects of the image can be distorted and manipulated at the pixel-processing stage. However straight the original shot, therefore, it can always be turned into something more abstract and visually challenging on the computer. The secret, however, is not to be too outlandish, and to use a consistent approach that becomes identifiable as your style, rather than simply using filter effects with reckless abandon.

These pictures were all taken during an afternoon's shoot in a bluebell wood. While the conditions were perfect for taking classic landscape shots of this spring scene, these images show just some of the effects that can be used to create a more abstract image.

Overexposure
This high-key image was created by manipulating the curves of a correctly exposed shot.

Selective color
To draw more attention to the strong shadow along the path, most of the color was drained from the shot using the *Hue/Saturation* control. The bluebells were left in color to give a hand-colored appearance (*see page 158*).

Zoom burst
Achieved by changing focal length during
a 1/8 sec exposure (*see page 80*).

Deliberately blurred
Focusing on an imaginary point just
in front of the camera creates a shot
that is so completely out of focus that
it becomes an intriguing abstract.

159

1.3 Monochrome

Despite the fact that even the most budget camera can shoot in color, black-and-white imagery still plays a prominent role in serious photography. Its popularity among pros can be partly explained by economics—it is still cheaper to print in black, rather than in full color. However, monochrome images have an artistic appeal of their own. Good black-and-white prints possess an aesthetic, timeless quality that color finds hard to match.

Much of the appeal of black-and-white imagery is simply that there is no color. Without this key compositional element, the frame can stress other elements more easily: texture and form, in particular, often appear more strongly in an image the moment that color is stripped out.

For the digital photographer, black-and-white images (or monochrome ones that use shades of a single color in conjunction with white) can be produced with ease from a color image file. In fact, shooting in color is the best policy even if you are intending to use the image in monochrome (*see pages 68–69, and pages 240–41*).

However, it is still useful to learn which types of images work well in black and white. Because we generally see everything in full color, this is harder to do than you imagine. You need to see the differences in tone, rather than the hue: areas of red and green, for instance, can appear as a similar density of gray in a conversion (unless they are manipulated to appear otherwise). A successful compositional trick is to ensure the subject or key focal point is noticeably darker or lighter in tone than the surrounding area or background, as your eye is automatically drawn to this.

Some subjects work particularly well in black and white—portraits succeed not only because monochrome allows you to accentuate form, but also because healthy skin tone and color-coordinated clothes are no longer important to a successful shot.

Losing the color from a scene can also be a distinct advantage when shooting in mixed lighting situations, where different color casts are hard to correct in post-production. You can therefore concentrate on the events of an indoor ice hockey match without worrying about the color temperature of the stadium lighting.

Black-and-white photography also comes into its own in poor lighting conditions outdoors. A gray day generally creates landscapes with insipid colors. Converted to monochrome, however, those thick clouds can be dramatically enhanced, to an extent that you simply couldn't get away with using color.

Gray weather
A castle on a gray May day. The composition works well, but the color version lacks punch. Converted to mono, however, the clouds can be burnt in to create a far more dramatic scene.

Essentially mono
Some scenes are practically in monochrome, anyway. This statue of Handel and the detail of the zebra have areas of color only in unimportant parts of the picture. Desaturating the shots in Photoshop creates stronger, classier images.

Digital imaging chips can see parts of the spectrum that the human eye cannot. Although they are filtered to avoid the unexpected problems that this could cause, many are capable of seeing infrared radiation, allowing you to see landscapes in the same way as some spy satellites and insects can.

To make infrared light visible, it is essential to use an infrared, or very dark red, filter over the lens. These are manufactured for use with black-and-white infrared film, so they are relatively easy to get hold of. This prevents a lot of light from reaching the lens, making a tripod almost essential, and produces a strong color cast, which is removed during post-production by converting the shot to monochrome.

The effect is similar to using films such as Ilford SFX—giving a ghostly-white glow to healthy foliage. The effect is particularly effective when shooting eerie-looking buildings in good sunlight during the summer (when foliage reflects more infrared light).

The processed shot, converted to monochrome, enhanced and sharpened. The glowing white leaves are typical of infrared photography.

A garden scene in color.

The same scene shot with an Ilford SFX infrared filter.

Sheng musician
Not all portraits work better in color than in black and white. This shot of a street musician provides more information about the instrument when kept in color.

Timeless black-and-white
A black-and-white picture helps to create a more timeless portrait—and makeup and clothes have much less dominance than they would have in color.

1.3 People

Styles of portraiture vary, but most photographers endeavor to capture a likeness of the human face that does not distort or exaggerate the form of the features. Lighting and lens choice, therefore, are key.

Photograph a person face-on from closer than a couple of feet or meters away and the perspective will tend to make noses, chins, cheekbones, and eye sockets look more pronounced. For close-ups, therefore, it is usual to use a medium-length telephoto lens setting. This ensures that you are far enough away to flatten the features in a flattering way, and still be close enough to talk to the sitter. An effective focal length of around 100mm is ideal; this angle of view is found on most standard lenses, including those built into many zoom compacts.

To complement this approach, the ideal lighting should be reasonably soft: harsh, direct lighting is liable to create distinct shadows under the nose and around the eyes, which will look unflattering. It is useful, however, if the lighting is not too diffuse– some directionality gives a suggestion of shadow that provides a feeling of three-dimensional form.

Unless shooting candids, the success of your shots is partly at the mercy of your subject. It is useful to keep a model relaxed, and to avoid the session becoming tedious, explaining what you are doing, and keeping calm, however uncooperative a person may seem, will help you get natural expressions. With pictures of people you can expect to reject 50 per cent of the shots because of awkward poses, closed eyes, and so on. Always review what you have shot before moving on, to ensure that you have enough frames to choose from.

Potato stall
The more people you have in the picture, the more chance of it going wrong. Fortunately, all three workers on this African market stall looked the right way, without appearing too posed.

Cutting up bodies

When shooting a close-up of a person's face, you should avoid framing it a way that the bottom of the frame cuts through their neck. This approach provides a shot where the person is liable to look as if they are decapitated. Instead, the base of the picture should be positioned to cut through the shoulders, with a slight gap between the top of the head and the top of the frame.

For wider, fuller figure shots of people, you should similarly avoid cropping so that the base of the frame cuts though other joints. The bottom of the picture should not run through the elbows or knees; instead, it should cut through the body between two joints, such as through the calves of the legs, or through the biceps of the arms.

Notting Hill Carnival
A wide aperture is often useful with portraits, to ensure that the background does not become a distraction.

Joan Collins
Where possible, always take multiple shots—this will help to increase the odds of getting the perfect expression.

Classical pose
If you can choose the setting, you can use the background as part of the picture—toning with the color of the person's clothes, for example. Here the classical pillars of the hotel work well with the ballgown that the woman is wearing.

Looking space

When photographing people in profile, you should try to ensure that the head is framed so that there is more room in front of it than behind it. This is done not only because it provides an off-center composition; when we look at a picture of person photographed side on, we automatically look across in the direction that the person in the picture is staring. If the frame is too close to the face, there is not enough "looking space", and the picture seems cramped and becomes uncomfortable to look at.

Not enough space in front of the face
With more space in front of the man's head than behind, the image appears better balanced.

Kit bag

The ideal equipment for a portrait photographer would include:

● A single zoom lens with a efl range of around 35–200mm is ideal: the mid-telephoto settings are ideal for close-ups; the longest telephoto settings work well for candids; and the 35mm wide angle setting is useful when photographing people from farther back, but when you want to include the background.

● A portable flashgun that can be used in low light or for fill-in. A bounce option should be available for diffusing the light indoors. When a suitable surface is not available, an attachable diffuser or softbox should be used (*see page 150*).

● For home studio shots, two lights are the ideal minimum—one to the side of the camera to provide the main "key" light, and another on the other side to fill in the shadows. The second light can be replaced by a reflector. Umbrellas and softbox attachments are ideal for diffusing the lights. A third light can be used to illuminate the hair or background separately.

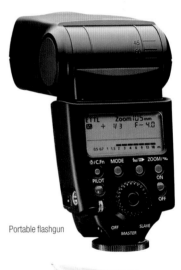

Portable flashgun

Collapsible reflector

● A collapsible reflector for fill-in outdoors or in the studio. An all-white version that doubles as a diffuser is ideal; alternatively, use a reversible white/gold reflector, which gives the option of providing a bronzed look on the skin tones.

1.3 Wildlife

For great wildlife photographs you need to be in the right place at the right time. Pictures of puffins with their colorful beaks filled with sand eels may look difficult to shoot, but can simply require traveling to the right clifftop. However, it may take weeks of patience and specialist knowledge to get a shot of rarer or more timid creatures.

Although wildlife is diverse, the basic techniques can be learned in your own backyard. Catching sharp, full-frame pictures of the birds in your back yard, for example, will develop your reactions and focusing skills for more exotic creatures; images of bugs and butterflies will hone macro techniques; shots of a cat or dog can help you develop a sense of the importance of background and expression. These skills can also be practiced at wildlife parks, zoos, and animal welfare centers, allowing you to develop a taste for adapting your camera techniques to different animals.

The focal length of lens that you use will depend on how close you can get to the creature, and its size. For decent close-up shots of small birds, an efl of 600mm is useful if you are to avoid too much cropping in post-production–simply because they may not allow you to get closer. With some other animals, your own safety is also a consideration: an efl of 400mm is useful for some larger animals, as it is unwise to get too close to hippopotami or lions, whether in an animal park or in the wilds of Africa.

Ensuring a suitable background is useful when shooting animals, whether or not they are in captivity. Camouflage can be a particular problem in the wild–even though the animals may be visible, they may not stand out clearly against the background. In zoos, most photographers try to avoid including any evidence of a man-made enclosure, so choosing the right angle of view and a suitably wide aperture are as important as waiting for the right moment to release the shutter.

Leopard
Leopards typically sleep and eat in trees, making this the obvious place to find and photograph them in the wild.

Butterfly
For this Giant Owl butterfly, the camera's macro mode was sufficient to give a full-frame shot. However, for decent-sized shots of bugs, a macro lens is essential.

Shooting through bars

Although thick metal bars are not a common obstacle to the photographer in modern zoos, wire fencing, clear acrylic screens, and glass viewing panels can all cause difficulties when taking pictures. It is essential to get these obstructions as out of focus as possible in the shot, otherwise mesh may become visible, and scratches on the acrylic sheet may lower resolution, reflections in the glass can distract from the subject.

It almost goes without saying that using a large aperture will help to throw these foregrounds out of focus. But this is not usually sufficient. It is far more important to get the lens as close to the screen or fencing as possible, with the front of the lens actually making contact with the panel if possible. With mesh fencing, ensure that the center of the lens lines up with a hole in the wiring, so the middle of the picture (at the very least) will have an unobstructed view. It may also be necessary to switch to manual focus.

By getting as close to the toucan's cage as possible and stopping down to the widest aperture that the lens allowed, the mesh was made to disappear.

Before

After

Seal
A shot of a wild seal like this may seem a difficult feat; in fact, in the right harbor, gray seals can be seen close to the quay, waiting for fishermen to throw away their unwanted catch.

Gorilla
It pays to be patient when photographing animals: get what pictures you can, then wait for a better pose. This cute shot was well worth waiting for.

Chipmunk
This chipmunk would have blended more with the bark of the tree, had it not been for the sunshine. The high angle of the light works well with the gravity-defying pose, creating what is effectively strong sidelighting.

Gray Heron
Learn the habits of the subject you want to shoot. A Gray Heron stands still as it fishes for its supper, making a static pose that is relatively easy to capture.

Kit bag

The ideal camera equipment for the wildlife photographer would include:

● A long telephoto zoom with a maximum efl of 300mm for general animal photography.

● A long telephoto prime lens or teleconverter (*see page 106*), to provide an efl of around 600mm for bird photography.

● A macro lens with 1:1 magnification for close-ups of bugs and other small creatures. Extension tubes can be used as a suitable alternative.

Robin
Backyard birds present a good subject with which to learn the essential skills of wildlife photography. A robin will perch and pose around the yard, but you have to act quickly to get the picture, and wait for a suitable backdrop.

1.3 Architecture

It is possible to photograph a building without using a wide-angle lens; in fact, it is often worth going out of your way to find angles that allow you to shoot an architectural subject with a telephoto lens. A distant viewpoint can give an alternative view of a well-known structure, while architectural details allow you to concentrate on pattern and detail in a selective way.

However, because buildings are large and surrounded by others, the most extreme wide-angle lenses are more useful for architecture than other subjects. And they become more so when shooting indoors, where the number of possible viewpoints is even more restricted.

The disadvantage of using a wide-angle for buildings is that in order to get the top of the building into the shot, the camera usually needs to be tilted. This then causes parallel vertical lines to converge in the image. The effect can be useful, as it creates strong diagonal lines–but it can become rather repetitive.

Shooting from farther away with a longer lens helps to alleviate the problem, as less tilt is necessary. An alternative approach is to find a high vantage point– an upper-floor window of a neighboring structure, perhaps–that allows you to get a squarer view so you can keep the camera's back vertical. A third choice is to use a perspective control lens–this expensive accessory, available for a select number of digital SLRs, allows you to shift the lens up to include the top of a structure without needing to tilt the camera.

Fortunately, however, converging verticals can be corrected quickly and inexpensively using standard image-manipulation software. The solution here is to stretch the building at the top to bring the vertical lines back into alignment. However, as this process inevitably means losing some of the picture area, it is worth planning for this manipulation at the time of shooting, deliberately framing the image loosely, so that essential elements are not lost later on.

Straightening up

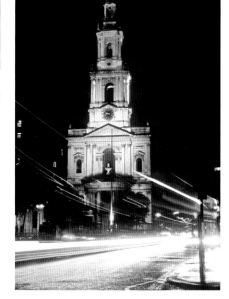

Different image-manipulation programs provide different ways in which to correct the converging verticals in your pictures. In Photoshop CS2, the technique is simply to use the *Crop* tool. With the *Perspective* option checked, you draw crop marks around part of the building that should appear a perfect rectangle in the final picture (but which looks like a distorted trapezium in the original). You then pull out the central tabs on all four sides to maximize the available picture area–a percentage of the picture will be lost–double-click the image, or click the tick icon, to execute the crop. The image is then stretched to produce your final, corrected image.

1.3

Leaning Tower of Pisa

The Leaning Tower of Pisa is one of the world's best-known buildings, and trying to find interesting ways to photograph it presents a challenge. The shot of the tower and neighboring cathedral is a standard view; the Dutch tilt, however, exaggerates the angle of the tower. An alternative is a wide-angle view from the base which ignores the subsidence, giving more emphasis to the many columns and galleries that make up the tower.

Rievaulx Terrace

Natural light that is halfway between sidelighting and full frontal lighting is often ideal for shots of buildings. It provides just enough shadows to suggest three-dimensional form, as in this shot of a classical-style temple.

Interior of Truro Cathedral

Super-wide-angles come into their own with interior photography. This shot of Truro Cathedral in Cornwall was taken with an efl of 18mm. To avoid using a tripod, the camera was fired while sitting in a pew, to minimize camera shake.

Restmorel

A super-wide-angle lens allows you to show a building within its surroundings. The grasses in the foreground of this ruined castle contribute to the mood of the picture.

Kit bag

The ideal equipment for the architectural photographer would include:

● A super-wide angle zoom covering effective focal lengths in the 15–30mm range. Alternatively, a wide angle or semi-fisheye converter could be used (see p104).

● A standard zoom offering effective focal lengths from 35–200mm. This allows you to shoot from a variety of distances when possible, and to crop in on details.

● A tripod is essential indoors, but is also recommended outdoors simply because you can take advantage of the static nature of buildings to optimize the image quality and the depth of field.

1.3 Sports

The vantage point is all-important in sports photography: you have to find a spot that is likely to give you a good view if, and when, something happens. The trouble with big events is that the best spots are taken either by other spectators or by accredited press photographers. For this reason, it is often best to concentrate on lower-league events or minority sports. With fewer people to get in your way, you can not only choose a good point to set up your camera, but you may also be able to swap positions to get a variety of shots.

The focal length of lens that you need will depend largely upon the sport, as this defines just how close you can get to the action. For good close-up shots of field sports, an effective focal length of 300mm or greater is usually essential. With track and cycling events, it may be possible to use a wide-angle lens, but this will mean shooting as the participant passes straight in front of you, which demands fast reaction times; using a

telephoto allows you to isolate action as it heads toward you, giving you more time to compose the shot.

Although it is possible to shoot sports with a slow shutter speed, to convey the movement through blur (see page 80), it is more usual to take pictures that freeze the action. If a fast enough shutter speed is not possible, panning can be used. But in many events, there are moments when the subjects are not moving as fast as at others: a Formula One car may travel at one-sixth of its full-out speed when cornering, for example.

In other events, there are moments when the competitor is almost still: a basketball player jumping at the hoop, for instance, moves up for a fraction of a second before coming back down, and there is a point where he is moving neither up nor down. This is the perfect moment for the shot—there will be slight lateral movement, of course, but a slower shutter speed can be used than would otherwise be possible. Many sports have such "peak of the action" moments.

Aiming your sights

Although many digital cameras have autofocus systems that can keep up with moving subjects, and can even predict where they will move between the moment you press the shutter and the picture is taken, for many sports it is usually safer to use manual focus. The advantage is that you can set up the focus, and preframe the shot, even before the picture presents itself. This is because so many action events follow a predetermined course— and once your vantage point has been selected, you rarely have the chance to get more than one type of shot from it.

The idea is that you prefocus on a point through which you know the subject will pass, choosing a focal length to suit your distance from this point. When the subject comes into view, the focus is then all ready to go—there is no chance of it locking onto the wrong point, and you minimize the delay caused by shutter lag. This prefocusing technique can be used for all racing events, but can also be adapted for many field sports, allowing you to prepare for set pieces.

An advantage of prefocusing is that it can mean that you take a succession of shots without having to alter the lens setup. For this showjumping event, the lens was focused on one of the bars of the fence, and a shot was taken as each horse jumped it.

1.3

Cycling
Some shots sum up the action much better than others. The telephoto shot of the cyclists shows the peleton well enough, but with two of the competitors choosing that moment to take on fluids, it hardly looks like a race. The wide angle shot taken at the same race works better: The use of slow-sync flash provides a feeling of movement, and the fact that the overall leader, in the customary yellow jersey, is in shot makes the picture that much more meaningful.

Soccer
An unorthodox soccer shot. The headless composition not only provides a more general "stock" shot, but helps show the dribbling skill of the striker as he avoids being tackled.

Football
You don't need movement to create an action picture. As the two teams line up against each other you can see the tension in the players' poses—helping show the explosive nature of the game.

Kit bag

The ideal equipment for the action photographer would include:

● A zoom lens with an efl of around 100–300mm provides coverage for a wide variety of events.

● A fixed focal length lens with an efl of 400mm is useful for close-ups. Alternatively, a teleconverter could be used.

● A monopod provides extra stability for long lenses, and a pivot point when panning.

Monopod

Hurdler
Big sports events present a problem with neighboring spectators, and with those on the other side of the venue. To ensure that these latter are suitably out of focus, a wide aperture is essential, making focusing accuracy even more important.

169

1.3 Travel

In many ways, there is nothing special about travel photography: wherever you may roam, the subjects are the same as if you were back home. You can shoot portraits of the people you meet; you can capture landscapes you encounter, and architecture you visit; you can even train your lens on the wildlife and sport that you may come across.

There are two things that make travel photography different, however. The first is that when you are on vacation, you not only have a new set of sights to give you inspiration for your pictures, you also have the time to make the most of these photo opportunities. With none of the usual constraints on time, you can afford to do things properly: you can wait for the right type of lighting, you can search out more interesting angles, you can experiment with different camera settings. You are limited only by how much of your day you want to devote to photography.

However, given that vacations do not go on for ever, it does pay to exercise some discipline. It is a good idea to plan the type or style of shots you want to take as early as possible, and then work out the best days and times of day to take them (*see box*).

The other difference with travel photography is that you may be restricted as to what you can carry around with you, even though may want to take everything you can to cover every eventuality. A heavy tripod is cumbersome to take on an airplane, or to carry on a sightseeing trip, but it may prove useful for night shots. A long telephoto lens may prove useful for a trip to a nature reserve, or to shoot water sports. A flashgun could be worth carrying to capture the nightlife. You need to make difficult decisions before you leave–and remember to take vital accessories, such as the battery charger.

Most importantly, unless you take a laptop with you, you will be separated from your PC for the duration of your trip. You won't be able to download your day's shoot to your desktop computer's hard drive each evening, and your memory may soon be full. You therefore need to estimate how many pictures you will be taking, and buy enough memory media to ensure that you do not have to delete shots you'd rather keep. Alternatively, you could invest in a portable back-up system–a pocket hard drive or a battery-powered CD burner, for example.

Some destinations are undoubtedly better havens for the photographer than others. Bustling Bangkok is certainly one of those cities that has pictures at every corner. But you don't necessarily have to travel far to find these picture paradises; it is worth researching the possibilities even before you book your vacation.

A snack shop banana salesman tries to market his wares.

Candid shot of Buddhist monk in typical orange robes, viewed from above at Wat Arun.

Duck being prepared on the street in Bangkok's Chinatown.

Ornate statue on guard in the Grand Palace, A large aperture keeps the background in check.

Smoothie stall—fresh fruit salad on wheels.

Wide-angle shot of the Marble Temple. The parasols help obscure other tourists in front.

Planning your time

● Use other people's pictures as a guide to the kind of shots that are possible. Look at guidebooks and websites to check the visual themes of a location. For the serious photographer, it is a good idea to do this even before you book the trip!

● Carry on looking at pictures when you arrive at your destination. Postcards are a great source of inspiration, showing you views that you might otherwise not discover in a short stay. You don't have to copy them–try to improve on them, or adapt them to your own style.

● Many of the most photogenic locations will also be the most popular with other tourists. This may mean planning to arrive at the site as early in the day as possible.

● Look out for details of events. Market days are often a photographer's paradise, for example, but as these may only happen weekly, you may need to plan your itinerary around them so as not to miss the opportunity.

1.3

Kit bag

The ideal equipment for the travel photographer would include:

● A battery and spares, with a charger and a suitable outlet adaptor for your destination.

● A cleaning cloth for the screen, and a blower brush for the lens and CCD.

● Camera bag—preferably one that does not advertise your wares to local pickpockets. Special backpacks with padded compartments are ideal if you are doing a lot of walking.

● Lenses and accessories to cover the likely subjects that you will be tackling during your trip.

● Camera instructions, in case a strange symbol appears on the screen while you are away.

● Receipts for your camera equipment may ease your passage through customs when entering, or returning from, certain destinations.

● A miniature tripod or beanbag, for long exposure shots without the need to carry a full-size tripod.

● Insurance documents: your camera equipment may be covered on your household policy, and vacation policies may offer adequate cover only for lower-cost cameras. You may wish to arrange a specialist policy tailored to the photographer. Carry details and serial numbers of your equipment on a separate piece of paper, in case your camera bag gets lost or stolen.

LJobo Giga3 Plus

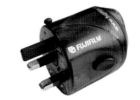

Travel outlet adaptor

171

1.3 Landscape

Wide-angle lenses have become synonymous with landscape photography. The great outdoors demands great angles of view if you are going to capture the whole scene.

However, although wide-angles have a valuable place in the landscape photographer's backpack, longer focal lengths can prove equally useful. A telephoto allows you to isolate a distant tree, for instance, while long lenses can be used to home in on the pattern of fields, or on the diagonal line created by the side of a mountain. Using a wide-angle lens for landscape, you must constantly consider how you are going to fill the foreground, looking for interestingly-shaped rocks or a bright flower to turn the dead space in the frame into an interesting compositional element; a longer lens can solve this problem, and has the added advantage that the pictures can often look that touch different from standard shots of the countryside.

The quality of natural lighting is all-important to the landscape photographer: differences in intensity and diffusion throughout the day, and the passage of the clouds, can become an obsession. But patience is the biggest virtue–great pictures often mean just sitting and waiting for the right combination of atmospheric conditions.

The seasons are also important. It is the seasons that give the landscape its color—the golds and oranges of Fall prove irresistible in deciduous woodland, and the annual flowers of an alpine meadow make Summer irresistible. But in other places, vegetation can look too green at some times of the year, becoming all-pervasive; in the English Lake District, for instance, some of the most successful shots are taken in early Winter, when the first snows on the fell tops contrast with the browns of dead bracken and the duller greens of dormant grass.

Perfect lighting
Late afternoon near Kennebunkport, Maine. The warm, low light creates long shadows, but works well with the Fall colors of the maples.

Monochrome for emphasis
The lines of the overgrown track and solitary tree were the attractions of this scene–shown in monochrome, they are not lost amongst the lush greens of summer.

Kit bag

The ideal equipment for the landscape photographer would include:

● A graduated gray filter for reducing the brightness differential between sky and land.

● A circular polarizing filter.

● A solid tripod with legs and center column that can be independently angled (those produced by Benbo and Uni-Loc are favorites of landscape photographers).

● A zoom lens with wide-angle coverage down to around 20mm (efl).

● A zoom lens with a telephoto range that extends to 200mm or more (efl), for isolating distant details.

1.3

Reflective surfaces
Water is a valuable ally for the landscape and garden photographer, reflecting the colors of the things around it, as well as that of the sky.

Seasonal variation
The landscape may not move, but it is forever changing. Poppies are a photographic favorite, but they are short lived, and may not appear in the same place two years running.

Depth of field
Using a telephoto lens helps you to help give the impression of compressed distance. In this shot, the camera viewpoint concertinas the rows of Tuscan vines together, to create a strong diagonal pattern across the frame.

Focal point
Trying to find a strong focal point is often a struggle with landscape photography. This ruined windmill works well in providing a central subject, although it is the contrast between the colored grasses and the cloudscape that really makes the picture.

Stitch up

Although specialist cameras for shooting panoramas can be bought, digital images shot by any camera can be combined to create a widescreen image. This panoramic approach allows you to photograph a broad vista without the need to include unnecessary amounts of foreground and sky, and without the need for an extreme wide-angle lens.

Some cameras provide a special mode that aids the composition of such shots (*see page 69*). However, software programs can be used to combine a sequence of shots with little difficulty—in fact, many will align these for you automatically (*see page 256*).

A simple photostitch created by merging together two shots into a single image. The technique allows the whole reservoir to be shown in an undistorted way, without the need for specialist equipment.

173

1.4 Scanning

It is tempting to divide photography into two eras. Once there was a time Before Computers (BC), but then, after over 150 years, the AD, or After Digital, age began.

But although film has been all but replaced by pixels and processors, most people still have drawers full of prints, slides, and negatives left over from this period. As slide projectors and enlargers fast become museum pieces, these silver halide images do not necessarily have to fade away. They can be given a new lease of life in the digital era, by simply being scanned.

By scanning film-based images, you look at old pictures with fresh eyes. They immediately enter the new workflow and can be printed out, emailed, and viewed as easily as images shot with a digital camera. Just as significantly, they can be tweaked in the digital darkroom. So not only can favorite images be enhanced, but those that had faults can be retouched and manipulated, turning failed film images into successful digital images.

To take the step from analog, physical images to digital, virtual ones the scanning process effectively takes a picture of the picture. The success and accuracy of this process is highly dependent on the equipment, technique, and settings used.

1.4 Flatbed scanners

The most common type of scanner is the flatbed—basic models are often provided with desktop computer packages. Although controlled from a PC, these essentially work like a photocopier: the image to be digitized is placed on a glass plate and held in position by a hinged lid or "hood."

Rather than copying the image with a single shot, the flatbed scanner uses a moving camera assembly that records the image a strip at a time. This imaging system consists of a light source and a sensor, and the image created by the former is reflected onto the latter using a strategically placed mirror. The sensor used is often a CCD device (like many cameras' sensors, *see page 24*) or perhaps a Contact Image Sensor (CIS). CIS devices tend to be more compact and energy-efficient than the older CCD technology; however, CCD still has the edge for high-quality applications.

Basic flatbed scanners are designed solely for use with photographic prints, pieces of paper, and other reflective materials. Some scanners, however,

provide an alternative light source in the lid, or offer an optional accessory that converts the hood in this way. This "transparency hood" is designed for use with any transmissive material, such as slides and negatives. However, for those with a large number of 35mm images, a slide scanner (*see page 178*) may be a better option.

Commercial scanning

Scanning images takes time, and if you want the best results, this can mean buying expensive equipment. It is therefore worth considering using the services of a professional "bureau" that will do the work for you. This is an economical solution for those with a small number of images to scan, but it may also be tempting for those who want to fast-track their favorite old pictures into the digital era.

The price that you pay will depend largely on the equipment being used, and the quality of result required. The size of the original images will also affect cost. These are some of the options:

Type of scanner The most expensive option is to have the image drum-scanned (*see box*). This quality is probably only worth paying for if you have a corporate client who will foot the bill. Most commercial and mail-order services will scan using a film scanner (*see page 178*) for slides and negatives, and a flatbed scanner for prints.

Resolution The maximum resolution will vary depending on the service. Choose the one that offers the resolution that meet your needs (*see page 180*).

File type Images will usually be returned on CD or DVD in either JPEG or TIFF file format. JPEG allows the lab to fit more pictures on a disc by compressing the data.

Dust removal Expect to pay more if the lab uses a scanner that uses ICE dust and scratch

removal (*see page 184*), as this means that each scan takes longer. It's well worth the extra outlay.

Single image, or whole film The cheapest scanning prices are available to those having the film digitized at the same time as it is being processed. If you just pick the best shots from your archives, expect to pay more per scan.

Index print Some scanning services will provide a printed insert for the CD jewel case, showing thumbnails of each of the images stored on the disc.

Buy in bulk The more pictures that you have scanned at one time, the less you can expect to pay per scan.

Platen size The dimensions of the glass define how large a print you can scan. Most models are large enough for 10 × 8in (25.5 × 20cm) prints and smaller. Some are available with an A3+ image area 19 × 11in (48.5 × 28cm). To make the most of the area available scan a number of prints, slides, or negatives simultaneously, and then crop the resulting file to create separate digital images.

Connection Most scanners offer a FireWire (IEEE1394) or USB connection to your computer, the exact type of connector is a significant factor in how long it takes to scan each image. USB 2.0 and FireWire are similarly fast, and both are considerably faster than USB 1.1 (*see page 264*). Not all computers support these connections, however.

Scan speed Some scanners are much faster than others. As well as the connection, the speed of the controlling computer, the resolution, and other settings chosen all affect the speed.

Software Scanners are supplied with "TWAIN" software to drive the scanner and provide operating controls; ensure that this is compatible with your computer's operating system. "Plug-in" software may be provided, so that the scanning program can be opened from within popular image-editing programs, such as Photoshop Elements.

Maximum resolution The resolution of the scanner defines the maximum number of pixels

LID

ON/OFF BUTTONS
Most other controls are provided via the PC.

HINGE

FEET
To ensure platen is level, and absorb external vibration.

LIGHTING AND
MIRROR ASSEMBLY
Ensure that prints are placed parallel with this, to avoid the need for rotation later.

GLASS PLATEN
Should be scrupulously cleaned before each scan, to remove any dust or dirt.

1.4

in the resulting image. The more you have, the more you can do with the image. Two figures are generally given for resolution—the first is the horizontal, the second is the vertical resolution (the precision with which the scanning head can be moved). A typical desktop model will offer 2400x4800 dpi (dots per inch), where the important figure is the 2400dpi—the sensor's optical resolution. Scanners designed for transparencies may have optical resolutions of up to 4800dpi.

Dynamic range A measure of the scanner's ability to differentiate between different tones, especially in the shadow areas (*see page 186*).

Interpolation Manufacturers may quote a figure that is higher than the optical resolution, based on the number of pixels that the software can extrapolate per inch of original. Essentially, the software just makes a guess at what the scanner might have seen, had it the benefit of more pixels. This "interpolation" or "enhanced resolution" rarely yields better quality images—just bigger files—and should be ignored.

Color depth The number of colors that the scanner can distinguish (*see page 180*).

Footprint Some scanners are bigger than others, but it is the amount of space they take up on your desk that is often the most crucial dimension. Some are designed to be used vertically, so as to reduce this "footprint".

Despite improvements to the quality available from flatbed and film scanners, drum scanners still generally produce the ultimate in quality. Used by professional repro houses, these devices are big and highly expensive. The extra dynamic range that they offer (*see page 186*), and their ability to be used with a wide range of film formats, make them appealing to demanding photographers who have a collection of images on sheet film. They also offer up to twice the

resolution of the best desktop and film scanners (around 11,000dpi from high-end drum scanners).

Using adhesive tape, a number of images are simultaneously mounted onto the surface of a removable transparent cylinder, or drum (which can be up to a 3ft/1m long). To improve adhesion, and to minimize problems with dust, the surface of the film is covered with a layer of oil-like liquid before scanning. It is a messy process.

The images are scanned by spinning the drum while a beam

of light illuminates a single, microscopic strip of the image from inside the drum. The image is then recorded using a vacuum tube sensor called a PMT (photo multiplier tube), positioned on the outside of the drum. This can detect a broader range of light, from white through to black, than possible with a CCD sensor, thus recording more detail in the dark areas of the film image.

Spare drums can be used to prepare the next batch as one set of images is being scanned.

177

1.4 Film scanners

Film scanners are designed solely for scanning transparencies and negatives. They work in essentially the same way as a desktop scanner, using a CCD that moves in tandem with a light source at the other side of the sheet of film. The light projects the image onto the CCD sensor, and each pixel converts this to an electrical charge, which is then processed and converted into digital form.

The big difference with a film scanner is that unlike with a flatbed scanner, you don't get to see what is going on. The scanning head and light source are hidden within the casing of the device, and mounted slides or strips of negatives are inserted into a slot or a special carrier, which is then inserted into the device.

As negatives and slides are, by their very nature, smaller than prints, the resolution of film scanners is greater than the average flatbed. The lowest resolution from a budget film scanner is around 1,800dpi while the best machines offer a sampling rate of 5,400dpi.

The majority of film scanners are designed to work only with the 35mm film format they, and assume that the maximum picture area is 24 × 36mm, so cannot be used with film taken with specialist panoramic cameras. Half-frame or panoramic shots that are smaller than the full-frame 35mm image area can simply be cropped using either the scanner's software, or an image-editing program.

Some models can be adapted to work with the APS (IX240) format, although this may mean having to purchase an additional film carrier. Although APS cameras offer a choice of three aspect ratios, their full negative size, whatever the camera setting, is 1.18 × 0.65in (30.2 × 16.7mm) which allows you to recrop the image in any way you see fit.

Roll-film scanners allow pictures shot with the majority of medium-format cameras to be scanned, as well as offering provision for 35mm images. The largest format catered for is usually 6 × 9cm and larger negatives or slides must be scanned on a flatbed scanner with a transparency hood, or a drum scanner.

Film or print?

The decision as to whether to scan from a print of the image or from the negative (or slide) is often made for you. The negative may have gone missing, or the print may have faded beyond redemption, or you may not have all the equipment necessary for dealing with both reflective and transmissive materials.

But what do you do if both options are open?

The answer may seem obvious. Scanning from a print creates a third-generation image—a copy of a copy of the original negative. So scanning from a negative cuts out the printing stage, where quality would inevitably have been lost.

However, if the print is a good one, you may still get a better result from this. A print has a narrower dynamic range (*see page 186*) than a slide or negative, and may well produce a better-exposed scan. In addition, because prints are larger, specks of dust and scratches are less noticeable in the final digital image. Color print film negatives seem particularly prone to scratches, increasing the likelihood that a pristine print will yield a better digital scan. Your decision therefore needs to be made on close inspection of the image in hand.

Chris George

Flextight

Imacon Flextight scanners offer a halfway house between top-of-the-range film scanners and a full-blown drum scanning system. They use what Imacon calls a virtual drum, with the unmounted transparency being held in a flexible carrier that curves when it is inserted into the scanner. The Danish-made system offers models with resolutions of up to 8000dpi and a dynamic range that is superior to standard film scanners. Carriers are available from 35mm through all the roll film sizes, right up to 4x5in sheet film.

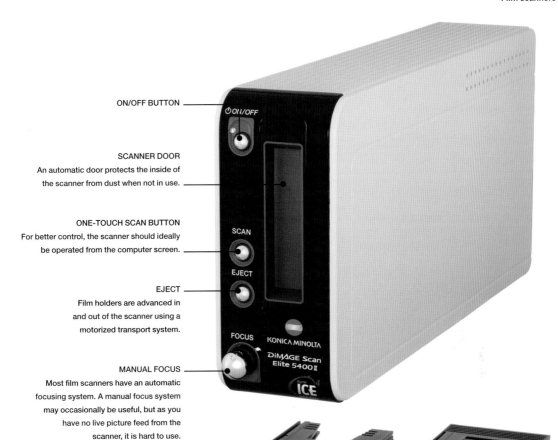

ON/OFF BUTTON

SCANNER DOOR
An automatic door protects the inside of
the scanner from dust when not in use.

ONE-TOUCH SCAN BUTTON
For better control, the scanner should ideally
be operated from the computer screen.

EJECT
Film holders are advanced in
and out of the scanner using a
motorized transport system.

MANUAL FOCUS
Most film scanners have an automatic
focusing system. A manual focus system
may occasionally be useful, but as you
have no live picture feed from the
scanner, it is hard to use.

FILM CARRIERS
Different carriers are provided
for different film formats or
types. The two provided with
this scanner can hold up to
four mounted 35mm slides, or
a strip of six 35mm negatives.

Connections Most film scanners
connect to the computer using
USB, or offer a choice between
USB or FireWire. Not all computers
support both systems, or they may
not be able to take advantage
of the extra speed that USB 2.0
offers over USB 1.1. However,
the type of connection used has
a major impact on the speed of
each scan.

Scan speed Some scanners
are much faster than others. The
actual speed will also depend on
the connection used, the speed
of the computer controlling the
scanner, and the resolution (and
other settings) selected.

Software As with a flatbed
scanner, the device is supplied
with "TWAIN" software which
drives the scanner and provides
operating controls. Ensure that it is
compatible with your computer's
operating system. "Plug-in"
software may be provided, so
that the scanning program can
be opened from within popular
image-editing programs, such as
Photoshop Elements. Obviously

a film scanner cannot be used for
scanning flat artwork, so it cannot
be used as a color photocopier,
nor for digitizing text.

Maximum resolution The
resolution of the scanner defines
the maximum number of pixels
in the resultant digital image. The
more you have, the more you can
do with the image (see page 180).
The maximum optical resolution
typically varies from 1800 to
5400dpi but a lower resolution can
be set when less detail or a smaller
image file is required.

Dynamic range A measure
of the scanner's ability to
differentiate between different
tones, especially in shadow
areas (see page 186).

Color depth The number of
colors that the scanner can
distinguish varies from model to
model. The best scanners offer
a 48-bit option (see page 180).

ICE This automatic dust and
scratch removal system (see
page 184) is not available on all
film scanners, but is a feature
well worth having.

Batch scanning Some scanners
have the facility to scan a number
of slides automatically: The Nikon
Coolscan 4000, for instance, can
load and scan up to 50 slides at a
time, using an optional attachment.

179

1.4 Resolution

Scanning resolution is not only a key decision when buying a scanner; it must be considered each time an image is digitized. Whether using a flatbed or film scanner, the maximum resolution possible depends on the model—and this can vary from 600dpi, right up to 5400dpi or even more. However, it is not necessary to use the maximum resolution available for every scan you make.

Just as with a digital camera, you can restrict the number of pixels that make up the digitized image by choosing a lower resolution setting. Reducing the resolution means that you have a smaller, more manageable file size, that opens quicker on your computer, is faster to manipulate, takes up less room on the hard drive, and is easier to send to others via email or the Internet. A lower resolution generally also means that the scanning time is quicker.

The advantage of a bigger file with more detail, however, is that the image is suitable for a wider range of uses. In particular, the resolution will define the maximum size at which an image can be printed out, and how much it can be cropped prior to printing.

As with a digital camera (*see page 28*), a compromise needs to be reached between space efficiency and speed on the one hand, and out-and-out quality on the other. The considerations are not exactly the same, however. Connected to your PC with its hard drive, memory capacity is less of an issue. However, the files that scanners can produce can be enormous compared with what else is on your computer: a scan from a 35mm slide using a 4000dpi scanner will be roughly 55 megabytes in size (using a 24-bit color setting: it will be 110MB using a 48-bit mode; *see box*). A modest 40GB hard drive (assuming half the capacity is reserved for other files and programs) will therefore fill up after scanning the equivalent of just ten rolls of film. You can, of course, offload the files to discs and other drives (*see page 268–273*) and compress files using a variety of techniques (such as LZW or ZIP), but file size is still a significant issue.

You should choose a resolution that suits the most demanding task that you are likely to require from the image. If you need a full-frame A3 print at best, then set the resolution for this (allowing extra for cropping, if applicable). Unlike camera resolution, the decision you make is not irrevocable: if you store prints, slides, and negatives carefully, you can always make higher-resolution scans in the future (when digital storage is less expensive, no doubt, and scanners will be able to extract even more detail from the original).

Color depth

Color depth, or bit depth, is a way of expressing the maximum number of colors or distinct tones that a scanner or camera is capable of recording.

A basic digital photographic image is made up using three primary colors: red, green, and blue (RGB). Each of these channels can record 256 different shades; this is known as 8-bit color, as 256 is the maximum number of permutations that are available using an 8-digit binary number, or byte as it is otherwise known (the possible values run from 00000000 to 11111111, or from 0 to 255).

But when these three channels are mixed together, each pixel has a value of 0–255 for each primary. This gives a phenomenal number of different possible color combinations—over 16,000,000 in all (256 × 256 × 256). This is also, confusingly, known as 24-bit color, as the number of permutations matches the number of different ways in which you can write a 24-digit binary number. As this is the maximum number of colors distinguishable by the human eye, there seems no real need to have a scanner (or camera) that can distinguish more tonal gradations and colors.

However, scanners commonly offer 12-bit (also known as 36-bit),14-bit (42-bit), and 16-bit (48-bit color) modes. A 16-bit channel provides over 65,000 shades—creating a 48-bit composite made up of 281 billion possible color shades.

Although the extra information is generally discarded before the image is finally printed or displayed, these additional values allow the scanner to detect subtler gradations in tone.

This is particularly useful when manipulating the image, as the excess of data means that even if some is lost during processing, you will still get the highest possible quality final image. Not all image-editing programs are compatible with these higher bit depths, however.

RAW images shot by high-end digital cameras also provide a 16-bit option when they are converted on the computer (*see page 202*).

The trouble with extra bit depth is that it increases the size of the resulting files: A 48-bit scan is twice the size of an otherwise identical 24-bit scan, and takes longer to scan and process. However, the detail extraction capabilities are particularly useful with high-contrast slides, where you don't want to lose the transparency's shadow detail.

Horses for courses

Use (output resolution)	Digital image file size
Full screen computer image (90dpi)	4MB
4 × 6in print (300dpi)	6MB
Letter/A4 print (300dpi)	25MB
A3 print (300dpi)	50MB
A3+ print (300dpi)	64MB
4 × 5in transparency (1200dpi)	82MB

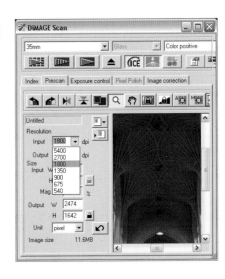

540dpi (741 × 493 pixels)

The digital image file size that you will typically need for common uses (based on uncompressed 24-bit color RGB TIFFs with no cropping).

These scans were all taken from the same 35mm Provia 100F slide; only the resolution was adjusted for each scan.

675dpi (927 × 617 pixels)

900dpi (1236 × 822 pixels)

1350dpi (1854 × 1234 pixels)

1350dpi (1854 × 1234 pixels)

2700dpi (3708 × 2468 pixels)

5400dpi (7416 × 4936 pixels)

Bit depth

Bit depth	Number of possible permutations
8-bit	256
12-bit	4,096
14-bit	16,384
16-bit	65,536
24-bit	16.7 million
32-bit	4.29 billion
36-bit	68.7 billion
48-bit	281 trillion
96-bit	7.92×10^{28}

File sizes

Original image size

Scanner resolution	35mm mounted slide	35mm negative	6 × 4in print	10 × 8in print
600dpi	1.3MB	1.4MB	24.7MB	82.4MB
1200dpi	5.1MB	5.5MB	98.9MB	329MB
1800dpi	11.6MB	12.4MB	222MB	742MB
2700dpi	26MB	27.9MB	500MB	1.63GB
4000dpi	57.1MB	61.3MB	1.07GB	3.58GB
5400dpi	104.1MB	112MB	1.96GB	6.52GB

File sizes are for uncompressed 24-bit color RGB TIFFs.

1.4 Making the scan

Once the scanner has been set up, and the controlling software has been loaded onto your computer, making a scan should be straightforward. However, many scanners offer a bewildering number of adjustments that can be made to the image during, and after, scanning.

For the most part, these can be safely ignored. Many of the adjustments provided simply duplicate those found in standard image-editing packages, such as Photoshop. It is tempting to tweak the color and exposure of the image before you scan, but there are disadvantages in doing it this way.

The biggest problem with using the scanner's controls is that any adjustment you make is based on the preview image that the software provides. The preview is an optional step in the scanning process, as you could simply go straight on to the final scan. However, this low-resolution version of the scan is helpful for checking that you have put the image in the right way round, that you have not set the scanner accidentally to its OCR mode, and that you have correctly chosen between print, slide, and negative.

The preview is designed to come on screen quickly, and doesn't give the detail of a full scan. It therefore has limited value for judging the settings for the scan. You can make corrections and then preview the scan again, but this takes time, and it is better working practice to adjust *Levels, Curves, Saturation,* and *Cropping* with a package such as Photoshop, simply because this provides a more accurate and instantaneous preview of any adjustment that you make.

The color adjustments do have their use if you find that there is a consistent color or exposure problem with your scans, which is likely to be different between film brands. With experimentation, you may be able to make a color adjustment at the scanning stage that then simplifies batch scanning of a particular emulsion type.

Some scanners come with some extremely intelligent utilities for correcting image problems, with names like ROC, GEM, and ICE (*see box*), which provide genuinely useful adjustments. However, even if your scanner does not have them, most of these adjustments can be made later by packages such as Photoshop (ROC, GEM, and SHO can even be bought as plug-ins to work within Photoshop and other compatible programs).

The one adjustment that is worth using, or at least considering, before you scan, is a dust-removal system—ICE and FARE are the two best-known. These use the scanning process to help identify the position of the dust in a way that can not be achieved once the image is digitized (*see page 182*).

The other adjustment that is tempting to include as part of the scanning process is sharpening. Scans, as with all digital images, tend to look slightly fuzzy in their raw state, and don't have the bite of the film original. This is a by-product of the way the image sensor works (*see page 24*), and therefore images need to be sharpened electronically before they are used. However, the amount of sharpening required will depend on how the picture is being used, so is best applied using editing software after all other manipulation has been done (*see page 226*). You should therefore scan without any sharpening.

Acronym translator

FARE
Film Automatic Retouching and Enhancement
Series of adjustments found on Canon scanners offering dust/scratch removal, grain correction, print color restoration, and backlight correction. Canon's alternative to GEM, ICE, ROC, and SHO.

GEM
Grain Equalization and Management
Reduces the visibility of grain when scanning slides or negatives. Usually has different levels of application to suit the characteristics of the emulsion. Technology licensed from Kodak subsidiary, Applied Science Fiction (as are ICE, SHO, and ROC), and used by a wide number of film scanner manufacturers.

ICE
Image Correction and Enhancement
Facility for removing dust and scratches
(*see page 184*).

ROC
Restoration Of Color
Tool to help turn back the years when scanning faded slides and prints.

SHO
Shadow and Highlight Optimizer
Helps retrieve shadow detail in high-contrast scenes.

You don't have to stick with the software that came with your scanner: you can use an alternative control utility, which may well give advantages in handling, color, and exposure compared to the program that came packaged with the device. The best-known is VueScan (www.hamrick.com), which is relatively inexpensive, works with Mac or PC, and claims to work with over 400 different scanners. An alternative is Silverfast (www.silverfast.com).

Three different scans of the same Fuji Provia 100F slide, using a film scanner at 2700dpi. All images were sharpened in Photoshop using USM.

Fully auto
Color and exposure are set by the scanner.

Manual
Curves control was used to show how a warmer, darker image could be created using the scanner software.

Pixel Polish
Using the Konica Minolta's scanner intelligent optimization setting, the longhorned cow looks better, but the grass now looks unnatural.

Main window of scanner software
Provides preview index thumbnails of the slides currently loaded in the carrier.

Variations window
Shows thumbnails of how different options would affect the image.

Color control window
Provides simple sliders for altering color balance of the preview.

183

1.4 Dust and dirt

Much as you do everything that you can to maximize the quality captured during the scanning process, it is the small things that let you down. Specks of dust may be invisible on a 35mm negative or slide, but when they are enlarged on the computer screen after the image has been digitized, they can they can appear as huge carbuncles.

Prevention, as with medicine, is preferable to a cure, but often already too late to store your film images carefully if they've already suffered years of neglect. You should, however, try to scan images in as clean an environment as possible, and keep the scanner stored between uses in a dust-free environment (in a bag within the box it came in).

You can, of course, remove dust from a film or print surface before scanning. A blower brush can prove relatively effective, but as film has the tendency to hold a static charge that attracts small particles, the surface

should be touched only as a last resort. Cans full of compressed air can be bought for the purpose, and can be used on lenses and other equipment, but there is a risk that the propellant is squirted out which could stain the film. A better solution is a foot-pump, such as you'd use to blow up an airbed—ensure this is dry and sand-free!

Dust is not the only problem: mould can be found on the surface of slides, and fingerprints leave an oily residue. To remove these prior to scanning, a more intrusive form of cleaning must be adopted.

Although software solutions are available for automatically removing dust and dirt from a digitized image, the manual cloning methods (*see page 222*) can be labor-intensive, and automatic methods can lead to a drop in overall image resolution. It is best therefore to get the original as clean as possible before the scanning begins and, when using a flatbed scanner, ensure that its glass is kept scrupulously clean.

Plug-in remedies

If your scanner does not have an ICE or FARE setting, you do not necessarily have to spend hours painstakingly spotting out the blotches on your dusty scans. Photo-manipulation packages provide some solutions, but some of the most effective are third-party plug-ins that work as an optional extra with programs such as Photoshop.

The one to try out first is Polaroid's Dust and Scratch Removal utility. This is available to download free of charge from the www.polaroid.com website; it is available for both Mac and PC platforms, and can be used either as a plug-in or as a standalone application (so you don't need to own Photoshop or Photoshop Elements).

Polaroid's plug-in provides a good-size preview of the problem with this badly scratched color negative.

The control box allows you to set the type of blemish (white or black), and then the degree of the problem—set the minimum amount you can get away with.

A preview shows the amount of dust and scratches found with the current settings. You can then adjust these as necessary to get a better selection before the dust-removal utility kicks into action.

Digital ICE is a feature found on many film scanners, and on some high-resolution flatbed scanners with a built-in transparency hood. Pioneered by Eastman Kodak, and licensed to other manufacturers, Digital Image Correction and Enhancement is a part-hardware, part-software solution that automatically eliminates dust and scratches when scanning.

In addition to the normal light source, an infrared lamp is used to detect the presence and position of dust and scratches, as these are at a different distance than the film emulsion surface. By analyzing the surrounding area, the blemished pixels are digitally replaced. Canon's FARE system uses a similar approach. Both systems work extremely well, and for the amount of retouching it saves, is a feature that you should check a new scanner provides, even if it does increase scanning time substantially.

However, ICE does not work with all emulsions: it does not work with traditional silver halide black-and-white films (but it does work with chromogenic black and white films such as Ilford XP1 and XP2, or Kodak T400 CN). Kodachrome films can also lose noticeable detail with ICE switched on, although later versions of the technology are better than earlier ones.

Without ICE
Dust and scratches are clearly visible.

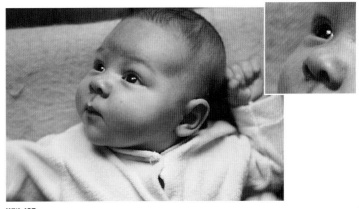

With ICE
Blemishes removed without any need for manual retouching.

1.4

Do not be tempted to try and clean the surface of a slide or negative with a standard lens cloth or tissue. Special lint-free, non-abrasive disposable cloths can be used lightly and do not scratch the surface of the gelatin or the emulsion. The best-known brand is PEC.PAD, made by Photographic Solutions and sold in packs of 100 4in (10cm) square wipes.

These wipes should be used with a foul-smelling but magical cleaning solution made by the same company, called PEC-12. Spray a small quantity of the solvent on the pad, and when rubbed over the surface of the film, it removes fungal growth, sticky residues, and grease marks with ease. With badly affected slides, it is best to remove them from their mounts before cleaning.

1.4 Increasing dynamic range

For the serious photographer, it is not the resolution, the color depth, or ICE that are the most important considerations when choosing a scanner. The key benchmark for a scanner's quality is its dynamic range—its ability to extract tonal detail from a high-contrast original.

Image density is measured on a logarithmic scale (like the Richter scale used for measuring earthquakes), where 0 is the brightest, purest white, and somewhere above 4 is the deepest, darkest black. There is no theoretical maximum to the density value, however, because it is a nonlinear scale, a density of 2.0 is ten times darker than one of 1.0, and a reading of 4.0 is a thousand times darker than 1.0. To put it another way, a density of 2.0 represents 99 per cent opacity, 3.0 represents 99.9 per cent opacity, and 4.0 represents 99.99 per cent opacity.

The maximum and minimum densities that can be recorded by a scanner are known as DMax and DMin. The dynamic range is calculated by taking one value away from the other. Typically a reasonable film scanner will have a dynamic range of 3.5 (with a DMin of 0.2 and a DMax of 3.7).

Manufacturers, misleadingly, often quote the theoretical maximum density range based on the color depth of the model, rather than that which can actually be achieved. So a 42-bit scanner is advertised as having a density range of 4.2, and a 48-bit scanner is specified as having a dynamic range of 4.8. Performance always falls short of this utopian figure. One of the main factors that affects the real DMax value is electronic noise; however good the scanner, the signal generated by the CCD is not completely clean, and this shows up in dark areas as colored pixels.

Dynamic range is much more of an issue with slide film than with negative film or prints. And the difference in a scanner's performance in drawing detail out of the shadows becomes much more significant when scanning a high-contrast slide, such as a backlit scene or a nightscape, or an underexposed shot. Less able scanners tend to turn more of the scene to jet black, losing subtle gradations of the darker tones. The slides that scan best are inevitably those that are frontally lit and have no areas of extreme shadow or highlights.

One way in which to eke as much detail out of the shadows of an image is to scan the slide two or more times, using different exposure settings at each pass. The idea is to set the exposure so that maximum detail and minimum noise are captured in the shadow areas with one scan, then to capture the other areas of the picture with a second scan. If there are extreme highlights, a third scan may also be useful.

The multiple scans at different densities are combined at the manipulation stage (*see page 254*). To help register the images easily with each other, do not remove the slide from the holder between scans; once they are sandwiched with each other, you then simply mask the areas you don't need from each version.

It is possible to recover shadow detail from a single scan using manipulation tools (*see page 208*), but there is only so far you can go before messing with the data becomes obvious.

Multipass scanning

The colored noise that appears most noticeably in the dark areas of a slide (and in the light areas of a negative scan) is random. Scan the slide again, and the noise will likely affect a different distribution of pixels. Multipass scanning, found on some scanners, uses this factor to reduce this electronic noise. By scanning the same image two or more times, it plots the differences between what should be identical digital images. It uses this information to isolate the noise and take corrective action. The greater the number of scans, the more efficient the method is—but obviously this greatly increases the time taken to digitize the image. You can usually specify between two and 16 passes.

Normal scan
Noise appears as blotchy specks in the darker areas of this night-time shot.

16x Multipass scan
The amount of noise in the same area is significantly reduced.

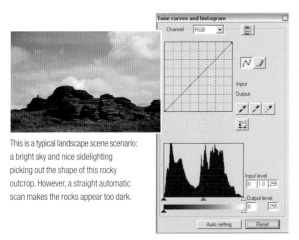

This is a typical landscape scene scenario: a bright sky and nice sidelighting picking out the shape of this rocky outcrop. However, a straight automatic scan makes the rocks appear too dark.

Combined in Photoshop, graduate masks were used to make a rough selection from each of the two versions. Then these masks were modified to suit the subject more specifically using the *Paintbrush* tool. The result is an image that has all the dynamic range of the slide, with a touch of added drama in the sky.

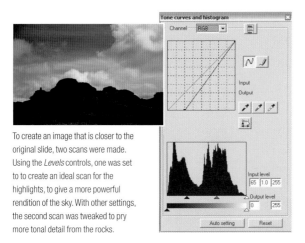

To create an image that is closer to the original slide, two scans were made. Using the *Levels* controls, one was set to to create an ideal scan for the highlights, to give a more powerful rendition of the sky. With other settings, the second scan was tweaked to pry more tonal detail from the rocks.

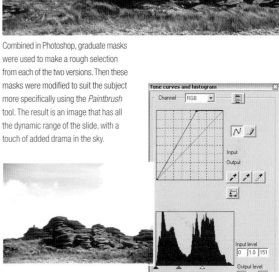

This is a particularly high-contrast scene, which even slide film failed to capture successfully. In this instance, three separate scans were made: one for the boats in the foreground, one for the bright area in the top right corner, and the other covering the rest of the image area.

Automatic

Combined

Highlights

Shadows

2.1

2.1 Hardware/Software

Manipulation is the optional step in the digital workflow. Once your pictures are taken, there is no need to play around with them on a computer. In fact, you don't need to own a computer at all. Millions of digital photographers skip this section and move straight on to output: they capture their images digitally, and then they get them printed out—connecting the camera directly to the printer, say, or taking their memory cards to a commercial processing center.

However, it is this stage that makes digital photography so different from the olden days of film. It is much more than simply the modern equivalent of a darkroom—it is the sheer ease of making changes to a digital image that is the starting point. You can correct minor mistakes in composition or color balance so simply that it is almost foolish to leave things as they are. In addition, the more sophisticated changes that can be made open up a completely new level of creativity and artistry in the photographic process.

Before you can cut loose and process the pixels in your pictures, there are two things you can't manage without. One is a suitable computer, and the other is image-editing software. And with so many other peripherals, programs, and plug-ins to choose from it is not always to identify what you really need on your desktop.

2.1 Digital darkroom

Digital-image manipulation used to be about the most demanding thing that you could do with a desktop computer. But in a few short years, minimum PC specifications have moved on so that editing your photographs will put a lot less strain on your computer system than games or video-editing.

However, the basic computer setup is still important, particularly if you are going to work on the highest resolution files, and expect images to open and render on screen with a minimum of delay. You may have to make do with the computer that you already have access to; but if you are shopping for a new model or upgrading your current system, there are some things that you should bear in mind.

Operating system

Although Apple Macs are still favored by creative professionals, Microsoft Windows is nowadays just as easy to use and offers at least as much functionality as Mac OS X. Although all the top image programs are available for both Mac and PC, there is a greater choice of low-cost software and freeware for Windows. The exact version of the operating system you have will limit the selection of software and peripherals too, and this should be considered carefully before upgrading to a brand-new OS too quickly.

Processing power

The faster the processor the computer uses, the faster it is likely to get things done. Go for the fastest that you can afford. Be warned, however, that you can't compare the speed (measured in megahertz/MHz or gigahertz/GHz) of Mac and PC processors directly.

RAM

The bigger the size of the image file you are working on, the more RAM you will need. So although the minimum requirements of the image-editing software may seem reasonable, this is an area that is worth upgrading first if your system becomes sluggish.

Digital images are going to be some of the largest files that your computer will handle. An uncompressed file from an 8-megapixel camera will be around 45MB if saved in 48-bit form, but if you start adding layers, it will double or triple in size very quickly. Your computer also has to remember additional information while you are working; it keeps a precise record of the last few changes you have made, for instance, so that it can undo the latest steps if required. This eats up the working memory. If the RAM runs out, the computer has to use spare capacity on the scratch disk (usually your hard drive), and this slows up operation.

In order to save RAM and minimize the risk of crashing, it is also best to forget your computer's multitasking capability. Quit other programs if you want to speed up your image-editing work.

Hard drive

The 80GB that came with your computer might have seemed as if it would last you and your children a lifetime. But when you start processing images, the disk space can soon be eaten up. You may want to keep several versions of the same file, and to keep great, good, and not-so-good images for future reference. And as computers have to store other things (including their own increasingly large operating systems and core programs), your hard drive may start creaking at the seams after shooting and manipulating a couple of hundred pictures. Get the biggest you can afford, or get an additional drive (*see page 270*).

Connections

The type of connections that a computer provides influences which peripherals that you can use, and the speed at which they can send and receive data to the computer. USB and FireWire are the most important of these (*see page 264*). Check the number of ports, as you often need more than you think. It is also handy to have some in an easily accessible position (on the keyboard, say, or on the front of the CPU), as well as others tucked out of sight.

Disc burners

Buy a new PC, and you should expect a combination DVD and CD burner as standard. Being able to transfer your images to disc is a great way of safely backing them up, easing up room on your hard drive, and giving copies of your pictures to friends. If you don't have one built-in, you can get one as an external plug-in accessory (*see page 272*).

Broadband

Fast Internet access has become the norm, but for the serious photographer, data transfer speeds can be particularly important. Software to trial or buy can be downloaded direct to the computer, and the files are often large. However, the upload speed is just as important. You may want to send an uncompressed picture to an online lab for printing, say. And you may want to use web-based album and image storage services (*see page 302*). Most Broadband services are asynchronous–you can download much faster than you can send. It is worth therefore looking at upload speeds when considering a Broadband provider.

Laptop advantages

When buying a new computer, it is worth considering a laptop rather than a desktop system. As long as you ensure that the screen is a suitable size and quality (*see page 194*), it can be used for editing images at home; and its portability means that it can also be taken out on shoots. Although you may not want to manipulate images on location, you have the advantage of being able to preview your shots on a larger screen at high magnification. In addition, the laptop's hard drive can be used to backup images and free up room on the camera's memory card.

If you attach all your peripherals to a USB hub on your desk, you need only plug in one cable to attach them all to your portable—simple and convenient.

Windows laptop

Apple Macintosh laptop

Useful peripherals

SCANNER

PRINTER

DVD BURNER

USB HUB

GRAPHICS TABLET

2.1

2.1 Choosing a screen

The screen may not seem the most important part of a PC system, but for the digital photographer its quality is key. Despite all the clever tools, image manipulation is a visual craft. The software largely relies on the premise of WYSIWYG, or "what you see is what you get"—you use the way that the image is displayed on screen to decide which corrections to make, and to decide how heavily they should be applied. If what is shown on screen is not a reasonable mirror image of the actual file, accurate and appropriate editing becomes guesswork.

This is not just a question of buying an expensive monitor, however; the way that it is used is even more important. In particular, it needs to be calibrated so that it shows colors as accurately as is possible (*see page 196*).

However, the hardware does have a part to play. The following are some of the issues and choices to consider when it comes to buying a new screen—whether as a standalone device, or as a built-in element of a laptop or desktop PC.

Tube or TFT?

Cathode ray tubes (CRT) have an edge on brightness and color richness that has made them the choice for the serious image manipulator. However, the constant improvement and affordability of LCD screens make these an acceptable alternative for most users. Practically all LCDs use active TFT technology (*see page 40*), and have the immediate advantage that they take up much less space on the desktop. If you choose a laptop, which provides further advantages for the photographer (see box), LCD is the only option you get.

LCDs maintain their color settings without adjustment better than CRTs (*see page 196*), and have no flicker (*see below*); however, there is a risk of dead pixels—non-functional dots that can be a real irritant when editing. You can check for these before purchase, but LCD screens are fragile, and pixels can "die" through careless handling.

Screen shape

Monitors traditionally have an aspect ratio of 4:3, the same as used by many digital cameras (*see page 114*), which may seem ideal for image-editing. The trouble is that editing programs require you to have other things on screen at the same time—tool palettes, for instance, and a selection of the numerous pop-up windows that provide further information and functionality during the manipulation process. Furthermore, pictures shot on most digital SLRs have a slightly wider aspect ratio. If you have a choice, therefore, it makes sense to use a widescreen-format monitor with an aspect ratio of 16:10; this provides room at the side of a full-screen-depth image for tools.

Size

The size of monitors is measured diagonally from corner to corner. However, with tube-based displays the corners and edges of the screen are hidden by the casing. This means that a 15in (38cm) TFT screen has the same visible screen area as a typical 17in (43cm) CRT display.

Size is helpful for getting a larger view of your images, but resolution should also be taken into consideration. Bigger screens obviously take up more room, particularly so with CRT models, which are usually as deep as they are wide.

Resolution

Many monitors allow you to scale the image up and down, so that it is made up of more dots or pixels. However, it is the native resolution that is important when comparing the quality of screen (particularly LCDs); it is also generally best to use a screen at this native resolution, as scaling inaccuracies may distort an image. An average low-cost 17in (43cm) screen now typically offers an SXGA matrix of 1280 × 1024. Resolution is generally dependent on screen size (*see table*), but a certain screen size is no guarantee of the native resolution.

Refresh rate

How quickly the image refreshes itself can be important with some applications, particular games and video. It is less of an issue with digital imaging, so the sluggish response rate typical of LCDs is not important. The flicker of CRTs is important simply because the faster the rate, the easier it will be on your eyes. This is an important factor if you are going to be staring at your images for hours. A flicker rate of 85Hz or above is ideal when choosing a CRT.

● Position the screen so that windows and lights do not cast reflections on its surface.

● If there is a window in the room, one of the best places to put the screen is in front of it. Then use blinds or drapes to diffuse the light.

● To help reduce reflections further, fit a viewing hood. These can be bought as accessories, and often come with professional graphic design screens. However, they can also be made easily with sections of black card.

● Elevate the screen so that the top of the viewing area is level with your eyes, or slightly higher.

● Keep the screen clean. CRTs are particularly prone to attracting dust, and should be wiped daily. LCDs need to be cleaned with more care to avoid scratching or damaging pixels.

● Forget those colorful patterns and pictures on the screen desktop—the colors can easily lead you to misjudge the colors of the image placed on top of this. Stick to a nice, neutral gray, which won't lead you astray. Save your favorite pictures as your screensaver (see page 301).

2.1

Name	Dot/pixel arrangement	Aspect ratio	Typical screen size
VGA	640 × 480	4:3	13in (33cm)
XGA	1024 × 768	4:3	15in (38cm)
SXGA	1280 × 1024	4:3	17in (43cm)
WXGA+	1440 × 900	16:10	17in (43cm)
UXGA	1600 × 1200	4:3	19in (48.5cm)
WSXGA+	1680 × 1050	16:10	20in (52cm)
WUXGA	1920 × 1200	16:10	23in (58.5cm)
QXGA	2048 × 1536	4:3	19in (48.5cm)
WQXGA	2560 × 1600	16:10	30in (76cm)

195

2.1 Screen calibration

Whatever type of screen you use (*see page 194*), it is essential that it is set up to show colors as accurately as possible. Keeping it set as the last person left it, or as it came out of the box, can mean that you correct the colors of your digital images unnecessarily or in the wrong direction. You might carefully adjust the images of the wedding you have shot, so that the gown looks white, but when you send the pictures to others, the gown looks green.

This might seem like an undue fuss, as the next person's screen may be badly adjusted. Similarly, many shots will look reasonable displayed with a wide range of slight color casts; after all, in the days of color negative film, prints looked slightly different depending on who printed them and even on who manufactured the film, but few people complained.

In the digital world, however, it is possible to be precise about color—and it is you who exercises the control. No one is saying that you have to produce images that match the real world with scientific precision; it is just that when you correct or distort color, you want to know that others will see the same hues when they view the picture (assuming they also calibrate their equipment correctly).

There are essentially two different ways in which to calibrate the color of a computer screen; you can use either your eye, or a machine to judge the color for you.

The visual method produces more accurate results than you might imagine, and relies on an onscreen utility that guides you through the process. Adobe Gamma is about the best known for Windows, while Apple Macs include a Display Calibration Assistant.

Alternatives include the Windows-based free Monitor Calibration Wizard (www.hex2bit.com/products/product_mcw_dl.asp), or the Mac shareware solution, SuperCal (www.bergdesign.com/supercal/).

With these programs, a series of screens ask you to adjust a slider until two shades of tone are barely distinguishable; the secret here is to lean back from the screen and squint at it slightly. Calibrate only after the screen has been on for at least 30 minutes, and under the lighting that you will use when editing.

You have to make two choices as part of the process: First, you have to set the screen for the color temperature (*see page 56*) of the ambient lighting. Many screens are set to a very blue 9500K, but for critical work most professionals use 5000K or 6500K (also known as D50 and D65) as their standard. Second you must choose the Gamma level, which is essentially the contrast of the image; usually you set 1.8 for Macs and 2.2 for PCs, but the tamer 1.8 setting is generally preferable for image manipulation. You need to do this calibration about once a month with a CRT, and every three months for an LCD.

The alternative is to buy a calibration kit: this uses a color meter that clips onto the screen, and objectively measures the color of targets flashed up by the accompanying software. It is a relatively expensive device, but it produces more precise and more consistent results than the visual method, making it a worthwhile investment for the serious photographer. Options include ColorVision's Spyder, Gretag-Macbeth's EyeOne, and X-rite's Monaco Optix systems.

Spyder
Systems such as ColorVision's Spyder 2 use a hardware/software approach to creating the screen's color profile. A densitometer attaches to the front of the screen, taking the place of the human eye in the step-by-step calibration process.

Simple solution

Calibration Print

Some processing labs do their best to help simplify the screen calibration process; they provide a free test chart as a downloadable image file, and provide the same image as a finished print from their printing equipment (this example is provided to customers of www.photobox.co.uk). Using the print as a guide, you can then adjust the monitor. This will help to avoid unexpected colors when using the lab's own service, but it may not be a universal solution (*see opposite*).

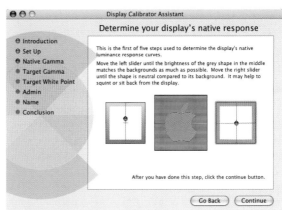

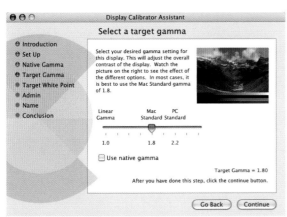

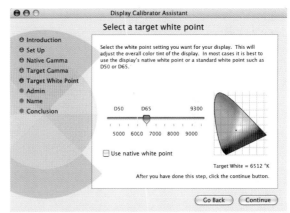

Calibrating your computer

The Mac OS onscreen calibration is typical of the visual approach to setting up a display's color characteristics. It guides you through the process and can be reasonably accurate once you get the hang of what it asks you to do—and once you know how to correctly select from the choices it forces you to make.

Color management

While calibrating your computer monitor is a major step towards being in real control of the color of your digital images, it is not the only one. Every device in the digital imaging chain has its own way of showing color: different cameras reproduce color in slightly different ways, as do scanners; other people's computer screens may have different color characteristics to your own; and printers vary not only in color reproduction from model to model, but also vary depending on the paper and ink you use (*see page 288*). To confuse things further, each type of device can see only a selected range of colors; and however wide this palette or "color gamut" might be, the precise colors that can be displayed vary from device to device.

A simple solution to color management is to invent a way of dealing with images that works with the devices that you use. You can calibrate your monitor and camera to display your picture accurately, and then set up the printer to reproduce what you see on screen as closely as possible.

This "closed loop" system is fine—but what if you want to send an image to a friend, upload an image to an online lab, or work on pictures shot with a different camera? The new device needs to be calibrated to work with your own personal color language.

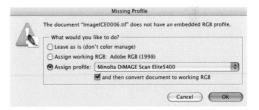

It is for this reason that a universal system is used. This translates each device's peculiar way of seeing color into a standard form, which can then be interpreted by the next device in the chain. In a properly color-managed system, each device has its own color profile, using a standard drawn up by the International Color Consortium (ICC). This ICC profile is either attached to the digital file itself, or provided as a lookup table for use by the next device's processing software.

Unfortunately, ICC profiles are not universally provided for each piece of equipment; often, at best, you simply get a generic profile based on the AdobeRGB or sRGB color space (*see page 30*). Similarly, not all software is capable of using color profiles. However, using specially produced color targets and software, tailormade ICC profiles can be generated for any capture device for use with compatible image-manipulation programs.

197

2.1 Man-machine interface

Digital image manipulation typically involves a lot of button-clicking. For every image you clean up and edit, it is possible to have clicked the mouse hundreds of times—and to have used the keyboard on dozens of occasions to access shortcuts, and to name the files as they are saved. These simple input devices generally come free with your computer—but although these will undoubtedly suffice, they are parts of the desktop setup worth considering carefully: the mouse, in particular, is frequently used as an artist's brush as well as a selection tool.

The one-button mouse that comes with Mac systems is designed to look nice, but can be easily replaced by a low-cost alternative that cuts down on unnecessary finger movement in the long run. A three-button mouse, as is standard with Windows systems, provides an option button that aids one-handed tool operation, and a scroll wheel that speeds up selections of files from long lists and can be used as a quick way of zooming in and out of an image. Those using laptops should also use a multi-button plug-in or wireless mouse, as trackpad or nipple controls are completely unsuitable for image-editing.

Those still using a mouse with a round rubber ball will find using a modern optical mouse significantly easier. An optical mouse does not need regular cleaning, and provides much smoother cursor movement; you can also dispense with the services of your mouse mat.

A cordless mouse is also worth considering—particularly if your computer already has Bluetooth capability. This mouse works by using radio waves to communicate with the computer; the advantage is that it tidies up the desktop; the disadvantage is that the mouse is more likely to go missing, and requires batteries for its power. Bluetooth keyboards can also be bought.

Mice

Mice were popularized as a man-machine interface in 1984 by the Apple Macintosh, and while the principles are essentially the same now, there is a lot more choice. It's a good idea to find a mouse you find comfortable, and the most accurate and reliable feature a light, rather than a ball, on the underside. If you're still using a ball mouse, upgrade.

Keyboards

There are two distinct types of keyboard out there—the traditional straight model and a variety of "ergonomically designed" ones. The latter are designed with typists in mind, and may offer little benefit to the photographer, who only makes occasional use of the keys to access shortcuts.

Avoiding aches, strains and pains

Editing digital images is rarely a five-minute process—you can end up spending hours in front of the screen refining your work. Long sessions, combined with bad posture, can lead to the risk of eye-strain, muscle aches, of repetitive strain injury (RSI). Consider these precautions:

● Take regular breaks from looking at the screen. Five minutes every hour is ideal. Actually get up, stretch your legs, and have a drink.

● Learn shortcuts for favorite tools and commands (see page 204) as this will minimize the number of mouse clicks you have to make.

● Ensure that your chair is adjusted to the right height for the work surface—your feet should be on the ground, and the keyboard/mouse should be at the same height as your elbows. This will ensure your arms work at a comfortable angle.

● Pay attention to pain, numbness, or tingling in fingers, hands, wrists, arms, shoulders, or neck. Take a rest if you get these warning signs; if the pain continues seek medical advice.

Graphics tablets

Some photographers prefer to use a graphics tablet in place of the mouse for image manipulation. This peripheral comprises of two parts: you move the cursor around the screen using a stylus or pen, which paints and prods on the pad. It is the pad that communicates with the computer, using either a USB lead or Bluetooth.

The advantage of the graphics pad is that the stylus is much more akin to using a brush or an airbrush. With practice, it provides smoother movement than a mouse, which is particularly useful when drawing a line to select or cut out an object. The stylus also provides extra functionality: just as with a real brush, the strength of the effect you are applying can be altered by the pressure that you apply. The price depends on the size of the canvas area of the tablet.

2.1 Choosing the editing software

Image-editing software comes in all different levels of sophistication, from basic push-button utilities that any child could use, right through to programs that are designed to meet the needs of professional repro houses.

Prices vary enormously, too. Seemingly sophisticated programs are often provided free with cameras and scanners, and are distributed as freeware or low-cost shareware, while software titles designed with the professional user in mind may well cost more than your computer or your camera. And even if you choose an expensive option, there are always extra utilities and plug-ins (*see box*) that coax you into spending more on additional pieces of software to add new functionality to your desktop.

You can dare to be different, but for the serious photographer there is a straight choice between two core image manipulation programs. The first, and the best known, is Adobe Photoshop, a professional-grade product that has stayed at the top of the tree since it was first introduced in 1990 well before the digital camera revolution had begun, and was originally intended for use with early desktop scanners.

The ninth generation of this software, Photoshop CS2, is still the program by which all others are judged. However, for around one-tenth of the cost, you can instead buy a stripped-down version of this program: Adobe Photoshop Elements offers much of the same functionality—and certainly more than enough sophistication for most photographers.

There are significant differences between the two, but if you were paying the full price for a copy of the software, you might well be tempted to save the extra bucks (investing them in an additional lens for the camera, say, or more memory). Certainly, Elements is an excellent learning tool. Furthermore, there are numerous "get-arounds" to help recreate full Photoshop features that don't seem readily available with Elements.

Elements is often bundled with cameras, scanners, and printers. Both programs can be tried for free, direct from Adobe's own download page of its website.

The Photoshop CS2 advantage

These are some of the key features that CS2 offers that you won't find with Elements 3:

● *Channels:* Enable you to split the image into its color components (*see page 206*).

● CMYK and LAB color modes, as alternatives to RGB.

● *Curves*: Probably the best way of changing the brightness or adjusting contrast (*see page 236*).

● Color balance adjustment.

● Color mixer adjustment.

● *Quick Mask* mode and layer masks.

● *History Brush*.

● Advanced color management.

● Advanced Web tools.

Despite the above list, both also have a lot in common:

● *Layers* and adjustment layers (*see page 206*).

● Support for 16-bit images (*see page 180*), although CS2 offers this with a greater range of adjustments.

● Support for most third-party plug-ins (see box).

● Adjustment layer masks.

● Support for RAW files.

● ICC color profile support.

● Range of filters and special effects.

It might seem that Photoshop and its sibling Photoshop Elements are the only digital imaging programs on the market. In reality there are many more you might like to consider—you might even find one of these installed on a new computer:

● Corel Paint Shop Pro (www.corel.com)

● Roxio PhotoSuite (www.roxio.com)

● Ulead PhotoImpact (www.ulead.com)

● The GIMP (www.gimp.org)

Corel Paint Shop Pro

This program's popularity is often attributed to wide range of features for a street price similar to Photoshop Elements.

Adobe Lightroom

A new category of digital imaging software is emerging, with both Adobe's Lightroom and Apple Computer's Aperture offering lightbox-like environments. They offer a faster workflow for photographers who like to get their work right "in camera," as well as superb viewing and cataloging tools, but still require Photoshop for serious manipulation.

2.1

Rather than having to come up with a completely new program, Adobe adopted a way of allowing other software manufacturers to add refinements and new features to the Photoshop family. Plug-ins are programs that work within Photoshop or Photoshop Elements (and some other manipulation programs). Some plug-ins perform a simple transformation, while others are extremely complex tools that can perform a variety of tasks.

Rather than adding completely new functionality, many plug-ins just offer ways of providing a more intuitive, or straightforward, way of making an adjustment. It is worth trying to download tryout versions before investing in the full product. Many plug-ins are sold in sets or suites, but some will inevitably be more useful to you than others.

201

2.1 Handling RAW files

Most image-manipulation programs can open a range of different image file formats, including the JPEG and TIFF files that are commonly produced by digital cameras and scanners (*see page 32*). The RAW files, which can be generated by digital SLRs and some other cameras, however, cannot be opened in the same way by these applications.

RAW files, as the name suggests, contain raw, unprocessed data. This is an interim format that cannot be accessed and manipulated in a conventional way until it has been fully processed, and then needs to be saved as in a standard file format (usually a TIFF). A further drawback is that different manufacturers use their own methods for storing the raw information, so it needs to be processed in different ways. It also adds another stage to the editing process, as you need to use another utility or application to produce a working image from its RAW state.

RAW, however, is the professional choice when shooting. Its primary appeal is that camera settings can be altered at a later date—you can therefore adjust white balance, exposure, shadows, brightness, contrast, and saturation at leisure. This allows you to control the "camera" more precisely than you could in the field, but acts as an insurance policy against gross shooting errors.

A further advantage is that RAW allows you to manipulate and save images in 16-bit form (*see page 180*), which produces smooth results when making alterations to exposure, tonal range and color balance using tools such as *Levels* and *Curves*.

There are essentially three different types of software that you can use to handle the RAW conversion process.

● The utility produced by the camera manufacturer.
● A program purpose-built for processing RAW files, such as Bibble (www.bibblelabs.com) or Phase One Capture One (www.phaseone.com).
● The plug-in converter that works from within image-manipulation programs such as Photoshop and Photoshop Elements.

Which you choose will depend on budget—and preferred workflow. Using the manufacturer's software is a free solution—useful if your chosen manipulation software does not support RAW. Purpose-built programs can prove expensive, but some find they offer an edge in extracting the best out of RAW's "digital negative"—and may offer useful batch processing tools.

Using Photoshop or Elements provides the immediate advantage that the format fits in better with a standard manipulation workflow; you usually open a new image to edit it, not just to convert it from RAW. Using separate programs, it is tempting to overcorrect using the RAW converter, making corrections that can just as easily be made in Photoshop—however, you generally have less control, and certainly less opportunity to go back at a later stage and tweak a correction. It is best to make gross corrections using the RAW converter and leave subtle color corrections, *Curves* adjustments, lens correction, and so on in Photoshop, where you can use *Layers* and multiple undo facilities to keep checking that you are really making an improvement to the picture.

After conversion, it is important that the RAW files are kept. These serve as a compressed original that you can return to in the future, should your manipulated file go astray, or you want to explore converting it in a different way.

Photoshop CS2

Photoshop's own plug-in automatically kicks into action when you try to open a RAW file. The tools in this screenshot demonstrate the advantage of RAW for correcting gross camera errors is obvious. Here, the lion shot was accidentally taken with a manual white balance setting that had been used the previous day. With other file formats you would reshoot if possible after checking the sequence, but with RAW this is not necessary—the WB setting is simply adjusted during the conversion process.

Bibble

Bibble is a purpose-built RAW converter that is available in low-cost consumer and high-cost professional versions.

DiMage Viewer

The manufacturer's free RAW conversion software does the job and provides a range of manipulation controls. However, it often lacks any real sophistication: Konica Minolta's Dimage Viewer is cumbersome, but it can be used to make obvious corrections before the image is saved ready for opening in Photoshop.

Capture One

Capture One was originally designed for use with Phase One's digital backs, but has been adapted for wider RAW use. It has a very high reputation for the results it produces, and for its usability.

Standardizing RAW

Not only do different camera manufacturers use different algorithms for storing RAW data; a RAW converter that works with a certain range of cameras won't necessarily work with a new model introduced into that range. For this reason, you need to check model compatibility to see if a piece of software really offers you RAW support.

Adobe is trying to standardize RAW with its own .DNG (digital negative) file format. The advantage of this format is that, unlike other RAW formats, it is not just a read-only format—you can save your files in .DNG form too. In fact, a freeware application is available from Adobe that will convert any RAW file to DNG (www.adobe.com/products/dng/main. htm). One advantage of using this is that you get a better archive format. It is more likely that the open-specification DNG format will be supported by future computers and software, rather than the model-specific RAW formats used today.

RAW files

Manufacturer	RAW file extension
Adobe	.DNG
Canon	.CR2
Canon (pro)	.CRW
Casio	.BAY
Epson	.ERF
Fuji	.RAF
Kodak	.DCR
Konica Minolta	.MRW
Leaf	.HDR
Leica	.RAW
Nikon	.NEF
Olympus	.ORF
Panasonic	.RAW
Pentax	.PEF
PhaseOne	.IIQ
Sigma	.X3F
Sinar	.STI
Sony	.SRF

2.1

2.1 Selection tools

The *Toolbox* is the most visible and most constant of the controls that an image-manipulation program such as Photoshop provides. It provides the pens, brushes, and erasers that are familiar to those who have used paint applications, and adds to it other tools, such as digital equivalents of the dodge and burn tools that were used by the traditional darkroom worker.

It is a mistake, however, to think that these are the only tools that such a program has to offer. Many others are hidden away in drop-down menus at the top of the screen, providing a wealth of manual and automatic controls. Items in the *Toolbox* may even be out of sight, hidden by the tool that has been left on top of the pile.

Not all the tools are particularly useful. Some, such as the *Sharpen* tool, are made redundant by more powerful controls, such as *Unsharp Mask*, that are curiously hidden with the filters (*see page 224*). Others, such as the *Path* tool (which is primarily used for cutouts), are more likely to be used by the graphic designer than the photographer.

However, it is helpful to know your way around these tools. Many are there not to make changes to the image directly, but to define parts of an image on which to work. As in the real world, there is often more than one tool that could be used to make the same selection. Furthermore, with complex shapes, it is often advantageous to use a number of tools in sequence to create the final selection (you can add to a selection by holding down the Shift key, for instance, or subtract from it by using it with the ⌥ (or Alt on a PC) key.

You can select each of the tools by clicking on it in the *Toolbox*, but it is worth learning the keyboard shortcuts for as many of them as you can remember. This will not only speed up your editing, but will also reduce the risk of wrist strain (*see page 198*). To switch to the *Zoom* tool, for instance, simply press the Z key, and to crop, press C; not all shortcuts are quite as easy to remember (*see box*). If there is more than one tool in the same compartment, you can access each in turn by pressing the appropriate letter key repeatedly; for instance, press the O key once you get the *Dodge* tool; press it again and you get the *Burn* tool; press it a third time and you access the *Saturation/Desaturation Sponge*.

Shortcuts to memorize

Keystroke	Action
⌘/Ctrl + O	Open new image file.
⌘/Ctrl + Shift + S	Saves file under new name or in different format.
⌘/Ctrl + 0 (zero)	Enlarges or reduces image to full-frame view.
⌘/Ctrl + ⌥/Alt + 0 (zero)	Sets magnification at 100 percent for pixel-by-pixel view.
⌘/Ctrl + Z	Undoes last step.
⌘/Ctrl + D	Deselects current selection.
⌘/Ctrl + A	Selects the whole image area.
⌘/Ctrl + Shift + I	Inverts current selection (selects what is not currently selected, and deselects what is selected).
⌥/Alt	Changes Cancel option in window to Reset.
↑ ↓ (cursor keys)	Increases or decreases value of a highlighted digit in a box. Quick way to alter percentage figure. You can also quickly enter a precise figure by pressing the appropriate digits, such as 7 followed by 0, for 70%.
G	*Gradient* tool
S	*Clone* tool
C	*Crop* tool
B	*Brush* tool
F7	*Displays* (or hides) *Layers* palette

Apple Macs and PCs have some different keys, so shortcuts in this book are given in the form Mac/PC. For example ⌘/Ctrl + Shift + S means Mac users should hold the keys marked ⌘ and Shift and tap the 'S' key, while Windows PC users should hold the keys marked Ctrl and Shift and tap the S key.

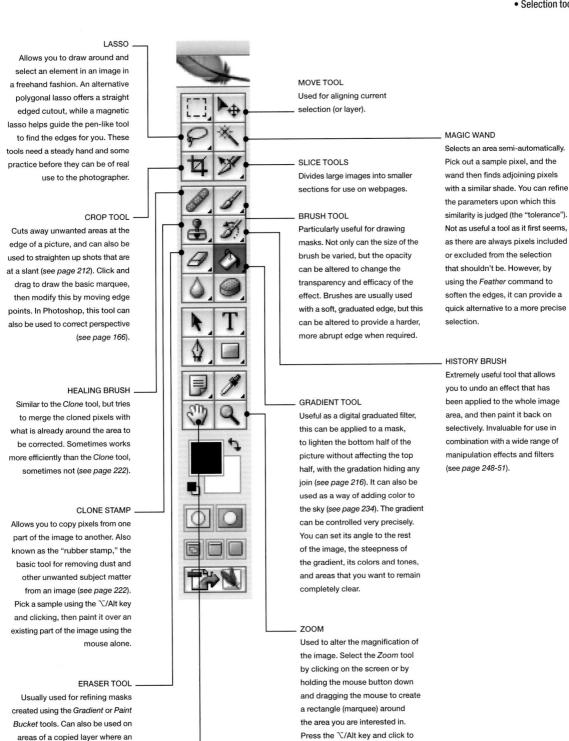

LASSO

Allows you to draw around and select an element in an image in a freehand fashion. An alternative polygonal lasso offers a straight edged cutout, while a magnetic lasso helps guide the pen-like tool to find the edges for you. These tools need a steady hand and some practice before they can be of real use to the photographer.

CROP TOOL

Cuts away unwanted areas at the edge of a picture, and can also be used to straighten up shots that are at a slant (*see page 212*). Click and drag to draw the basic marquee, then modify this by moving edge points. In Photoshop, this tool can also be used to correct perspective (*see page 166*).

HEALING BRUSH

Similar to the *Clone* tool, but tries to merge the cloned pixels with what is already around the area to be corrected. Sometimes works more efficiently than the *Clone* tool, sometimes not (*see page 222*).

CLONE STAMP

Allows you to copy pixels from one part of the image to another. Also known as the "rubber stamp," the basic tool for removing dust and other unwanted subject matter from an image (*see page 222*). Pick a sample using the ⌥/Alt key and clicking, then paint it over an existing part of the image using the mouse alone.

ERASER TOOL

Usually used for refining masks created using the *Gradient* or *Paint Bucket* tools. Can also be used on areas of a copied layer where an effect has been applied so that the effect only shows in certain areas (particularly useful if program does not have *History Brush*).

HAND

Drags areas of magnified image that are not currently visible into view.

MOVE TOOL

Used for aligning current selection (or layer).

SLICE TOOLS

Divides large images into smaller sections for use on webpages.

BRUSH TOOL

Particularly useful for drawing masks. Not only can the size of the brush be varied, but the opacity can be altered to change the transparency and efficacy of the effect. Brushes are usually used with a soft, graduated edge, but this can be altered to provide a harder, more abrupt edge when required.

GRADIENT TOOL

Useful as a digital graduated filter, this can be applied to a mask, to lighten the bottom half of the picture without affecting the top half, with the gradation hiding any join (*see page 216*). It can also be used as a way of adding color to the sky (*see page 234*). The gradient can be controlled very precisely. You can set its angle to the rest of the image, the steepness of the gradient, its colors and tones, and areas that you want to remain completely clear.

ZOOM

Used to alter the magnification of the image. Select the *Zoom* tool by clicking on the screen or by holding the mouse button down and dragging the mouse to create a rectangle (marquee) around the area you are interested in. Press the ⌥/Alt key and click to zoom out. You invariably need to zoom in and out frequently while manipulating, as you need both close-up and overall views to check how seamless a change has been. It is often easier to use the ⌘/Ctrl key and then press the + and - keys repeatedly to alter magnification; this can even be done when the *Toolbox* is not active.

MAGIC WAND

Selects an area semi-automatically. Pick out a sample pixel, and the wand then finds adjoining pixels with a similar shade. You can refine the parameters upon which this similarity is judged (the "tolerance"). Not as useful a tool as it first seems, as there are always pixels included or excluded from the selection that shouldn't be. However, by using the *Feather* command to soften the edges, it can provide a quick alternative to a more precise selection.

HISTORY BRUSH

Extremely useful tool that allows you to undo an effect that has been applied to the whole image area, and then paint it back on selectively. Invaluable for use in combination with a wide range of manipulation effects and filters (*see page 248-51*).

2.1

2.1 Elements of the image

It is possible to work directly on an image that has been transferred from a camera or saved from a scanner. You can manipulate all the pixels—or just a selection of them–making adjustments and improvements as you would to a picture that has been drawn on a piece of paper.

However, it is much better to make as few alterations to this "original" as possible (even though the real original file should always be kept intact; *see page 210*); instead, you should use layers to make the majority of your alterations. You can think of layers as acetate sheets above your original upon which you make alterations. If you make a mistake, or change your mind about a change, you can simply get rid of the layer, or modify it, without affecting what is below.

However, layers are not just transparent sheets: they can be copies of the original "background" layer; they can be completely opaque, obscuring everything below; the opacity can be varied, but also the way in which the layer interacts with those below can be altered; a layer can be set, say, to be visible only where it is lighter or darker than the layer below it; the order of layers can be altered by dragging them to the appropriate position in the *Layers* palette; they can even be dragged from one open image on the desktop to another (so the same alteration can be applied quickly to a series of shots).

Not all adjustments, unfortunately, can be made to layers: crop the image, for instance, and it affects every layer. But by using layers whenever possible you can experiment with using effects at different degrees, and in combination with others, without having to worry about having to start again should you change your mind later. Best of all, you can save the image with the layers intact, so that you can adopt a different approach when you return to the image days, months, or years later.

Layers can be set to affect just part of an image—the sky, say, or red flowers in the foreground. These selections are recorded as a mask that defines exactly which parts of the image are included in this adjustment. Masks are like a layer within a layer, although technically they are a special type of channel (*see box*), known as an Alpha channel. They are grayscale images: black represents areas that aren't affected, white areas get the full effect of the correction, and shades of gray show areas that are partially affected. Masks can be created using selection tools, or can be painted on directly. Because they are separate entities, you can go back to refine and change them whenever you want to.

The downside of using layers and masks is that they increase the size of the image file, sometimes substantially so. However, the benefits that they offer in terms of workflow, insurance against disaster, and experimentation make them an essential part of any image manipulation, however straightforward. Individual layers can be merged with others to help simplify the stack of versions and adjustments that you produce, and when you are completely happy, you can "flatten" the image to create a new background layer; however, it may be advantageous to save the new flat image under a separate name, keeping the layered version for future reference and refinement.

Layers

Simple layered image
This is a basic use of layers with transparency. The resulting image is made up of two layers: a shot of an empty sky and another image of the Chicago skyline where all but the buildings has been deleted to leave a transparent area. Here, Photoshop's Layers palette shows both layers with the transparent area of the Chicago layer shown as a checkered gray and white squares.

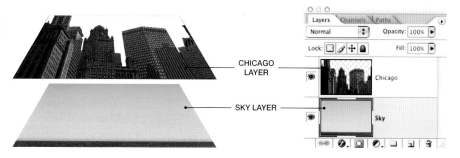

CHICAGO LAYER

SKY LAYER

Layer masks

A useful—and very flexible—aspect of layers is masking. Here a *Hue/ Saturation* layer has been masked so that only the areas covering the blue house remain active. The same approach can be used on any layer, and preserves the original data.

Adjustment layers

This image required a *Color Balance* adjustment to remove a strong red tint. Rather than use the *Image > Adjustments* menu, which alters the pixels permanantly, an adjustment layer is a more flexible alternative. It appears in the layers palette like a regular layer, only affecting those beneath it, but can be edited later. The original image, beneath, remains unaltered.

2.1

Channels

Every digital image created by a camera or scanner is produced (and usually saved) in RGB form. In many adjustments, manipulation software allows you to alter these red, green, and blue components separately; *Curves* (see page 236) and *Levels* (page 214) can be applied to one of the colors, for instance, which can prove a useful way of controlling the overall color of the image.

But in the full version of Photoshop and some other manipulation programs, you can actually access the red, green and blue parts of the image separately. These are known as channels, and in a sense can be thought of as another kind of

layer. They are generally displayed in monochrome when viewed separately, but gain color when two or more are shown together.

The advantage of having direct access to the channels is not obvious. But with some effects you may find that they produce fewer side effects when applied to a single channel: when trying to reduce grain in a scan, for instance, you often find that one channel is grainier than another, and by applying the correction to just this layer, you avoid unnecessary softening of a key part of the image.

Professional manipulation software provides other "color modes", which split the image

into different channels. Converting the image to CMYK (cyan, magenta, yellow, and black) can help to preview how an image will appear when printed, for instance.

In terms of manipulation, the L*A*B mode is particularly useful. This splits the image into two color channels (A and B), and a third, lightness channel. As the lightness channel has no effect on color, it can be a useful place to make manipulations that would otherwise cause unwanted coloration in the image.

The color mode can be changed temporarily to make a particular adjustment that suits the new mode, before reverting to the more usual RGB way of working.

2.2 The art of manipulation

In the digital darkroom there is no single way of doing things; in fact, image-manipulation software frequently provides a variety of different routes in which to make a particular adjustment, or even to select a particular area to work on.

Which method you choose is partly dependent on the software that you use. *Curves* is a fundamental adjustment that most serious photographers use on practically every image that passes through their computer. However, it is not found in basic programs, but this does not mean that similar results cannot be obtained.

Personal taste and familiarity also help decide which effects to use. The *Healing Brush* may seem superfluous, for example, if you mastered the *Clone* tool before this advanced blemish remover was invented. There are also plenty of fully automatic, one-touch corrections that can prove tempting to those who have little time to spare. However, these simple solutions rarely provide a perfect result, and are much harder to tweak later on in the editing process.

Digital-image manipulation is a craft—part science and part artistry. It is important to master the basic tricks and understand the wealth of data that the software can provide; then, with these skills harnessed, you can use them not only to improve your images, but to develop your photographic style in new directions.

2.2 Basic techniques

While *Layers* allows you to undo corrections that you have already made (*see page 206*), it is not the only safety net provided by Photoshop and other editing programs. The first line of defence against making an inappropriate change to your image is the Undo function; unlike most other programs, good manipulation software allows you multiple undos, allowing you to retrace your steps by dozens of different stages.

This Undo facility is not simply there for correcting mistakes; it becomes a way of checking that you are making progress. By going back one or more steps you can see that the alterations that you are working on are making the picture look better, and are not leaving any noticeable side-effects. The Undo facility can be accessed from the drop-down menu, but it is worth learning the shortcut for this maneuver, and for the keystroke combination that steps you forward to the point where you last left off.

Memorizing this history of what you have done can demand serious amounts of working memory, and because of this you can usually specify how many different history states the program will memorize—30 is a reasonable number if you are using *Layers* efficiently at the same time. To ensure that this does not slow the computer down, make certain you have no other applications running that could also put demands on the working memory (graphics and video software tends to be especially demanding, as do games). In the full version of Photoshop, your recent history of changes is detailed in its own desktop palette, allowing you to click from one state to the next.

The important thing to remember about history states, however, is that they are not stored with the file, so they are lost when you save and close your image. Furthermore, the history works in a true chronological sequence. If you go back a number of states to undo an earlier adjustment, you may lose useful corrections as well (which will then have to be redone). For this reason, it is better to turn off a layer (or delete it) whenever possible, rather than using a series of Undo commands.

Keep the original

When working on an image, you should always work on a copy, rather than the original, of the camera file. Instead of having to duplicate the file, you can use the Save As, rather than the Save, command when you have the file open.

However, you should ensure that you get into a habit where there is no chance of accidentally rewriting the original. This is particularly important when shooting JPEG files, which can lose some of their quality each time they are recompressed; for this reason, you should save the version you are manipulating as a TIFF or in the software's own format (.PSD for the Photoshop family) while you are working on it, so that the maximum image quality can be preserved. It is also a good habit to save originals and manipulated versions in separate folders to avoid confusion.

A file-naming protocol should also be adopted that makes the difference between the two files obvious. Most cameras can be set to use a sequential numbering system for your images; if you retain this number within the file name, whatever extra words or letters you add for your own

The Save As dialog box
The original scanned file is simply called "791.tif", which gives an indication of when it was scanned and on which archive disk it is stored. The manipulated version is given a more descriptive name to suit the project in hand—here it is "Venice"—but the number "791" is appended so its identity and heritage can easily be seen.

clarification at each stage of its evolution, you will always be able to see at a glance the link between two or more different versions of a file.

The History palette

The History palette shows in detail what has been done to this image of Venice's Bridge of Sighs since it was opened for the current editing session. By moving up and down the palette, the image can be returned to any of the intervening states—for a quick visual comparison, or to completely undo what has been done since.

Photoshop Elements General Preferences dialog box

History states

Reducing the number of history states that Photoshop, or Photoshop Elements, remembers will help your computer run faster, but the ability to retrace your steps is useful insurance and usually worth the drop in speed.

Photoshop CS2 General Preferences dialog box

2.2

211

2.2 Cropping

The ease with which images can be cropped is one of the most basic advantages of digital photography. By doing this on the computer you can see precisely how far to move the borders of the frame, and experiment with different variations before you choose the one that you are happy with. And by making the crop on a copy of the original (*see page 210*), you can always return to the unexpurgated version in the future.

The primary reason for cropping is to improve the composition; however well you frame the picture, some tightening up of the shot is often useful. Cropping allows you to narrow the angle of view, particularly if you did not have a long enough telephoto available at the time of shooting, or fell victim to the slight difference between what you see in the viewfinder and what is actually captured by the sensor.

Cropping also allows you to remove unwanted elements from the image—things you didn't notice at the time, perhaps, or that require the change of aspect ratio that cropping allows. Even when printing onto conventional-size pieces of paper, a squarer or narrower image can be accommodated simply by leaving wide borders (*see page 290*).

There are good reasons for making cropping the first thing to do once the image is opened: you don't want to have to remove dust from areas that you have no intention of keeping, and you don't want exposure evaluation skewed by dark corners that won't survive the finished work. If the crop is significant, the reduction in the scratch size of the file will also free up working memory, helping the computer to process image manipulations faster.

Because a crop cannot be performed on a layer and may involve starting again, should you change your mind, you should think carefully before executing the cut. In particular, it may be better to remove an unwanted element using cloning techniques (*see page 222*), rather than by cutting away that section of the frame. You must also consider other cloning you may want to carry out in the frame; it may be useful to use elements from the cropped part of the image as the source for the *Clone* tool: an unwanted person on the grass in front of a building, for instance, may be best replaced with lawn that you are going to crop.

Click-and-drag
A basic crop involves holding the mouse down and drawing a marquee frame over the wanted area of the image. You can refine the selection by moving the "handles" at the corners and center points of this frame. The cropped area is a different shade, which the user can choose—it is best not to make this too opaque, so that you can still see the whole image. Here, three presentable versions of a panoramic view of Florence.

As part of the cropping process, you can also rotate the image. This is particularly useful for shots of buildings and landscapes where the uprights are not quite upright and the horizons appear to be sloping. Even a tilt of a degree or two can look obvious when the image is enlarged on the computer, but this not so easily noticed when looking through the viewfinder.

Lining up the appropriate edge of the frame accurately with the horizon (or vertical line of the building) is not always that easy. One solution is to draw the marquee so one of its edges follows the line (even though this looks like you are cropping the image excessively). Rotate the marquee by clicking on a point outside the chosen area, drag to rotate the frame, then simply rotate until the line of the frame and the line in the image appear parallel. Once the angle of the crop is sorted, pull out the handles to confirm the real extent of the crop.

You will notice that when using this tool, the handles automatically "snap" to the edges of the image whenever they get too close; this is can be infuriating when trying to crop accurately. The solution is to hold down the Control key (Mac) while moving the border.

Cropping out error

As shot, the conical stairwell is slanting to the side slightly. This is corrected using the Crop command, lining up one of the edges so that it splits the pyramid in two. When the marquee is correctly rotated, it is then extended to provide as much picture area as possible. Sometimes you can extend beyond the available area slightly then clone in the missing parts; this allows you to maximize the image area.

Cropping freehand allows you to maximize the image's compositional strength. However, this may well mean that your image has different proportions to other pictures in a sequence (which may be important), and makes it less likely that the shot will fit full-frame, without borders, on standard cuts of paper. However, the *Crop* tool does allow you to set fixed proportions so that the marquee always produces a crop that conforms to the aspect ratio you require (it will even crop for fixed paper sizes, resizing the image to suit the resolution needed).

2.2 Levels

To the nonscientist, the *Levels* control can appear incomprehensible. Its graph-like readout, however, is well worth getting to understand, even for those with a more artistic temperament. It is the most basic control for altering both the exposure and contrast of our image—even if little adjustment is needed, it is one of the first things to check when working on an image.

The *Levels* dialog box presents the picture as a histogram, just like that used to assess exposure with some cameras (*see page 54*). It shows the tonal values of every single pixel in the image in a graph-like form, from the darkest blacks (level 0) through to the whitest whites (level 255). These represent the 256 possible values, and are the averages of each of the 8-bit red, green, and blue channels (shown on a scale of 0-255, even when looking at a 16-bit image). You can also see the values for the channels separately (*see page 216*).

The values shown are not of particular interest; the shape and the position of the histogram is. A graph that is stacked up on the left, at the shadow end, is probably underexposed and has had some of its tonal range "clipped" (or is very black). A graph that is stacked up on the right, at the highlight end, is overexposed and similarly "clipped" (with large areas of pure white). An ideal graph offers readings spread right across the graph, with some whites, some dark blacks, and a full range of midtones in between. The graph will dip down at each end, and will have one or more peaks in between.

When you look at the *Levels* display, however, you will notice that not all graphs stretch right across the baseline—they are squeezed into the middle, or are missing values at the black or white end of the graph. It is to these graphs that the *Levels* dialog offers immediate improvement. Bringing the sliders directly below the graph (white and black triangles) to the points where the histogram begins to rise will create a visible improvement in contrast. With experience, you can see pictures that can definitely benefit from *Levels* adjustment—they look gray and lack punch.

It is possible to make a *Levels* adjustment directly to the image. But rather than altering the original, background layer, it is better to use an adjustment layer, which can be created for a number of essential picture controls, including *Levels*. An adjustment layer is essentially a set of instructions that apply to the layers below it; unlike an image layer, it contains no pixels. A mask is automatically generated for the layer when it is opened, but this remains clear (and has no effect) until painted on.

Open up a *Levels* adjustment layer, and you can adjust the sliders to suit the picture; your settings are previewed on the screen, but the background is not affected. You can therefore go back and readjust the levels, turn off the layer, or make use of the mask to reduce the effect in some areas of the image. And you can do this any time you wish.

A terrible scan shows just how much a *Levels* adjustment can do to correct an image. The graph shows that the image lacks a full range of tones. The histogram only really gets going at level 29, and tails off completely at level 245. Moving the sliders into these points creates a much better-looking image of the harbor.

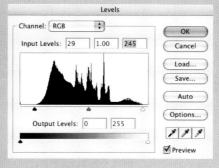

The *Levels* control is one of the adjustments that is best applied in 16-bit mode if possible. The extra data means that after the adjustment, the tonal gradation is much smoother. The improvement is not easy to see immediately, but it can be seen if you look at the histogram for the corrected image (or open up another *Levels* box).

This shot of a Gingko Biloba leaf benefits from pulling in the black level point slightly, in order to darken the background. The result looks much the same, whether in 8-bit or 16-bit mode. However, if you look at the subsequent histograms, the 8-bit version has breaks in the curve—comb-like gaps that show jumps in gradation. A comb-like graph is inevitable with some types of manipulation, and may be exacerbated by adding other effects. An extreme comb-like graph shows visible posterization in the image, adding a painting-by-numbers effect to what should be smooth gradations of color.

The 16-bit manipulated version of the image shows no breaks in the graph; this offers an image that is technically superior and would be able to take more abuse in Photoshop than the 8-bit version.

Image before manipulation
Black slider needs pulling in slightly.

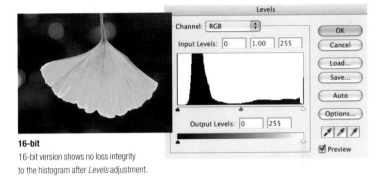

16-bit
16-bit version shows no loss integrity
to the histogram after *Levels* adjustment.

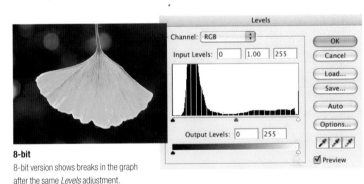

8-bit
8-bit version shows breaks in the graph
after the same *Levels* adjustment.

● The black- and white-point sliders are not the only things you'll find in the *Levels* adjustment dialog.

● An auto setting will make computer-generated adjustments. These usually tend to be too extreme, but it is worth seeing what the setting does (undoing the adjustment afterwards); as with other auto adjustments, this sets the benchmark as to how things can be improved—you then have to use the manual controls to do better.

● A central slider underneath the histogram can be used to lighten and darken the midtones in the image. This is only of use if your image-manipulation program does not have a *Curves* adjustment, which does the same thing, but with more control.

● The output sliders at the bottom of the box reduce the range of *Levels* used when displaying or printing the image. Pulling these sliders in very slightly, can offer advantages in commercial printing—decreasing the black output can save a small fortune in ink, for instance.

2.2 Using Levels selectively

When looking at the *Levels* display, it is often worth taking the time to switch from RGB and look at the levels for each of the color channels individually. This is an option that is provided in both Photoshop and Photoshop Elements.

Quite often, the shape and the position of each of these three histograms will be different. In cases like this it is worth changing white and black levels for the individual channels, rather than in the normal RGB mode. By doing this, you can often find that color casts in the image disappear at the same time, reducing or eliminating the need to change these with controls more specifically designed for color adjustment.

This approach, however, should not be used in conjunction with an *Adjustment Layer* mask. This mask is a powerful additional reason for using adjustment layers, rather than directly working on the image; but in this case, it is best to adjust levels and color balance separately.

An *Adjustment Layer* mask enables you to black out, or gray out, areas that you do not want to be affected (or want to be affected less) by the transformation. It is a technique that has some limited use with *Levels*, but proves even more useful with other adjustment layers.

Once the adjustment layer is selected in the *Layers* palette, you paint directly on the image—you see the mask in the palette gradually being shaded in. In addition to the *Paintbrush*, the *Gradient* and *Bucket* tools can prove useful. You can fill the whole mask black or gray with the *Bucket* (with a tolerance set to 100%), then reveal areas you want affected by the layer with white paint. A *Gradient* creates a smooth, gradual mask, which can then be tweaked, if necessary, with the *Paintbrush*. The gradient is added by drawing a line across the image to indicate its direction. The precise form of the gradation can be specified using the sliders in the *Gradient Editor* (accessed by clicking the current gradient type in the tool characteristics bar). The *Gradient* tool is not the easiest to use—and you often need to experiment to get the right effect—but it is invaluable for getting seamless results from masks.

Dodging and burning

The *Dodge* and *Burn* tools are digital recreations of old darkroom tools: by dodging, you selectively lightened a shot under the enlarger, by burning, you selectively darkened chosen areas.

The modern equivalents are much easier to use, and offer far more control—you paint over the selected areas and simply undo the last move or so if you go too far. However, you have to make this adjustment to an image layer. Rather than use the background, make a copy of it (or part of it) on a new layer, and experiment with this. You can then merge it with the background when you are completely happy.

The great advantage of these tools is that they can be set to just affect the shadows, midtones, or highlights in a particular area: Setting the *Dodge* tool to highlight is a simple way of making teeth look whiter in portraits, for example. Using burn on its shadow setting can help to increase contrast in selected parts of the image, perhaps accentuating lines that you want to emphasize.

Lion yawn
To further emphasise the sharp teeth of this yawning lioness, each tooth has be lightened with the *Dodge* tool set first to highlight, and then to midtone. It is important to make the change gradually—setting the exposure for the tool to just 1%—to ensure that you don't overdo the effect. The nose and mouth palate were then made more prominent by using the *Burn* tool set to shadow.

Rollercoaster ride

This shot of a twisting rollercoaster required slight changes to both the white and black sliders. However, looking at the channels separately, the blues needed less white point adjustment than the reds and greens. This creates an image with better contrast, at the same time adjusting the color balance slightly.

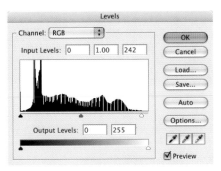

Wat Po

This huge statue of Buddha is indoors, and is not very evenly lit by the ambient light. For this shot, the levels were adjusted in two stages. First, the levels were set for the main part of the golden figure. Then a second *Levels Adjustment* layer was used to adjust the white point and lighten the dark areas around the eyes, nose, and chest. A rough mask was created using a *Gradient*, then this was refined using the *Paintbrush* tool.

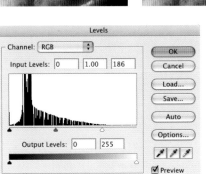

2.2

2.2 Color balance

Although digital cameras automatically correct color balance at the time the picture is taken, the automatic white balance system is far from 100 per cent foolproof (*see pages 56–61*). And even if the auto or manual setting provides an accurate rendition of the scene, there are times when you may wish to give the image a cooler or warmer color cast for artistic reasons.

There are a number of ways to change the overall color of an image. For those shooting RAW format files, this is most sensibly done while the files are being converted (*see page 202*).

The difficulty with altering the color balance is that the process relies upon visual judgement. Our eyes are fairly tolerant to color casts, and therefore it may not obvious which way to skew the colors, even when you have identified that something is wrong.

Using the *Levels* control on the red, green, and blue channels separately (*see page 214*) provides some clues in the histogram for some subjects, but not for those with a predominant color. It is also possible to set the white balance by selecting a point in the image that you wish to appear white or black; however, as these seemingly neutral tones often have a hint of hue, you still need to judge visually as to the usefulness of the change.

The *Variations* option provides a useful starting point for those who find color balance adjustment difficult as it shows side-by-side comparisons of different corrections, helping you to identify which color needs to be added to the mix. However, the facility is far from perfect (*see box*).

The best option is offered by the *Color Balance* control, which offers sliders where each primary color is paired with its complementary color. You therefore increase the red in the scene by pushing the corresponding slider toward the red side, to give a positive value, or you reduce red by pushing the slider toward the cyan side, to give a negative value. The numbers are unimportant; the visual effect guides you.

Variations

The *Variations* option provides you with visual representations of every possible color filtration adjustment that you could make, in the ring-around fashion that is familiar to those who have used a color enlarger. You can set the different filter colors to varying strengths; increasing the strength slightly can help guide you to the right filter, but it is usually best to apply the correction at the lowest intensity and then check whether any further adjustment is needed. This approach helps get round the disadvantage that *Variations* only provides thumbnail-size shots with which to prejudge the effect of a particular correction. The other major disadvantage of *Variations* is that it is a correction that is applied direct to the background layer or a copy of it.

Variations dialog
High ultraviolet levels have given this shot of a pirate ship an overall blue color cast. The *Variations* screen makes it clear that by adding more yellow, a more neutral result can be achieved. Adjustments should usually be made only to the midtones, and checking the *Show Clipping* box allows you to see when you have corrected colors to such an extent that they cannot be accurately displayed.

Before

After *Variations*

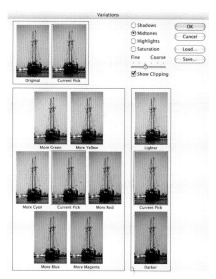

218

Before

Color cast

An aerial shot of the domes of San Marco, Venice, at night, where the floodlighting creates an orange color cast. Rather than losing this warm coloration completely, it has been partially neutralized by altering using different *Levels* adjustments to each of the three color channels: the black points of blue and green channels are moved in, brightening the shot as well as changing the color balance, while the red channel is left untouched.

After

Before

After

Color Balance

A key advantage of the *Color Balance* control is that it can be applied as an adjustment layer, so values can be reset at any point without affecting other alterations. This wintery scene is a touch too blue, and the color of the stonework has been lost; the main adjustment, therefore, is to add more yellow, but small adjustments to the other two sliders have also been made.

2.2 Color saturation

Color has a strong psychological effect in a photograph—the strength of particular hues can attract the eye into a composition, while combinations of color can either complement each other or clash (*see page 116*). Digital manipulation packages provide a variety of tools that allow you to maximize and control the effect that color actually plays in the final image.

The intensity of color in an image can be controlled largely through saturation. How saturated an image initially appears on screen depends on a number of factors, such as the lighting and the amount by which the camera has already boosted the colors (*see page 30*). Inevitably, there will be times that you want to increase saturation, and others when you will want to reduce it.

The most useful saturation tool in the Photoshop family is *Hue/Saturation*. This not only offers the benefit of making the correction in a adjustment layer, but also allows you to adjust the image either globally or a color at a time.

In addition to the central *Saturation* control, the dialog box offers two further sliders. The *Hue* control changes colors, and can be useful, say, for changing the greenery in an image until it appears the shade of green that you want. The *Lightness* control is particularly useful when you want to suppress a color in a scene— by making it lighter or darker, it may merge better into the surrounding area.

When working on a particular color, the control offers you a choice of six preset ranges—reds, greens, blues, cyans, yellows or magentas. But if these do not match your target area you can set your own color range, using the three eyedroppers to pick a color and then adding or subtracting colors from the range.

Although colors can be isolated in this way, there are times when this approach won't work– manipulating the reds in a person's clothes, for example, will also have an effect on the skin tones. In this case, the solution is to use a mask. When working on several different colors within an image, it is best to use separate adjustment layers for each.

Sponge

A simple way in which to work on small areas of color, without the hassle of having to create a mask, is to use the *Sponge* tool. This works like a paintbrush directly on the image layer, and can be set to either saturate or desaturate the colors that it paints over.

Set to *Saturate*, it is a quick solution for boosting blobs of color within a scene. It can be used to intensify the color of someone's eyes, for instance, or to boost the visibility of individual lights within a nightscape. As with the *Dodge* and *Burn* tools, it is best to set the strength of the brushstrokes (the "flow"), to a low value, then build up the effect a brushstroke at a time. To keep the effect even, paint a selected area with a single brushstroke, without releasing your finger from the mouse.

Set to *Desaturate*, the *Sponge* tool can be equally useful for toning down small-scale, distracting elements in a background. Fluorescent colors in an out-of-focus background can be effectively treated in this way—whether the pink top of a spectator on the other side of the field in a sports shot, or the yellow, reflective license plate of a car in a street scene.

Before

Creepy crawlies
Arachnophobes, avert your eyes! This is a shot of a red-kneed tarantula—but the lighting conditions have meant its knees look more of a dirty brown than red. Using the *Sponge* tool set to *Saturate*, the coloration of the large creepy-crawly has been enhanced.

After

Before

After global saturation

Fishing boat paintwork

Color is the key part of the composition in this close-up of a Mediterranean fishing boat. Boosting all the colors using the master *Saturation* control creates an image with more impact. An alternative approach, however, is to work just on the green parts of the paintwork, using the eyedropper tools to define the precise colors in the image you want to work on.

After saturation of just the greens

Drawing the eye

Despite concentrating on the pumpkins, this image has a lot to draw the eye. The solution is to use a *Hue/Saturation* adjustment layer to desaturate the background, defining the area to be affected using a carefully painted mask.

Hue/Saturate command used to desaturate background colors.

Before

Layers palette: Shows mask for saturation adjustment.

After

2.2

2.2 Cloning

The ease with which you can retouch your images is one of the most compelling reasons for using digital manipulation software: almost every picture you take can be improved by removing technical imperfections or elements of the composition that you would prefer not to be there.

How much cloning is required depends first on the source of the digital image. Files that have been scanned from prints, slides, or negatives will have varying amounts of dust marks and scratches, depending on their storage, how well they have been cleaned, and whether ICE was used (*see page 184–85*). Some will require extensive work with hundreds of spots to be removed, while others will be clean.

Images shot with a digital camera should have far fewer technical defects, but there will be occasional pixels that are obviously the wrong color (created by malfunctioning photosites), and digital SLRs may show signs of sensor dust (*see page 19*).

The basic technique for retouching is to use the *Clone Stamp* tool (or *Rubber Stamp* tool). This is a brush-like tool that allows you to obscure the offending marks by copying neighboring pixels over the imperfections. The tool is usually set to have a soft edge, so that the cover-up blends in, and the size of the brush should roughly match the width of the mark.

The best technique is to use a spotting, pointillist style, cloning material a blob at a time. You select the point that you want to clone from by pressing the \(\mathcal{T}\)/ Alt key as you click down the mouse, and then move the mouse to the area to be painted over and click.

Choosing the right source area is essential in order to get an invisible mend. You therefore need to check your results continuously, and be ready to undo one or more of your latest corrections if the effect is not quite right. Cloning is ideally done at 100% magnification (to avoid problem pixels being hidden as they are rescaled by the screen); however, it is worth periodically reducing magnification to get an overall impression of your work.

Exactly the same techniques can be used to cover up unwanted picture elements, such as spots on a portrait subject's face, TV antennas on a castle roof, or passers-by in a tranquil landscape. Some traditionalists may think this is cheating, but the ability to improve composition in post-production allows you to use vantage points that might otherwise be unusable.

With this type of cloning, you frequently need to be more creative with your choice of source point. You need to guess what might be behind the obstacle, but you can only choose from the options available in the image. Furthermore, you need to avoid the repetition being obvious; this often means merging pixels from a variety of sources to create a different-looking pavement slab or patch of grass to those already in the shot.

Healing Brush

An alternative to Photoshop's *Clone Stamp* tool is the *Healing Brush*. This works in exactly the same way, but rather than simply slapping the cloned material over your chosen spot, it looks at the surrounding pixels and tries to blend the material in as seamlessly as it can.

As with all such "intelligent" tools, the results can be incredibly good—the source area needs to be chosen less precisely, and the tool can work wonders at retouching a clear blue sky (the graduation of which makes normal cloning difficult). However, the *Healing Brush* can end up getting things hopelessly wrong. It is hard to predict when it will and won't work perfectly, but it is well worth trying when the *Clone Stamp* tool is proving unsuccessful.

Cloning tips

● When blending skies and other large areas of graduated color, it may be necessary to decrease the saturation of the *Clone Stamp* tool below the usual 100% in order to find a suitable neighboring match.

● With small areas of dust and other marks, it can be useful to change the blending mode of the *Clone Stamp* tool from its "Normal" setting: set to lighten when trying to remove dark marks, or set to darken when removing paler marks; this minimizes the area that has been affected by the clone.

● While finding your feet with cloning, or for making complex changes, place the retouching on a separate layer and add a new, empty layer in the *Layers* palette. Then, when cloning, select the "Use all layers" option: you will clone from the background, but paint onto the new layer. This will make it easier to redo the retouching at a later stage, should this prove unconvincing.

This shot of San Gimignano in Tuscany has scanned well, and ICE has managed to eliminate any dust on the slide surface. But the shot can still benefit from extensive cloning, even if what has been done is not immediately obvious from the full-frame shots.

Spot of dust removed from distant hillside. Pale areas will always show dust more than darker ones.

Telephone pole removed.

Tourist coaches in the parking lot are removed.

Cloning must be done gradually; this pole took 26 brushstrokes to remove.

The most difficult of the poles to remove, as it crosses so many other subject elements.

2.2

Digital manipulation lets you see things that you would never have noticed on the original slide. Here, a white piece of trash in the field is replaced with poppies.

223

2.2 Filters

Despite the title, filters are very different from the optical accessories of the same name (*see page 108*). While some offer basic optical effects, most produce rather more extreme transformations to a picture.

The confusing thing about filters is that these drop-down options do not just include special effects: Some, such as *Gaussian Blur* (*see page 248*) and the *Unsharp Mask* (*see page 226*), are essential image-manipulation tools.

The special effects filters, almost by definition, are far less frequently used by photographers—just as with the more outlandish optical filters, they produce effects that are often over the top, and viewers will soon get tired

of them if used repeatedly. However, it is the degree to which these special effects can often be controlled and manipulated to suit a particular image that means that they should not be dismissed out of hand.

Many of the "artistic" filters provided may not always produce convincing works of art, but they provide a useful way in which to help abstract an image. To the graphic designer who is trying to produce an interesting image of an extremely familiar object or scene, these transformations can be invaluable. Used with discretion, they can also provide a way in which the digital photographer can stamp his or her style on a portfolio of pictures.

Plug-in filters

Programs such as Photoshop and Elements come with a limited selection of filters. A much wider range of effects is available by using plug-ins (*see page 201*). Some filters are available as freeware or shareware; others are sold in suites and cost a significant amount of money. Fortunately, you can trial most filters before you buy, to check their suitability and worth, as most you are likely to use once or twice, if at all. Once downloaded to your computer, the plug-in or folder is simply placed within the filter folder of your Photoshop application; the new effects become available when the application is restarted.

No filter

"Breakfast" filter

These shots were made using two of the effects available with the Plugin Galaxy suite of filters. This offers a folder of 21 plug-ins that are capable of producing over 150 basic effects. Each can then be tweaked further using onscreen slider controls.

"Pop Art" filter

No filter

Filters provide two different ways of translating this chocolate-box image of Bruges in Belgium into something a touch more abstract.

Watercolor filter

Stained Glass filter

2.2

Filter tips

● Filters need to be applied to an image layer, but you can isolate the effect in a layer by making a copy of the background and adding the special effect to this copy.

● Try applying the filter to just part of the image, rather than all of it. Choose the area you want to work on with the appropriate selection tools, then add the filter effect.

● Filters can also be used selectively by using the *History Brush* (see page 251).

● An easy way to get filter effects that are different is to combine two or more filters, using each in succession.

Combining filters

For this low light shot of a teddy bear standing against a bedroom wall, three filters were applied in succession: first a *Watercolor* effect was added, followed by a *WaterPaper* texture, and the color range was then restricted using the *Posterize* filter.

225

2.2 Sharpening

One of the ironies of digital imaging is that every digital camera and scanner deliberately blurs the image as it is captured (*see page 25*). They do this to avoid interference patterns which might be created by the grid-like way in which the pixels are arranged; then, to correct for the degradation in image sharpness, these devices offer settings that electronically resharpen the image.

Whenever possible, though, it is best to shoot and manipulate digital images in the softened, unsharpened state. There are two reasons for this. First, different images require different amounts of sharpening, partly due to the subject matter, and partly depending on how they are going to be used. Second, the sharpening process produces side-effects, such as glowing edges, that can be made much more visible by manipulation. For these reasons, sharpening is something that is done as the last step in the manipulation process before the file is saved.

Photoshop and similar programs provide a number of one-step sharpening filters but these are generally crude, and are less than ideal solutions for many images. The sharpening tool of choice is the curiously named *Unsharp Mask* (or USM), which is also found in the *Filter* menu.

The *Unsharp Mask* gets its name from an old trick used in the printing industry in which an image plate was made to look sharper when printed by sandwiching it with a defocused negative plate of the same image. The software version of this trick offers three variables that control the degree that the image is sharpened. Unfortunately, as one can counteract the effect of the other, it is less than intuitive to work out where each should be set.

The key is to look carefully at the important parts of the image by dragging the magnified preview to telltale areas in turn, to check the effect. You want the main focal points of the image to appear sharp, without degrading image quality; however, you must also check other areas of the image; out-of-focus areas can look strange when over-sharpened (the effect can be applied selectively if there is no compromise solution, *see page 250*). Also bear in mind that more sharpening is needed if images are to be printed, than if they are simply to be displayed on screen.

USM controls

Amount
This is the easiest of the controls to understand, offering values from 1–500%: The higher the amount, or strength, the more the image is sharpened. A typical starting point for this is 100%, with average final values being 50–200%.

Radius
Sharpening is applied to edges of elements in the image, and this control defines how far either side of a found edge the effect is applied. The higher the value, the greater the sharpening effect; but this also increases overall contrast. A typical starting value is around two pixels, with typical final values being 1–10 pixels (the actual amounts will also depend on the size of the image; the more pixels the higher this setting will need to be).

Threshold
This defines what counts as an edge within the image—the higher the value, the greater the difference is needed between two areas before an edge is sharpened. Confusingly, therefore, the lower the figure set for the threshold (or clipping amount), the greater the sharpening effect. Increasing the threshold can be a good way of avoiding film grain and digital noise being sharpened. A typical starting value is around five levels, with end values usually being in the range 1–15.

This landscape shot has only minor detail, so needs only a small amount of sharpening.

This still-life shot has more obvious detail than the landscape; however, sharpening needs to be kept under control otherwise the highlights on the olives become ugly.

Moderate sharpening

Undersharpening

Oversharpened

2.2

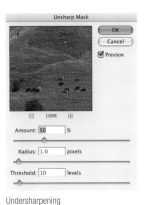

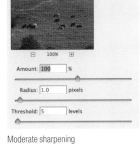

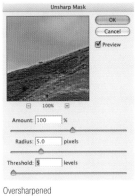

Undersharpening

Moderate sharpening

Oversharpened

2.2 Saving images

Although digital cameras save images in only three different file formats (*see page 32*), the number of options available becomes far greater when saving your image once it has been manipulated. Programs such as Photoshop offer a choice of 20 different formats to choose from, many of which then offer a bewildering mix of further multiple-choice options.

The file format you choose depends on a number of factors—most importantly, how the image is going to be used. The file format will dictate what other applications can open it, and therefore how widely it can be understood, but it will also dictate what is saved: some formats force you to lose layers and other features that may be worth preserving. And as processing power and memory are always at a premium, the format and the options chosen also have a significant effect on the file size.

Inevitably, you can't do everything with just one format. JPEGs are undoubtedly the most useful format for using your images within other applications, for use on the web, and for sharing for others. They can be compressed by huge amounts to shrink the size, and can also be slimmed down significantly while retaining practically all their visible image quality (*see page 32*).

But despite the usefulness of JPEGs, this is not the format in which to archive your images. Once manipulated, you need to save the file so that it becomes the new master copy of the image—one that you can use to create JPEGs for specific uses in the future, or to manipulate in new ways. For this you need a file format that preserves as much of the detail of your image as possible. This is true even if the original

image was created by the camera as a JPEG; especially so, in fact. Resaving a JPEG as a JPEG loses extra detail, as the compression process is applied again; to preserve the image at its manipulated quality, you need to use an archive format.

Such a format should also be capable of saving layers. On many images some of the layers are simply working notes, and you are happy to lose these when you are satisfied with the image, usually by merging them with the background using the pop-up menu from the *Layers* palette. However, some layers are worth keeping, allowing you to make changes more easily next time you want to print the image, say. This is also a wise idea for those who are learning about digital manipulation—after some practice, you may wish to see how your skills have improved by going back and reworking earlier image projects.

Two file formats are best suited to the job of archiving. The first option is to save the file in the application's own proprietary format, such as Adobe's Photoshop or .PSD format. This is fine for personal use, but it may be more difficult to share your image with others (if this is important), as they would not only need Photoshop, but ideally the same edition.

TIFF is probably most widely used format for archiving images at full image quality. Used straight, it is a lossless format (*see page 32*) that preserves all the pixels without any compression or simplification, and gives the option to retain the layers generated by Photoshop. However, it does offer secondary choices that allow you to compress the data in a lossless way (like LZW), so as to partially reduce what can end up being rather large files.

JPEG options

The main choice when saving as a JPEG is the quality of the image, and the corresponding file size that this amount of compression results in.

Quality
In Photoshop, compression is provided on a 12-point scale (some other applications offer 100 levels). The lower the number, the smaller the file and the more the image quality is reduced.

Format
Baseline Standard and Baseline Optimized are essentially the same format, but the Optimized version provides around a five per cent reduction in file size. Progressive JPEG is a special format used by some web designers; it allows a page to show a low-resolution image while a higher-resolution version is in the process of being downloaded.

Size
This gives an idea of the JPEG size, a useful thing to know, as size can vary enormously for two different

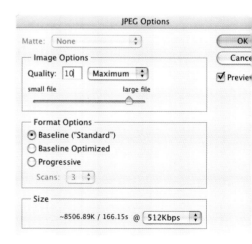

pictures with the same number of pixels. A download speed for different Internet connections is also provided, to help you choose whether you have set enough compression.

LZW

Lossless compression system named after its inventors (Messrs. Lempel, Ziv, and Welch). A very useful option for archiving, as it reduces file size (typically by around 30 per cent, more for images with large areas of flat color) without losing any quality. The drawback is that it slows down file opening, though this is less significant now computers are faster.

ZIP

Alternative lossless compression system but slows down file opening even more than LZW.

JPEG

It might seem a contradiction in terms, but TIFF offers a lossy compression option using the same JPEG algorithm that gives its name to the JPEG format. To be avoided for archive purposes.

Layers

You are given the option to discard layers as you save. Saving them will at least double the file size (and the increase will be more if there are additional image layers or masks).

File type	Extension	Layers	Uses
Encapsulated Postscript	.eps	No	Print industry
Photoshop DCS 1.0 & 2.0 (variants of EPS)	.eps	No	Print industry
Genuine Fractals	.stn	No	Upsizing (see page 282)
Compuserve Graphic Interchange Format	.gif	No	Web design (256-color limit)
Portable Document Format	.pdf	Yes	Digital document design
Portable Network Graphics	.png	No	Web design
Large document format	.psb	Yes	Large images (over 30,000 pixels wide)
Scitex CT	.sct	No	Print industry (for use with Scitex imaging systems)
Targa	.tga	No	Computer-aided design

2.2

1st generation

12th generation

Both these shots are JPEGs. The first is an enlargement from a first-generation JPEG, created from a high-resolution TIFF scan from a 35mm negative. The second is the same image, but here the file has been opened and resaved a dozen times, to create a 12th generation version. Conventional wisdom says that the second should be noticeably degraded, even though the quality level was set to 10 throughout. However, on close inspection, the two files are virtually identical, with only some artefacts near high-contrast areas of the image. If you use JPEG for archiving, always use the same compression setting, however, as changes introduce more variation and more degradation.

1st generation

12th generation

2.3 Advanced technique

The rise of digital processing, as much as digital photography, presents the photographer with a bewildering array of options once their picture is uploaded. Hundreds of styles and techniques once considered art forms are brought within reach by virtue of the undo tool and the ease and simplicity of working at your own desk. Moreover, in the digital age the line between photographers and designers is not so much finely-drawn as nonexistent. Photoshop straddles that divide, and since it is considered equally essential by both groups, so at some point you'll no doubt find yourself stepping past the withering divide.

Whatever effect your going for, Photoshop and its kin are well suited to the purpose. Advanced is not a synonym for difficult—many of the techniques that follow are very simple—what many have in common, however, is that they affect selective areas of an image. Only in darkroom conditions, with great skill and care, could film images be treated similarly. In other words, what's done here used to be advanced.

By learning how to take advantage of Photoshop's features-within-features—like the blending modes which can be applied to change the look of a layer—or by using channels to experiment with an image's fundamentals, you can create something altogether new. What you choose to do with your photographs is, more than it ever was, up to you. Some effects you might use all the time, others rarely, and still others you may never use. Whatever the case, it's worth knowing they're there.

2.3 Blending modes

Applications such as Photoshop offer so many controls that few photographers ever use more than a small fraction of the tools that are available. Basic techniques, such as RAW conversion, setting levels, cropping and cloning, are more than adequate for transforming what was shot on the camera into a presentable, printable final photograph. However, once the basic skills have become familiar, there are benefits in delving deeper into the myriad menu options that are on offer.

Layers lie at the heart of good image-editing practice; but although they are used for basic transformations whenever possible, they can be more than simple digital sheets that lie on top of each other. Layers are sometimes essentially opaque, and sometimes partly or wholly transparent, however, there are times when they can be made to interact with each other in ways that don't fit in with the usual "stack of acetate sheets" analogy, often used to explain layers.

Even in Photoshop Elements, each layer can be set to a different blending mode. Set to *Normal*, the blending mode works in a predictable way, with the *Opacity* slider controlling the transparency or efficacy of the layer.

But other modes work in different ways. Here, the corresponding pixels in the two adjoining layers are scrutinized. Set to *Darken*, and pixels from the upper layer are only visible if they are darker than those below; use *Lighten*, and the opposite is true. Use *Multiply* as the blending mode, and the effect is like sandwiching two transparencies together. In all, your program may have over a dozen such modes, each mixing the layers together in different ways.

Some blending modes are more useful than others, but it is the visual effect that counts, so experiment with each in turn to see which works best with the image being worked on. Blending modes can also be used with painting tools—you will be able to select them from the Tool Options bar.

Changing opacity

Normal blending mode: 0% opacity

Normal blending mode: 25% opacity

Normal blending mode: 50% opacity

Normal blending mode: 75% opacity

Normal blending mode: 100% opacity

This series of shots illustrates how that by simply altering the blend mode you can generate very different results. In this simple sandwich of two images, the opacity of the blend has been set from 0 to 100%. In practice, blend modes are often used at lower opacities, and may be masked so the effect only alters part of the frame. It can sometimes also be useful to use different blends in combination, employing a series of layers.

Layers Channels Paths

Normal Opacity: 25%

Lock: Fill: 100%

Layer 1

Background

✓ Normal
Dissolve

Darken
Multiply
Color Burn
Linear Burn

Lighten
Screen
Color Dodge
Linear Dodge

Overlay
Soft Light
Hard Light
Vivid Light
Linear Light
Pin Light
Hard Mix

Difference
Exclusion

Hue
Saturation
Color
Luminosity

Base layer

Upper blending layer

Color blending mode

Color Burn blending mode

Darken blending mode

Difference blending mode

Exclusion blending mode

Hard Light blending mode

Hard Mix blending mode

Hue blending mode

Lighten blending mode

Linear Burn blending mode

Linear Dodge blending mode

Linear Light blending mode

Luminosity blending mode

Multiply blending mode

Pin Light blending mode

Saturation blending mode

Screen blending mode

Soft Light blending mode

Vivid Light blending mode

2.3

233

2.3 Shadow and highlight control

One of the difficulties with digital photography is that cameras are not capable of capturing the full range of tones that can be seen by the human eye. This is especially noticeable with high-contrast scenes—areas that we remember as being in half-shadow lose detail and appear in the image as expanses of darkness; brighter parts of the image, meanwhile, appear to be burned out.

This problem can be controlled to a certain extent by using the *Curves* control selectively (*see page 236*), or by using Photoshop's specialist *Shadow/Highlight* function (*see box*). However, you can use blending modes instead.

The secret here is to blend the background image with a copy of itself. You can do this by simply dragging the background layer in the *Layers* palette to the new layer icon; however, it is best to do it using an adjustment layer—it doesn't matter which adjustment you use, as all the controls will be left untouched (you can rename the layer for easy identification). You then set the blend mode to *Screen*, if you want to lighten the image, and set the blend mode to *Multiply* to darken the image.

In most instances, you will only want to apply the effect to part of the image. You do this by filling the mask with black using the *Bucket* tool, and then painting the areas you want to alter using the *Paintbrush* set to white. Varying the opacity of the brush allows you to darken or lighten parts of the image by different amounts.

Shadow/Highlight wizard

Before

After *Shadow/Highlight* command

High walls and a bright sky create a high-contrast scene in this shot of a village in the south of France. Using the *Shadow/Highlight* command reveals details in the shadowy buildings.

Adobe Photoshop's *Shadow/Highlight* command can have an almost magical effect on high-contrast photographs, turning silhouettes into well-lit images. Like the *Healing Brush*, it is an intelligent adjustment that is much more sophisticated than its controls make it appear; it works by lightening shadows and darkening highlights, comparing each pixel in relation to its neighbors.

The trouble with the command is that it is tempting to overcorrect and end up with an image that does not look realistic. Even the default setting, which applies the shadow adjustment at 50 per cent, is too strong (it is worth using the option to reset this default). Used with small percentage values, and by prudent use of the additional control sliders provided however, the adjustment can be extremely useful, in particular for retrieving shadows.

One disadvantage of the technique is that the effect cannot be applied as an adjustment layer–it is actioned on the background directly (or on a copy of it). You can, however, use the effect in selected areas: You can use Quick Mask to highlight areas you want unaffected before you use the transformation; and better still, you can use the History Brush (*see page 250*), after the adjustment has been actioned, to select areas you want to remain transformed.

Original high-contrast image.

Multiply blending mode (at 70%) applied to whole frame.

Eliminating high contrast

An aerial view of a Scottish street shows a typical high-contrast scene: the foreground is in shadow, and some parts appear too dark; the road in the middle distance, however, is in sunlight, and appears washed out. The solution is to use two layers. The first adjustment layer is set to *Multiply* at 70%, which gives more than enough darkening in the brighter areas of the scene. A second adjustment layer is created and set to *Screen* to lighten the square and buildings in the foreground. The mask for each adjustment layer is made black (using the *Bucket* tool set to a tolerance of 100). Using a white paintbrush, each mask is then adapted in turn, so that the blending mode works only on the appropriate area.

Screen blending mode (at 40%) applied to whole frame.

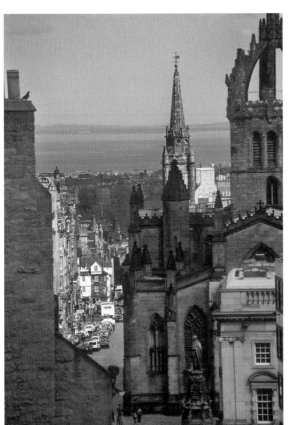

Final image, with masks limiting blending mode effects to the appropriate problem areas.

2.3 Blending with gradients

Blending modes are useful not only for merging two different images together, or for combining two identical images to make a better whole. They are also invaluable for blending color washes into an image.

It is possible to create a layer that is a plain, uniform color, and then get this to merge with the background layer below, using different blending modes. Much more useful to the photographer is to blend in a layer of graduated color. The principle is similar to using a graduated filter (*see page 108*) on the camera lens, and is most frequently used to add color to a drab sky.

The advantage of the digital solution, however, is the scope you have to adapt the gradient to the particular image and change it again until you are happy. You can specify any color, and have it gradate from one color shade to another; you can specify exactly where the color begins and the clear part ends; and you can control exactly how quickly the color grades through to its full intensity. And that's even before you start experimenting with the different blending modes.

Photoshop and Elements provide the added benefit that gradients can be applied as adjustment layers. Each has its own mask so the gradation doesn't have to be completely linear and you can paint out areas where you don't want the color to show. This is particularly useful, as the skyline in photographs is rarely a straight line, for instance, and a mask can be painted on so that buildings and trees are not hidden behind the new layer of digital color.

The difficulty is specifying the gradient. At least three different dialog boxes need to be completed to choose general properties, the color used, and the characteristics of the gradation itself. The last of these, the *Gradient Editor*, is the most awkward, as you set the various stops needed by sight alone—often you have to go back and tweak the settings several times before you are happy with the positioning and gradation.

You must also set the blend mode before you finalize the gradient, as this will have a major effect on the visibility and intensity of the result. The *Multiply* and *Darken* modes are usually the most effective.

A new sky can turn a drab image into a powerful one. Here the intense sun creates a washed-out sky above the City of London. Adding a deep blue gradient improves the sky, but the horizon is so low in the frame that it obscures the famous buildings. The solution is to paint a mask so that the gradient is only fully visible in the sky area. A intricate mask like this can take an hour or more to paint before you are completely satisfied with it, but the result is well worth it if you don't have the chance to revisit a site under better lighting conditions.

Before

With gradient

Final image with gradient and mask

A gradient adjustment layer is created.

The basic *Gradient Fill* dialog lets you set the direction of the gradient. Double-clicking on the gradient bar brings up the *Gradient Editor*.

The *Gradient Editor* is where the parameters for the gradient itself are set, using the various sliders above and below the gradient preview shown in the middle of the box. The *Colour Picker* can be called up by double-clicking on the stops below the line.

Strengthening skies

Camels crossing the river at Agra, India. Hazy conditions mean that the sky and the horizon are washed out. Adding a stronger blue sky creates a more powerful image.

The *Colour Picker* allows you to pick the exact shade and hue you want to use. Pastel shades of blues and oranges usually work best for skies.

Before After

2.3

2.3 Curves

For most serious digital photographers, the *Curves* adjustment is probably one of the most helpful controls, and is used on practically every image. It is essentially an exposure and contrast tool, which is used to darken and lighten the midtone areas of a photograph.

Like the *Levels* control (*see page 214–17*), the *Curve's* dialog displays a graph which is then used to alter the image. Unlike *Levels*, however, the graph doesn't tell you anything about your picture. Its shape simply gives a visual representation of the transformation that it will make, and it plots the density of the image as it is now against the image as it will be when the adjustment has been made. When the control is opened, the graph is a straight diagonal line; this is because the input and output are the same, and you have yet to make any changes.

You make alterations by pushing the line up or down, but as the end points are anchored, this creates a curve on the graph. These fixed points represent the very darkest and lightest tones in the picture, which are left unaltered. They can be dragged from inside *Curves*, but are much easier to control using *Levels*. The normal working practice, therefore, is to set the white points and black points using *Levels*, then, using another adjustment layer, altering the density of the midtones. If the image looks dark, drag the graph up. If the image looks too light, drag the graph down.

Varying the exact points at which you push the line up and down, you can alter some parts of the picture slightly more than others. Push it up near the bottom of the line, and you lighten the darker tones more than the lighter ones—the amount of correction necessary is judged visually, solely on the basis of the onscreen image. You can check the density of any part of the image simply by clicking on it, and this point is then temporarily shown as a point on the graph.

Curves corrections normally need to be subtle— and as with *Levels*, the adjustment is best made in 16-bit mode if available, to minimize degradation of the image.

Several anchor points can be created to manipulate the shape of the adjustment more precisely, but it pays to be gentle if you don't want the correction to give unpleasant results. However, slight S-shaped curves can provide a useful way of altering the contrast of an image. Darkening the darker midtones (by pushing the tail of the graph down), and then lightening the lighter midtones (by pushing the top of the graph up) for instance, you can increase contrast.

RAW files

Curves is one of the controls offered by most RAW conversion programs (*see page 202*). However, as with all alterations made at this stage, it is not possible to make alterations to this adjustment without reconverting the original file. It is therefore sensible to make as much alteration as you know is absolutely necessary in *Curves* at this stage.

You may find that a particular camera always needs a degree of RAW correction in certain lighting conditions, so it makes sense to apply this to all the images affected. Make subtle corrections, however, using Photoshop itself (in 16-bit mode, if possible), as this provides the ability to isolate the adjustment in its own layer.

Curves can be adjusted during RAW conversion with Photoshop CS2.

The *Curves* adjustment is probably the most significant feature missing from Photoshop Elements, and is therefore one of the strongest arguments for investing in the full-blown professional version of Photoshop (*see page 200*). You can add the adjustment, however, using the RAW format and then using a RAW conversion program with *Curves* (Photoshop Elements' RAW facility does not offer this).

Future proofing

This shot looks slightly dark overall, particularly in the shadow areas. It can be corrected by pulling up the base of the curve line by a fraction. The correction is applied in an adjustment layer, so it can be corrected later, or so a mask can be created to apply the effect to just some parts of the image.

Brightening shadows

This shot of a hedgehog is too dark in the shadows, but the highlights do not need brightening. The solution is a reverse S-curve controlled from two points, that lowers the contrast of the image.

Strengthening color

Here, the image has been darkened using the *Curves* control to create a more graphic picture with stronger shadows and a darker background.

239

2.3 Using channels

Most digital manipulation can be carried out successfully in the same color mode used by computer screens, digital cameras, and scanners. However, there are occasions when it proves useful to access the individual color channels in RGB, or to change to the alternative CMYK or L*A*B color modes (*see pages 206–7*).

The beauty of having both channels and alternative color modes is that they allow you to approach the manipulation in a different way. Switching to a single channel, for instance, may make it it much easier to use selection tools to cut out an object from its background. But these different ways of displaying the image data also mean that you can correct faults in the image without creating further problems in the process.

Removing grain from scanned film images, or minimizing noise in high-ISO digital shots, always means sacrificing some of the quality and detail. However, if you look at the image split up into its component channels, you will usually find that the grain

is much more prominent in one channel than others. By applying the corrective filter in this channel alone, therefore, you can minimize image degradation.

Similarly, many image adjustments and filters can have an unfortunate effect on colors. It is for this reason that the L*A*B mode can often prove so useful. With the color information being entirely isolated in the A and B channels, the correction can be made solely to the Lightness (L) channels without creating color distortions.

It is important to realize that tools such as the *Curves* adjustment also vary in operation, depending on the color mode being used. Furthermore, it can be useful to change to L*A*B from RGB for one part of the image-editing process, before returning to RGB. L*A*B also brings with it the advantage of a wider color gamut than RGB (it can reproduce more colors), so this mode is often useful when making significant changes to the color balance of the image.

Switching to CMYK

The CMYK color mode is not as useful as L*A*B or RGB when manipulating, as it has a more restricted color space. However, the fact that CMYK has four channels means that this mode can be easier to use for precise color correction. Similarly, the channels

can provide an easier way in which to make a selection, or provide a more pleasing monochrome conversion (*see page 240*).

Where the CMYK mode proves invaluable, however, is showing how images are likely to look when printed (*see page 288*); some users prefer to work in CMYK entirely for this reason. However, Photoshop provides a quick preview facility for showing what an image you are working on will look like in a specified CMYK color space; furthermore, it can even indicate colors that are "out of gamut" and will not be displayed accurately when printed. These previews allow you to see whether the color loss is significant, and whether it is worth tweaking the colors so that they will convert more accurately.

Preparing for printing

This shot of belly dancer costumes in a Turkish market has bright man-made colors that will look more vivid on an RGB screen than they do when printed. Switching to the CMYK gamut warning mode highlights the problem colors in gray. Because the image requires bright colors rather than accurate ones, they were changed using *Hue/Saturation* to more printable, vibrant tones.

Nepalese palace

This scan of an entrance to the Royal palace in Kathmandu, Nepal, was shot on slide film, and the grain is quite visible in the shadow areas. Looking at the channels, the grain is much more pronounced in Blue; Photoshop's *Surface Blur* filter was applied to this channel alone, concealing much of the grain without having any major impact on the overall sharpness of the shot.

Original scan

All RGB channels together

Red channel

Green channel

Blue channel

Channels palette

Surface Blur dialog box

After *Surface Blur is* applied to Blue channel

Final image

Sharpening for a rugged look

Sharpening this shot of a coastline helps to accentuate the craggy rock formation. However, if this is applied to all the channels, it creates color problems—the yellow lichen on the cliff face, in particular, becomes garish. A solution is to convert the image (temporarily) to L*A*B mode then apply the *Unsharp Mask* filter to the L channel alone. The cracks in the rocks are then accentuated, without affecting the color of the lichen.

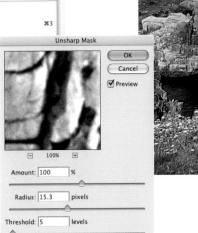

2.3

241

2.3 Converting to black and white

Changing a color image into a black-and-white one is a simple, one-step procedure with most programs. With Photoshop, for instance, you can simply change the color mode of the image to *Grayscale*, which allows you to discard the color data and reduce the file size at a stroke.

Such conversions, however, rarely produce the best monochrome version of a color image; much better results can be obtained by retaining the color information and using this to control exactly how different hues are transformed into shades of gray. For this reason, you should resist using the monochrome digital effect found on many cameras (*see page 68*).

By looking at the RGB channels on their own, for instance, you can often find that these give very different grayscale versions of the same scene. The effect is similar to using colored filters with black-and-white film. The channels do not have to be used individually, however— Photoshop's *Channel Mixer* facility, for instance, allows you to mix the channels in different proportions until you get the effect you want; checking the monochrome box ensures that however you move the sliders, you still get a black-and-white image. Furthermore, the effect is applied as an adjustment layer, so it can be readjusted at a later date.

An alternative approach, particularly useful for programs that don't offer split channels, is to use the *Hue/Saturation* adjustment. Simply by moving the master *Saturation* slider to the far left creates the monochrome image; then, by adjusting the lightness of each of the six primary and secondary colors you can change the tone of specific elements in the picture: reducing the lightness of blue and cyan, for instance, darkens the sky.

The bare bones conversion from color to black-and-white is only one part of creating a successful monochrome image. Pictures that work well in mono are not always those that work well in color (*see page 160*), and color and monochrome interpretations of the same file need rather different treatments in the digital darkroom: you normally need to increase the contrast (ideally using an S-shaped *Curves* adjustment) to give a punchy result, and without the worry of color distortion. Much heavier editing to areas is possible with black-and-white conversion than with color images.

Colour original

Layers palette showing the steps

Shot on a drizzly morning, this color image is not particularly promising: the poor colors and lack of contrast are impossible to correct without distorting the colors in the scene unnaturally.

One solution is to convert the image to black and white; here, this has been done using a *Hue/Saturation* layer, as this allows us to change the tonal strength of the main elements. However, more adjustment is needed.

To produce a dramatic sky from the clouds, different *Curves* adjustments were made above and below the horizon; masks were handpainted to control exactly where each has influence.

The final touch was to add an empty layer for final adjustments; the main use for this was to lighten the tone of the twisting road, by lightly painting white over its surface using the Brush set to the *Linear Dodge* blending mode.

Final mono conversion

Architectural mono

Some of the different ways that a color
picture can be converted to black and white:

Full-color original

Converted to Grayscale mode Red channel alone Green channel alone Blue channel alone

Desaturated using *Hue/Saturation*
adjustment, then tones adjusted by
altering the lightness in each of the
six preset color ranges.

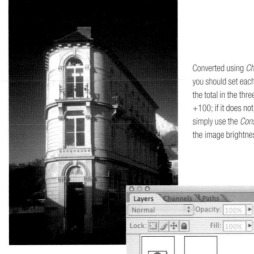

Converted using *Channel Mixer*. Ideally,
you should set each of the sliders so that
the total in the three value boxes equals
+100; if it does not, however, you can
simply use the *Constant* slider to bring
the image brightness back to normal.

2.3 Toning and tinting

The crafts of toning and tinting have been used since the earliest days of photography in order to provide an interesting twist on color. Both have presented difficulties, however: toning traditionally involved using dangerous chemicals to achieve unpredictable, hard-to-replicate results, while tinting required some artistic talent. Both processes involved starting with a finished black-and-white print that could easily be ruined during these post-production treatments.

The arrival of the digital era means that now both can be replicated on the computer—mistakes can be undone without restarting, and results that you are pleased with can be reprinted exactly. What makes these processes even more approachable is that you can start with a color image. This is a particular advantage with tinting, as it means you can retain the color information you want and then desaturate the rest of the shot to create an image that is essentially monochromatic, but which has certain key areas in full color.

Coloring an image to produce a toned effect is extremely straightforward even even relatively basic image-manipulation software such as Photoshop Elements. More complex effects, which mimic the way that toners can be used to color certain shades of gray differently from others, require more professional packages such as Photoshop itself, that allow *Channel Mixing* and *Curve* adjustments.

Simple toning

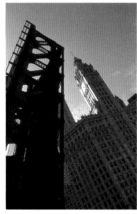

● The easiest way to produce a toned monochromatic image is to use the *Hue/Saturation* control.

● The dialog box for this color adjustment facility has a special check box, marked *Colorize*, which converts the image to monochrome.

● Using the *Hue* slider, you choose the single color used to create the different tones.

● The *Saturation* slider can then be used to pick the strength of that particular color.

● The master *Lightness* control can be particularly useful if you want to use the image as a background for a page of a brochure, say, or a website.

Turning back time on Chicago's Wrigley Building, using *Hue/Saturation* adjustment to add a sepia tone.

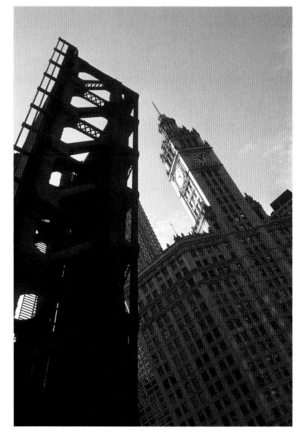

It is relatively straightforward to tint a picture digitally using a monochrome RGB image as the starting point, and then selectively painting elements in the composition on a separate layer using a paintbrush. By controlling the opacity of the color added, and using different *Layer* blending modes (the *Color* or *Overlay* modes are usually best), you can create images that look very much like those created with traditional tinting inks, crayons, or pastels. An alternative approach is to start with a color digital image, then selectively desaturate it.

● Decide which areas of the image you do not want in color, and those you do.

● Create a *Hue/Saturation* adjustment layer and choose the main color you want to desaturate from the drop-down menu. Move the *Saturation* slider to the left to remove the color. Use the adding pipette to enlarge this color range as far as possible without including areas you want to remain in color.

● If some areas that you want to remain in color are the same as those you want to turn to monochrome, use the mask of the *Hue/Saturation* adjustment layer to delineate the area you want to work on.

● Tweak the level of desaturation; sometimes it is worth keeping some color to give a toned look to the background. The intensity of this colour can be reduced by increasing the *Lightness* slider.

A duotone is a traditional reprographic technique where two different inks are used to produce a colored monochromatic image where there is more tonal depth than a single ink could produce. A digital version of this technique is available on the full version of Photoshop, but because it uses *Curves* adjustments (*see page 236*) it is not provided with Photoshop Elements.

First, a copy of the image is converted to Grayscale (*see page 240*), then it is converted again to the Duotone color mode. This gives you the option to choose two colors of PANTONE "ink," which will be used for the image. Separate curves are created for each color, so that each ink is stronger in different parts of the image, depending on the tonal density.

245

2.3 Selectively adjusting color balance

Although it is relatively straightforward to remove color casts from images and to correct white balance (*see page 218*), there are times when it seems impossible to get the settings right—just as one part of the image starts to look as you want it to, the color of another section of the picture goes haywire.

This conundrum is almost always created by "mixed lighting." For simplicity, photographers and camera white balance systems usually assume that scenes are lit by a single light source. But this is not always the case: shadow areas outside, for instance, often appear blue, as they are lit by sky light rather than the direct sunlight. The difference in color is not always noticeable, because one light source is much brighter than the other.

Mixed lighting difficulties are at their worst when two or more light sources in a scene are of similar brightness. A picture taken indoors may be lit by both the sunlight and interior room lights, for instance, and if the sunlight is weak or the interior lights are strong, both have a significant effect on the illumination; one light source is likely to be much warmer in temperature than the other.

The problem is often evident with architectural shots taken after dark: streets and buildings are lit with a mixture of floodlighting systems, all of which add their own color tones to different parts of the image.

Some color imbalance is usually acceptable to the human eye, particularly if the main subject looks right. However, there are occasions where adjustment is necessary. The solution is to adjust individual colors within the image, rather than changing the color balance as a whole. For the Photoshop user, the most intuitive tool to use is the *Selective Color* control, which is best used as an adjustment layer. This allows you to make color adjustments to the six primary and secondary colors, but also lets you adjust the color balance of blacks, whites, and grays within the image; these colors are adjusted using the cyan, magenta, yellow, and black slider controls.

The other useful tool for color balance problems is the *Replace Color* command. This allows you to pick and refine a color range from within an image using an *Eyedropper* command, then to use standard *Hue/Saturation* and *Lightness* controls to adjust these colors.

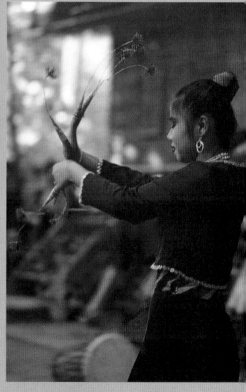

Finger dance

This shot of the traditional Thai fingernail dance was shot in an open-sided arena that allowed tourists to watch the show in the shade. However, the mix of floodlighting and daylight played havoc with the white balance. No overall compensation setting corrected the image; instead a *Replace Color* adjustment layer was used to weaken the yellow cast in the skin tones.

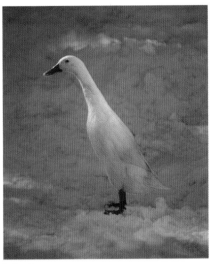

Indian Runner on snow

Unfortunately, the resulting picture is not impressive—the duck is lit by direct sunlight, but most of the snow is in shadow, which appears with a heavy blue color cast. This can be mostly corrected by using the cyan and blue adjustments in *Selective Color*, then the background is given a final tweak using the *Replace Color* adjustment.

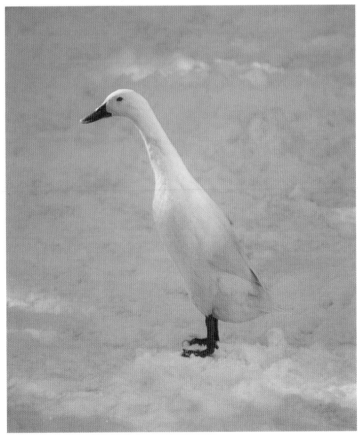

2.3 Advanced cloning

Whether removing small specks of dust or passers-by from the foreground, the techniques for removing such unwanted picture elements usually remain the same—finding a suitable match from elsewhere in the image, and then cloning it into position using the *Healing Brush* or *Clone* tools (*see page 222*).

Once the source point has been set, it does not have to be reselected for each brushstroke or dab. These tools are usually used in "aligned" mode: after the source point is defined, subsequent brushstrokes source from the same distance and direction as before, rather than from the same point. With many retouching jobs, this means that the source point can be left the same for several brushstrokes before it needs to be redefined. However, in some instances where there is only a limited area to clone from, it is often worth switching to the "non-aligned" mode, where the brush returns to the same set source spot each time the brush is used.

Unfortunately, it is not always possible to find a suitable source that can be painted directly across,
even if the opacity and blending modes are varied. But this does not necessarily mean that you cannot manipulate something within the picture to suit. Even though the new element that you are seeking may not be present, there may be something very similar that is just the wrong shape or scale. By copying this part of the picture and then distorting it so that it fits, you can therefore renovate the image seamlessly.

With symmetrical subjects, you can cut an element from one half of the picture and copy it onto a new layer, where it is flipped and moved to the required position. Because nothing is perfectly symmetrical, the new element may need to be distorted using one of your program's transformation tools so that it fits exactly: similarly, slight density and color adjustments may be necessary. You can "feather" your initial selection to create a soft edge or, better still, graduate the edges of the piece of patchwork once in position with the *Eraser* tool (varying the opacity helps to create an invisible join).

Vanishing point

Introduced with Photoshop CS2, the *Vanishing Point* tool offers a way of cloning that distorts the material as it is painted on. The logic behind this is that with some pictures, cloned material that looks suitable simply does not fit, as the cloned area is at a different distance than the problem area and so is the wrong size to work. This clever tool allows you to define the perspective lines within an image and then get anything that is cloned to conform to these lines.

It is particularly useful, say, if you want to cover over a section of tiled floor or an expanse of decking: you can source from a similar section that was closer to the camera, and get the pixels to shrink to fit perfectly as they are painted on.

Troublesome background
In this shot of an old clock tower, the brick building at the end of the road fits in badly with the historic surroundings. Using the *Vanishing Point* tool, the row of house roofs is extended beyond the clock to obscure the modern block. The joins are then carefully patched up using standard cloning tools, and a new gradient sky is added.

Before

Cleaning tourist spots

When the interior of this world-famous museum was redeveloped, a balcony was built for visitors to get a spectacular view over the modernized atrium. Unfortunately, the view is ruined by the sheer number of people in shot. Although a few figures are fine to give an idea of scale, the static groups could do with being removed, and the line of students sitting in the center of the image is particularly distracting. However, this can be dealt with by making a copy of the other side of the doorway and flipping it over so that it can be positioned to hide the seated group entirely. The selection is kept in its own layer, and is distorted slightly so that its perspective fits in perfectly with what is already there. The patch is then tidied up by softening the edge with the *Eraser*, and using standard cloning techniques. This process was then carried out four further times to remove groups from the scene.

Layers palette showing the five patches that were created to cover up the unwanted groups of people.

After

2.3 Blurring

While all digital images need to sharpened somewhere along the workflow (*see page 226*), there are occasions where it can be beneficial to take the opposite tack and blur at least part of the image.

The *Blur* tools are some of the most useful available in post-production, because they can be applied in such a way as to recreate effects that are usually applied at the time of shooting—they can be used to restrict depth of field, for instance, mimicking the visual effect of a larger lens aperture—and blur can also be applied in such as way as to suggest that a slower shutter speed was used by the camera.

Although direct-action blur and smear effects are available in the toolbox, the most useful effects are offered by the *Gaussian Blur* filter, which allows you to specify the amount of blur and preview the effect before it is applied. As with most filters, the effect has to be applied directly to an image layer when used to replicate a narrow depth of field (*Gaussian Blur* can also be usefully applied to masks to help soften hard lines).

You can apply the effect to a selection created using a quick mask on the background, or to a copy of it; the latter has the advantage that you can vary the opacity of the mask, so the effect can be applied in some areas more than others to better replicate the gradual nature of depth of field.

An alternative solution is to use the *History Brush* (*see page 251*), which allows you to apply the effect to the whole canvas. You then undo the effect in the *History* palette, and paint it back selectively, using the *History Brush* tool, which means you can apply the effect more heavily in some areas than others.

For Photoshop Elements users who don't have the benefit of *History Brush* or *Quick Mask*, an alternative is to make a copy of the background on a new layer, apply the filter to the background, then use the *Eraser* on the new layer to superimpose the areas you want to remain 100 per cent sharp. The opacity of the *Eraser* can be reduced so that some of the defocused areas appear sharper than others.

Zoom burst

Before

Photoshop's *Radial Blur* filter allows you to create perfect zoom bursts, whatever the lens or shutter speed you originally used to take the picture. One of the advantages of using manipulation for this effect, rather than the camera, is that you can center the radial lines wherever you like in the frame, without the need for cropping. In this shot of a funfair ride, the dodgem car in the bottom left of the picture has been made a stronger focus of attention, as the zoom lines spread out from this point.

Radial Blur settings box

After

Motion effects

Before

Blur tools and filters can help recreate a variety of different camera effects. One of the difficulties with these post-production techniques is that they can be too perfect and even. To be more convincing, the blur needs to be administered in a haphazard way.

The *Motion Blur* filter is excellent for providing streaked lines across the frame. You can use this to create a panned effect, with a blurred background and a sharp subject, but if you simply blur the background (by selecting it before the effect is applied, or using the *History Brush* to add it afterwards), the main subject will appear too sharp. A small amount of blur needs to be applied to the subject as well, and this can be achieved using the *Quick Mask* or *History Brush* tools.

The *Motion Blur* filter also applies blur in a strictly linear fashion, but not all subjects move in perfectly straight lines. In a

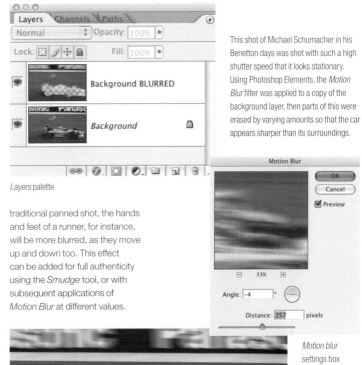

Layers palette

traditional panned shot, the hands and feet of a runner, for instance, will be more blurred, as they move up and down too. This effect can be added for full authenticity using the *Smudge* tool, or with subsequent applications of *Motion Blur* at different values.

This shot of Michael Schumacher in his Benetton days was shot with such a high shutter speed that it looks stationary. Using Photoshop Elements, the *Motion Blur* filter was applied to a copy of the background layer, then parts of this were erased by varying amounts so that the car appears sharper than its surroundings.

Motion blur settings box

After

Gaussian Blur

The *Gaussian Blur* filter allows you to create differential focus effects that are simply not possible with most lenses. Here, this portrait of a man in historical costume is weakened by the crowds in the background. The blur was set to ensure that these were rendered unrecognizable, and was applied to the whole frame. The *History* palette and *History Brush* were then used to cancel the effect temporarily, then apply it selectively to the background.

2.3

2.3 Selective sharpening

With most images, sharpening is applied either to the whole image (*see page 226*), or to the whole of the *Lightness* channel (*see page 238*). However, applying sharpness across the full picture area inevitably calls for some compromise: reveal detail in one area, and you bring out noise and create artefacts in another. It can therefore be useful to apply the *Unsharp Mask* filter selectively, so that some parts of the image are sharpened to a lesser extent than others, or not at all.

Not only does this mean that you can bring out the detail where you really need it, but also that you do not have to worry about areas of even tone, such as skies, turning into a grainy, blotchy mass. Out-of-focus areas provide a texture-free background presence, and the viewer's eye is attracted more strongly to the sharper focal points in the image. A side effect of this selective sharpening technique is that it can create images that look more three-dimensional, with the unsharpened areas receding and the sharper areas jumping forward at you.

By far the best tool to use is the *History Brush*, which can be used in conjunction with most adjustments and effects, providing a way to paint on the effect in selective areas in varying amounts. But the *History Brush* is particularly useful for sharpening as, although it must be used on an image layer, this is the last thing that is done in the manipulation workflow.

Using the *History Brush* technique you can be relatively heavyhanded with the *Unsharp Mask* settings—you can forget other parts of the image; it is in the key details that you want to get the sharpening right. Once the USM filter is actioned, the effect is temporarily undone in the *History* palette, while the *History Brush* box next to the last *History* state is checked (with the now—pale words "USM filter" beside it). Selecting the *History Brush* itself from the tool palette, you now paint over the image layer (usually the background, or a copy of it); by varying the opacity of the brush, the sharpening can be applied by different amounts to different areas.

High pass filter

Before

This image was taken with an infrared filter over the camera lens to produce an eerie, monochromatic image (*see page 161*). This technique produces soft images, but after manipulation, the shot does not need any further increase in contrast. The solution was to blend a *High Pass*-filtered copy of the image in overlay mode.

Using the *High Pass* filter instead of *Unsharp Mask* is a good way of sharpening an image strongly without creating excessive contrast. The *High Pass* filter, which is filed under *Other* in the filter menu, essentially gives an embossed look to a picture. As such it is not applied to the image layer itself, but to a copy of it—this highlights the edges that you want to accentuate in the picture. This copy is then merged with the main image layer using a contrast-increasing blending mode—*Soft Light* or *Overlay* usually work best.

An advantage of this technique is that you have two bites at how much the image is sharpened. First, there is the amount of *High Pass* sharpening applied, which is entered as a pixel radius as you preview the effect. Second, you can vary the opacity of the blended layer until you get the exact result you want. The effect can be applied selectively, by using a mask with the copy layer.

After

Unsharpened

Whole image area, and all channels, sharpened

Using the History Brush

In this shot of a Clivia, there are two separate picture elements. The petals do not need sharpening, as they suit a soft, abstract approach. The sharpness of the yellow ovaries, however, could benefit from accentuating; using the *History Brush* to apply the *Unsharp Mask* filter selectively creates a noticeable 3D effect.

Selectively sharpened using *History Brush*

2.3

Smart Sharpen

Photoshop provides its own alternative to the *Unsharp Mask* sharpening system. The advantage of the aptly-named *Smart Sharpen* filter is that it can be applied by varying amounts to the midtones, highlights, and shadows. This provides a simple way in which to control the granularity in key areas such as the sky and the darkest tones, while still being able to sharpen key focal points.

After *Smart Sharpen* filter

The *Smart Sharpen* tool is quite good at being able to rescue images where the subject was not quite in focus at the time the picture was taken; it won't perform miracles, but it is well worth trying out. In this shot, the train is sharp, but the driver's face is soft. *Smart Sharpen* helps restore the correct focus.

253

2.3 Distortion

The virtual nature of pixels means that it is possible to distort images in ways that make a funfair hall of mirrors appear positively tame: in some cases, it is as if the pixels are on rubber so that the image can be pulled in any shape; in others, they are ball-bearings that can be swirled and twisted into myriad patterns.

Of all the available distortions, those that can be used to alter perspective are the most useful to the photographer. A primary use is for architectural shots, where the tops of wide-angle shots can be stretched so that converging vertical lines are forced to run parallel once again (*see page 166*).

Photoshop provides several ways of creating these distortions, but some do not always give quite the results that you expect. By correcting the perspective, some tools also shrink the the structure so that it looks unnaturally short, which may mean using a separate

Stretch command. Other tools may assume that you were standing straight on to the building, and that the camera was not tilted. For these reasons, it may be best to work with the *Free Transform* tool, which allows you to stretch the image from eight separate points; a full preview allows you to see exactly what you are doing. A grid pattern can be superimposed over the image as you work, so that you can check the angles of both horizontal and vertical lines.

It is worth remembering, however, that, as with large-format cameras (*see page 21*), perspective distortions do not have to be used to create a plan-perfect image; sometimes there may be artistic benefit in increasing the distortion. Similarly, it is the distortion created by super-wide-angle lenses that often makes the picture; correct the verticals, and the photographic merit is lost.

Before

After *Perspective Crop*

Converging verticals

Shot from ground level, the tilted camera creates an image where the frames of the ornate windows are no longer square. Using the *Perspective Crop* tool restores the right angles, but the shape of the structure is now ridiculous. Using the *Free Transform* utility allows everything to be stretched into place until you are happy with the result.

After *Free Transform*

Lens Correction

Hidden away among Photoshop's more zany distortion filters is the invaluable *Lens Correction* utility. This provides, as the name suggests, a number of different tools for compensating for faults introduced by the camera's lens. You can reduce color fringing around the edges of subjects, caused by the lens focusing different wavelengths of light at slightly different points; there is also the facility to correct both vertical and horizontal perspective in a simple and logical way. The most useful tool, however, is the *Vignette* utility, which corrects for the darkened corners that are inevitable when using some super-wide-angle lenses. This selective lightening facility is available with some RAW converters (including Photoshop's own), and is also invaluable with images shot in other formats, and for scanned files.

Lightening corners

As with all distortion tools, there is only so far that you can correct for converging verticals without losing some essential picture area. However, the ability to remove the darkened corners, caused by the use of a 17mm (efl) lens, helps to create a more pleasing image.

Liquify

The most bizarre Photoshop and Photoshop Elements distortion tools are found by launching the *Liquify* utility: this program-within-a-program allows you to create all manner of cartoon-like effects. For this monochrome shot, the eyes and nose were selectively enlarged using *Liquify's Bloat* tool; the lips were then puckered using *Liquify's Pinch* tool; the irises and hood were then hand-tinted by painting over the image in *Color* blend mode.

Before

The *Liquify* preview screen and *Toolbox*

After

2.3 Combining pictures

Combining two or more different pictures within the same frame allows digital photographers to create new realities. This kind of manipulation can be considered an art form in its own right—one that is less to do with photography and more to do with using images as a medium.

This form of image manipulation remains contentious in some quarters as it goes further than simply tidying up an image. This is particularly so when the result is not obviously an artistic interpretation, but is executed to look like a believable camera photograph.

Putting different shots into a single image does not have to be complex, however: a simple multiple exposure may be done to replace a sky in a landscape with a more dramatic one, for example. For the portrait photographer, there may be some benefit in combining two frames from one shoot—if you photograph two people together, they rarely both look at their best simultaneously; but you can merge a facial expression from one shot into another to get the perfect joint pose.

One of the secrets of photomontage is to isolate each element using layers, so that small corrections can be made to one piece of the jigsaw without affecting the others. Because each piece may need its own set of adjustments, effects, and distortions, layers are arranged in groups or folders. Layers work within the folder, so adjustments don't affect other elements. The folders then act as master layers that then interact with each other (and with other non-partitioned layers) in the usual way, using different blending modes, masks, and opacities.

Layered montage
In this crude photomontage of three separate images, each element is isolated in its own folder-full of layers. This allows us to remove each element in turn, with its corresponding adjustments: at a click we can remove the rainbow from the shot, to leave the simple double exposure created by merging the windmill and the sunset.

In addition to the standard blending modes (*see page 232*), Photoshop allows you to control the exact densities at which the blend will become visible. this is a complex tool that allows you to specify that you only want the blend to affect the light tones and not the dark tones, for instance. This auto-masking facility can have some unexpected and unpleasant results, but can sometimes create effects that would otherwise be almost impossible, or very time-consuming, to obtain.

Dragging the left and right sliders under the two *Blend If* controls creates dramatic results with abrupt transitions at the places where the layers become visible. Splitting each slider into two (by dragging in while the ⌥/Alt key is held down), you can feather the transition lines to achieve a smooth-looking result.

This shot is essentially two versions of the same camera image combined. The first set of layers provides suitable adjustments for the car, while the second sets the exposure for the moody sky. The two image layers are combined using the *Advanced Blending* facility, which allows you to specify where the darker layer will show through.

257

2.3 Photomosaics and joiners

Photomontages do not necessarily have to involve superimposing different images on top of each other. With photomosaics and joiners, pictures are placed side by side to create a jigsaw effect, creating one big picture from a number of smaller images.

Stitching panoramas is essentially a camera technique (*see page 172*), as you need to have a suitable succession of pictures before the manipulation process can be done. The idea is that you break down a wide vista into a succession of shots, capturing just one narrow angle of the view at a time. This allows you to take super-wide-angle shots without the need for specialist lenses, and without the need for cropping.

When shooting, it is important that there is sufficient overlap between each successive frame; to capture a suitable number of frames, it is customary to shoot with the camera frame in the upright position. To make the joining process as easy as possible, the camera should not tilt or move horizontally or vertically between exposures; it should simply rotate. A tripod with a pan head is useful here, but not essential.

A number of purpose-written programs are available for stitching your images together. These can provide features such as being able to produce a 360 degree view, which can then be used as an animated illustration on a website. However, for straightforward "joiners," the *Photomerge* utility found in Photoshop and Elements is more than clever enough.

Photomerge gives you the option of trying to place each of the fragments into perfect alignment automatically, if this fails, you can drag and drop each of the shots manually. Further features allow you to distort the picture to give a better wide-angle perspective, and an *Advanced Blending* facility works to smooth the joins as best as it can.

A side-effect of the jointer technique is that it provides a way of giving your camera more pixels. Shoot eight shots with a 5-megapixel camera and you have a 40-megapixel image (although allowing for overlaps, this is more likely to be in the region of 25-megapixels). This technique can therefore be a great way of capturing more detail from your images.

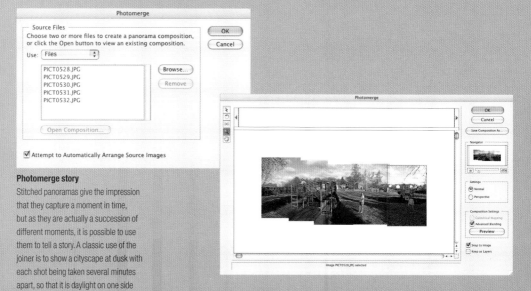

Photomerge story

Stitched panoramas give the impression that they capture a moment in time, but as they are actually a succession of different moments, it is possible to use them to tell a story. A classic use of the joiner is to show a cityscape at dusk with each shot being taken several minutes apart, so that it is daylight on one side of the joiner and dark at the other. In this example we see a stitched shot of a children's playground, with a young girl who appears a number of times. This technique can be used to tell a story within the same frame, and is a lot more straightforward (and fun) than using standard photomontage techniques.

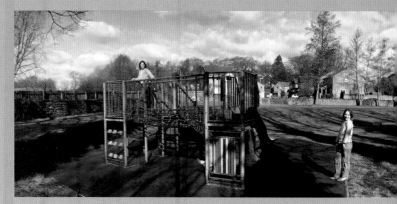

Photomosaics use individual images as simple tiles of color, which are then used in their hundreds or thousands to create an image. Thanks to the computer, each tile does not have to be painstakingly put in place. You don't even need to come up with a design to use as your plan—one of your photographs (or a graphic, such as a company logo) is used as the basis for the mosaic.

Creating photomosaics requires specialist software: a number of examples are available, from low-cost shareware through to professional applications capable of coping with images made up of tens of thousands of tiles.

While the software can piece together the composite automatically, and can squeeze, crop, and compress images to fit, you do need to do some preparation yourself: you must provide enough source pictures to work from, reduced to a suitable file size. Several hundred images is the bare minimum for a reasonable result, but the more the better. Once prepared, the images can be used for as many mosaics as you want to make, so it is worth spending time trying to find good images with a range of tones and colors. Depending on the software, you may be able to specify how often a particular image can be re-used in the same mosaic, and how close it can appear to an identical tile.

Statue of Liberty
This photomosaic of the Statue of Liberty is made using 1,980 tiles in a program called 2gether1 (downloadable for Mac or PC at www.2gether1.de). The amount of time the rendering process takes varies on the parameters set; however, you can see the image take shape, and can even record the compilation process as a QuickTime movie.

2.3 Reinventing darkroom techniques

The arrival of digital manipulation has brought about a revolution in photography: programs like Photoshop allow you to do things with imaging that were simply not possible in the days of film. There is an almost limitless number of new tricks and techniques to try out, some of which, no doubt, are still waiting to be discovered by photographers for the first time.

Despite all these fresh effects and filters, however, it is only natural that photographers also want to recreate the techniques that evolved during the first 160 years of photography. Converting image files to black and white, and toning digital pictures using Photoshop, for example, provide modern ways of presenting photographs in nineteenth century styles.

Manipulation programs are capable of mimicking a wide range of other old techniques, both obscure and popular. Software developers often produce plug-ins or downloadable actions that simplify recreating these old tricks, but it can often be more fun to make do with the standard adjustments and effects that are provided by Photoshop.

Cross-processing

Cross-processing is a technique that was much loved by music industry and fashion photographers, where color print film was processed in slide chemistry, or slide film was processed as if color negatives, to give strange distortions in color and contrast that appealed to magazine art editors.

As with split-toning, this trick can be recreated by playing around with the *Curves* for each channel—in this case working from a full-color image. Portraits work best: in this example, the adjustment recreates the processing of C41 negative film in E6 slide chemistry, giving a green-blue tinge to the skin tones.

Before

Curves adjustments: contrast is increased in RGB and in the Red channel, while highlights are suppressed in the Green and Blue channels.

After

Split-toning

Before

Split-toning is an old darkroom technique where a black-and-white print is treated with two metallic toners in succession, so that some of the midtones in the image are one color, and others are another. The trick can be applied to an RGB scan of a black-and-white negative, or to a desaturated digital camera file. The adjustment is made using different *Curves* (or *Levels*) adjustments to the Red, Blue, and Green channels—in this shot, the curves were tweaked until the grays were toned part-green and part-magenta.

The differing *Curves* adjustments in the three channels

After

Sabattier effect

The Sabattier effect (or solarization, as it is sometimes known) used to involve exposing the film or printing paper to light before it was fully developed. This caused a slight reversal in some of the tones, creating a curious hybrid that was part-positive and part-negative. You only had one chance at getting the secondary exposure right—and if you did get a good result, it was hard to repeat.

In Photoshop, there are no such difficulties, and the Sabbatier principle can be applied to both monochrome and color images with ultimate control of the image. The basic principle is to manipulate the graph in the *Curves* adjustment to form a U-shapde line; by further distorting the curve, you can create even crazier effects. Once you have something you are vaguely happy with, color can then be adjusted by the curves in each of the channels, or by using other color-adjustment tools.

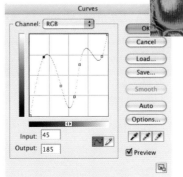

Roadside pumpkin display

Creating a curved line that bends this way then that has the effect of inverting some tones and colors, while leaving others relatively normal. It gives a fresh, if psychedelic, appearance to this Vermont farmer's Halloween display.

2.3

261

3.1

3.1 From camera to PC

Whether you manipulate your pictures or not, the computer is the natural hub for anything that you do with your digital images. It provides the ability to view pictures, to import them into other applications, share them with others via email, and to print them out for yourself. Most importantly, the PC provides a place where image files can be stored, backed up, and safely archived; there comes a time when camera memory has to be freed up so that more pictures can be taken.

Once images have been transferred from flash card to desktop computer, there is no need for them to remain forever on the hard drive. This may simply be a temporary holding bay for recent pictures, as they are sorted through, edited, and viewed on a big screen—but because digital pictures have no physical presence, and are all too easy to destroy, they must be carefully shepherded and copied, so that pictures that you want to keep for the long term are not accidentally deleted or corrupted.

3.1 Camera connections

Connecting a digital camera to a PC is not usually a complicated task—the camera should be supplied with a suitable cable that connects it to a free port on the computer. The computer may be able to read the camera's built-in or flash card memory without the need for any further instruction; the folder of pictures appears on the desktop or in the My Computer window, in much the same way as when you insert a CD. In other cases, you may need to install the supplied "driver" software that allows the camera and computer to communicate.

USB has become the standard port for both PCs and Macs, so the cable in the box is likely to work with the vast majority of computers. On older cameras and computers, however things may be different. Pre-USB, both cameras and computers used serial cables to link up, and the installation of the right driver software is essential for these.

The type of port does not just define the type of cable that you need; it also dictates the speed at which files will be copied from one device to another. USB is significantly faster than serial, for instance—an important factor with high-resolution files.

USB comes in several different forms, with USB 2.0 being the fastest. Unfortunately, many devices are advertised as being USB 2.0-compliant, while offering only the connection speed of older USB types. The speed of connection, whatever the connection, is almost always slower than the maximum data speed, which is usually measured in bits per second, whilst memory is measured in bytes (equivalent to 8 bits). In practice, devices offering a FireWire connection tend to offer faster sustained file transfer than USB devices. FireWire, or IEE1394, is found as an option on some high-end cameras and other peripherals (such as scanners).

Some cameras, particularly camera phones, offer cable-free connection using one or more wireless technologies. The most basic of these is infrared, which requires the phone and computer to be lined up exactly, and in close proximity, to transfer the file. More useful, and faster, is Bluetooth, which is built into some cameras as well as phones. This is a short-distance radio link (with a typical range of around 30ft/10m).

Some professional cameras and high-end phones offer a WiFi (IEE802.11b or g) option; this is another radio link, which allows the use of local area network facilities at Broadband connection speeds, but without the need for cabling.

TV playback

Most digital cameras come not only with PC cables, but also come with cables that allow you to hook the camera up to your TV. This allows you to view your images on a large screen, to review your work, and share the shots with others; and is particularly useful when a computer is not available. The television simply becomes an additional camera monitor; you get no extra editing or backup facilities.

The cable usually provided has a yellow phono (or RCA) plug that fits into the video input at the front of the television which is usually used for connecting games consoles or camcorders; Phono-to-Scart adapters can be bought if the TV doesn't have a phono input. As different color standards are used by televisions around the world, it is necessary to switch the camera to the right system (NTSC for North America, PAL for Europe).

The video signal produced by the camera is a composite one, and doesn't actually make the most of the picture quality available from top-of-the-range TV sets. However, special card

readers (such as the Vosonic DV-325) offer a component video signal, which feeds into the set's S-Video input. This increases horizontal resolution from around 350 lines to over 500 lines but will only display JPEG files. Some TV sets are manufactured with built-in memory card slots.

Televisions are great for checking pictures, or sharing them with a group, but at 480 lines visible vertical resolution (or 576 in Europe), their quality is well below that of a standard computer monitor.

Card readers

Multi-purpose gadget
Card readers typically have several slots, for use with different memory card types.

Instead of using your camera to transfer your picture files to the computer, you can use a card reader, a low-cost device that has a number of advantages:

● It can be left permanently connected to your PC.

● You don't tie up your camera, and you save on unnecessary battery usage.

● It is available for all card types; many card readers are multiformat, and are capable of downloading from a number of different cameras and camphones.

● It provides a solution if your computer seems to have the "wrong" port or operating system for your camera's own cable.

● It may be faster at downloading than the camera.

There is one major disadvantage, however: this is the risk that you leave your card in the reader and take the camera out on location without any means to actually take pictures. This risk can be minimized by always carrying one or more spare memory cards.

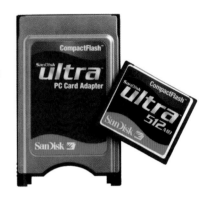

Laptop adaptor
Adaptors to enable cards to be slotted into the PCMCIA slots found on many laptops can be bought.

Speed of connection

Cable connections	Maximum connection speed (kilobits per second)	
Serial (RS232)	115	
USB	12,000	
USB 2.0	480,000	
FireWire 400 (IEEE1394)	400,000	
Wireless connections		
Bluetooth (v1.0)	723	
Infrared (IrDA-1)	115	
WiFi (802.11b)	11,000	
WiFi (802.11g)	54,000	

3.1

3.1 Backing up and storage

You can never be too careful with digital files: unlike physical prints and pieces of paper, digital information is vulnerable in ways that we find hard to appreciate until things go drastically wrong. When the worst happens, it is not simply a matter of a ripped corner or a discolored picture—you may well be left with nothing at all.

The dangers are not just the obvious risks. You need to safeguard against a computer being stolen, along with a hard drive full of irreplaceable images; you need to plan against fire and flood; you must appreciate that hard drives have been known to break down, taking all their files with them into the abyss; and however careful you are, computer viruses can pose as much threat to your pictures as to other data on your drive.

The more common danger to digital image files is accidental deletion. People delete their images from their memory card to free up space before they have been backed up onto the computer; images are saved as they are manipulated in such a way that the original file is overwritten; images are sensibly backed up onto CD, but when the backup version is desperately needed, it turns out that the copy was corrupted when it was written, making it useless. Sometimes you realize the mistake immediately (and have the opportunity to do something about it), but sometimes it can be months or years later that you realize that an image has gone missing.

Such horror stories inspire caution; but there are limits. It might be tempting to never delete an image file, and always save any alterations made as a new file—the cost to memory, however, means that there comes a time when some files have to deleted. Image files are often large compared with other information stored on the computer—and it doesn't take long before you have hundreds or thousands of them; you are forced to remove them not only from your camera memory cards, but also from your hard drive.

It is therefore essential to develop good archival habits and to stick to them before you run out of space (when it is all too easy to delete the wrong file in the quest to regain those extra megabytes of storage). You need to have a failsafe routine:

● It may be useful to delete files on the camera, but only use the "Delete All" command once the images have been successfully downloaded onto the computer.

● Always keep the original camera file intact.

● Save manipulated versions using a different name to create a separate file (using the "Save As" option).

● Back up your images onto CD, DVD, external drive, or online server sooner rather than later.

● Consider having two or more copies of each file on separate physical media, and store them in separate places (*see panel*).

Multiple copies

● Big businesses ensure that all digital data is backed up at least once a day and is stored offsite, in a secure store in a separate building, and often in a different city. These emergency planning procedures ensure that a corporation can recover from disaster as quickly as possible with all its records intact.

● Such regimental procedures might seem unnecessary for your personal snaps, but pictures are often people's most valued possessions, and you can't reshoot a wedding, and it may not be possible to go back to all the places you've visited. And while you can insure against the theft of your equipment, you can't get compensation for the pictures that are stolen with them.

● Making a backup disc of your images is a sensible precaution, but if this is destroyed at the same time as your PC, then it was of little use.

● Keep your backups in a different place in the house from your computer and camera.

● Make copies of the backups that can be stored in a different location, such as a friend's house.

My hard drive

Many computer users have a habit of referring to the main system housing of their machine as the "hard drive" or "the CPU." In reality it is neither, but it houses both—CPU is an acronym for Central Processor Unit, the microchip that acts as the computers "brain," and a hard disk drive is a delicate component which stores information magnetically on spinning platters. It is this which retains information (including your pictures and software) when your computer is switched off. Whlie their reliability is astounding, especially looking back just a few years, it is not absolute, and the data is even more tightly packed than on the surface of a DVD. Make regular backups.

3.1

269

3.1 Hard drives

Once the operating system and programs have taken their share, the standard hard drive of the computer has a surprisingly small amount of space for images. The gigabytes of free space could store almost limitless amounts of words and figures, but high-resolution images produced by a digital camera or scanner will soon make the disk bulge at the seams.

It is important to ensure that a hard drive is not allowed to become too full. The computer will slow down noticeably as the amount of available space reduces; large files will be written in small chunks to fill the gaps on the disk, taking more time to open and save, and making it harder to recover them in the event of accidental deletion or hardware failure; moreover, programs such as Photoshop rely heavily on the spare space, using it as a scratch disk where work in progress, and different history states, are temporarily recorded.

One of the simplest solutions to storage problems is to invest in an external hard drive. This small box can be left permanently connected to your computer, and can be used in tandem with your built-in hard drive. But it can also be disconnected to transport a large number of files to another computer, or for safe storage in a separate location. The key features of an external hard drive are:

● Storage capacity (measured in gigabytes): ideally this should be larger than your built-in drive.

● Connection speed: backing up a large number of files can take hours. The speed of operation is dependent upon the type of socket used. FireWire drives tend to be significantly faster than USB equivalents (*see page 264*), but there are other factors.

● As with all peripherals, you be sure to check compatibility with your computer and current operating system before buying.

Pocket drives

Jobo GigaVu Pro
Weighs just over 8oz (225g), and can store and display 60GB of pictures.

Portable hard drives are designed to be used on location, without the need for a computer. The camera is either connected directly to the drive, or there is a built-in card reader. Running on battery power, some hard drives have built-in color LCD screens that allow you to see the images downloaded onto them. The capacity varies, but models can be found that match the storage of a typical built-in hard drive.

Some portable music players can also be adapted for use as digital image stores: cables are available for the best-selling iPod, for instance, that allow you to copy images straight from your camera; and all newer iPods feature a color screen to view them on.

iPod
Plays downloaded music, but can also back up your images.

External hard drive
External hard drive, adds storage capacity to your computer.

RAID

A professional solution to storage is a RAID drive, which is essentially several hard drives bolted together that work as a single unit. They have huge capacity—this entry-level RAID drive from La Cie has five bays and a capacity of 2.5 terabytes (over 22,500,000MB).

Online servers

Online services that allow you to back up valuable files using an Internet link are become more and more popular. They provide a level of security that is hard to match at home, with no need for additional hardware and offering great convenience.

The trouble is that images are usually too large to make this a viable archiving solution for the photographer. The maximum capacity offered may be less than the amount of data stored on one

memory card, so although it could be used for storing JPEGs of your most precious images, it is not a full solution. Services offering large capacity storage (such as XDrive) are, for the moment, too expensive for this type of use.

In addition, most people's Internet links are significantly slower at uploading data than downloading it, making this an unwieldy way of transferring significant numbers of large files.

.Mac
Useful for backing up and synchronizing data and low-resolution images, but not great for high-resolution photographs.

3.1

3.1 CD and DVD storage

Optical Discs are ideal for backing up and archiving image files—they take up little space, and the blank media, if bought in bulk, need cost only pennies apiece. In addition, because most recent computers have a disc burner of some sort built in, there is no need for additional hardware.

CD burners are the most common, and are usually capable of using either CD-R or CD-RW disks. The advantage of the latter is that you can rewrite information, but as this provides little advantage for archive purposes (and a risk that you might delete the images accidentally), it is best to stick to cheaper CD-Rs, which give a maximum capacity of around 700MB per disc.

Blank DVDs require a special DVD writer, which can be bought as a standalone peripheral if your computer doesn't have one built in. These writers provide a minimum sixfold increase in capacity, compared to recordable CDs; typically, they provide 4.7GB of space, although some multilayered formats that offer more are available.

Choosing between DVD and CD as a backup medium might seem like a straightforward decision—DVDs cost less per megabyte of storage, and as you can fit more on one disc, they take less room in your storage system. However, the important thing about backups is to do them regularly. Waiting until you have over 4GB of data before you archive your images may leave files without backups for far too long.

DVDs are available in a number of different formats; as with CDs, for archive purposes simple recordable disks are preferable to rewritable ones and compatibility issues with different players mean that single-layer disks are the safest option. This then leaves you with a choice between DVD-R and DVD+R formats, originally produced by rival camps of manufacturers. Fortunately, most recent DVD drives are capable of playing both types and all currently available drives should be capable of burning both types of media.

Software for recording image files (and other computer data) is provided with the burner or computer. More sophisticated programs, which provide a range of formatting options, are also available, but the extra options are not necessary for backup purposes: you simply want a solution that records the data in a way that it will replay again on your current computer (and any subsequent drive that you may own in years to come).

The software will offer a number of different writing speeds—the maximum available will depend on both the specification of the burner and the blanks used. It is generally thought that there is no advantage in terms of accuracy in choosing a slower writing speed; however, to avoid errors you should always select any "buffer underrun protection" option, which helps prevent the laser running out of data to write, thereby causing the disc to be ruined. Other applications should be left idle during copying.

You should also use any verification option provided by the copying software. This checks that a perfect copy has been made, which is essential for backup purposes—if you make a copy of a file for a friend and it doesn't play, this is unlikely to be the end of the world; put original photographs onto disc, however, and any fault in the copying process is more acute. Because you may not check the disc for months or years, you could be unaware of the problem until the backup is really needed. For this reason, it is also good practice to put disks you have just recorded back into your computer to see that they really are readable.

Portable burners

An alternative to the portable hard drive (*see page 271*) is the portable CD burner. This allows you to download image files direct from your memory card onto disc while you are away from your computer. Although with some models it is possible to burn the contents of a memory card onto two or more discs, it is a sensible precaution to ensure that the amount of data on the card is less than the capacity of a single disc (700MB for a CD-R).

Apacer portable CD burner
Burns discs direct from a memory card, and is powered by a rechargeable battery.

ULead's DVD SlideShow

1. Choose the images you want in each album.

2. Design the opening main menu page of the DVD.

Pictures recorded on a blank DVD or CD will not usually play in your domestic DVD player; there are some models that have a JPEG replay facility, but in most cases you have to burn the images using the Video CD format that all DVD players understand. For this you need a special piece of software.

There are a number of good shareware programs around, but commercial titles such as ULead's DVD SlideShow are relatively inexpensive, and can be downloaded on a trial basis before you purchase. Pictures can be placed into different albums, which can be selected from the index page when used in a movie DVD player. The pictures in each album then change automatically every few seconds, accompanied by the soundtrack of your choice.

3. Preview the slide show before recording onto a blank disc using the Video CD format.

Roxio Toast Titanium
Offers advanced CD and DVD format options.

External DVD burner.

If friends and family hassle you to let them see or have copies of the pictures that you have shot at a particular event, it is much easier to burn them a CD with all the shots, rather than trying to email them or print them out. A blank CD is cheap, takes just a minutes to burn, and is easy to mail. Your friends can then print out the images that they want, or just look at them on the computer. If they don't have a PC, create a Video CD (*see box*) that they can watch on their TV.

Sonic
Standard Sonic burner software distributed with many PCs: records image files as a Data Disc (not as a music CD!).

273

3.1 Cataloging

The more digital images you create, the harder it becomes to keep track of them all: when they are contained on your hard drive, it is relatively easy to track down a particular image that you want to print. But once your images start to spread onto countless discs and additional drives, and are saved in a number of slightly different versions, finding a particular shot becomes difficult–and browsing through every single file becomes impossible. It is at this stage that photo-database or cataloging applications come into their own. Essentially these are are picture browsers, but unlike basic viewing software, they perform two additional tasks:

● First, the cataloging software creates its own low-resolution thumbnail of each of your images. These are kept separate from the actual image file, and these picture databases should be small enough in size to be stored permanently on your hard drive.

● Second, it keeps a detailed electronic card index system for each picture; it stores the EXIF camera details for each shot; it keeps a track of where the original file is kept; and it allows you to add your own information, in terms of keywords and captions. You therefore don't need to search through each of the thumbnails to find an image—you simply search using a word that you know should be in this collection of metadata, such as the location or the year the picture was shot.

As with all file-keeping, these databases are only good if they are kept up to date—and they require regular attention to work efficiently. If they are used as part of your regular backup routine, they take little time to manage—which you get back with dividends in the time you save looking for files.

The best known photo database title is Extensis' Portfolio, although there are alternatives (*see box*). A simple method of using this effectively is to drag each camera folder onto the program's catalog page just after it has been copied to your hard drive. Rough keywords (location, event, and so on) can be given to all of the images shot on a particular day (these can be refined later, if you wish). The software then gets on with the job of creating your digital contact sheet. Further versions of these images (after manipulating, and so on) can then be cataloged at the time they are backed up onto disc.

The secret to successful cataloging, however, is to start building your database before your picture-filing system has got into too much of a mess.

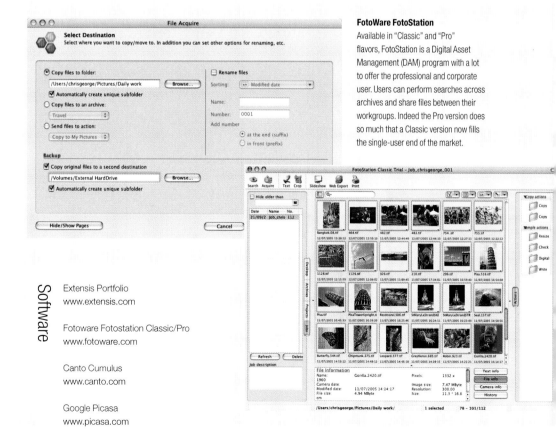

FotoWare FotoStation

Available in "Classic" and "Pro" flavors, FotoStation is a Digital Asset Management (DAM) program with a lot to offer the professional and corporate user. Users can perform searches across archives and share files between their workgroups. Indeed the Pro version does so much that a Classic version now fills the single-user end of the market.

Software

Extensis Portfolio
www.extensis.com

Fotoware Fotostation Classic/Pro
www.fotoware.com

Canto Cumulus
www.canto.com

Google Picasa
www.picasa.com

Importing

The first step with new pictures is to add them to a new or existing catalogue on your computer system. This generates small JPEGs of your originals. As the digital asset management will log other file types, you can set which files it ignores during the cataloguing process (so you don't get two catalogue entries if you shoot in RAW + JPEG mode, for instance).

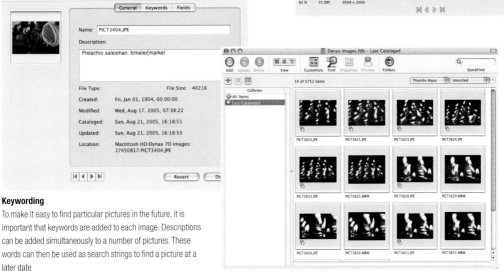

Keywording

To make it easy to find particular pictures in the future, it is important that keywords are added to each image. Descriptions can be added simultaneously to a number of pictures. These words can then be used as search strings to find a picture at a later date

Apple Aperture

Professional image management software, such as Aperture are designed to offer both picture processing and cataloguing facilities.

Extensis Portfolio

Portfolio is not Extensis's only asset manager, having also made a name for themselves with font manager Suitcase. Now in its eighth incarnation, Portfolio offers full metadata cataloging of your files, including custom fields and media burning.

3.1

275

3.1 Data recovery

It may never happen, but chances are that one day you will accidentally delete a picture that you wish you had kept. This is far more likely to happen when using the camera to edit what is on your card, than on your computer, as you do not have the safety net of the recycle bin; once you press the camera's delete key and confirm, the picture is gone.

However, as with all computer data, the bits of data have not actually been shredded. They are still there, but are now hidden from view, and to get to them, you need to use specialize data-recovery software. A wide variety of programs specially designed for hunting out deleted (and even corrupt) image files is available.

But before you use them, you must stop using the card in question. The more pictures you take after you have deleted a particular file, the higher the probability that it will be overwritten and will not be retrievable. This is yet another good reason why it pays to always have two or more memory cards to hand; you can therefore leave the card untouched until you can use your computer.

Image-recovery software is not particularly expensive, and—better still—with most programs you only pay for results. In general, you can download the software and use it on the offending memory card, and it will list (and possibly display thumbnails of) the images that it can successfully salvage. If it finds the picture that you are looking for (among those that you have already backed up, or intended to delete), you then pay for the software to do the full job.

Similar software is available for recovering deleted files from hard drives. To avoid further information being written to the drive, the recovery software is usually supplied on a CD, which allows you to reboot the machine using a skeletal operating system provided on the disc.

Card corruption

Accidental deletion is not the only disaster that can be remedied using image-recovery software. These programs also attempt to recover files that have become corrupted on a memory card. Corrupt files are, by their very nature, more difficult to salvage successfully than deleted ones; so prevention is essential (*see page 35*); however, if a card is accidentally removed while the camera is still writing data, for example, it may be possible to get round the error messages.

Recovery programs often have extensive or advanced search facilities that can hunt out files that do not have file names or are missing pieces of formatting. Be warned, however that the full search modes can take a good while to sift through a full memory card—and there is no guarantee of success. That said, when you get a "corrupt card" error message on your camera, it is worth trying one or more of these programs to see if you can recover the pictures before the card has to be wiped and reformatted.

CD care

As any music fan knows, CDs happily play one day and then jump, or refuse to play at all, the next. Discs, whether CD or DVD, are not perfect storage solutions, but to ensure that your picture archive discs protect your images in such a way that they can be retrieved without fuss next time they are needed, these circular sheets of laminated plastic need to be handled with care:

● Always hold the discs at the edges, to avoid fingerprints on the surface.

● Store discs in a special sleeve or jewel case when not in use, to avoid any scratches.

● Store discs away from extreme temperatures and high humidity. CDs warp easily, and have been know to be eaten away by fungal growth.

● Only write on the surface with a marker designed for use on CDs. Don't use sticky labels.

● If a disk refuses to play, don't panic. Give the surface a clean with a soft, lint-free cloth, and try again.

● Stubborn discs may well play in one disc drive, but not another. Try another computer, or two.

● The most common reason for misbehaving discs is scratches on the surface. These do not affect the recorded data but interfere with the laser as it tries to read the pits buried below the surface. Disc-polishing kits can remove the scratches and make the data accessible again.

The excellent PhotoRescue Pro allows you a high degree of control over what the scanning operation looks for. It also proves good at detecting RAW files that some other programs fail to identify. Here, a trial of the software was carried out on a spare 256MB card that contained undeleted pictures from two different cameras, as well as several that had just been deleted. It not only found these, but also discovered files that had been deleted several months before.

Lexar's ImageRescue program is provided on some of its memory cards; copy it to your hard drive before you start taking pictures with the camera.

Digital PhotoRescue Pro
www.objectrescue.com/
products/photorescuepro/

Photorescue
www.datarescue.com/
photorescue

MediaRecover
www.mediarecover.com

Image Recall
www.imagerecall.com

Image Rescue
www.lexar.com/software/image_
rescue.html

Recover My Photos
www.recover-my-photos.com

Photorecover
www.lc-tech.com/software/
prwindetail.html

Digital Picture Recovery
www.dtidata.com/photo_recovery.asp

Flash File Recovery
www.panterasoft.com/file-
recovery

PhotoOne Recovery
www.photoone.net

3.1

3.2 Counting the dots

Just how far can you enlarge your digital images when they are printed? The simple answer to this depends on the number of pixels in the picture. Each pixel represents a square in the image, and you usually want to print it so that these squares are not visible. How small these squares need to be, however, depends on how fussy you are. The general accepted standard for professional printing is that 300ppi (pixels per inch) is perfect, while for most people's purposes 200ppi is more than adequate; the difference between these two figures makes a huge difference to the maximum size at which a picture can be printed (*see page 28-29*).

200ppi is not an absolute minimum, however—you can stretch the pixels slightly further and be happy. What is more, how big the squares can realistically

be will depend on how far away the print is when you view it: if each of the pixels was printed so that it appeared 1in (2.5cm) across, a 1-megapixel picture (which would then measure 100ft/30m across) would look just fine from a block away.

Working out the maximum printable size for the number of pixels that you have in your picture is straightforward, using the utilities provided by manipulation programs such as Photoshop and Elements. The *Image Size* window (found in the *Image* drop-down window) shows you the printable size for the currently set number of pixels per inch. You can then change the pixel concentration to make the picture larger or smaller. If the image is then printed at 100% (*see page 290*), this is the size that the image would be on the paper.

DocDimensions
In Photoshop you can set up the main image window so that the maximum printable size is always shown in the frame.

Image Size
Photoshop's *Image Size* dialog tells you how far an image can be enlarged for a given pixel concentration. Leave the *Resample Image* box unchecked, and by entering different resolutions you can see the resulting width and height of your picture. Here, a full-frame shot from a 6-megapixel camera can be printed at 10 × 6.7in (25.4 × 16.9cm) at 300ppi, but can be printed over double that size at 200ppi—15 × 10in (38.2 × 25.4cm). If you were willing to settle for the lower 100ppi standard, you could print this image four times larger still, at 30 × 20in (76.5 × 51cm).

3.2 Counting the dots

Just how far can you enlarge your digital images when they are printed? The simple answer to this depends on the number of pixels in the picture. Each pixel represents a square in the image, and you usually want to print it so that these squares are not visible. How small these squares need to be, however, depends on how fussy you are. The general accepted standard for professional printing is that 300ppi (pixels per inch) is perfect, while for most people's purposes 200ppi is more than adequate; the difference between these two figures makes a huge difference to the maximum size at which a picture can be printed (*see page 28-29*).

200ppi is not an absolute minimum, however—you can stretch the pixels slightly further and be happy. What is more, how big the squares can realistically be will depend on how far away the print is when you view it: if each of the pixels was printed so that it appeared 1in (2.5cm) across, a 1-megapixel picture (which would then measure 100ft/30m across) would look just fine from a block away.

Working out the maximum printable size for the number of pixels that you have in your picture is straightforward, using the utilities provided by manipulation programs such as Photoshop and Elements. The *Image Size* window (found in the *Image* drop-down window) shows you the printable size for the currently set number of pixels per inch. You can then change the pixel concentration to make the picture larger or smaller. If the image is then printed at 100% (*see page 290*), this is the size that the image would be on the paper.

DocDimensions
In Photoshop you can set up the main image window so that the maximum printable size is always shown in the frame.

Image Size
Photoshop's *Image Size* dialog tells you how far an image can be enlarged for a given pixel concentration. Leave the *Resample Image* box unchecked, and by entering different resolutions you can see the resulting width and height of your picture. Here, a full-frame shot from a 6-megapixel camera can be printed at 10 × 6.7in (25.4 × 16.9cm) at 300ppi, but can be printed over double that size at 200ppi—15 × 10in (38.2 × 25.4cm). If you were willing to settle for the lower 100ppi standard, you could print this image four times larger still, at 30 × 20in (76.5 × 51cm).

Dots and pixels

Economy
Normal – 360dpi
Fine – 360dpi
✓ **Photo – 720dpi**
Photo – 1440dpi
Photo – 2880dpi

There is a temptation when talking about printing to muddle up pixels and dots. The resolution of digital images is measured in pixels; however, pixels in an image file have no physical dimension—it is only when they are displayed or printed that they have size. It is at this point that we talk about pixels per inch, which helps us to calculate just how large an image can appear for a given use.

However, digital printers and paper are sold on the basis of how many dots per inch (dpi) that they are capable of dealing with. In some cases, the printer will also ask you to choose which dpi setting you want to use.

Dots per inch, however, are not the same as pixels per inch; the dpi rating is simply a way of describing how small a blob of ink the printer can create on the paper. In general terms, the more dots of ink, the finer the detail. But the advantage only shows if you use paper that is capable of showing it. In fact, it is not only a waste of ink to use higher dpi settings with certain papers, it will also produce worse results.

Generally speaking:

● 360dpi is the minimum resolution setting for use with normal paper and basic inkjet stock.

● 720dpi and 1440dpi are reserved for good-quality photo paper.

● 2880dpi or higher is best used only with fine, glossy media.

Some inkjet printers quote two figures for resolution, such as 2400 × 1200dpi: The first figure tells you the number of dots that can be created across the page, and the second how many can be created down the page.

This section, from a picture of the bell tower in Rhodes, has been digitally resized to show the effect of resolution on print quality. The difference between 200ppi and 300ppi is not easy to see.

50ppi

100ppi

150ppi

200ppi

250ppi

300ppi

3.2

3.2 Upsizing

Using standard calculations, an uncropped picture shot with a 3-megapixel camera is only capable of being printed at just under 10×8in (25.4×20cm) at 200ppi. It can only be output at around 7×5in (17.6×2.5cm) if you want to use the more exacting 300ppi standard (*see pages 28–29, and 280–81*). However, it is perfectly possible to create much larger prints with this camera, without breaking any rules. The solution is to manipulate the image, adding more pixels to the picture, so that it can be enlarged further without the squares showing.

Interpolation, as this process is known, involves the use of software to make an intelligent guess as to how the new pixels are squeezed in among the existing ones. It is a technique that is generally frowned upon when used by cameras or scanners, but is widely used by professionals when preparing images for clients. Upsizing means that an image produced by a digital camera can be printed out at a far greater range of sizes than would otherwise be possible.

Because the process increases the size of the image file, it is best only to upsize the image when necessary. It is not just useful for extra-large prints; it also becomes essential when you have had to greatly crop an wildlife or sports image, say, because you did not have a long enough lens to get in close enough at the time of shooting.

The simplest form of interpolation is to use one of the *Resample* options provided in Photoshop and Photoshop Elements, found in the *Image Size* box. Check the *Resample Image* box, and then enter the dimensions and pixel resolution you require. The program then resamples the image to meet your requirements.

Interpolation is not a magical process—it cannot create images as good as those that have the requisite number of pixels originally. There is always some quality loss, but given this, the result is far better than simply blowing up the pixels to get a larger image.

The key to maintaining as much quality as possible is the type of interpolation method used. Photoshop offers a choice of five; for photographic purposes, the *Bicubic* options are the ones to go for. The basic *Bicubic* option is designed for all-round use and for results with smooth tonal gradations; *Bicubic Smoother* is optimized for upsizing images; and *Bicubic Sharper* is designed for sampling down the size of the file.

The resampling process should be carried out before the image is sharpened. For large changes in the number of total pixels, it is worth doing the upsizing in stages, rather than all at once.

Full frame

Before

Photoshop interpolation

Bicubic interpolation is best applied in small amounts. For this shot of a wallaby, to double the dimensions of the image, it was resampled at 110% using the *Bicubic Smoother* setting seven times in a row. Because of a kind of "compound interest," this doubles the number of pixels in each dimension, providing much better scope for a selective enlargement.

Image Size

Pixel Dimensions: 1.62M (was 1.34M)

Width: 685 pixels
Height: 827 pixels

Document Size:

Width: 109.95 percent
Height: 110 percent
Resolution: 300 pixels/inch

OK
Cancel
Auto...

☐ Scale Styles
☑ Constrain Proportions
☑ Resample Image: Bicubic Smoother

After stepped *Bicubic* interpolation

Genuine Fractals

How would you like Genuine Fractals to save this document? Default produces better compression, lossless produces a digitally exaxt replica.

(Lossless) (Default)

Although bicubic interpolation is fine for small changes in image size, a number of specialized programs are available for creating larger image files from your pictures.

The best-known of these is Genuine Fractals, a plug-in that is designed to be used with Photoshop and Elements. This enables you to resample an image at up to 700% of its original size, using algorithms that produce more natural-looking results than bicubic interpolation.

The bizarre feature of Genuine Fractals that it doesn't just upsize images—it compresses them too, saving in its native (.stn) format. This reduces file sizes by up to 50% if you choose the lossless option, or 80% if you choose the "visually lossless" option.

You don't have to use this compression system, however: the interpolation can (in recent versions) be applied directly to standard image formats. The resizing tools are found under Photoshop's *Automate* menu, where you choose the dimensions or percentage of enlargement required, and then the lengthy resampling is carried out for you. The new, larger, file is saved using a new name.

Seeing more clearly
This shot of a cat on a window ledge in France has been heavily cropped, and at 300ppi can be printed at 11 × 9in (28 × 23cm). Using Genuine Fractals interpolation, a 300% enlargement is applied, producing a file that is capable of a 35 × 29in (88.8 × 73.5cm) print at 300ppi.

Resampling software

Genuine Fractals
www.ononesoftware.com

Shortcut Photozoom (S-Spline)
www.trulyphotomagic.com

ResizeIT
www.outdoorgrace.com

SAR Image Processor
www.general-cathexis.com

pxl SmartScale
www.ononesoftware.com

3.2

283

3.2 Inkjet printers

Color inkjet printers are the best, and most popular, all-round choice for producing prints at home; this is the type of printer that most people have available anyway. And while the laser printer favored in the office is superior for outputting pages of text, the inkjet outperforms the laser when reproducing photographs.

Inkjet printers work by squirting microscopic drops of ink onto the paper. As with all printers, the colors used are not the red, green, and blue that are used by digital cameras and scanners. Instead a combination of cyan, magenta, yellow, and black (CMYK) inks are used. It is not necessary to convert the image from RGB to a digital CMYK form, as this is done automatically by the printer's software.

Although all inkjet printers are capable of producing excellent results, if set up correctly and used with the right inks and paper, there are a number of features that are worth taking into consideration when buying a model for producing photographs:

Maximum print size

Most desktop printers are designed to be used with papers up to A4 and Letter sizes (*see page 294*). However, some miniature models just produce small 4×6in (10×15cm) enprints, of the size traditionally produced by photographic labs. Consumer models that can handle A3 and A3 Plus paper sizes can also be bought at reasonable prices, while professional models can cope with even larger sheet sizes.

Roll paper handling

All printers have an automatic feeding tray for handling precut sheets of paper; on some you can also mount rolls of paper. The main advantage of this is that the print size can be altered to suit the aspect ratio of the picture; a 4in (10cm) roll of paper can then be used to produced 4×8in (10×20cm) panoramas, 4×5.3in (10×13cm) computer-screen-shape prints, and a full range of other sizes in addition to standard 4×6in (10×15cm) pictures.

Bleed printing

Many inkjet printers cannot print right to the edge of the paper, forcing you either to leave a border, or to use special paper with perforated edges. Bleed printing enables you to fill the entire paper area with the image—although you should expect slight softening in quality towards the edges.

Number of inks

Although all printers use cyan, magenta, yellow, and black inks, some photographic models use extra colors to provide a wider color gamut: "Light cyan" and "light magenta" are common additional inks, and a "light black" is also used with seven-ink systems.

Number of ink reservoirs

On basic inkjet printers, the ink is supplied in two cartridges: one holds the black ink, and the other holds the cyan, magenta, and yellow. The trouble with this approach is that the color cartridge has to be replaced as soon as just one of the color reservoirs has run dry; if you print a lot of copies of an image with a dominant color, this could prove particularly expensive. Some printers provide each of the colors in separate cartridges, which is economical for many users.

Maximum resolution

The number of dots per inch that the nozzles are capable of delivering varies (*see page 280–81*), which may have an effect on image quality, particularly with finer grades of paper.

Speed of printing

Some printers output your photographs faster than others. This is worth considering if you are going to print lots of pictures in a single session.

Connection

Most printers connect to the computer using a USB port (*see page 264*), but some models offer connection via FireWire, parallel, or serial ports. As with all computer peripherals, you must also check other system requirements, as the print management software may not work with all operating systems.

Footprint

How much room will the printer take up on your desk. This is a not insignificant factor, since even standard letter (A4) sized printers can have a lot of bulk. The best advice is to measure your space and check the size of the unit before buying. When doing so, remember to factor in some space around the printer to access buttons and paper trays.

Many photo printers can print direct from the camera or the memory card, without the need for a computer. Things to look out for when considering one of these are:

● **Built-in memory card reader** Check compatibility with the cards your camera uses.

● **Built-in LCD screen** Lets you preview your image before you print (essential if not using camera or computer). Note that some LCD screens are provided only for instructions and options, and do not preview your images.

● **Editing options** Can you crop your pictures or make other adjustments? The amount of control that you have to manipulate and print the image is greatly restricted when compared to using a computer.

● **Pictbridge** A system used by camera manufacturers whereby you can control printing from the camera itself when connected to a compatible printer.

● **Wireless connection** Some printers can connect to cameras without the use of cables, using Bluetooth (see page 264–65). Bluetooth functionality can be added to some printers as an optional extra; WiFi and infrared options can also be found.

Epson PictureMate
Printers such as the Epson PictureMate are designed solely to produce standard 4 × 6in (10 × 15cm) photographs.

Canon i9950
PictBridge enables connection of a camera directly to a printer without needing to use a computer.

Epson 2100
This top-of-the-range consumer model is capable of handling paper sizes up to 13 × 19in (33 × 48cm) size (A3+), and uses seven different color inks in separate cartridges.

PostScript is a computer language that is used in professional printing to describe images, text, and graphics. For a printer to be able to understand and print PostScript files, it must have Raster Image Processing (RIP) software, or hardware that can convert PostScript back into the complex pattern of dots that the printer actually makes on the page. PostScript inkjet models tend to be top-of-the-range and large-format models, designed for proof work by designers and publishers. Some consumer models can be converted to work with PostScript using suitable RIP software.

Canon BJ-W9000

3.2 Alternative printers

While the inkjet printer is the most popular choice at home, it is not the only option for the photographer. The dye sub, or thermal, printer can produce prints that look more like traditional photographs; this is a particularly popular technology for printers that are designed to produce small, 4×6in (10×15cm), prints, but affordable models capable of 10×8in (20×25.5cm) and A4 prints can also be found.

These printers tend to be more expensive than equivalent inkjet models, and the running costs are also usually higher. The dye-sublimation process vaporizes a special colored ribbon, which is absorbed directly into the paper. An advantage of this system is that you know exactly how many prints you are going to get per ribbon; the rolls have consecutive panels of cyan,

magenta, yellow, and black dye. The rolls of ribbon are sold in packs with the paper, giving a completely predictable cost per print. Resolution is typically 300ppi, but because the tone is continuous, rather than being made up of blobs of ink, this gives a higher quality result than an inkjet. A further advantage is that thermal prints are fully dry when they come out of the printer (inkjet prints should ideally be left to dry for several hours).

However, one disadvantage is that the size of your output is fixed by the printer (although you can print several shots on one sheet, to create smaller images). Such printers are not usually capable of bleed-printing, so borderless prints are normally only possible using special paper with tearaway edges.

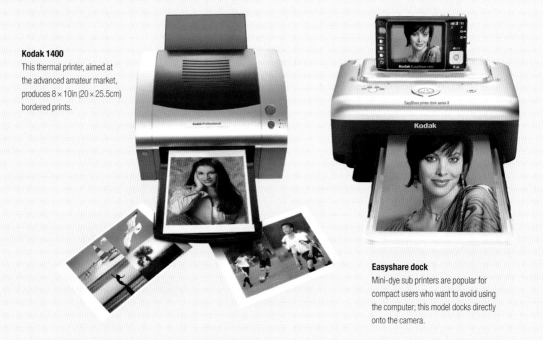

Kodak 1400
This thermal printer, aimed at the advanced amateur market, produces 8×10in (20×25.5cm) bordered prints.

Easyshare dock
Mini-dye sub printers are popular for compact users who want to avoid using the computer; this model docks directly onto the camera.

Canon Selphy cp600
Small dye sub printers are useful for making prints while on the move, this particular model can be powered from a rechargeable battery.

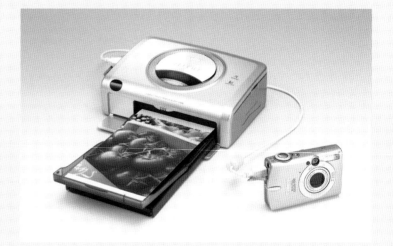

Commercial printing

Professional processing labs are of obvious interest to those who do not have access to a suitable computer or printer. But the range of services that they offer can also be of interest to those who have a home printing setup:

● Photography stores can print direct from your memory cards or from CD. Some self-operated kiosks permit you to crop images to suit the print size ordered, and to add effects.

● Online labs get you to upload images from your computer using either a standard web browser or a free downloadable program. Because of the constraints on Internet upload speed, you can usually send only JPEG files. These are stored on the lab's server, and you then order your prints.

● With online labs, prints are returned by mail—because of postage and packaging costs, they are best used when ordering a largish number of prints. Commercial labs tend to be more expensive, but work out better value for one or two prints.

● Online labs can prove much cheaper than printing out at home, particularly if you buy in

bulk: special deals are available for, say, buying 100 prints—and these may not all have to be ordered at the same time.

● Lab prints are printed onto "real" photographic paper—the light-sensitive material packed with silver crystals that has been used to produce photographs for generations. The archival characteristics of these prints are better than low-cost inkjet prints (see page 292).

● You can get larger prints than your home printer is capable of, or get single enlargements without the expense of buying an entire pack of paper.

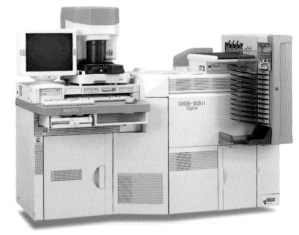

Typical commercial minilab
Produces prints on light-sensitive paper from your digital files.

● Professional print outlets can produce billboard-size prints at surprisingly low prices, using specialist machines such as the Durst Lamda or Océ LightJet.

Online processing
Sending your images to an online processor involves choosing compatible files from your computer—but the images may take some time to upload. Once ordered, your prints could be with you on the following day.

3.2

287

3.2 Color control

Home printing can be a frustrating business—having carefully manipulated and tweaked your shot on screen, you then find that the print looks nothing like the image did on your monitor: the hard copy lacks any punch, and the colors have gone awry.

You can get things to look better by playing around with the color controls provided in the printer software, but this not only wastes time, but also uses up what can be expensive sheets of paper and valuable quantities of ink.

The solution to the problem is in the color management. Every device sees or displays color in a different way, and for them to understand each other, the most effective solution is to adopt a common language. This is provided in the way of an ICC profile (*see pages 196–97*)—essentially a set of instructions for showing the printer's color characteristics.

The first step is to ensure that the screen has been properly profiled (*see page 196*)—if this is inaccurate, it is going to be hard, if not impossible, to correct the printer. You must also realize that a print is never going to look precisely like an onscreen preview: a monitor is backlit, while a print relies on reflected light to be seen, and this automatically means that a screen image looks brighter. Then there is the fact that printers use CMYK inks to create a physical representation of what is usually an RGB file; this almost inevitably means that the intensity of some colors is lost, as this color space is more limited. You can, however, get a better preview of what the print will look like by using the CMYK proofing option available in Photoshop (*see page 238*).

Despite these differences, the print should not look substantially different from the screen version. To achieve this, you must create a profile for the printer, this is not always as difficult as it might seem. If you use the ink cartridges and the paper produced by the printer manufacturer, profiling is generally handled for you. You simply need to tell the printer the type of paper that you are using and the resolution that you want to use, and it should handle the color management for you.

But if you want to try different makes of paper (*see page 294*) or different types of ink (*see page 292*), you may well have to guess what settings to use.

Dye sub users have it easy, as they don't have any choice but to use the manufacturer's own paper and ribbons. But even if you use the materials that the printer manufacturer produces, there can be differences from one machine to the next.

Custom profiling fine-tunes the color output to the individual printer with a certain combination of ink and paper. This is done by printing out special color targets and then analyzing the exact color that has been printed. There are two ways of doing this:

● The cheapest solution is to buy the printer profiler software and then use your own flatbed scanner to analyse the printed test target.

● A more efficient system is to use a package that provides a densitometer with the software. This reads the color values from various patches on the printed test chart.

Profiling by mail

Some people make their living sorting out color profiles for graphic designers, photographers, and others; they sort out your screen, and create profiles for every other device in your workflow. The trouble is that these experts can be expensive to hire, particularly because, with monitors, they need to make a site visit, and with scanners and cameras you need an expensive target that they do not want to let out of their sight.

Profiling printers is a different matter. Professionals can do this using email and snail mail. You download one or more targets and print them out to the professionals' precise instructions; you then send the prints back for analysis, and the professionals then email you back the ICC profile. The profile is

only usable with that printer and with one combination of ink and paper; however, if this is the setup you always use, this method can prove a lot cheaper than buying your own calibration solution.

Companies that offer a postal printer profiling service include:

SCS Imaging
www.scs-imaging.co.uk

Pixl
www.pixl.dk

Pixl color chart
One of the color charts that the Danish specialist Pixl asks you to print out when using its postal profiling service.

Epson color choices

Even if you use the manufacturer's own paper and ink, it can be worth playing around with the color settings. On Epson printers, it can sometimes be better to use the *No Color Management* or the *Photo-Realistic* color control, depending on the paper type. The *ColorSync* setting is used with custom ICC profiles.

Media profiles

The simplest approach to printer color profiling is to use the inks and papers made by the manufacturer. With this Epson printer, choosing a specific paper type actually sets a specific ICC profile for the printer to use.

ICC profile drop-down screen

The ICC profiles created and provided for different equipment are all stored together. Here, Epson's own ICC profiles are jumbled with profiles created for the same printer by other ink manufacturers, and others produced by custom color calibration.

Printer-profiling software/hardware

Profiler Plus
www.colorvision.ch

PrintFix
www.colorvision.ch

Monaco EZColor
www.xritephoto.com

Eye-One Photo
www.gretagmacbeth.com

Color Confidence Print Profiler
www.typemaker.co.uk

Printer color calibration system

The plug-in Colorimeter measures the exact color of a printed test chart and feeds back the results to the ICC-creating software.

Rendering intent

Some colors in your images will not be printable as they appear onscreen, however well you calibrate your screen and printer. This is because these particular colors simply cannot be produced with any combination of ink.

With programs such as Photoshop, you can specify exactly how these "out of gamut" colors will appear in the print; essentially, this "rendering intent" specifies how the software chooses the nearest available color to use.

For photographic purposes, *Perceptual* rendering is usually the best option to use: this squeezes the color space to fit that of the printer, making changes to more colors than simply those that are out of gamut and providing the most natural-looking result.

Top tips

● Inkjet prints may come out of the printer touch-dry, but you should only judge the final color when the print is fully dry. This can take up to 24 hours—an hour is an absolute minimum.

● Prints can be stacked on top of each other as they dry, but put a sheet of plain paper between each one.

● Dry prints in a dust-free, fume-free environment.

3.2

289

3.2 Software control

Your pictures can be printed from practically any program that lets you view the files in the first place. However, with photographs it pays to have as much control over the output as possible, and for this a manipulation package such as Photoshop or Elements is ideal.

When you print out your picture, you want to be able to specify not only exactly how much the image is enlarged or reduced—you also want to be able to control exactly where it sits on the piece of paper.

The first decision to make is whether you want the image to have the same aspect ratio as the paper it is printed on. This will create either a borderless image or one with a proportional all-round white edge, depending on the printer and the settings. The easiest way to do this is with the *Crop* tool set to the print size and resolution you require (*see pages 212–13*). But this will resize the actual picture file, so be careful to do so without overwriting the master file; instead, you can crop using the aspect ratio alone, and leave the resizing to the print software.

The printer utilities that come with photo-quality printers provide options that preview the positioning of the image before you print. These are very useful as they can save as much paper and ink as setting the correct color profile or paper type (*see page 288*). In the preview you can see whether the picture has been scaled to fit sensibly within the paper area, and gives a visual check that you have remembered to set the full-bleed option, if this is what you want.

Instead of always printing images to fill as much of the available paper as possible, it can sometimes be more impressive to leave a generous white border around the image. This may seem like a waste of paper, but you save on ink and provide a white surround that gives a low-cost alternative to the card mat overlay used by picture framers.

The software can be set to automatically center the image within the paper area, as you play around with a suitable magnification. You may prefer, however, to leave slightly more space at the bottom than at the top—a technique used by some picture framers to ensure there is room for the artist's signature. When leaving a white border, it is worth using the printer software to add a thin black line around the image: this will help delineate the edge of the picture better; a border measuring one or two points is usually sufficient.

The most important thing is to remember to check all the software settings before you actually print. If you accidentally have the paper type set to "plain" when using glossy photo stock, your picture will be dark and overinked; another simple, but expensive mistake is to set Letter or A4 paper, when in fact you are using A3.

Before making large prints, it is always worth using the nozzle check utility to ensure that none of the jets are blocked. Similarly, if the printer has been left idle for more than a few days, it can be worth using the printer's self-clean routine to ensure that everything is ready for action (don't use this more than is necessary, however, as this utility can waste ink).

Borders

While printer software typically provides a facility for adding colored borders and keylines to your hard copies, there are ways of creating more elaborate frames for your prints. Many plug-in filters, in fact, are designed to provide a wide range of artistic borders for your pictures (a good example is PhotoFrame, at www.ononesoftware.com).

It is also relatively easy to create your own border design using the basic tools provided by Photoshop and similar programs, which can be used to create non-rectangular, or even irregular shapes to the printed image. Similarly, you can create borders with blocks of color, graphics, or even other images. To do this you may need to create space around the outside of the image using the *Canvas Size* control, which enlarges the file without affecting the pixels of the image itself.

Flamingo
A distressed border, from the PhotoFrame library, was applied to this reflection of a flamingo, along with a good measure of Photoshop's own noise filter.

Acer Leaf

To create a soft, spattered edge to the printed image, a mask was painted to obscure the edges of the composition. The mask alone was then given a heavy dose of grain, using Photoshop's own filter.

Photo/Graphic Edges

AutoFX's Photo/Graphic Edges is a Photoshop plug-in that provides a wide range of impressive-looking edge and border effects.

Balloon

The frame for this image was created by painting the new area of the canvas with the *Pattern Stamp* tool.

Roses

To create the frame around this image, the canvas size was enlarged in five different steps; each time, a different color was used to fill the new area of the image.

3.2 Ink types

When it comes to choosing the ink cartridges that you use with your inkjet printer, it pays to be fussy, as manufacturers' own refill packs are extremely expensive when compared to the "compatible" cartridges that you can pick up at large stores and from Internet traders.

These compatible products are usually more than good enough for printing letters, college projects, and research that you've found online. But they rarely deliver the goods when it comes to accurate photo-quality output. It is not just about print quality—smooth delivery of the ink is also vital, and low-cost compatibles may clog the jets more frequently and end up costing you dear in wasted paper. Buying the manufacturers' own inks also makes color management more straightforward (*see page 288*).

Choosing compatible inks, however, is not always a bad idea. There are companies that specialize in producing replacement cartridges for serious photographers—Lyson and Permajet being two of the best known. Because they produce inks only for popular makes and models of printers, if you want to take advantage of the extra choice these ink specialists provide, you need to choose your printer with care (Epson and Canon printers tend to be the best supported, but even then not all models

are catered for). To simplify the use of these inks, the manufacturers typically provide their own, tailormade ICC profiles for their inks when used with a particular paper.

Color, cost, and consistency are not the only factors to be taken into consideration when buying ink; you should also take into consideration how long you want the print to last—inkjet prints can start to fade within weeks in less-than-ideal situations, such as direct sunlight. Choosing the right ink and paper combination is a major factor if you are striving for longevity.

Because inkjet photographs have not yet been around for a long while, what anyone says about their permanence is little more than a guess (even if it's an informed one). Manufacturers are starting to take the problem of print lifespan seriously—however, just because one says that its inks will last for 100 years, the claim may well be based on keeping the picture out of the light in an album that protects the ink from contact with the air, and even then you can be sure it's untested. Most inkjet printers use dye-based inks, but, some can also be used with pigment-based ink sets that give distinct advantages in terms of archivability. Sprays can also be used after printing, to help protect the ink from fading.

Bulk ink systems

One of the advantages of using a specialist ink, rather than that supplied by the printer manufacturer, is that you can save money. This is particularly the case if you purchase a Continuous Ink System (CIS), which replaces the cartridge and its built-in reservoirs with an interface that is fed ink from separate bottles stored outside the printer. The series of hoses is not a particularly neat-looking solution, but the advantage is that the individual bottles can be replenished when the level stops dropping: there is no need to replace the cartridge with its built-in chip. The initial setup is not cheap and is only available for some models—but for those producing even moderate volumes of enlargements, it can prove a worthwhile investment.

Continuous ink system

Printing black and white images with a color inkjet printer can be an infuriating business: colors start appearing in tones of gray, ruining your image, and the black ink seems incapable of delivering the full range of midtones that you would expect from a photographic print. The solution is to use a special inkset that gets rid of the colors and instead uses between four and seven shades of black or gray dyes or pigments. These inks are only produced for certain printers, but can be found in both cartridge or continuous ink system form.

Permajet's seven-pigment continuous ink system for black and white specialists.

Lyson Quad Black inks

Toned effects

Black and white images rarely print well in black and white; unless you can use specialist inks, the easiest solution is often to give a toned effect to the picture (see page 242–43)

(see page 242–43)

Using the printer manufacturer's own inks is a safe bet when printing photographs.

To save money on ink, it may be worth using two separate printers at home: a basic model can be used for printing out correspondence, while another is used solely for photographs. This way, you can use low-cost compatible ink cartridges in the former, while the latter can use the manufacturer's own replacements, or high-quality equivalents designed specifically for the photographer. Inkjet printers can be bought cheaply (the manufacturers make their profit from the consumables), so this approach could start saving you money in little time.

3.2

3.2 Choosing paper

For the best-looking inkjet prints, you need the best-quality paper—but identifying this is not at all easy. Although price is a reasonable indicator, even low-cost papers entice you with terms such as photo-quality, 2880dpi, heavyweight, and glossy. Because such nebulous terms are used differently by different manufacturers, comparing the alternatives to find cost-effective paper can seem impossible.

It is perfectly possible, of course, to use the standard, photocopy-grade plain paper that most of us use for our other day-to-day printing jobs. This will do for emergencies, or if you want to add an image to a letter or flyer, but it will not do your pictures full justice—and it certainly won't feel or look like a real photograph. Furthermore, it is not the economical solution it first appears: plain paper is highly absorbent, and will use more ink than other paper types, while top-quality photo papers have a resin coating that gives the image its glossy, or textured, finish.

There are certain things to look out for, however, when comparing different papers:

Weight

The weight of the paper is a good initial indicator as to its quality. It is the one specification that the manufacturer generally quotes (and if the pack doesn't tell you, be suspicious). The heavier the better—but only within reason; thick card wouldn't run through your printer, and wouldn't produce good photographs anyway. Paper weight is measured in North America in imperial pounds (the weight quoted is for a 500-sheet ream of that type of paper at a standard size, so it is not necessarily the weight of the size you are buying), while in Europe, the weight is measured in grams per square meter—the actual weight for a theoretical sheet of the paper measuring 1000 × 1000mm (39.4 × 39.4in). The standard weight of photocopy paper is 21lb, or 80gsm; the lowest grades generally sold to photographers are around 40lb (150gsm), and are often called "inkjet paper." Top-quality "photo paper" will have a weight approaching 66lb (250gsm).

Size

The maximum size of paper that you can use will depend on your printer (*see pages 284–85*), but if you look at what is available from specialist suppliers, rather than your local store, you'll find that there is a wide choice (*see box*). Common sizes are based on standard ISO and American paper sizes, and on traditional photographic print sizes; the exact sizes that are easily available will depend on where you are

in the world. If you have a suitably-equipped printer you can also choose rolls, rather than sheets, and cut your prints to size after printing (*see page 284*).

Finish

The majority of photo papers offer a high gloss finish. This produces a brighter image, and is capable of showing more detail. However, for artistic reasons other finishes may be preferred. Epson's Semi-Gloss, for instance, gives a glossy effect with slightly less shine. Satin and canvas papers provide a texture to the surface of the picture. And matte finishes can provide a print that feels more like high-quality watercolor paper.

Opacity

A measure of how opaque the paper is, given as a percentage. Normally stated only for top grades, where the figure is around 99%.

Brightness

Another percentage figure, which shows you just how white the white is.

Double-sided?

An advantage of standard photocopy paper is that you can print on both sides—handy for newsletters and the like. Most photographic inkjet paper is single-sided; the back has a different coating to the front, and may even have the manufacturer's name emblazoned on it. Quality double-sided photo paper can be found, and this can be useful for creating postcards and so on.

Instructions

The type of paper you use will affect the color characteristics of your printer. If you use the manufacturer's own paper, the software will be able to specify the paper type and corresponding ICC profile. If you use another type of paper, you rely on the paper manufacturer to tell you what settings to use for your printer and ink. Often the instructions are generic, at best, forcing you to perform your own experiments to get the right settings, unless you have the capability of creating your own ICC profile (*see pages 288–89*).

Archivability

Some papers claim to offer a longer life print than others when used with the appropriate ink (*see pages 292–93*).

You don't have to use your inkjet printer to print only on sheets of paper; you can also buy other media that will present your pictures on other materials:

Iron-on transfers

These let you put your images onto clothing and fabric. The sheets have a layer of solid glue on a backing sheet. You print the image, back to front, on the dull-looking glue side, cut round the image or design to remove as much of the unprinted sheet as possible, then bond the transfer to the material, using an iron on the backing sheet side; while warm, remove the backing sheet carefully. Don't expect the results to last for too many cycles in your washing machine.

Business cards

Pre-cut sheets of card enable you to create your own visiting cards along with a portrait or other appropriate photograph. Their microperforations never create a perfect-looking cut edge, however.

Magnetic sheets

Create your own refrigerator magnets or removable vehicle livery using your inkjet.

Fender stickers

These vinyl-coated sheets, with an adhesive backing; need to be sprayed after printing if they are to be waterproof.

Greeting cards

You can make these yourself using standard inkjet papers, but kits are available that make

the job of making a personalized family greeting card that little bit easier.

Jigsaws

Pre-cut puzzles that can go through your inkjet. Not enough pieces to keep the jigsaw diehard perplexed, however.

Metallic paper

This won't give the best photographic effect, but can be particularly useful for making labels for homemade wines, preserves, and the like.

Transparent film

For use with old-fashioned overhead projectors, or as backlit signage.

Decal paper

A decal is a design that is prepared on one type of material and then transferred onto another. Iron-on fabric papers and refrigerator magnet papers use this decal technique, other decal materials can be found for putting inkjet images onto wood, ceramic tiles, skin, and soap.

You can use lower grades of paper to create "contact sheets" of your images, providing you with a handy reference of your pictures. Photoshop and Photoshop Elements have a handy utility that automatically creates these sheets of thumbnails, fitting as many images onto a sheet as you choose. It can take some time to create the composites at your chosen resolution, but this is a job that you can leave the program to get on with while you do other things; you just print out the sheets when it is finished.

Name	Imperial size	Metric size
Enprint	4 × 6in	10 × 15cm
A6	5.8 × 4.1in	10.5 × 14.8cm
US Letter (or Letter, or A)	11 × 8.5in	27.9 × 21.6cm
A4	11.7 × 8.3 in	29.7 × 21cm
Tabloid (or B) 17x11in	43.2 × 27.9cm	
A3	16.5 × 11.7in	42 × 29.7cm
Super B, (or A3+ or Super A3)	19 × 13in	48.3 × 32.9cm
C	22 × 17in	55.8 × 43.2cm
A2	23.4 × 16.5in	59.4 × 42cm

Imperial	Metric
Pounds per ream	Grams per square meter
21lb	80gsm
24lb	90gsm
38lb	141gsm
47lb	180gsm
52lb	196gsm
55lb	205gsm
60lb	225gsm
65lb	245gsm

3.3 From PC to program

It is tempting to think of photographs as being personal possessions that we present on screen or as prints when we want to show people an image. But the beauty of digital imagery is that the picture is not a physical entity. As with any computer file, therefore, it can be sent to and seen by someone on the other side of the globe in a blink of an eye—and it can be incorporated into a thousand-and-one different applications and digital documents.

Email means that images can now be transmitted to clients or friends; at a high enough quality, if you so choose, that they can be used for prints. But the World Wide Web provides the photographer with a much larger audience: an online gallery offers the potential for thousands of people to view your images without the expense of mounting an exhibition, and with a far wider reach. You don't need to be the greatest photographer to enjoy the comments and exposure that that such a virtual show may bring. These exhibitions do not have to cost much, or even anything, to set up, as there are an increasing number of community sites where photographers can get together to show their best shots. And unlike other special interest sites on the Web, the main language is the pictures itself, enabling you to communicate your vision to those of all tongues.

3.3

3.3 Emailing

Helpful experts often recommend that you should compress your images before emailing, so that the file sizes are kept small. The merit of this is that the pictures are quick to upload, and for the recipient to download—and don't clog up their mailboxes.

The trouble is that this can mean that the image sent is far too small to be of practical use. Send a picture of the kids to Australia, and your friend down under may want to print it out; email a shot of a new product to customers, and they may want to use the image in presentations and flyers.

Sure, at one time everyone's email connection was slow—squawking in the background as it pushed messages at a snail's pace. But now large files can be sent at a reasonable speed, everyone has gigabyte harddrives, and the download takes place in the background and doesn't really hold anyone up. There are some people in the world who still have dial-up systems, but they are the exception rather than the rule, and you are likely to know how fast a connection your recipient has.

Things haven't got to the stage, however, where you can send a selection of RAW or TIFF files and expect them to get through. Most connection providers put a maximum limit on the size of file you can send, or a total limit on what can be in a recipient's mailbox. Some accounts still limit you to 1MB per message, and some cell phones automatically strip out attachments if they are over 300KB; however, most decent mail providers should permit you to send and receive files that are at least 10MB—and you can expect such size limits to become less severe over time. For the meantime it is sensible to stick to JPEG files, as you can control their size with the amount of compression used, and because this is a format that anyone can open with the minimum of fuss.

Photographs are usually sent as attachments, complete files that piggyback on the mail message itself. With most email applications you simply click on a paperclip icon, or similar, to choose the image. When received at the other end, an increasing number of browsers show JPEG files within the message itself and without the need for further software. Those that don't may force you to open the attachment with a JPEG-reading program—which may take a few seconds longer, particularly if the file has been hidden away in a folder reserved for incoming attachments.

3G

Most cell phones can send photographs taken with their built-in camera direct to an email address, or to another phone that supports the MMS picture-messaging service. However, some cell phones can also be used as digital modems, for sending pictures from a laptop or palmtop computer.

With older GSM cell phones, the connection speed is not usually fast enough for sending large image files. However, more recent 3G handsets offer upload connection speeds that—theoretically, at least—can surpass those offered by fixed-line Broadband systems. You can link a cell phone with a laptop, using a cable or Bluetooth, to email a picture taken with any camera at any resolution. An alternative is a data-only 3G device that fits into the PCMCIA slot of a laptop. As 3G connection is often charged by the amount of data transmitted, you need to watch the cost of sending images this way.

WiFi

WiFi is not just a handy way of getting your pictures from your camera to your computer without the need for cables when you are back at base. This high-speed radio link can also be used as a way of sending pictures back to your computer, or anyone else's for that matter, while you are out on assignment, and without the need for a computer. WiFi is already available on some compact cameras and professional digital SLRs. Given the right setup, this means that pictures could be sent when on vacation, say, back to your computer by taking advantage of the many pay-as-you-go WiFi hotspots found at Starbucks cafés, hotels, and the like. Cost and speed may not make this viable in the short term, but it is an exciting proposition for the future.

Rather than sending your picture as an attachment with an email, some email programs instead let you send an Internet link to the picture itself. This can be left as a clickable hyperlink so that the recipient can decide whether they want to see the image in question—particularly useful if you suspect they may pay dearly for downloads. Alternatively, the linked image can be set to load automatically as the message is read. This kind of practice is followed by those advertisers that send you colorful HTML-based emails that sell their wares.

The difficulty with using linked or embedded images is that the picture needs to exist somewhere on a website already. However, this does not mean that you have to set up your own web presence. Image Shack (www.imageshack. us) is a neat service by which you can upload low-resolution images (under 1MB in size) and automatically generates weblinks and coded tags that you can then paste into emails, online auctions, bulletin boards, and more.

Cable Modem
A cable modem provides a fast connection for sending files by email or over the Internet, but note that the upload speed is typically four times slower than the download speed that your provider shouted about.

Size of file	Connection speed			
	56KBps	256KBps	1MBps	4MBps
250KB (low-resolution JPEG)	35sec	8sec	2sec	0.5sec
5MB (high-resolution JPEG)	12min 11sec	2 min 40sec	40sec	10sec
20MB (high-resolution TIFF)	49 min	10min 40sec	2min 40sec	40sec
50MB (high-resolution scanned TIFF)	2 hours	27min	6min 40sec	1min 40sec

3.3

299

3.3 Slide shows

Those of a certain age may shudder at the memory of family gatherings where slide shows meant ages sitting around in semi-darkness as the pictures and projector were coaxed into action. For the digital photographer, the modern equivalent of the slideshow involves a minimal amount of effort, and can prove to be one of the best ways to showcase your images to friends and family.

Although the serious photographer should resist the temptation to use photographs as a computer desktop (*see page 196*), the screen saver facility that is often found as part of the computer's settings provides you with a way of displaying your pictures when the screen has been idle for a certain number of minutes. Rather than using the psychedelic moving patterns or clever animations that turn your screen into a fishtank, you can display images from a particular folder. You can choose to show them in sequence, or to pick them at random, and you can set the interval between each picture.

For those who want to show pictures to a wider audience or in a room that doesn't have a computer, the best way to present a slide show is to use a television screen. Your camera can usually play back pictures automatically through the TV's phono/video input (*see page 264*) and you can edit the show, loading just your favorites onto the memory card for the presentation. An alternative is to create a DVD or CD, which will create a polished presentation with music and which can be played back on a standard DVD movie player (*see page 273*).

For big audiences, such as photographic clubs or schools, a data projector can be connected directly to a camera or laptop. The key feature to look out for when choosing one of these is the brightness, which is measured in ANSI lumen; the higher the number, the less likely you will need to darken the room completely, the further you will be able to project the image to make it larger, and the less need you will have for a special, high-reflectance screen.

LCD picture frames

Instead of printing your pictures so that you can frame them, you can use miniature LCD screens that sit on your mantelshelf, displaying the particular image file you have saved to its internal memory. Not only can you change your pictures at regular intervals, but they can also be set up to show a succession of shots. Some have built-in card readers; this Nokia version accepts images beamed to it using infrared. A low-cost alternative is this Kodak accessory, which acts as a mount and controller, turning your camera into a freestanding slide show.

Nokia SU-7 Image Frame
Something of a concept product, this lifestyle toy can run custom slide shows and even receive picture messages.

Kodak EasyShare V550
This tiny digital camera, measuring just 92 × 50 × 22mm, makes the most of its 2.5in screen even when charging.

Powerpoint presentations

If you want your slides to carry educational or sales messages, you need to turn to a presentation-authoring program, such as Microsoft's Powerpoint. With this you can merge text, graphics, and pictures on separate pages, which can then be displayed on screen or emailed. Used on screen in this way, it is best to select pictures with simple composition, and strong graphical shapes—these get your visual message across without distracting from the detail provided by the words.

Low-cost LCD projector
Connects directly to a laptop or digital camera.

Screen saver slideshow
The Mac's screen saver enables you to play pictures randomly from any folder on your hard disk, or from any iPhoto album.

3.3 Online albums

While email gets your pictures to the people you know (or at least those you know the addresses of), it doesn't offer a wide reach. Furthermore, it doesn't let viewers browse through a range of pictures in search of those they really like. The Web changes all this: now you can have an online album with pictures that could be seen by anyone who happens to come by.

But there is no need to set up your own website to do this. There are plenty of sites around that are like virtual exhibition spaces, where you can upload your pictures using their tools. All you need is your Web browser and a set of digital images formatted to a suitable size (*see pages 304–05*).

One advantage of this route is that your pictures already have a captive audience. Many of these sites have active communities, where online visitors trawl through the work of others. Frequently, there is the facility to comment on what you see, like a virtual visitors' book for each shot. As your gallery has its own web address, you can pass this on to everyone you know who you would like to see your pictures.

Of course, you may not want everyone to see your pictures: you may be happy for distant relatives to see the shots of a riotous party, but wouldn't want any old Joe to come browsing through. Some sites enable you to password-protect certain pages, or specify in some other way who can view them. This facility is widely used by professional photographers, who can ensure that only the paying client sees the results of the latest shoot.

There are certain things you should look at carefully when choosing where to put your pictures on view:

Price

There are a lot of sites that offer "free" storage for your pictures. But hosting a website full of pictures costs money, so you need to work out how the site is going to make ends meet. Web companies, after all, come and go quickly, and you don't want to set up your gallery only for it to disappear. Online photo processors (*see pages 286–87*) usually offer free online galleries, which obviously hope to make money from you and your friends ordering prints. But read the small print; often, they will trash your pictures if you haven't made an order for a certain number of weeks.

Capacity

Most sites put a limit to how many pictures you can have on display or how many megabytes of storage you can take up on the server. Some offer greater capacity in return for a higher monthly fee.

Bandwidth

It is not just the storage that costs websites money—it is the amount of traffic. You may, therefore, find that there is a ceiling to the number of megabytes you can upload each month; there may even be a cutoff for the number of views your albums get, to put off users who might attract thousands of visitors.

Design

Some albums look better than others on screen. Although this is a matter of taste, it is worth taking advantage of the free trials that most of these services offer, to see which one suits you best. Equally variable is the quality of the control software for uploading the files in the first place, and arranging them into a suitable order.

Features

Can people leave comments about your pictures? Is there a facility to sell pictures online? Can you make some galleries private so only selected people can see them?

Blogging

A weblog, or blog as it is more commonly known, is essentially an online diary where people upload their thoughts and favourite links on a regular basis for the whole to share. There are a number of companies that provide online blogging services, and many of these enable you to add photographs. Typepad's (www.typepad.com) subscription service is one of the best known of these, and has a thriving community of bloggers. Not only can you upload photo albums from your PC, you can also upload images direct from compatible cell phones, providing a truly visual record of the things that you do and see in everyday life.

Nokia phone with TypePad compatible LifeBlog application lets you update your online photo diary while on the move.

Flickr

Flickr (www.flickr.com) offers impressive storage and community facilities, with a free option for those who want to display under 200 images. A subscription service offers unlimited storage.

Pbase

PBase (www.pbase.com) offers a great deal of control over how your pictures appear in the online albums—you can try the service free for 30 days. The yearly subscription you pay depends on the amount of storage you want.

Pigs & more

Photobird

Photobird (www.photobird.com) is another example of a subcription online album service.

Photobox

Photobox (www.photobox.com) offers a free album service, but the photofinisher expects to make its money through you and your friends buying prints.

Shutterfly

Shutterfly (www.shutterfly.com) is another online print lab that offers a sophisticated album service. There is even an option to email invites to friends, so that they will know you have new pictures on display.

3.3

303

3.3 Output for the Web

The most important factor when preparing a photograph for use on the Web is cutting down the file to the smallest size possible. The typical web user is impatient, and doesn't want to be kept waiting as your high-resolution image file downloads to his or her screen; if pictures do not appear near-instantaneously, they may never wait to see your images.

This first rule of Web design is made even more critical by the second: you assume that the user has only a basic, low-speed Internet connection, and a small, low-resolution screen. If you want as many people as possible to see your site, you create it for the lowest common denominator at every step.

The result of this is that you want small thumbnail images on your webpages to be around 20KB, and the biggest to be not much more than 100KB. This means that there is a lot of chopping down to do, if you are starting off with your master TIFF archive file, which may be at least 20MB in size. Of course, any Web version is always saved as a copy—the original is kept intact.

There are three file formats that are commonly used for photographs on the Web. GIF (Graphic Interchange Format) uses a limited palette of colors to restrict space, but this means that it is better used for graphics than for photographs with a full tonal range. The PNG (Portable Network Graphics) is specially designed for Web imagery, but being newer than its rivals, is still not widely used. This leaves the trusty JPEG, with its full palette of colors and immense scalability, as the favorite format for photography on the Web.

To create a small enough JPEG file, it is necessary to reduce the pixel dimensions and to apply a good dose of compression. This can be done in Photoshop itself, scaling the pixel dimensions down using the *Image Size* control; use the *Save As* box to choose the JPEG quality setting that provides a suitably small file size. However, there are applications that are specifically designed for preparing images for Web use. Photoshop has its own in the shape of its supporting *ImageReady* utility, a simplified version of which is found under the *Save For Web* option. With either you can compare different file-saving options side by side, or one by one, so that you can decide which is best for the job in hand.

Protecting your property

One of the risks of putting your pictures on the Internet is that it is easy for people to download your images and insert them into their own webpages. Fortunately, because most images on the Web are at a low resolution and of a low quality, people are not going to get much joy trying to print them out. However, some photographers do want to provide full-screen versions of their images, which could well end up being ripped off by unscrupulous users around the globe. For most of us, the risk and possible loss is insignificant. To others, professionals in particular, it is worth trying to minimize the risk in whatever way possible.

A popular way of doing this is to add a "watermark" to the image. This normally consists of the photographer's name and the copyright sign, ©, which are added to the photograph in Photoshop using the *Text* tool on a separate layer. Its visibility can then be altered by changing the blending mode and opacity of this layer. Unfortunately, this solution also reduces the impact of your picture onscreen.

Digital watermarking
To protect this shot the copyright notice was typed onto a new layer, and the blending mode was set to *Soft Light*. For a subtler effect, the opacity of the layer could have been reduced.

Progressive JPEG

The progressive JPEG provides an interesting solution to the problem that small image files have little detail, but large image files take too long to appear onscreen. The progressive JPEG combines a low-resolution file with a higher-resolution example so that you get the best of both worlds. When you look at the page, you see the low-resolution version to begin with, and this is replaced by successively more detailed versions. Between three and five "scans" can be used.

Slices

Slicing is simply a way of cutting an image into a number of different blocks, which load as separate images on a webpage to make a complete picture. The advantage of this approach is that the slices can be chosen to isolate areas of fine detail, where you can apply less compression than on areas with less visual importance. A useful side-effect of slicing an image is that it makes it harder for people to copy your pictures.

Resample down

You can reduce the number of pixels in a picture using Photoshop's *Image Size* control. As with upsizing (*see page 282*), you set the dimensions that you want, depending on how large you want it to appear on screen. Use either the *Bicubic Sharper* or the standard *Bicubic* interpolation options.

3.3

305

3.3 Creating your own webpage

While posting pictures in your own album on a community site (*see page 302*) may suit some people, others prefer to have something a touch more exclusive. The advantage of having your own site is that you have much greater influence over the design—and you can register your own domain name and become your own .com media mogul.

Designing a website can seem a daunting proposition. Webpages are often full of reams of code, which can prove a complete turnoff to those that think of themselves more as artists than computer programmers. However, a basic site is extremely easy to construct. Many manipulation and cataloging programs have utilities that can turn a folder full of your pictures into a Web gallery, complete with all the necessary HTML code, in just minutes. Photoshop, for instance, provides a range of different styles for your pages, to give some individuality—although the popularity of the program undoubtedly means that thousands of others will be using the same design.

A step up from this is to buy into one of the numerous "shell" packages that are offered to photographers. Essentially, these offer a range of range of template designs for you to choose from, which enable you to put a number of pages of information online, along with a photographic catalog. The beauty of this approach is that there is little or no code to learn—you make changes to your pages using your Web browser—and the company that sells the shell sites can also host the pages for you, all for a fixed annual fee.

The cost of these packages varies enormously—as does the artistry of the design. Most offer a free trial, which means you can check that your pages look good, and that the software is easy to use, before you sign up for a live service. The price will depend on the number of pictures you have online, and the type of Web address you go for. Ideally, you want a site that lets you start off in a small way, knowing that you can upgrade to showing thousands of images, and offering online sales, sometime in the future.

Designing your own pages

Although webpages rely on code to create the design, you can design an entire website without having to learn a single line of HTML language. The key to doing this is to use one of the WYSIWYG (what you see is what you get) page design programs that are around. In fact, many users may already have one lurking on their hard disk, as Microsoft's FrontPage is often found bundled with its Office suite of applications.

For those without this, there are freeware and shareware programs available. NVu (www.nvu.com), for instance, can be downloaded for free (www.nvu.com), and there are versions for Windows, Mac, and Linux operating systems. Using such programs makes Web authoring as simple as designing a newsletter.

NVu screengrabs

It may be not the most dynamic homepage on the Web, but this took just a couple of minutes to run up using NVu. The interface can display the code that even such a seemingly simple page requires.

Simple website

This shows the rough structure of a website created using one of the lowest-cost Web packages, designed especially for photographers. The Clikpic template can be changed at will from the administrator's pages, which are password protected, as can the choice of pictures and the supporting text. You can even sell prints with this system. Designed specially for this book, the site can be seen at www.chrisgeorgephotography.com.

Centered Frame 1 – Basic
Centered Frame 1 – Feedback
Centered Frame 1 – Info Only
Centered Frame 2 – Feedback
✓ Dotted Border – Black on White
Dotted Border – White on Black
Flash – Gallery 1
Flash – Gallery 2
Gray Thumbnails
Horizontal – Feedback
Horizontal Gray
Horizontal Neutral
Horizontal Slideshow
Simple – Horizontal Thumbnails
Simple – Thumbnail Table
Simple – Vertical Thumbnails
Simple
Table – Minimal
Table 1
Table 2

Web Photo Gallery

Site
Styles: Dotted Border – Black on White
Email:
Source Images
Use: Folder
Choose... Macintosh HD:Low-res CC pix:
☑ Include All Subfolders
Destination... Macintosh HD:Users:chrisgeorge:Desktop:
Options: General
Extension: .html
☐ Use UTF 8 Encoding for URL
☑ Add Width and Height Attributes for Images
☑ Preserve all metadata

OK
Cancel

ClikPic
www.clikpic.com

Amazing Internet
www.amazinginternet.com

Hosting Photography
www.hostingphotography.com

BetterPhoto
www.betterphoto.com/
sites4photogs.asp

Photogalaxy
www.photogalaxy.co.uk

Foliolink
www.foliolink.com

Big Black Bag
www.bigblackbag.com

Foliosnap
www.foliosnap.com

Site on Spot
www.siteonspot.com

Photoshop web gallery

Photoshop CS2 provides a choice of 20 different designs for its *Web Gallery* tool. Select the folder that you want to be designed in Internet form, and the software will do all the hard work for you. Pictures are seen as thumbnails, but you can click on each one to get a larger view.

Useful addresses

Hardware

Agfa www.agfa.com

Alien Skin (plug-ins)
www.alienskin.com

Apple www.apple.com

Archos www.archos.com

Bogen Imaging
www.bogenimaging.us

Bowens
www.bowensinternational.com

Broncolor www.bron.ch

Canon www.canon.com

Casio www.casio.com

Chimera
www.chimeralighting.com

Duracell www.duracell.com

Elinchrom
www.elinchrom.com

Energizer
www.energizer.com

Epson www.epson.com

Fujifilm home.fujifilm.com

Hahnel www.hahnel.ie

Hama www.hama.com

Hasselblad
www.hasselblad.se

Hensel
www.hensel-studiotechnik.de

HP www.hp.com

Imacon www.imacon.dk

Iomega www.iomega.com

Jobo www.jobodigital.com

Kodak www.kodak.com

Konica Minolta
konicaminolta.com

Kyocera
www.kyoceraimaging.com

LaCie www.lacie.com

Lastolite www.lastolite.com

Leaf www.leafamerica.com

Leica www.leica-camera.com

Lexar www.lexar.com

Lexmark www.lexmark.com

Lumiquest
www.lumiquest.com

Mamiya www.mamiya.com

Manfrotto
www.manfrotto.com

Microtek www.microtek.com

Nixvue www.nixvue.com

Novatron www.novatron.com

Olympus
www.olympus-global.com

**Pacific Image Electronics
(PIE)**
www.scanace.com

Panasonic
www.panasonic.com

Paterson (Benbo)
www.patersonphotographic.com

Pentax www.pentax.com

Phase One
www.phaseone.com

Quantum www.qtm.com

Ricoh
www.ricohpmmc.com

Rollei www.rollei.de

Samsung
www.samsungcamera.com

Sandisk www.sandisk.com

Sanyo www.sanyo.com

SeaLife
www.sealife-cameras.com

Sigma
www.sigmaphoto.com

Sinar www.sinar.ch

Sony www.sony.com

Stofen www.stofen.com

Tamron www.tamron.com

The Pod www.thepod.ca

Umax www.umax.com

Varta www.varta.com

Wacom
(graphics tablets)
www.wacom.com

Warm Cards
www.warmcards.com

Westcott
www.fjwestcott.com

Software

Adobe www.adobe.com

Andromeda
www.andromeda.com

Apple www.apple.com

Berg Design
(monitor profiling)
www.bergdesign.com

Bibble
www.bibblelabs.com

Canto www.canto.com

Colorvision
www.colorvision.ch

Corel www.corel.com

Digital Domain Inc
www.ddisoftware.com

DxO www.dxo.com

Extensis www.extensis.com

Eye One Color intl.i1color.com

Fotoware www.fotoware.com

Google Picasa
www. picasa.google.com

Gretag Macbeth
www.gretagmacbeth.com

**Kodak Austin
Development Centre**
(scanning tools)
www.asf.com

Microsoft www.microsoft.com

Monaco www.xritephoto.com

Monitor Calibration Wizard
www.hex2bit.com

OnOneSoftware
www.ononesoftware.com

Nik Multimedia
(plug ins)
www.nikmultimedia.com

Photo Plugins
www.photo-plugins.com

Plug-ins.com
(plug-ins portal)
www.plugins.com/photoshop

Roxio www.roxio.com

Silverfast www.silverfast.com

Tala www.talasoft.com

TuCows
(freeware/shareware portal)
www.tucows.com

ULead www.ulead.com

Xaos Tools www.xaostools.com

News/advice

Adobe Resource Center
www.studio.adobe.com

Alpenglow imaging
www.alpenglowimaging.com

Boot Log www.rickmaybury.com

Cleaning Digital Cameras
(digital SLR sensor cleaning)
www.cleaningdigitalcameras.com

DC Views www.dcviews.com

Digicamhelp
www.digicamhelp.com

Digital Camera Info
www.digitalcamerainfo.com

Digital Camera Resource Page
www.dcresource.com

Digital Photography Review
www.dpreview.com

Ephotozine
www.ephotozine.com

Imaging Resource
www.imaging-resource.com

pcphoto review
www.pcphotoreview.com

Luminous Landscape
www.luminous-landscape.com

Photography Blog
www.photographyblog.com

PhotoNotes
www.photonotes.org

Photoxels www.photoxels.com

PhotoZone www.photozone.de

Planet Photoshop
www.planetphotoshop.com

Polaroid www.polaroid.com

**Rob Galbraith Digital
Photography Insights**
www.robgalbraith.com

Shutterbug
www.shutterbug.com

Steve's Digicams
www.steves-digicams.com

**Technical Advisory Service
for Images** www.tasi.ac.uk

Wayne Fulton's Scanning Tips
www.scantips.com

Online services

BetterPhoto
www.betterphoto.com/
sites4photogs.asp

Canon iMage Gateway
www.cig.canon-europe.com

ClikPic www.clikpic.com

First4Fotos
www.first4fotos.com

Flickr www.flickr.com

Hosting Photography
www.hostingphotography.com

Image Shack
(free web hosting for images)
www.imageshack.us

Kodak Gallery
www.kodakgallery.com

MyPixMania
www.mypixmania.com

PBase www.pbase.com

Photobird
www.photobird.com

Photoconnect
www.photoconnect.net

Photogalaxy
www.photogalaxy.co.uk

Snapfish
www.snapfish.com

Truprint www.truprint.co.uk

Miscellaneous

ICC
(International Color Consortium)
www.color.org
http://www.intemos.com

Ilford
(printer supplies)
www.ilford.com

Lumijet
(printer supplies)
www.lumijet.com

Lyson
(printer supplies)
www.lyson.com

Permajet
(printer supplies)
www.permajet.com

Pixl
(colour profilers)
www.pixl.dk

Photographic Solutions
(PEC sensor/film
cleaning products)
www.photosol.com

Pricerunner
(free price comparison service)
www.pricerunner.com

Silverprint
(printer supplies)
www.silverprint.co.uk

Tetenal
(printer supplies)
www.tetenal.com

View Link
(links galore)
www.view-link.com/
photo-resources04.html

WetPixel
(underwater photography)
www.wetpixel.com

Glossary

Aberration An optical fault in a lens creating a less-than-perfect image.

Adobe RGB RGB color space commonly used by serious photographers.

AE Abbreviation of automatic exposure.

AEL Automatic Exposure Lock. A push-button control that lets you choose which part of the scene the camera takes its meter reading from, and then lock this setting while the image is reframed.

Aerial perspective A impression of depth created in an image by haze, fog, or pollution. The further an object is away from the camera, the more air and particles the light has to pass through, so distant objects appear less distinct and in paler colours.

AF Abbreviation of autofocus.

AF illuminator System used by some cameras and flashguns to assist autofocus in low light. A pattern of red light is projected onto the subject, which aids the contrast-detection autofocus to adjust the lens correctly.

Alpha channel A monochromatic layer within an image, used in digital manipulation as a way of masking selected parts of the image.

Ambient light The existing light in the scene, excluding any light source added by the photographer.

Analogue A nondigital recording system, where the strength of the signal is in direct proportion to the strength of the source.

Angle of view A measurement of how much a lens can see of a scene from a particular position, usually measured in degrees. The longer the focal length of the lens, the smaller the angle of view. Zoom lenses have adjustable angles of view.

Antialiasing A method of smoothing diagonal lines in digital images, to avoid a staircase, or stepping, effect created by the individual pixels.

Aperture The opening in the lens that restricts how much light reaches the image sensor. In all but the most basic cameras, the size of the aperture is adjustable. The aperture setting used has an important role to play in both exposure and depth of field.

Aperture priority Semi-automatic exposure system, where the aperture is set by the photographer, and the shutter speed is then set by the camera to suit the light level reading taken by the camera's own meter.

Apochromatic (Apo) A lens designed to compensate for chromatic aberration by bringing all wavelengths of light into the same point of focus. This type of lens is used for telephoto lenses, where the color fringing caused by chromatic aberration can be a particular problem.

APS-C Size of sensor used in some digital cameras, measuring around 7/8x5/8in (22.5x15mm), and with a 3:2 aspect ratio; gets its name and dimensions from the APS film format, used in its Classic (C) aspect ratio.

Archival Any process or material that is designed to improve significantly the life expectancy of the image.

Array The arrangement of image sensors in a digital device.

Artifact (or artefact) Flaw or unwanted information in a digital image, usually caused by limitations in the recording or manipulation process.

Aspect ratio The relationship between the width and height of a picture, describing the proportions of an image format or a photograph. The aspect ratio of most digital SLRs is 3:2; for most other digital cameras it is 4:3.

Aspherical lens A lens element whose surface is not perfectly spherical. Aspherical lenses are often used in wide-angle and wide-apertured lenses to help provide distortion-free images.

Attachment A digital file that is sent with an email.

Autofocus A system where the lens is adjusted automatically by the camera to bring the designated part of the image into sharp focus.

Autofocus illuminator See AF illuminator.

AWB Automatic White Balance. System that automatically adjusts the color of the recorded picture so that it looks normal to the human eye.

B Abbreviation of bulb. A shutter speed setting on a camera that allows you to keep the shutter open for as long as the shutter release is held down. Used for long exposures that last for seconds or minutes.

Back-light button Simple manual exposure adjustment that enables the user to give the image slightly more exposure than the camera's built-in meter suggests. A back-light button typically adds between one and two stops more exposure.

Back-lighting Light source that is on the far side of the subject, in relation to the camera.

Backup Copy of a digital file, kept in case of damage to, or loss of, the original.

Ball-and-socket Type of tripod head that allows simultaneous movement of the camera in more than one plane. Enables quick adjustment of camera, but lacks the precision of the pan-and-tilt head.

Barn doors Hinged flaps on studio lights that enable control of the spread of light.

Barrel distortion Type of lens distortion, or aberration, where straight lines at the edge of an image tend to bow outward, like on a barrel. Common defect of extreme-wide-angle lenses. Can be corrected using manipulation software.

Bas relief Digital effect that recreates a traditional darkroom technique where a negative and positive are sandwiched together and printed slightly out of alignment. This gives a carved-in-stone look to the resulting picture.

Bellows An accessory used in macro and large-format photography. A rectangular tube of black material creates a chamber between the lens and the image sensor. This length of the chamber can be made longer or shorter to alter the magnification of the image.

Bit The basic unit from which any digital piece of data is made up of. Each bit has a value of either 0 or 1. The sizes of digital files are usually counted in bytes, which are each made up of 8 bits.

Bit depth The number of bits used to record the color of a single pixel. Digital cameras and scanners usually use at least 8 bits for each of the Red, Green, and Blue channels, providing a 24-bit depth and possible 16,700,000 colors; some devices offer higher bit depths.

Bleed A picture that is printed, or subsequently trimmed, so that the image goes right to the edge of the paper.

Bluetooth Wireless connection used to link different digital devices and accessories using radio signals; has a typical range of around 33ft (10m).

Boké or bokeh Description of the out-of-focus characteristics of an image, or the lens creating them.

Bounce flash Indirect flash lighting technique, where the flash gun is angled to bounce off a wall, ceiling, or other reflector. This scatters the illumination, creating a softer lighting effect.

Bracketing System for increasing the chances of getting the right exposure by taking a sequence of pictures with a slightly different exposure setting for each.

Brolly or umbrella Umbrella-like reflector that attaches to a studio light. It produces soft lighting over a wide area. Some brollies can also be used as diffusers.

Bubblejet Type of inkjet printer, as manufactured by Canon.

Buffer Temporary memory used by a camera or a computer. The size of the buffer in a camera helps dictate the maximum burst rate, and the number of shots per burst.

Burning in Darkening selected areas of the image during digital manipulation.

Burst rate Continuous shooting speed of a digital camera, which enables a sequence of images to be taken in rapid succession, measured in frames per second (fps). The rate can only be sustained for a certain number of shots.

Byte Standard unit for measuring memory capacity of digital storage devices. Each byte can have one of 256 different values and is equal to 8 bits.

Cable release Mechanical or electronic device for firing a camera from a short distance away. Often used as a way to minimize vibration when using a slow shutter speed and a camera support, such as a tripod.

Camera movements The ability to maneuver the lens and imaging plane independently of each other. This gives a high degree of control over perspective, image distortion, and the plane of focus. Found on some medium- and large-format cameras.

Camera shake Blurring of the image caused by movement of the camera during the exposure. Handheld cameras are prone to camera shake, and a fast shutter speed needs to be used to eliminate the problem.

Camphone Cell phone with a built-in digital camera.

Catadioptric Type of telephoto lens available for some digital SLRs that uses a mirror to increase the length of the light path and thus the focal length, while keeping the length and weight of the lens down. Also known as a mirror lens.

Catchlight White highlight in the eye of a portrait subject that is a reflection of the light source. The shape, size, and intensity of the highlight will vary depending on the lighting setup.

CCD (Charge Coupled Device) Type of imaging sensor commonly used in digital cameras. Located at the focal plane, it converts the focused image into an electrical signal. Similar in function to a CMOS sensor.

CD-R (Compact Disc Recordable) A compact disc format that can be recorded only once. Has a maximum capacity of around 700MB. Widely used for backup and storage of digital files. A miniature 31/8in (8cm) CD-R format has even been used directly by some cameras.

CD-Rom (Compact Disc, Read Only Memory) A compact disk with prerecorded data which cannot be recorded over by the user. Widely used for the distribution of computer software.

CD-RW (Compact Disc Rewritable) A compact disc format that can be recorded over many times. Has a maximum capacity of around 700Mb. Widely used for backup and storage of digital files. A miniature 8cm CD-RW disk has been used as a recording medium by some Sony digital cameras.

Center-weighted Type of built-in metering system, provided as an option on some cameras. Center-weighted meters measure light intensity across the entire image area, but bias the average in favor of light taken toward the center of the frame. The system is not foolproof; it is easier to predict when it will make an inappropriate reading than more sophisticated metering systems.

Chromatic aberration Lens fault, common in telephotos, where different shades of white light are focused at slightly different distances.

CIE Commission International de l'Éclairage; organization that sets color standards and created the L*a*b color space.

Circle of confusion Disk of light in the image, created by the lens from a point of light in the subject. The smaller these disks are, the sharper this part of the image appears. If small enough, the disks appear as points to the human eye, so look acceptably sharp. The largest-size disk that looks like a point is known as the least circle of confusion; this measurement is fundamental to accurate calculation of depth of field.

Circular polarizer Type of polarizing filter. Circular polarizers can be used with modern cameras without interfering with the operation of exposure metering and autofocus systems, unlike older and cheaper linear polarizers.

CIS (continuous ink system) Bulk ink delivery system that can be used with some inkjet printers to replace the limited-capacity cartridges usually employed to store and deliver ink.

Clipping Losing detail in the highlights or shadows of an image due to over- or under-exposure, or excessive digital manipulation.

Clipping path Line used used in digital manipulation to define a cutout in an image, separating, say, the main subject from the background.

Clone tool Facility in image-manipulation programs that enables you to replace an area of the image with a copy taken from another part of the image. Used for removing blemish marks and unwanted subject matter from a digital photograph.

Close-up lens Filter-like accessory that fits on the front of the camera lens to magnify the image. This low-cost macro accessory can be used on most types of cameras. Close-up lenses come in a variety of different strengths, measured in diopters.

CMOS (Complementary Metal Oxide Semiconductor) Type of imaging sensor used in digital cameras. Located at the focal plane, it converts the focused image into an electrical signal. Similar in function to the CCD sensor.

CMYK Cyan, Magenta, Yellow, and black (Key)—the four primary inks used in commercial and desktop printing to produce full-color images. Digital photographs and scans are recorded in RGB (Red, Green, and Blue), but they can be converted to the CMYK colour space using image-editing software. It is not necessary to convert before printing.

Codec Compression-Decompression. Set of rules for compressing data into a more manageable file size, as used when creating a JPEG image file.

Color depth Alternative term for Bit depth.

Color filter array (CFA) The pattern of red, green, and blue filters used over the photosites in an imaging sensor. Usually half the photosites (or pixels) have green filters, a quarter have red filters and a quarter have blue filters.

Color gamut The range of colors that can be displayed by a digital-imaging device.

Colorimeter An instrument for measuring the density and color of an area on a print or screen; used for color calibration of printers and screens.

Color management Overall system that tries to ensure that the colors of an image are displayed and output in exactly the same way, whatever the device being used.

Color profile Description of how a device displays, or records color. Provides an international language that ensures that different devices can all produce similar-looking results with the same file. The standards for color profiling are set down by the ICC.

Color space Theoretical definition of the range of colors that can be displayed by a device or mode.

Color temperature Measurement of the color of light, usually expressed in degrees Kelvin. The human eye adjusts automatically for color temperature much of the time without us realizing; digital cameras can make electronic adjustments using their white balance systems to mimic the eye and brain.

Coma Lens fault, or aberration, that can create blurring at the edge of the image.

Compact A type of camera with a shutter mechanism built into the lens. Compacts are generally point-and-shoot designs that are easy to carry around. Most digital compacts have built-in zoom lenses.

CompactFlash Type of removable memory card.

Complementary colors A pair of colors which, when mixed together, create white light. The complementary color of red is cyan, the complementary of green is magenta, and the complementary of blue is yellow.

Continuous autofocus AF setting where the focus is constantly adjusted until the shutter is actually fired. Useful for moving subjects, where it would be unhelpful for the focus distance to be locked as soon as initially found.

Contrast-detection autofocus See Passive autofocus.

Contrast range A measurement of the difference in brightness between the darkest and lightest parts of an image.

Cove Curved background used in studios so that there is no visible join between the backdrop and the surface on which the subject is placed.

Covering power The largest image area possible from a particular lens. This is usually circular in shape and just large enough to completely cover the actual sensor being used. Some digital SLR lenses have a smaller covering power than others, in order to make them smaller, but this restricts the range of camera models they can be used with.

Crop To remove unwanted parts of an image.

Cross screen filter See Starburst.

Curves Powerful tonal adjustment facility found in some image-manipulation software.

Cyan Color that is a mix of blue and green light. The complementary color of red.

Dedicated Type of flashgun that is designed to provide direct one-way or two-way communication with the camera. The amount of dedication varies enormously depending on the flashgun and camera. Increased dedication tends to provide more accurate flash metering, as well as making the flash system easier to use successfully.

Depth of field A measure of how much of a picture is in focus, from the nearest point in the scene to the camera that looks sharp, to the furthermost point that looks sharp. Depth of field is dependent on the aperture used, the distance that the lens is focused at, and the focal length of the lens.

Depth of field preview Device found on some digital SLRs that enables you to see the viewfinder image at the actual aperture you will be using for the exposure. This gives a visual indication as to how much depth of field there is, and which parts of the resulting picture will be sharp or blurred. This is necessary, as the viewfinder normally only shows the image as it would appear if the widest aperture available were used.

Depth of field scale Markings found on some lens barrels which can be used to work out the depth of field for particular apertures, and which can be used for manual focus adjustments to maximize or minimize depth of field.

Depth program Program exposure mode where the aperture and shutter speed are set automatically in order to provide maximum depth of field while maintaining a shutter speed that is fast enough for handheld photography. With some cameras, the different subject distances, measured by the multipoint autofocus system, are also taken into account and the focus is adjusted to suit.

Diaphragm Another term for the aperture. The adjustable blades that regulate how much light enters the lens.

Differential focusing Using depth of field to ensure that one element in the picture is sharp, while others are as out of focus as possible.

Diffraction Scattering of light caused by deflection at edges of an opaque object. Diffraction causes slight fuzziness in the image when the smallest apertures are used.

Diffuser Any material that scatters the light as it passes through it, softening the illumination and making shadows less distinct. Diffusers are commonly used with artificial light sources. In sunlight, clouds act as natural diffusers.

Digital SLR (Single Lens Reflex). Type of camera where the eyelevel viewfinder shows you the subject through the same lens that will be used to expose the imaging chip. A hinged mirror is used to reflect the image to the viewfinder, and this flips up out of the way when the picture is taken.

Diopter Optical measurement used to describe the light-bending power of a lens. The dioptre value of a lens is equal to the number of times that its focal length will divide into 1000mm. Diopters are used to measure the magnification of close-up lenses, and of viewfinder lenses.

Dioptric correction Facility provided on some cameras for adjusting the viewfinder to suit the user's eyesight. Limited adjustment is built-in, some cameras permit further modification with the use of additional diopter lenses.

Dodging Lightening selected areas of the image during digital manipulation.

Double exposure Two images superimposed on each other. Provided as a special effect on selected cameras. See Multiple exposure.

Dpi (dots per inch) A measure of the resolution of a printer or other digital device.

DPOF (Digital Print Order Format) Facility available on some digital cameras with which users can mark the images they have taken of which they wish to have prints made.

Driver Software used by a computer to control, and communicate with, a camera, printer, drive, or other peripheral.

Glossary

Duotone Digital darkroom technique that simulates using two different color inks to print black and white images; each ink has a separate curve adjustment, so that some tones appear a different color than others.

DVD (Digital Versatile Disc) Family of disc formats, offering a range of capacities and varying cross-compatiblity. Recordable and Re-writable DVDs provide a low-cost, high-capacity medium for archiving and backing up digital images. The capacity of a single layer disc is around 4.7MB.

Dye sublimation Type of printer used to make high-quality prints using special ink ribbons and paper. The results look and feel very similar to traditional photographic prints.

Dynamic range A measure of the range of image densities that can be recorded by a device, from its brightest white (dMin) to its darkest black (dMax). A key indicator in the quality of a scanner. It is measured on a logarithmic scale, where 2.0 equates to an intensity ratio of 100:1, and 3.0 provides an intensity ratio of 1000:1. There is no theoretical upper limit to the dynamic range, but in practice, the best devices reach 4.0 most.

efl (effective focal length) Measure for comparisom of the angle of view and magnification of different lenses and lens settings, whatever the size of imaging chip being used. The actual focal length is converted to the equivalent focal length that would give the same angle of view on a camera using 35mm film or a sensor measuring 1.5x1in (36x24mm). See Focal length.

Element Individual optical lens. Most photographic lenses are constructed using a number of lens elements, placed parallel to each other along a single axis; some are placed together in groups.

Enprint Standard size of photographic print provided by many commercial processing laboratories, typically measuring 4x6in (10x15cm).

EPS (Encapsulated PostScript) A digital file format used for saving graphics and image files.

EV (Exposure Value) Scale used to denote the exposure required without the need to specify either shutter speed or aperture. A particular EV setting has its own set pairs of possible shutter speed and aperture. Exposure values are often quoted in combination with an ISO speed to denote a specific light level.

Evaluative metering Metering system used on many cameras where light readings are taken from a number of different areas, or zones, across the image. These are then compared to data programmed into the camera, so it can work out an appropriate exposure setting. Information from the multipoint autofocus system is also used, to ascertain the likely position of the subject. This "intelligent" metering system can avoid many of the failings of simpler exposure

metering systems. However, it is impossible to second-guess, so it can be difficult to predict the occasions where it will get the exposure wrong. Also known as matrix metering.

EVF (Electronic View Finder) Eyelevel LCD screen, as found on camcorders and hybrid cameras.

EXIF (Exchangeable Image File) Camera settings recorded by many digital cameras as part of the image file. This data automatically notes a wide range of information about the picture, including the date and time it was recorded, aperture, shutter speed, model of camera, whether flash was used, number of pixels used, metering mode, exposure mode, exposure compensation used, and zoom setting. The information can subsequently be read by suitable software.

Exposure Total amount of light used to create an image.

Exposure compensation A control for manually overriding the built-in exposure meter of a camera to provide more or less light to the sensor.

Extension tube Accessory used in macro and close-up photography that fits between the digital SLR body and the lens. The extra extension between lens and image sensor enables the lens to focus closer and to provide a higher image magnification than would otherwise be possible. Extension tubes are usually sold in sets of three, and are used singly or in combination to provide a total of seven different magnifications.

Eye relief Measurement of the optimum viewing distance between the user's eye and the camera's viewfinder.

Eyepiece correction See Dioptric correction.

f number The aperture setting. The number is the focal length of the lens divided by the diameter of the aperture; because of this, larger f numbers represent smaller aperture sizes. f numbers are used so that exposure settings for a particular scene can be expressed without having to know the focal length actually used.

f stop See f number.

Fall off Gradual loss of light or sharpness toward the corners of an image. Caused, for example, by the lens not having enough covering power. See Vignetting.

FARE (Film Automatic Retouching and Enhancement) Series of adjustments found on Canon scanners, offering dust/scratch removal, grain correction, print color restoration, and back-light correction.

Fast ISO setting An ISO setting that makes the sensor more sensitive to light than usual, and thus requires less exposure than usual. Fast settings are

useful in low light situations where long shutter speeds are not suitable. A drawback is that grain-like noise within the image becomes more pronounced as the ISO speed is increased. See ISO.

Fast lens A lens that has a wider maximum aperture than is usual for that particular focal length or zoom range. Fast lenses are not only useful in low light; they can be invaluable for throwing backgrounds out of focus to a greater extent than usual.

Fast shutter speed Relative term for an exposure that is shorter than average, usually set to avoid the blur that would otherwise be created by subject movement.

Feathering Technique used in manipulation to soften the edge of a selected area. A certain amount of feathering is usually necessary to ensure that there are no visible joins.

File format The way in which a digital file is saved. A digital image can be saved in a wide variety of different file formats, the most commonly used being RAW and JPEG. The format dictates which programs will be able to read and open the file. It also dictates the amount of information and the detail that is stored. Other formats include TIFF, EPS, and GIF.

Fill-in flash Flash used as a secondary light source. A fill flash feature is an option on many cameras with a built-in flash unit. With it you can soften shadows on foreground subjects, helping to avoid problems with back-lighting. Fill-in flash can also be used to enhance the colors and contrast of foreground subjects in dull lighting conditions.

Filter Transparent attachment that fits in front of a lens or a light source and modifies the light or the image in some way. The term is also used for a wide number of special effects and tools available with image-manipulation software.

FireWire High-speed computer interface used to connect different digital devices, such as external hard drives. Also known as IEEE1394 and iLink.

Fisheye Ultra-wide-angle lens where the image is deliberately distorted in order to maximize the field of view.

Fixed focal length lens A lens that is not a zoom, with a single, nonvariable angle of view.

Fixed focus lens (Prime Lens) A lens with no focus adjustment, as used on ultra-low-cost compact cameras and camphones. A combination of a wide-angle lens and small maximum aperture are used to ensure that everything from around 6ft (2m) to the horizon is sharp.

Flare Stray, non image-forming light that reaches the sensor, creating unwanted highlights or softening the image. Lens coatings and hoods are designed to

minimize flare. However, flare can prove a problem when shooting toward a bright light source.

Flash synchronization Process that ensures that the peak output from the flash tube precisely coincides with the shutter being fully open. On digital SLRs with focal plane shutters, full synchronization is only possible at certain shutter speeds.

Flash meter Handheld exposure meter that measures output from a studio flash setup. The lights are usually connected to the flash meter itself, which then fires the flash units; the flash meter can also be used to take incident and reflected light readings.

Flatbed scanner Desktop scanner with glass platen that is designed for producing digital scans of flat photographs and artwork; some models have special hoods for scanning transparent materials, such as slides.

Fluorescent light The lighting produced by striplight tubes. The color balance can vary enormously, depending on the type of tube, and manual white balance settings therefore often offer several fluorescent settings. Daylight-balanced fluorescent tubes are used in some studio lighting systems.

Focal length Optical term describing the distance between the optical center of a lens and its focal point. In practice, the focal length is a measure of the magnification and angle of view of a given lens or zoom setting. It is usually measured in millimeters. However, its usefulness as a way of comparing different lenses is diminished by the fact that the exact focal length required to give a particular angle of view will depend on the size of the imaging chip used by the camera in question. See efl.

Focal plane The flat surface upon which the image is focused in a camera. This is the plane where the photosites of the CCD or CMOS image sensor are positioned.

Focal plane shutter A shutter mechanism that sits just in front of the image sensor, used on digital SLR cameras.

Focusing screen Surface upon which the viewfinder image of a digital SLR is projected. Its textured surface is designed to accentuate the degree by which the image is sharp or not, thereby providing assistance when focusing.

Focusing steps Number of distinct positions that the lens can be adjusted to by the autofocus system. Basic autofocus cameras have a very limited number of steps. Those with longer lenses, close focusing capabilities, and wider apertures may need hundreds or thousands of steps to focus accurately. On some cameras, such as digital SLRs, the autofocus system is essentially stepless, with almost infinite adjustment of focus being available.

Follow focus Technique by which the focus is adjusted continuously to track a moving subject.

fps (frames per second) Measurement of the continuous shooting rate of a camera.

Freeware Software that is distributed for use without any charge to user. See Shareware.

Frontal lighting Lighting directed toward the subject, and therefore positioned behind, or level, with the camera.

Gain Amplification of an electronic circuit. Used in digital cameras and camcorders as a way of electronically boosting the sensitivity of the imaging chip in low light. See ISO.

Gamma A method of measuring or setting contrast.

Gaussian Blur Image-manipulation effect that enables you to blur parts of an image or mask to varying degrees.

Gel Gelatin filter bought in sheets for altering the color balance of studio lights, or light coming through a window.

GEM (Grain Equalization and Management) Software that reduces the visibility of grain when scanning slides or negatives. Usually has different levels of application to suit the characteristics of the emulsion. Technology licensed from Kodak subsidiary, Applied Science Fiction, and used by a wide number of film scanner manufacturers.

GIF (Graphic Interchange Format) Digital file format sometimes used for compressing graphics and images for Web use.

Gigabyte (GB) Unit for measuring computer memory, roughly equivalent to 1,000,000,000 (strictly, 2 to the power of 30 bytes or 1024 megabytes).

GN See Guide number.

Graphics tablet Computer accessory comprising a pressure-sensitive mat and a stylus pen, used as an alternative to a mouse. Preferred by some for image-manipulation, as it provides finer, smoother control over brushes and lasso tools.

Gray card Card with an 18 per cent gray tint that is used for exposure metering. A meter reading taken from the surface of the card, rather from the subject, can be used to measure the ambient light levels. This is useful when photographing non-average scenes— such as those that are predominantly black—which would otherwise mislead the meter.

Grayscale A digital black and white image made up of 256 shades of gray tone.

Halo A bright outline around a subject—an unwanted artifact usually due to excessive image sharpening or extreme JPEG compression.

High key An image in which bright, white tones dominate.

Highlight The brightest areas of an image—the white areas in a picture.

Histogram Graph used as a way of depicting the brightness, tonal range, and contrast of an image during digital manipulation. Also used as a way of evaluating exposure by some cameras.

Hotshoe An accessory shoe with an electrical contact, for mounting and connecting a flashgun to a camera.

HSB (Hue, Saturation, Brightness) The three dimensions commonly used to adjust color in image-manipulation.

Hybrid camera Camera that is designed to be handled in similar fashion to a digital SLR, but which uses a built-in zoom with the lens shutter mechanism of a compact camera. The eye-level viewfinder provides a video preview of the image using a minature LCD screen.

Hyperfocal distance The shortest distance at which a lens can be focused so that depth of field stretches to infinity for a given aperture and focal length. When focused at the hyperfocal length, depth of field will stretch from exactly half the hyperfocal distance to infinity.

ICC (International Color Consortium) Organization responsible for standards for color profiling.

ICE (Image Correction and Enhancement) Facility for automatically removing dust and scratch marks during scanning. Developed by Kodak subsidiary, Applied Science Fiction, and used by many scanner manufacturers.

IEEE 1394 See FireWire.

iLink See FireWire.

Incident light meter Handheld light meter that measures the amount of light falling on a scene, rather than the amount that is being reflected. An incident reading has the advantage that it is not affected by the overall tone of the scene.

Infinity Optical term to describe objects that are so far away from the lens that light from them reaches the lens as parallel rays. In practice, it is usually used to mean objects that are on or near the horizon. Represented on lenses by the symbol ∞.

Inkjet Popular form of desktop printer.
Interpolation An artificial way of increasing resolution of a digital image used by some cameras and scanners. The software guesses the values of imaginary pixels in between those it actually has the measurements for. Can be used in post-production to enable an image to be printed to a larger size than would otherwise be possible.

Intervalometer Feature that enables a camera to take pictures automatically at set intervals.

Inverse square law Property of light where the intensity of light decreases in proportion to the square of the distance from its source. Because the sun is so far away, this has no noticeable influence with natural light. However, it has a significant effect over the characteristics and usable range of flash, and other artificial light sources.

Iris Another name for the diaphragm, or aperture, of a lens.

ISO 9660 Standard used for recording CD disks, which is designed to aid compatibility with different drives and computer operating systems.

JPEG (Joint Photographic Experts Group) A file format used widely for digital images. A variable amount of compression can be used to vary the amount of detail stored and the resulting file size. It is the standard format used by digital cameras (although RAW or TIFF formats may also be provided as options).

Kelvin Unit used in measuring color temperature.

Key light The main or dominant light source.

L*a*b color A color space that can be used in saving or processing digital image files. The files consist of three channels—a luminance channel (L), which contains brightness values alone, and two color channels, A (green to red) and B (blue to yellow). Temporarily converting a file to L*a*b mode provides a number advantages when applying certain manipulation effects. See CIE.

Lasso Selection tool used in digital-manipulation software. Enables you to outline an area to work on by drawing a series of points around it.

Layer Facility found in image-manipulation software for the user to lay a different version or different elements of an image on top of each other. The original image can be protected as the background layer, while alterations are made to copy layers. Layers can be opaque—or can be merged with layers below in a number of different ways. Layers are an essential tool in serious image-manipulation.

LCD (Liquid Crystal Display) Type of display panel used widely on cameras to provide information to the user. Color LCDs are capable of showing detailed images, and are used as viewing screens on digital cameras.

Leaf shutter See Lens shutter.

LED (Light Emitting Diode) Colored indicator lamp used on many cameras for a variety of purposes.

Lens hood Attaches to front of lens to prevent stray light from outside the image area entering the lens. The lens hood is important for preventing flare, and needs to be designed for the specific lens it is used on so as not to cause image falloff.

Lens shutter Combined aperture and shutter housed within the lens itself and commonly used on compact cameras.

Levels Exposure, contrast, and color-balance tool used in digital image-manipulation. Histograms are used as a guide as to the corrections that need to be made. See Histogram.

Light tent Studio accessory made of translucent material suspended around a subject to diffuse the light and to eliminate surface reflections. Used when photographing highly reflective subjects such as glassware and jewellery.

Light meter Device for measuring illumination levels and determining exposure.

Linear polarizer Old-style form of polarizing filter, unsuitable for use with most modern cameras. See Circular polarizer.

Lithium battery Type of high-power single-use battery suitable for some cameras and flashguns.

Lithium ion Type of rechargeable battery, lighter and smaller than traditional nickel cadmium and nickel metal hydride rechargeable cells.

Lithium polymer Type of rechargeable battery, much lighter and smaller than traditional nickel cadmium and nickel metal hydride rechargeable cells.

Long lens Alternative term for a telephoto lens.

Lossless compression Procedure by which the size of an image file is made smaller without losing any information from the image. LZW lossless compression is often used with TIFF images.

Lossy compression Process by which information is lost from a digital image file in order to make the file size smaller. JPEGs use this form of compression.

Low key An image that is dominated by dark tones.

Low pass filter Filter that protects the CCD or CMOS imaging chip of a camera, and softens the image slightly so as to minimize moiré pattern interference.

LZW (Lempel Ziv Welch) Compression algorithm that reduces the size of a TIFF image file, without losing any of the image data. See Lossless compression.

Macro Term generally used to describe equipment or a facility for taking pictures at a closer shooting distance than usual, to provide a bigger image of the subject. Historically speaking the term macro refers to when the recorded image is lifesize or larger, with a magnification ratio that is 1:1 or greater.

Magenta Purple color, a mixture of blue and red light. Magenta is the complementary color of green.

Glossary

Magic Wand Pixel-selection tool used in manipulation software, such as Photoshop. By clicking on one area of the image, all pixels with a similar color or density are selected. The tolerance setting dictates just how similar the pixels need to be.

Magnification ratio Relationship between the size of the focused image and the size of the subject. If the image is lifesize, the magnification ratio is described as 1:1.

mAh (milli-Ampere/hour) Measurement of the maximum capacity of a rechargeable battery.

Manual exposure Exposure mode where both shutter speed and aperture are set by the photographer.

Marquee Tool used in manipulation programs for making regular-shape selections such as ellipses or rectangles.

Matrix metering See Evaluative metering.

Megabyte (MB) Unit for measuring the capacity of computer memory. Equal to 1,048,576 bytes (two to the power of 20 bytes).

Megapixel Measurement of the resolution of a digital camera, equal to 1,000,000 pixels.

MemoryStick Family of removable memory cards used by some digital cameras; pioneered by Sony.

Metadata Text information that describes an image file, such as EXIF camera settings and user-added captions.

Metered manual Exposure mode where, although shutter speed and aperture are set manually by the user, information as to their suitability is provided by the camera's own metering system.

Microdrive Miniature hard drive pioneered by IBM that can be used instead of a CompactFlash memory card in certain digital cameras.

Mired A measurement of color temperature calculated by dividing 1,000,000 by the color temperature as measured in Kelvin. The scale makes it easier to calculate the filtration needed to convert the white balance of an image. Found as an adjustment in some image-manipulation software (particularly during RAW conversion).

Mirror lens A type of telephoto lens; see Catadioptric.

Modeling light Facility provided with most studio flash lights, which uses tungsten lighting to provide a preview of the illumination that the flash will provide. Used when setting up the lights and deciding on their relative strengths and positions.

Moiré Interference lines created when recording a grid-like pattern using the grid-like arrangements of pixels of a camera or scanner.

Monochromatic Single-colored. Used to describe black and white and toned photographs. Is sometimes used to describe any full-color image where there is a very restricted range of colors.

Monopod One-legged camera support. This does not provide complete stability to the camera, but enables slower shutter speeds to be used than would otherwise be possible with a handheld camera. Used widely by sports photographers due to its maneuverability.

Motordrive (or motorwind) Camera facility for taking a number of pictures in rapid succession. The camera continues to take pictures as long as your finger keeps the shutter release down, or until it runs out of working memory.

MultiMediaCard (MMC) Type of removable memory card used by some digital cameras.

Multipass scanning Technique offered by some scanners, where an image is scanned two or more times so as minimize the random noise patterns added to the image during scanning.

Multiple exposure Two or more images superimposed on each other. See Double exposure.

Multizone metering See Evaluative metering.

ND See Neutral density.

Neutral density (ND) Optical or electronic filter that reduces the amount of light reaching the image sensor equally across the entire field of view. It permits longer shutter speeds or wider apertures than would otherwise be possible in the lighting conditions.

NiCad (nickel cadmium) Type of rechargeable battery used in some photographic equipment.

NiMH (nickel metal hydride) Type of rechargeable battery, similar to NiCad, but with easier handling characteristics and better power output.

Noise Unwanted interference in an electrical signal. Seen as a grain-like pattern in dark areas of a digital image. Noise increases with a higher ISO setting is used.

Out of gamut Colors that are not being capable of being displayed in a particular color space. An out-of-gamut warning system is provided with some image-manipulation software so that you can preview the colors that will need to be changed when printing an RGB image in the more restrictive CMYK color space.

Orientation sensor Sensor used in some cameras that can tell when you turn the camera to take a vertical shot.

It stores this information so that it displays the image correctly when played back on the camera LCD or TV screen.

Pan and tilt head Tripod attachment that provides independent movement of the camera in both horizontal and vertical planes.

Panning Moving the camera during exposure to follow a moving subject.

Panoramic An image with an aspect ratio where the width is significantly greater than the height.

Parallax error The difference between what is seen in the viewfinder and what is recorded by the camera. The problem is caused when the viewfinder and lens have slightly different viewpoints, as with the optical viewfinder of most compacts. The difference in framing is only significant at close shooting distances.

Partial metering Type of metering system where the exposure reading is taken from a small area in the center of the field of view. Similar to spot metering, but the reading is taken from a larger area of the image.

Passive autofocus Autofocus system that adjusts the focus of the lens by analyzing the image itself, rather than actively measuring the subject distance. Passive autofocus is used by most digital cameras, and is also known as phase-detection or contrast-detection autofocus.

PC lens Perspective control lens; another name for a shift lens.

PC socket Simple electrical connection socket found on some cameras for conncting a flash to a camera to enable synchronization; widely use for connecting studio flash.

Pentaprism Five-sided prism used in the eyelevel viewfinder of digital SLR cameras. It ensures that the image appears the right way up and the right way round in the viewfinder, correcting for the effects of the mirror and the lens.

Phase-detection autofocus. See Passive autofocus.

PictBridge System for printing direct from a camera to a compatible printer without the need for a computer.

Pincushion distortion Lens fault, or aberration, causing straight, parallel lines at the edges of the image to bow inward.

Pixel Abbreviation of Picture Element. The basic building block of a digital image. The unit of measurement used for determining the resolution of a digital camera or a digital image.

Pixelated A digital image where the individual pixels have become visible. This is usually due to over-enlargement or poor resolution of the original image.

The effect can also be created with manipulation software, using effects such as a mosaic filter.

Plug-in Piece of software that adds functionality to an existing computer program. Plug-ins are available for some image-manipulation programs, providing an increased range of effects and transformations.

Polarizer A filter that transmits only light vibrating in one plane. It can be used to deepen the color of part of a picture, such as the sky. It can also be used to eliminate or reduce reflections on non-metallic surfaces, such as water or glass. It must be rotated in front of the lens until you achieve the desired effect. See Circular polarizer.

Posterization Technique where the number of colors or tones in a photograph is noticeably reduced. Instead of gradual changes in density and color, the picture is made up of bands of identical density, similar to a painting-by-numbers picture. Posterization can be used as a special effect, but it can often be an unwanted side-effect of overmanipulation of an image.

PostScript Computer language used by the print industry for describing images, illustrations, and text.

ppi (pixels per inch) An indication of the resolution of a digital image.

Predictive autofocus Sophisticated autofocus setting where the focus is not only adjusted until the shutter is actually fired, but continues to be adjusted during the delay between pressing the shutter and the picture actually being taken. This enables the camera to focus more accurately on moving subjects.

Prefocusing Manual focusing technique used for moving subjects. The lens is focused on a point or at a distance which you anticipate the subject will move through. The shutter is released when this point is reached.

Prime lens A non-zoom lens—a lens with a single, fixed focal length.

Program exposure Any exposure mode where the camera sets both aperture and shutter speed automatically.

Program shift Program exposure mode where the camera sets the shutter speed and aperture automatically, but the photographer has the option of altering the bias between the two readings to set a preferred shutter speed or aperture without changing the overall exposure.

Quick-release shoe Method for attaching and removing a camera from a tripod. A plate attaches to the camera using the traditional screw-in arrangement; the plate then slots into a recess on the tripod.

Rangefinder Manual focusing system used occasionally on digital cameras (such as the Epson R-D1). The viewfinder

device shows two images seen from slightly different viewpoints, and when the two coincide in the vewfinder, the shot is in focus.

RAW A native file format offered by some digital cameras. Image data is stored in a semi-processed state and must be fully processed on a computer. Enables exposure compensation and color balance to be altered after camera exposure, and typically provides a 48-bit color depth option.

Rear curtain sync Flash feature found on some digital SLRs and flashguns that synchronizes the flash output when the second shutter curtain is about to close. Usually, the flash fires at the point where the first shutter is fully open. The facility gives more natural-looking images when using flash in conjunction with slow shutter speeds.

Redeye Effect often caused by flash where light reflects from the retina, illuminating blood vessels in the subject's eye, producing a red-colored pupil in the image.

Reflected light reading The most usual type of exposure meter reading, where the amount of light reflecting from a subject is measured. An alternative approach is to use an incident light meter.

Reflex lens A type of telephoto lens; see Catadioptric.

Render intent The algorithm used when converting from one color space to another.

Resolution The ability of a lens or digital-imaging device to record fine detail.

RGB Red, Green, and Blue. The three primary colors used by digital cameras, scanners, and computer monitors to display or record images. Digital images employ the RGB color model, but they can be converted to other color models (such as CMYK) using suitable software.

Rim lighting Back-lighting where the edges of the subject are illuminated in such a way to create a halo-like effect.

Ring flash Flash lighting system that uses a circular flash tube attached to the front of the lens to provide even, shadowless lighting. Used in macro photography. Oversized ring flashes are available for studio use, providing donut-shape catchlights when used for portraits.

RIP (Raster Image Processor) Software or hardware used with high-end printers, which enables PostScript images to be printed.

ROC (Restoration Of Color) Software used to help turn back the years when scanning faded slides and prints, developed by Applied Science Fiction and supplied as a feature on some scanners.

RS232 Multi-pin interface port used to connect computers to some digital cameras, printers, and other peripherals.

Rule of thirds Compositional technique where key elements within the image are deliberately placed off-center.

Rubber Stamp See Clone tool.

Scanner Computer peripheral that converts a physical picture into a digital image.

SD (Secure Digital) card Type of removable memory card used by some digital cameras.

Second curtain sync Alternative term for rear curtain sync.

Secondary mirror A mirror used in digital SLRs to project some of the light passing through the lens to exposure and autofocus sensors.

Selftimer Camera facility that incorporates a delay between the pressing of the trigger and the beginning of the exposure. Traditionally used to enable the photographer to appear in the shot. But it can also be useful as as a way of minimizing vibration when using a slow shutter speed with some form of camera support.

Shareware Software that is distributed without cost, on the understanding that if you keep and use the software, you then pay a small fee to the developer.

Shift lens An interchangeable lens available for a small number of digital SLRs and medium-format cameras. The lens provides a limited range of camera movements;including a facility for the lens to be shifted upward to avoid converging verticals when photographing tall subjects. Also known as a PC lens.

SHO (Shadow and Highlight Optimizer) Helps retrieve shadow detail in high-contrast scenes. Developed by Kodak subsidiary, Applied Science Fiction, and used by many scanner manufacturers.

Shutter lag Delay between pressing the shutter and the picture actually being taken.

Shutter priority Semi-automatic exposure mode where the shutter speed is set by the photographer, and the aperture is then set by the camera to suit the metered light readings taken by the camera.

Skylight filter A UV and warm-up filter combined; sometimes left permanently attached to a lens as a way of protecting the front element from being scratched.

Slave Device that triggers a flash unit automatically when another flash is fired. The slave uses a light-sensitive photoelectric cell, and cuts down on the number of cables needed in a studio.

Slow sync flash Technique where a slow shutter speed is used in conjunction with flash. The flash usually provides the main source of illumination, but the ambient light creates a secondary exposure that can be useful in suggesting movement, or for providing detail in a background that would otherwise have looked unnaturally dark.

SmartMedia Type of removable memory card used by some digital cameras.

Snoot Conical or cylinderical lighting accessory that is fitted to studio lights to restrict the spread of light.

Softbox Lighting accessory fitted to studio lights in order to diffuse the illumination. Usually square, octagonal, or rectangular in shape, it produces even lighting over a limited area.

Soft proof Using the computer or camera screen to assess the quality of an image.

Spot meter Exposure metering system where a meter reading is taken from a very small area in the center of the frame.

sRGB RGB color space frequently used by digital cameras, but providing a narrower range of colors than the Adobe RGB space.

Standard lens A focal length of lens roughly equal to the diagonal of the image sensor area. Typically has an efl of around 50mm.

Starburst (Cross-screen filter) Optical filter with an etched grid-like pattern on its surface that causes bright highlights to turn into star-like patterns.

Stop A unit of exposure. Changing exposure by a single stop is equivalent to doubling or halving the amount of light reaching the image sensor. The distance between each of the standard aperture settings (f2.8, f4, f 5.6, f 8, etc) is a full stop.

Stop down To close down the aperture.

Sync speed The fastest shutter speed that can be set on a camera that enables synchronization with the flash. See flash synchronization.

Teleconverter A camera accessory that increases the focal length range of a lens. Teleconverters may be attached to the front of the existing lens, or may fit between the lens and the camera body.

TFT (Thin Film Transistor) High-quality color LCD technology, widely used for viewing monitors on digital cameras.

Thumbnail A small, low-resolution image.

TIFF (Tagged Image File Format) Digital image format used to record files with maximum available detail. Files can be large, although this can be reduced using lossless compression (see LZW).

Time lapse Technique where pictures are taken of the same subject at regular intervals. Automatic camera facility for recording an event that takes place over a long period of time, such as a butterfly emerging from its chrysalis.

Tripod Three-legged camera support.

Tripod bush Threaded socket found on the base of cameras, used for attaching tripods and other accessories.

TTL (Through The Lens) metering Exposure system where the intensity of light is measured through the main camera lens.

Tv (Time Value) Abbreviation used for shutter priority on some cameras.

TWAIN (Technology Without An Interesting Name) Software, similar to a driver, that enables the operation of a scanner from another computer program, such as Photoshop.

Unsharp Mask (USM) A widely used technique used for sharpening digital images. It gets its name from a print industry process, where a soft-focus negative is sandwiched so as to increase edge contrast.

USB (Universal Serial Bus) Standard interface used to connect cameras and other peripherals to a PC.

UV filter Optical filter that absorbs ultraviolet (UV) radiation. Can be used to improve visibility and quality in mountain and maritime landscapes.

Vignetting Darkening of the corners of an image, normally due to lens falloff. Can be corrected in software.

White balance Digital camera system that sets the color temperature for the scene being photographed. This can be set automatically, with the system attempting to set the color so that it looks normal to the human eye. Many cameras also offer manual white balance settings.

Wide-angle converter Accessory that attaches to the end of a lens to increase the angle of view.

WiFi High-speed radio connection system for connecting cameras, computers, and other digital devices over short ranges.

X3 Type of CMOS digital image sensor, invented by Foveon and used on Sigma digital SLRs, where each pixel can take readings for all three primary colors of light.

xD card Type of removable memory card used by some digital cameras.

Zoom A lens with a variable angle of view.

Zoom burst Special effect where the angle of view of a zoom lens is changed during exposing, creating blurred radial lines across the picture.

Zoom ratio Relationship between the shortest and longest focal length setting of a zoom lens. A 30–120mm lens has a zoom ratio of 4:1, or 4×; a 7.2–72mm lens has a zoom ratio of 10:1, or 10×.

Index

Index

Index